THE OTHER BLACKLIST

MARY HELEN WASHINGTON

THE OTHER BLACKLIST

The African American Literary and
Cultural Left of the 1950s

Columbia University Press / New York

Columbia University Press
Publishers Since 1893
New York Chichester, West Sussex
cup.columbia.edu

Library of Congress Cataloging-in-Publication Data
Washington, Mary Helen.
 The Other Blacklist : the African American Literary and Cultural Left
of the 1950s / Mary Helen Washington.
 pages cm
 Includes bibliographical references and index.
 ISBN 978-0-231-15270-9 (cloth : alk. paper) — ISBN 978-0-231-52647-0
(e-book)
 1. American literature—African American authors—History and
criticism. 2. American literature—20th century—History and criticism.
3. Politics and literature—United States—History—20th century.
4. African Americans—Intellectual life—20th century. 5. Right and
left (Political science) in literature. 6. Cold War in literature. I. Title.

 PS153.N5W349 2014
 810.9'896073—dc23
 2013031563

Columbia University Press books are printed on permanent and durable
acid-free paper.
This book is printed on paper with recycled content.
Printed in the United States of America

c 10 9 8 7 6 5 4 3 2 1

COVER DESIGN: Julia Kushnirsky
COVER IMAGE: Charles White, *Let's Walk Together*, from the Charles
L. Blockson Afro-American Collection, Temple University Libraries.

References to websites (URLs) were accurate at the time of writing.
Neither the author nor Columbia University Press is responsible for URLs
that may have expired or changed since the manuscript was prepared.

For the next generation of our tribe:

Darionne Washington
Cordell Washington
Denzel Washington
Cordajah Washington
Rodney Washington
Sean Washington
Azaria Washington
Aliyah Washington
Olivia Kyla Mitchell
Solomon Mitchell
Nathaniel Wilson
Xavier Wilson

May they jump at the sun.

CONTENTS

ILLUSTRATIONS

ACKNOWLEDGMENTS

I HAVE LIVED with this book for such a long time (twelve years, at last count) that the list of people who have sustained me has grown long, but remembering the generosity that has been constant over these years is a great and humbling pleasure. The support of my colleagues at the University of Maryland, College Park—Theresa Coletti, Kent Cartwright, Christina Walter, Bill Cohen, Bob Levine, Howard Norman, Jackson Bryer, Randy Ontiveros, John Auchard, David Wyatt, Martha Nell Smith, Zita Nunes, Merle Collins, Joshua Weiner, Michael Collier, Edlie Wong, Keguro Macharia, Shawn Saremi, and Barry Pearson—has been critical in reminding me that it only counts when you turn your ideas into a physical object. The university has generously supported my work with numerous research grants from the College of Arts and Humanities, including the Distinguished Faculty Research Fellowship and travel grants from the University's Driskell Center for the Study of the African Diaspora. My wonderful year in Los Angeles (2000–2001), supported in part by a fellowship from the UCLA Institute for American Culture, enabled me to jumpstart this project.

My UCLA crew was there at the beginning of *The Other Blacklist* and supplied great moral and intellectual support: Richard Yarborough, who has always been my best scholarly mentor, friend, supporter, and reader,

and Harryette Mullen, who surely knows how important she has been as inspiration, cheerleader, generous colleague, model scholar, and excellent LA cultural tour guide. Gerard Maré led me on several hikes through the mountains of LA, which helped ground me for periods of silent, butt-to-chair work. He and King-Kok Cheung provided me with a beautiful LA retreat house that year, overlooking the canyon, a perfect place to work. I am very grateful for the people at the many institutions where I conducted research, especially to the UCLA institute, the staff at the Schomburg Center for Research on Black Culture, Diana Lachatanere, and Colin Palmer. I have also received support from the University of California, Berkeley, Bancroft Library (especially Susan Snyder), the Moorland-Spingarn Library of Howard University (especially Joellen ElBashir), the Cleveland Historical Society, Western Reserve Historical Museum, Chicago Art Institute, the Chicago Public Library (especially Michael Flug and the staff at the Vivian Harsh Collection), and the Cleveland Public Library.

Thanks to the "bunch of radicals"—Bill Maxwell, Jim Miller, Jim Smethurst, Alan Wald, Barbara Foley, Brian Dolinar, James Hall, and Bill Mullen—who encouraged, critiqued, read drafts, kept me going, and did the research that made mine possible. Mark Pascale (Chicago Art Institute) and Daniel Schulman, art scholars extraordinaire, shared their work on Charles White and made that chapter possible. Doug Wixon steered me to the important relationship between Gwen Brooks and Jack Conroy and shared his research generously. Peter Clothier graciously sent me all of his biographical and critical material on Charles White. Thanks to my excellent readers: Richard Yarborough, Zita Nunes, Cheryl Wall, Christina Walter, Harryette Mullen, Jim Smethurst, Alan Wald, Bill Maxwell, Jean Sammon, and Ponchita Argieard. Cheryl Wall may not even remember, but she read early drafts of the Lloyd Brown chapter and gave invaluable advice. Paul Lauter has been there as a friend and mentor since he roped me into the Yale conference in 1976, and he encouraged and sustained my early work on black women writers. The art historian Professor Patricia Hills read and commented on the Charles White chapter with honesty and brilliant suggestions. The writers Paule Marshall and Alice Walker have always been my friends and supporters, the inspiration for my work

on black women writers, and examples of women who take their lives and work seriously.

Many thanks are due my Books98 crew for their deep respect for the literary word and loving responses to what must have seemed like an interminable writing process: Shirley Parry, Elizabeth (Ginger) Patterson, Jerome (JP) Patterson, Dominique Raymond, Kent Benjamin, Sherry Weaver, Mari Matsuda, Chuck Lawrence, Karen Outen, Yvette Irving, Jim Miller, Shaun Myers, and Kaylen Tucker. To my Dissertation Crew: you are the reason I entered this field back in the 1970s and the reason I am still here: Laura Williams, Shaun Myers, Kaylen Tucker, Shirley Moody-Turner, Schuyler Esprit, Scott Eklund, Christopher Brown, Robin Harris, Daniel Hartley, Anne Carroll, Roberta Maguire, Kathlene McDonald, Nazera Wright, and Kevin Meehan.

For the example and high standards they set by their superb scholarship: Lawrence P. Jackson, Doug Wixon, Gerald Horne, Penny Von Eschen, Kevin Gaines, Stacy I. Morgan, Nikhil Pal Singh, Barbara Foley, Michael Denning, Judith Smith, Jacqueline Goldsby, Robin D. G. Kelley, Dayo Gore, Erik McDuffie, Alan Wald, Jim Smethurst, Bill Mullen, Edmund Gordon, Sterling Stuckey, and Bill Maxwell (who introduced me to the art of trading FOIA files). I am surrounded here in my study with your books stacked up on all sides, urging me to finish.

For moving this project into digital shape, I owe so much to my research assistant and newly minted Ph.D., Dr. Laura Williams. There were others in this past ten years that moved this production along with their scholarly, editorial, and technological expertise: Anne Carroll, Schuyler Esprit, Scott Eklund, Cecelia Cancellaro, T. Susan Chang, and Robin Evans.

For giving me total access to the Charles White papers and thus making the Charles White chapter and the cover of *The Other Blacklist* possible, I owe Ian Charles White big time.

Of the many people I interviewed, none was more inspiring than those intrepid activist-scholars of the Left: Joseph Kaye, Lloyd L. Brown, Phillip Bonosky, Esther and James Jackson, Dorothy Sterling, Ernest Kaiser, Herbert Aptheker, Ruby Dee, Elizabeth Catlett, and Jack O'Dell. Those precious hours interviewing this crew helped me formulate this project. From

1996 until his death in 2001, writer-activist and friend Lloyd Brown sent me weekly letters, talked with me on the phone, sat for long interviews, and retrieved every piece of data I asked for, giving me a much appreciated tutorial in leftist literary and political history. Evelyn Brown Colbert answered every query about her husband, Frank London Brown. William Branch and Ruby Dee gave me valuable information and cautioned me about romanticizing the Left. Ernest Kaiser wrote many letters, all in longhand on yellow legal paper, filled from top to bottom with cautions, critiques, and directives. Thanks to the Chicago folks, Bennett Johnson, Oscar Brown Jr., and Michael Flug, who gave me invaluable direction and help.

To my Detroit crew, David Rambeau, Woodie King Jr., and Ed Vaughn (of the famed Vaughn's Book Store), and Dudley Randall, who pushed me to the left when I was still in the kindergarten of political thought. I still remember the support of my Detroit writing group, Jill Boyer, Toni Watts, Betty de Ramus, Frenchy Hodges, Melba Boyd, and especially Paulette Childress for friendship over the years and the miles. Many thanks also to my Detroit Marygrove College crew for their wise and generous support of the literary arts and often for their spare bedrooms: Sister Barbara Johns, Lillian and Don Bauder, Kathy Tkach, Kathleen Kirschenheiter, Lorraine Wesley Tyler, Frank Rashid, and Rose Lucas. Many thanks to the Boston crew, my mentors in teaching, scholarship, and life: Mary Anne Ferguson, Linda Dittmar, Lois Rudnick, Evelyn Moore, Genii Guinier, Monica McAlpine, and Carolyn Cavenny. And, especially for my dear friend Bob Crossley, who named this book *The Other Blacklist*.

To Alice Walker, for living the principles she writes about. Many years ago, she insisted that I write the introduction to the *Zora Neale Hurston Reader*, arguing, against my resistance, that I was the perfect choice for that project, and her encouragement has made all the difference.

I am sure my editor at Columbia, Philip Leventhal, knows how much I appreciate his warm, wise, and energetic support as this manuscript began the process of becoming a book. He answered every e-mail, even the slightly hysterical ones on Saturday nights, and kept me on track when things seemed to me very uncertain. Whitney Johnson came on board and joined Philip in urging me on to the end.

To my Cleveland crew, my sisters and brothers—Beverly, Myrna, David, Byron, Tommy, Bet, and Bernadette—whose ubiquitous question, "Aren't you finished with that book yet?" prodded me back to my desk many times. Many thanks to my friend and earliest feminist model, Lois Horn: She was my Sula when I was growing up in Cleveland, a woman with agency, power, generosity, and a mind of her own. And to my beloved friend Ponchita Argieard, whose professional training as a social worker, resistance to official institutions, and willingness to explore opened both of us to a love of art, music, and literature. My mother, Mary Catherine Dalton Washington, did not get to see this book come to life, but she was, for all of her eight children, the first and best model of how to stick to a hard project. She gave us unquestioning love, gentle discipline, and an example of extraordinary courage. To Darionne, Cordell, Denzel, and Cordajah Washington: for getting me out of my head and into countless swimming pools, libraries, tobogganing trails, ice-skating rinks, museums, parks, baseball fields, and PTA meetings—I hold you in the deep heart's core.

ABBREVIATIONS

ACAG	American Contemporary Art Gallery
AGLOSO	Attorney General's List of Subversive Organizations
AMSAC	American Society for African Culture
ANLC	American Negro Labor Congress
ANT	American Negro Theatre
APC	American Peace Crusade
AWP	American Women for Peace
AYC	American Youth Congress
BAM	Black Arts Movement
CAA	Council on African Affairs
CCF	Congress for Cultural Freedom
CCNY	City College of New York
CCR	Commission on Civil Rights
CNA	Committee for the Negro in the Arts
Comintern	Communist International
CORAC	Council on Race and Caste in World Affairs
CP	Communist Party
CPUC	Communist Party Unemployed Councils
CPUSA	Communist Party of the United States of America
CRC	Civil Rights Congress

FEPC	Fair Employment Practices Committee
FOIA	Freedom of Information Act
FTP	Federal Theatre Project
FWP	Federal Writers Project
HUAC	House Un-American Activities Committee
HWG	Harlem Writers' Guild
JSSS	Jefferson School of Social Science
LAW	League of American Writers
LSNR	League of Struggle for Negro Rights
MCPFB	Midwest Committee for Protection of Foreign Born
NAACP	National Association for the Advancement of Colored People
NMU	National Maritime Union
NNC	National Negro Congress
NNLC	National Negro Labor Council
SAC	Société Africaine de Culture
SNYC	Southern Negro Youth Congress
SSCAC	South Side Community Art Center
SSWC	South Side Writers' Club
SNYM	Southern Negro Youth Movement
UE	United Electrical, Radio, and Machine Workers of America
UEMWU	United Electrician and Machine Workers Union
UPWA	United Packinghouse Workers of America
UPWU	United Public Workers Union
USIA	United States Information Agency
WPA	Works Progress Administration
WPUC	Women's Peace and Unity Club

THE OTHER BLACKLIST

INTRODUCTION

Thus the debate about the domestic cold war—
including what to call the repression that was part of
it—tells us that while the cold war may be over, its
ghosts linger on. And they continue to haunt.

—VICTOR NAVASKY, *THE NATION*, 2001

RACE, RELIGION, THE 1950S, AND THE COLD WAR

I came of age in the 1950s in the Catholic schools of Cleveland, Ohio, places where religion, the Cold War, and racial integration converged and where the dangers of communism were brought home to Catholic schoolchildren in spectacles as intense and dramatic as miraculous apparitions. We read anticommunist comic books in school, prayed en masse for the conversion of Russia, and feared the Iron Curtain not as symbolic imaginary but as imminent threat. By the time I left the eighth grade, the names of Cardinal Mindszenty, the anticommunist cardinal of Hungary, and Louis Budenz, a former communist, Catholic convert, and paid FBI informer, were as familiar as the Little Flower and Our Lady of Fatima. The institutional Catholic Church in the United States was virulently anticommunist and supportive of Senator Joseph McCarthy, at least partly because religious persecution in communist countries was to the Catholic Church a real and present danger. The U.S. Catholic Church was also highly segregated. There were separate seminaries and convents for black priests and nuns and, though I didn't know it then, there were also behind-the-scenes struggles by black parents and community folk in the 1930s, 1940s, and 1950s that forced U.S.

Catholic schools and organizations to integrate. These disturbances never made it into any histories of Catholic education, but they were a part of black oral history. Since a major support for antiracist radicalism in the 1940s and 1950s was the Communist Party and radicals of the Left, the U.S. Catholic crusade against communism was accompanied by, and helped sustain for all those years during the Cold War, a deep suspicion of civil rights activism.

I was in elementary school when the 1954 *Brown v. Board of Education* Supreme Court decision was made, a landmark decision that not only was pointedly minimized by the Catholic hierarchy of Cleveland but also was used to bolster its anticommunist rhetoric. A month after the *Brown* decision, Cleveland's major Catholic paper, the *Catholic Universe Bulletin*, complimented the court for its temperate choice in not trying to change "long established institutions and traditions *over night*" and for "taking the wind out of the sails of the Communists." Without any suggestion of spiritual concern for the segregated children of God, the editorial chided those "petty politicians" (read: civil rights leaders) for trying to make personal gain out of a "pretended white supremacy" that could not exist, the writer claimed, in "the democratic atmosphere of America." The editorial ends on this triumphal but premature announcement of national black inclusion: The "studied efforts to make second-class citizens of certain minority groups [are] now out of our national picture" (June 1954, 4). No wonder we forty or so black students among nearly one thousand whites at St. Thomas Aquinas School felt we were there on white sufferance, outsiders among the children of Irish, Italian, and Eastern European immigrants, tolerated so long as we learned the important lessons of assimilation and invisibility.

The convergence of the Cold War and integration during my education meant that I imbibed a version of black racial identity filtered through and shaped by Cold War politics. It was an antiblack, self-abnegating form of racial identity based on white tolerance and black invisibility. Black teenagers in the 1950s had so absorbed these "lessons of Jim Crow" that they had adopted a humorous takedown for anyone whose behavior was considered "acting black" (loud colors, loud talking, uncouth behavior) and fell short

of those elusive standards for white acceptance: "You ain't ready," someone would snap, which was shorthand for "You aren't ready for integration." The worst epithet we could use to describe racial discrimination was the anemic term "prejudice"; we didn't know then that race militants and leftists called it, more accurately, "white supremacy," thus making clear that there was an organized racialized structure based on political, economic, and social oppression, not just bad white behavior, and that the goal for black equality was not only changing minds and hearts but challenging institutions.

I begin with these personal reminiscences to highlight the ways that a deep animosity to black civil rights struggles ran like a vein throughout U.S. Cold War culture, preparing even those of us who benefited the most from civil rights militancy to be stand-up little anticommunists. The Cold War strategies that were used to undermine civil rights and civil rights activists are perhaps most obvious in the files of the FBI, where blacks and civil rights activists were the targets of FBI probes. The "equation between the red and the black" (Caute 1978, 167) was so fixed in the mind of J. Edgar Hoover that he recommended that the writer Richard Wright be kept on the Security Index because his "militant attitude toward the Negro problem" signified a weak commitment to anticommunism (Robins 1992, 285). Similarly, the FBI declared the once-acceptable James Baldwin "dangerous" in 1960 "as he became more vocal in criticizing segregation" and had participated in a rally to abolish the House Un-American Activities Committee (HUAC) (Robins 1992, 346). People who were called before "loyalty boards" were routinely interrogated about their position on racial equality in ways that assumed civil rights work was a sign of disloyalty, a typical question being: "Do you think an outspoken philosophy favoring race equality is an index of Communism?" (Caute 1978, 283).

THE BLACK-RED NEGRO

Yet until the recent outpouring of new scholarship, the Cold War was figured as white in the national imaginary and was routinely resegregated by Cold War scholars, who produced versions of the Cold War that featured the *white* Hollywood Ten, *white* Red Diaper babies, *white* HUAC

hearings, *white* red feminism, and a *white* blacklist.[1] On the other side of this cultural divide, the Black Popular Front—the "Other Blacklist" of my title—has almost always been marginalized in black literary and cultural studies. Though nearly every major black writer of the 1940s and 1950s was in some way influenced by the Communist Party or other leftist organizations, and although the Left was by all accounts the most racially integrated movement of that period, the terms "U.S. radicalism," "left wing," "Old Left," "New Left," and "communism" came to signify white history and black absence.

Blacks came to the Communist Party through various channels: through unions, labor organizations, and grassroots antiracist work; through the WPA or anticolonial work like the campaign against South African apartheid; through community and cultural groups like the South Side Community Art Center in Chicago; and through the peace movement. As the witch hunts of the McCarthy Senate investigations and HUAC geared up, every kind of legitimate dissent, including teachers who tried to institute Black History Week in schools and unions that did antiracist work, was targeted as "subversive." There may indeed have been reasons to oppose communism, but the war on radicalism that eventually turned into full-scale McCarthyism was ultimately "not about spies or celebrities or even grand inquisitors," as Mike Marqusee so clearly shows in a 2004 review in *The Nation*. In Marqusee's catalogue of Cold War targets, anticommunism was organized to obstruct any avenue of possible dissent: "factories and offices, schools, local libraries, PTAs. Radio stations. Comic books. TV series. Advertisements." And, I would add, it was a war against black resistance. In the 1940s, when the leftist Esther Jackson and her husband, the black communist James Jackson, organized the Southern Negro Youth Movement in Birmingham, Alabama, to fight segregation and black poverty, their work was dismantled by the machinations of both the Ku Klux Klan and the FBI, which had declared war on civil rights. As Esther retorts, "We were fighting against white racist brutality in Birmingham, not taking orders from Moscow."[2]

No one could have convinced me as a twelve-year-old Catholic schoolgirl or even as a twenty-something graduate student in the early 1960s that

communism meant black people any good. But if I had listened carefully to the adults, I might have overheard them talking of unions, Paul Robeson, and civil rights. *The Other Blacklist* is my attempt to finally overhear those long-forgotten, repressed conversations. They reveal important and elementary facts about the Communist Party's positions on race that bear repeating: "The CP was the only major American political party that formally opposed racial discrimination; it devoted considerable resources to an array of anti-discrimination campaigns; and it created a rare space for Black leadership in a multiracial institution" (Biondi 2003, 6). The CP signaled its commitment to black liberation as early as 1928, at the Sixth Congress of the Communist International (Comintern) in Moscow, when, with the encouragement of black activists, the CP made a statement in support of black rights to full equality. With its slogan of "self-determination in the Black Belt" focused on black equality struggles in the U.S. South, the Party embraced both black nationalism and fought against white supremacy, a dual project rooted in the belief that "antiracism should be an explicit component of the anticapitalist struggle" (4).[3] The CP's antiracist history was the catalyst for the writer-activist Julian Mayfield's decision to join the CP while in his early twenties. As he recalled in a 1970 interview: "The Communist Party, it seemed to young people, offered the best advantage, the sharpest weapon by which to attack the society. . . . [So] we joined the most powerful, radical organization we could" (Mayfield 1970). For Mayfield, like many other black activists, that choice was made primarily because of the CP's commitment to racial struggle.

Given the political history of the Communist Party as far back as the 1920s, it is clear why the CP attracted blacks, especially during the Depression. In industrialized cities, where blacks were at the bottom of industry's discriminatory structures and were trying to organize themselves as workers, the militant efforts of the communists to unionize workers, stop evictions, protest police violence, integrate unions, and give positions of authority to blacks in the unions must have seemed like beacons of light. The CP gained black support and black confidence in the rural South because of its work organizing the Sharecroppers Union and in the northern industrial cities because of its organizing of the local CP Unemployed Councils, which

fought for welfare relief and against evictions. Starting in the 1920s, the CP coordinated with, joined, or supported a range of black organizations: the American Negro Labor Congress 1925), the League of Struggle for Negro Rights (which replaced the all-black ANLC in 1930), the National Negro Congress (1935–1947), the Council on African Affairs, the Southern Negro Youth Congress (1937–1949), the American Youth Congress, and the Civil Rights Congress (1940–1955). The Chicago community activist Bennett Johnson described the Party as an almost ordinary aspect of the political landscape in Chicago, second only to the policy racket as the most popular organization in Chicago's black communities in the 1930s: the policy racket took care of black entrepreneurs, and the Communist Party took care of the people who were playing the numbers. Horace Cayton wrote in *Black Metropolis*, his sociological study of black Chicago, that in the 1930s the Party was such an accepted organization that when a black family feared an eviction, it was not unusual for them to tell their children to run and "find the Reds" (cited in Storch 2009, 113).

The Left played such an important part in black struggle during the 1940s that scholars refer to that period as the Black or Negro Popular Front to indicate that for blacks the classic period of the Popular Front (1935–1939)[4] extended well into the next decade and beyond (Biondi 2003, 6). I extend the period of the Black Popular Front to 1959 because the artists in my study continued to work collectively on the Left in Popular Front–style organizations. With the impetus of World War II and the black militancy it encouraged, the Left gained a much-needed boost in the fight against racism. The war provided a nice set of ideological slogans—represented best by the *Pittsburgh Courier*'s "Double V" campaign (victory against fascism abroad and victory against racism at home) and the "Don't Buy Where You Can't Work" campaigns. But it was the CP and the black labor Left that supplied the armor for those slogans. Leftist labor leaders—like Ferdinand Smith of the National Maritime Union; Ewart Guinier of the United Public Workers Union; leaders of the Communist-led United Electrical, Radio, and Machine Workers of America; the Left-led National Negro Congress; and the leaders of the National Negro Labor Council, Coleman Young (mayor of Detroit from 1974 to 1993) and Nicholas Hood

(who would serve as a Detroit councilman for twenty-eight years)—led the struggle for black jobs in war production and in unions and made fair employment practices central to their political agendas. Black leftists also kept watch on the unfolding of events abroad as Asian and African states gained independence, a connection that many scholars see as one of the ways internationalism stimulated black American militancy. Beyond the war, African American civil rights activists tried to internationalize black struggle with petitions to the United Nations: the NAACP's 1947 *An Appeal to the World* and the Civil Rights Congress's 1951 petition, *We Charge Genocide*,[5] both of which offered a powerful critique of America's institutionalized racism. These were left in the dustbin: the U.S. State Department refused to allow these petitions to be presented to the world body. Nonetheless, these strategies show that, in Biondi's (2003, 8) words, "the left's wartime rhetoric, like mainstream civil rights rhetoric, cast racial justice in the national [and, I would add, international] interest." In his commencement address to Vassar College in 1945, the leftist actor Canada Lee called this kind of left-wing political work "equality with significance" (Biondi 2003, 21).

THE BLACK LEFT: DOWNTOWN CLEVELAND, 1952

In 1952 in Cleveland, the National Negro Labor Council held its second convention not far from the parochial school I attended. Coleman Young, the NNLC's executive secretary, and Nicholas Hood, its president, addressed the convention with stirring speeches about the NNLC's spectacular labor victories. Young recounted the story of the capitulation of the Sears Roebuck Company, which had, for the first time, begun to hire black workers "in all categories" and to include blacks in all its job-training courses. Hood's speech, on the other hand, emphasized the internationalist focus of the civil rights movement, linking the struggles of black labor in the United States with the fight in South Africa against apartheid and

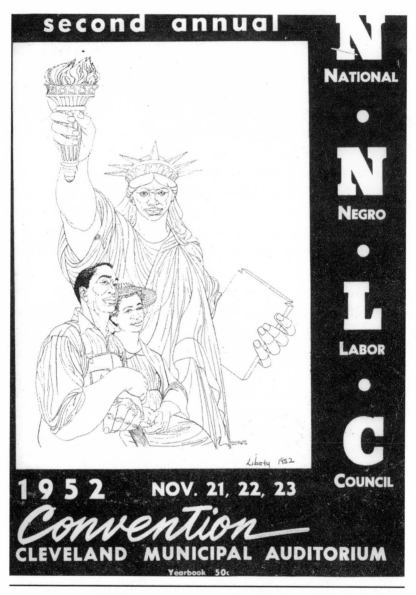

FIGURE 0.1. Poster by Charles White for the second convention of the National Negro Labor Council, Cleveland (1952).

Source: C. Ian White and the Charles White Archives. © Charles White Archives.

the movements for democratic and economic rights in "Asia, Africa, the Middle East, [and] Puerto Rico" to "End White Supremacy Rule" (quoted in Gordon 1953, 14).[6] The delegates approved a program that called for a jobs campaign "to get jobs for Negroes in all industries," to get one million signatures on the petition of the Fair Employment Practices Committee, and to include "FEPC clauses in union contracts." They also approved continuing the fight for repeal of the repressive Smith and McCarran laws, reaffirmed "solidarity with liberation movements of colonial peoples," and called for "special actions in the interests of Negro women workers." The NNLC got even more specific about antiblack labor practices, with its delegate Vicki Garvin reminding the participants that there was full-scale discrimination against blacks in industry, offices, department stores, public utilities, and in the emerging commercial airline industry. The policies of the airlines meant that they would hire no black pilots nor black flight attendants (then called "stewardesses"), pushing many of the NNLC's 1,500 delegates to leave the convention center and stage "a mass job demonstration at Cleveland's downtown airline ticket counter" (Lang 2009, 172). The NNLC also made sure its convention produced a radical cultural program. As one of the invited guests at the Cleveland convention, Paul Robeson sang to the 1,500 delegates. The left-wing visual artist Charles White was commissioned to do the drawing for the convention program, and he did not disappoint. His drawing featured the Statue of Liberty as a black woman holding the torch above a black couple, the man in overalls and the woman in the peasant dress of a worker. In his signature style, White enlarged the forearms of Liberty and of the couple to suggest their strength. Their faces look to the future with determination and expectancy. From the convention program designed by a left-wing artist to the speeches by Hood and Young, the entertainment by Robeson, its internationalist perspective, and its civil rights demonstration against the airlines' racism, the NNLC's 1952 convention was the epitome of a militant, muscular, and modern civil rights agenda. Formulated and carried out in downtown Cleveland at the Public Auditorium, the convention took place just a few miles from where I was learning that the fight to gain black economic and political equality was a communist plot.[7]

THE BLACK LEFT IN AFRICAN AMERICAN
LITERARY HISTORY

In the 1960s and 1970s, my anticommunist education continued at the universities where I was trained in literary criticism via the New Critical bibles of Brooks and Warren's *Understanding Poetry* and *Understanding Fiction*. These Cold War–influenced productions assured their readers that the literary or cultural object could only be judged by its own internal formal qualities and must be separated from "outside" influences like historical or political contexts. So I recognize the New Critical biases in the stunning absence of Cold War history in many African American literary and cultural histories and anthologies. To take the most well-known and influential anthology as an example, the *Norton Anthology of African American Literature* (Gates and McKay 2004) labels the period from the 1940s to the 1960s as "Realism, Naturalism, and Modernism," as though these formal literary categories emerged full-blown, at the height of the Cold War, detached from the ideological and political pressures of that period. Furthermore, this labeling of a period in purely aesthetic terms is anomalous in the *Norton Anthology*; all of the other periods in the anthology—"The Literature of Slavery and Freedom," "Literature of the Reconstruction to the New Negro Renaissance," "Harlem Renaissance," and "The Black Arts Movement"— are anchored in their political, historical, social, *and* literary contexts. That structure breaks down when the editors confront the Cold War period, a pattern of cultural amnesia that is understandable given the normalization of anticommunism in U.S. culture, the demonization of the Communist Party, and the tight reins of secrecy maintained by people who were subjected to blacklisting and McCarthyism.

The *Norton* essay does catalog many of the political and social issues (atomic explosions, fascism, World War II, social revolution, labor issues, the fall of colonialism, and the civil rights movement) that the editors present as a part of the "sprawling mess of raw material" that writers drew from, but it does not present these social issues as influencing aesthetic form. The only recognition of the *politics of aesthetics* is the essay's denunciatory view of

social protest as producing the "brutal realism and naturalism" of the work of Richard Wright. Distancing Ralph Ellison from his own Marxist and procommunist involvements, the *Norton* essay elevates him as the figure of "artistic maturation," whose highly acclaimed 1952 novel *Invisible Man* "unburdened [the novel from] the narrow naturalism" of Wright and led black narrative into the higher realms of modernism. This critical narrative normalizes 1950s New Critical assumptions that literature was supposed to be preserved from ideology and dismisses the socially conscious literature of the 1930s and 1940s, in the words of the *Norton* editors, as "an exhausted mode." Consider that during this political moment in the 1950s black writers and intellectuals were being intimidated, arrested, interrogated, indicted, jailed, deported, and blacklisted. Yet the absence of any reference to the blacklist, the Cold War, the Popular Front, the assault on Paul Robeson, W. E. B. Du Bois's arrest, the HUAC investigations, the silencing of Langston Hughes, the denial of passports to Robeson and Du Bois (among others), the labeling of every civil rights organization as subversive (including the NAACP), and FBI censorship[8] both misses the richness (and messiness) of the literary and political debates of this period and consolidates a Cold War narrative that ultimately marginalized black literary history.[9]

The Other Blacklist proposes a counternarrative that begins with the Black-Left history that is missing in the *Norton*. Besides a kind of cultural and philosophical compatibility between communism and African American literary culture that scholars like Alan Wald, James Smethurst, William Maxwell, and Brian Dolinar, Aaron Lecklider, and Cheryl Higashida (to name a few) have so thoroughly documented, Wald maintains that the Left offered black writers the institutional support that they could get nowhere else in white America: the publications and clubs and committees that were created for black writers (at least in part) by Party members and with Party support, spaces in which "Black writers came together to formulate ideas, share writings, make contacts, and develop perspectives that sustained their future creative work" (Wald 2001, 267). As Wald (and many others) concludes, until the late 1950s, these left-wing clubs, schools, committees, camps, and publications "constituted the principal venues" for the production of African American literary culture. As James C. Hall (2001,

19) insists, "no adequate history of post–World War II African-American cultural accomplishment can be undertaken without a full accounting of the psychic, political, and other costs of the cold war."

Focusing closely on six artists who were aligned with the Left, *The Other Blacklist: The African American Literary and Cultural Left in the 1950s* proposes an alternative literary/cultural history, one represented by debates, conferences, symposia, institutional affiliations, political commitments, FBI investigations, and government spying networks. I view this project as a more inclusive, dynamic, and dialectical method of doing cultural and literary history, one that is committed to documenting, though not uncritically, the central role of the Communist Party and the Left in the shaping of mid-twentieth-century African American cultural history and aesthetics. The six figures in my study—the novelist and essayist Lloyd L. Brown; the visual artist Charles White; the playwright and novelist Alice Childress; the poet and novelist Gwendolyn Brooks; the novelist Frank London Brown; and the novelist, essayist, and activist Julian Mayfield—represent a range of experiences with the Left. Although Lloyd Brown and Julian Mayfield are the only self-identified members of the CP in this study, all these figures were at some point active with leftist organizations. Lloyd Brown, Julian Mayfield, and Charles White were openly and organizationally involved with the Communist Party of the United States; like White, Alice Childress was actively involved with, though not necessarily an official member of the Party; Gwendolyn Brooks, who is almost never connected with the Left, was a part of the left-wing Chicago Black Cultural Front in the 1940s and 1950s; Frank London Brown was also involved with the Left in the 1950s, mainly through his radical union work in the left-wing United Packinghouse Workers Union. By extending the period of the Black Popular Front to include the 1950s and placing these artists squarely within Black Popular Front politics, I show how, through their writing, painting, and activism, they carried the resistant traditions of the Black Popular Front of the 1930s and 1940s into the 1950s and became a link to the militant politics and aesthetics of the 1960s and 1970s. *The Other Blacklist* aims, therefore, to challenge the ideas, assumptions, and practices of contemporary African American anthologies that tend to minimize or exclude altogether the role

of the Left and the Communist Party in African American cultural production. Rather than reduce the literature of the 1950s to aesthetics, I read the 1950s as a dynamic, exciting period of debate, a moment when the Black Left continued to work despite the pressures of the Cold War, and I intend to acknowledge, though not uncritically, the central role of the Communist Party. This, then, is the question that *The Other Blacklist* tries to answer: *What happens if you put the black literary and cultural Left at the center of African American studies of the Cold War?*

THE BLACK NATION THESIS: POLITICS AND AESTHETICS, TOGETHER AGAIN

First, it becomes necessary to acknowledge the central intellectual role of the CP in black literary studies, beginning with what the intellectual Left called the "black belt" or "black nation" thesis. In 1928, at the Sixth World Congress of the Comintern, the international Communist Party considered the question: Do black people in the United States constitute a nation, a national minority, or a nation in the "black belt" South and a national minority in all other regions? It passed the resolution asserting that African Americans in the black belt (the southern states) of the United States do constitute an oppressed nation with a right to self-determination. Communists offered "Self-Determination for the Black Belt" first as a slogan for organizing efforts in both the North and the South, which eventually helped the Party establish the Alabama Sharecroppers Union in 1931 and organize steelworkers and longshoremen in some southern cities.[10] But the idea of black nationhood also appealed to African American writers, including Langston Hughes, Lloyd L. Brown, Alice Childress, Richard Wright, Ralph Ellison, Margaret Walker, and Chester Himes, all of whom, with varying degrees of enthusiasm, embraced some aspects of the "black nation" thesis. Richard Wright's writings perhaps best illustrate its appeal to writers and intellectuals. In his 1937 manifesto, "Blueprint for Negro Writing," Wright gave what is probably the most

compelling and coherent statement of the appeal of the nation thesis for black writers. Insisting that black writing must focus on the folklore, customs, and vernacular traditions of the black masses, Wright urged black writers to embrace the nation thesis to discover and represent "the collective consciousness of the race" found in these traditions—and also to do so because of their potential to inspire political action:

> In the absence of fixed and nourishing forms of culture, the Negro has a folklore which embodies the memories and hopes of his struggle for freedom. Not yet caught in paint or stone, and as yet but feebly depicted in the poem and novel, the Negroes' most powerful images of hope and despair still remain in the fluid state of daily speech. . . . Negro folklore contains, in a measure that puts to shame more deliberate forms of Negro expression, the collective sense of Negro life in America.
>
> (1382–1383)

Black leftist artists increasingly represented black vernacular forms in their texts, including folklore, folk speech, and celebrations of jazz and the blues. Both Wright and Ralph Ellison—as well as all the writers examined in *The Other Blacklist* and most of the black writers at mid-century—incorporated black vernacular forms in their work as representative of a larger effort to embody and represent a unified and oppositional black community. While the Communist Party's notion of an African American nation rising up within the American South or forming a collective oppositional force was never a realistic political goal (and in fact was ridiculed and rejected by many African Americans), the potential of an organized black community, particularly one that celebrated black culture and history, excited many of the leading black intellectuals of this era. From Margaret Walker to Ralph Ellison, black writers found their literary direction in reclaiming the "folk." According to the cultural historian Robin D. G. Kelley, these Marxist ideologies that valued the black working class, recognized the aesthetic value of black "folk" culture and black history, and celebrated traditions of black resistance became both a vehicle for black communist political operations and, most importantly for black writers, an aesthetic imperative (1996, 109).

Of course, as Kelley also notes, African Americans "brought their [own] grass-roots, race-conscious cultural traditions to the Party," including their deep religious beliefs—and, yes, the Party may have tried to transmute every expression of black culture into communist revolutionary significance, which writers often resisted. But the presence and power of the nation thesis for black writers is clear. I point this out as a response to the claim of African American literary historians that "during the forties and fifties, as previously during the Harlem Renaissance and earlier periods, there was no consciously formulated black aesthetic" (Hill et al. 1988, 1078). From the 1930s to the 1960s, that is, for a substantial part of the twentieth century, African American literary criticism and practice was, in fact, significantly influenced by the formulas of the Marxist-Leninist nation thesis and its focus on black folk culture as the basis for a national, oppositional culture.

THE *BLACK* BLACKLIST

Besides a philosophical compatibility between communism and African American literary culture, which is especially obvious in the ways that the black nation thesis was deployed for aesthetic purposes, the Left, as Alan Wald has observed, offered black writers the institutional support that they could get nowhere else in white America. Weaving back and forth between Chicago and New York, *The Other Blacklist* revisits scenes of major black leftist activity in the 1950s, where the subjects of my study encountered that left-wing support system, Lloyd L. Brown and Alice Childress, in New York, and Gwendolyn Brooks, Frank London Brown, and Charles White, along with artists and activists of the South Side Community Art Center, in Chicago (although White was fairly peripatetic, spending time in Mexico and New York before settling in California). During the 1950s, Black Popular Front activists organized and worked with freedom structures—like Robeson's Harlem-based radical newspaper *Freedom* (1950–1955), which covered arts, culture, and politics on the national and international stage and reported extensively on the government repression of radicals and radical

thought, with the goal of developing a politically informed and resistant black community. The arts-and-culture-centered Committee for the Negro in the Arts (1947–1954) produced plays by black writers at the progressive interracial Club Baron theater, at 437 Lenox Avenue at 132nd Street, and these plays might then be reviewed by Lorraine Hansberry in the left-wing newspaper *Freedom* and by the communist Lloyd Brown in the Marxist journal *Masses & Mainstream*, and proceeds from the box office might go to benefit the left-dominated Civil Rights Congress. Black Popular Front activists founded the progressive American Negro Theatre (where leftist artists including Alice Childress, Sidney Poitier, Harry Belafonte, Ossie Davis, and Ruby Dee got their start) and produced plays, some with subversive racial potential. The militant internationalist woman's organization Sojourners for Truth and Justice (1951–1952) protested against the injustices to black women at the hands of the criminal justice system (Gore 2011, 65–89). In 1951, in a second-floor loft at 125th and Seventh Avenue in Harlem, the white communist Philip Bonosky and the black leftist John Killens formed the Harlem Writers' Workshop (later the Harlem Writers' Guild), which encouraged and helped publish progressive black writers. Black leftists spent time at recreational spaces such as Camp Unity in Wingdale, New York, the first interracial adult camp in the United States, and Camp Wo-Chi-Ca, an interracial coeducational summer vacation camp in Port Murray, New Jersey, both of which sponsored black cultural events. Black visual artists showed their work at galleries such as the socially conscious ACA Gallery, operating then at Ninety-First Street and Madison Avenue, which featured the work of Charles White and Jacob Lawrence at a time when mainstream art galleries did not show black art. Black leftists were enrolled in left-wing educational institutions including the George Washington Carver School in Chicago, the Sam Adams School in Boston, the Jefferson School in New York, the California Labor School in San Francisco, and the People's Educational Center in Los Angeles. Many black leftists did work with the CP and in many cases did the dangerous work of defending leftist activists indicted under the Smith and McCarran Acts. When mainstream literary publications completely ignored black culture and black life, the Marxist, leftist, and communist journals covered, theorized, and critiqued African

American cultural production: *New Masses*, *Masses & Mainstream*, the *Sunday* and *Daily Worker*, *Contemporary Reader*, and *Negro Quarterly*. Left-wing and Marxist publishers like International Publishers and Masses & Mainstream Press published these writers when the white mainstream, and even white left-wing liberals, would not.[11]

Given this history, I take the liberty of extending the duration of the "Black Popular Front" or "Black Cultural Front," or Negro Cultural Front, to highlight the continuing influence of the black literary, cultural, and political Left throughout the 1950s. These were the spaces, which until the late 1950s, as Wald (2001, 267) rightly claims, "constituted the principal venues in which many Black writers came together to formulate ideas, share writings, make contacts, and develop perspectives that sustained their future creative work."[12] In other words, during the Cold War, when blacks were not even a blip on the white American cultural radar, it was in these leftist spaces of the Black Popular Front that African American literary culture was debated, critiqued, encouraged, performed, published, produced, and preserved.[13]

THE BLACK POPULAR FRONT: RACE RADICALISM IN THE 1950S

We have to understand that the U.S. government, with its Cold War mindset, was not only in the business of trying to repress the Left; it was also shaping debates over race, integration, and civil rights.[14] Several excellent studies of the civil rights years expose the role of government intervention in deliberately constructing a Cold War narrative of racial progress that undermined civil rights struggles.[15] A case in point is the fate of the NAACP petition to the United Nations in 1947, "An Appeal to the World," inspired and led by W. E. B. Du Bois, asking that body "to redress human rights violations the United States committed against its African-American citizens."[16] The petition was rejected after U.S. opposition—which included Eleanor Roosevelt—because terms like "human rights," "violations of the

United States," and "African American citizens" made it too radical for government sensitivities. The petition, however, became "an international sensation" when the Soviet Union demanded an investigation. But the State Department's response to what was considered both a Cold War win for the Soviets and a black eye for America was not action but pamphleteering. In the early 1950s, the U.S. Information Agency put out a pamphlet, *The Negro in American Life*, in order to portray American history as a story of democracy at work overcoming the evils of the past.[17] The pamphlet presented a "carefully crafted" portrait of race relations in the United States: black and white children were pictured in totally integrated classrooms and housing projects. In contrast to past evils like slavery, "Negroes," it claimed, were now "large landowners," "wealthy businessmen," "physicists," "metallurgists," and "chemists." Moreover, the pamphlet emphasized, education was lifting up the Negro, making him "more worthy of equal treatment." The pamphlet's rosy view of American race relations in the 1950s is depicted in its final picture of an integrated housing project. In what is a clearly staged photograph, black and white couples and their children are shown talking together amicably in someone's backyard, with the success of the integration project underscored by the caption beneath the picture: "These neighbors in a housing project, like millions of Americans, are forgetting whatever color prejudice they may have had; their children will have none to forget" (Dudziak 2002, 54).

The 1954 *Brown v. Board of Education* Supreme Court decision, which was argued, at least partially, on the basis of the psychological harm of racism to black children, was essential in the mass marketing of this story of racial progress.[18] As several contemporary studies of the *Brown* decision show, the focus on "stigmatic harm as the essence of Jim Crow" shifted the focus of civil rights struggles away from the more militant economic- and labor-based civil rights struggles of the 1940s. Risa Goluboff's study *The Lost Promise of Civil Rights* details that shift, showing that "The NAACP's victory in *Brown* fundamentally changed the scope of civil rights lawyering and the constitutional imagination" (2007, 238). What that meant is that racism as psychological harm replaced the Left's emphasis on labor, unions, and economic inequality; the young student, rather than the adult

worker, would become the "central figure of American civil rights" (250). As this conservative 1950s racial discourse[19] continued to promote a focus on signs of "racial progress," the race militancy of the Left would seem too radical, even "un-American," and those leaders on the Left who continued to pursue a more radical attack on state-sponsored racial inequality would be harassed and blacklisted.

Conservative integrationist narratives had filtered down into national discourse on civil rights even before *Brown*. In 1950, the editors of *Phylon*, a journal of black literature and culture published at the historically black Atlanta University, sent out a questionnaire to major black writers, college professors, and intellectuals about the state of black literature and published those responses in the December 1950 issue as a symposium on race and literary representation. The third question on the questionnaire suggested that the editors were fishing for a State Department–approved answer that would minimize racial conflict: "Would you agree with those who feel that the Negro writer, the Negro as subject, and the Negro critic and scholar are moving toward an 'unlabeled' future in which they will be measured without regard to racial origin and conditioning?" Several of the twenty-three respondents said that black writers and intellectuals could reach that "unlabeled future" and achieve what was then widely referred to as "universality" by minimizing blackness, race issues, and civil rights demands. Several even argued that "universality" required eliminating black characters and racial themes altogether, praising writers like Frank Yerby and Willard Motley for making their main characters white.[20] Except for the respondent Ira D. A. Reid, who taught at Haverford College, all the professors in the symposium, under the protocols of state-sponsored racial segregation, were employed at black institutions. Not one of them acknowledged, however, that their own positions at these racially segregated institutions undercut the "race progress" narrative they promoted.[21] In a telling sign of Cold War pressures, some of the respondents reproduced, almost verbatim, the official State Department line that racism was "a fast-disappearing aberration, capable of being overcome by talented and motivated individuals."[22]

The symposium respondents were not alone in promoting conservative race politics. Hollywood's "Negro problem films" of the late 1940s and early

1950s, like *Intruder in the Dust* (1949), *Home of the Brave* (1949), *Pinky* (1949), *Lost Boundaries* (1949), and *No Way Out* (1950), continued the practice of focusing on the psychological anxieties caused by racism and by holding up highly successful "Negroes" (the black doctor in *No Way Out* and *Lost Boundaries*, the nurse in *Pinky*, the black entrepreneur in *Intruder in the Dust*, and the soldier and soon-to-be-businessman in *Home of the Brave*) as signs of how racism could be overcome. In each of these films, race problems are ameliorated by the interventions of a nonracist white person and a highly competent black person tackling "the Negro problem" in his or her own individual life. In contrast to the Left's analysis of racism as an ideology rooted in systems of slavery, colonialism, and imperialism, conservative race texts presented race problems as psychological problems of individuals. The Cold War historian Penny Von Eschen (1997, 156–158) meticulously documents how Cold War politics helped initiate this "powerful rewriting of 'race' in popular African American [and American] discourse" by shifting racial discourse from an analysis of institutional and historical racism to an emphasis on the psychological and sociological meanings of race. By keeping the focus on U.S. race problems as rooted in colonialism and imperialism, the radical Left refused to sanction the State Department's propaganda that racism was rooted in individual prejudices and needed only a larger dose of American democracy for its total annihilation. Von Eschen argues that it was in the interest of the United States to dissociate U.S. race problems from colonialism and imperialism. The United States could then shift the spotlight away from the role of American racism as part of a global problem of racism and domination and turn it into a "domestic" problem, one easily overcome with the application of American democratic values. Cold War international politics, as well as *Brown*'s "remaking of Civil Rights," thus helped produce a domesticated version of race, one disconnected from the struggles of other colonized peoples, and only a minor disturbance in the triumphal story of American democracy.[23]

My intention in *The Other Blacklist* is to show how these artists on the Left—Lloyd Brown, Alice Childress, Charles White, Frank London Brown, Gwendolyn Brooks, and Julian Mayfield—through their writing, visual art, and activism disrupted these State Department–authorized ver-

sions of race, racism, and integration. In their literary and visual texts they challenged those conservative race narratives through three major representational choices: they focused on the radioactive subject of racial violence as a product of white supremacy; they connected U.S. race issues to international systems like colonialism; and they represented the Left, including the Communist Party, in complex ways—often, but not always, positively. Like the proletarian artists of the 1930s, the artists I will discuss in this book deliberately chose to document highly controversial racial subjects—not sufficiently "universal" by conservative 1950s norms—that allowed them to produce a critique of white supremacy and white racist violence. Mayfield recalls the "big" Left political campaigns of the late 1940s and early 1950s that became the subjects for leftist writers and artists: the Trenton Six, six men sentenced to the electric chair in 1949 for killing a white man in Trenton, New Jersey, despite a lack of evidence and evidence of a frame-up and coerced confessions; the Martinsville Seven in Virginia, seven young black men who were tried and eventually executed for the rape of a white woman; the 1950 Rosa Ingram case, which involved a mother and her two sons on trial for killing a white man who tried to sexually assault Mrs. Ingram; Willie McGee, on trial and executed in Mississippi in 1951 for allegedly raping a white woman with whom he was sexually involved. These were some of the stories highlighted by the leftist writers and visual artists in my study, stories that allowed them to pursue their critiques of antiblack, class, and gender violence. Because they understood race in a global as well as a domestic context, the artists in my study often represented these issues as part of an international process: Childress's 1951 play *Gold Through the Trees*, for example, juxtaposes the story of the Martinsville Seven against the 1948 antiapartheid South African Defiance campaign, explicitly exposing the international implications of white supremacy.

The visual artist Charles White chose as his subjects "the everyday, ordinary, working-class people, the most African looking, the poorest, the blackest in our ranks," which countered the images of assimilation offered by the State Department. Besides his magnificent murals of African American culture, White produced in the 1940s and 1950s powerful renderings of Rosa Ingram and her sons and the Trenton Six. These were published

only in leftist publications like *Freedom*, the *Daily* and *Sunday Worker*, and *Masses & Mainstream*. He continued that kind of politically focused art in the 1970s, donating his artwork in support of the campaign to free Angela Davis. Lloyd Brown's *Iron City* recounts the almost entirely unknown story of the quadruple lynching of two black couples in Monroe, Georgia, in 1946 and the story of the violent campaign to force blacks from jobs on the railroads; Frank London Brown's 1959 first novel, *Trumbull Park*, centers on the real-life struggle to integrate public housing in Chicago in the mid-1950s. Hansberry's and Brooks's earliest poems were about lynchings, and Brooks's 1953 novel *Maud Martha* is deeply involved in issues of racial struggle, women's independence, class, and labor rights; Brooks's 1960 volume of poetry *The Bean Eaters* includes poems about the Emmett Till murder, the integration of Little Rock Central High School, and housing segregation.

Childress, White, Brooks, Lloyd Brown, London Brown, and Mayfield all represented communism or the Left as a complex, meaningful, and often effective force in African American life and were thus able to draw on leftist forms and left-wing radical critiques in their expressive work. They experimented with political drama, documentary montage, black cultural forms, political satire, and theatrical genres like the Living Newspaper and the Living Theater, which had been popular proletarian cultural forms of the 1930s. They were not afraid to address issues of class, gender, and race that had been declared politically subversive during the Cold War. I maintain that these resistant notions of black subjectivity, which countered the conservative constructions of race we see in the reactions to the 1954 *Brown v. Board of Education* decision, in the *Phylon* symposium, *and* in my Catholic school instruction, are the signal achievement of these artists on the left.[24]

READING FBI FILES, READING ANTHOLOGIES

Because J. Edgar Hoover suspected that anyone working against segregation or in the field of civil rights also had communist ties, the FBI (in league

with Joseph McCarthy's Permanent Subcommittee on Investigations and HUAC) persistently targeted the black intellectual and cultural community of the 1950s. The literary historian William J. Maxwell labeled Hoover's FBI, with only a bit of irony, a "publicly funded institution of literary study," the only one, Maxwell insists, that always took African American literature seriously (forthcoming, 3). Irony aside, the FBI's spying on black Americans from World War I through the 1970s is best described as "consistently hostile to African American aspirations" (Kornweibel 1999, 178); it was an arm of the federal government dedicated to spying, illegal searches, and deliberate intimidation and harassment of American citizens. The bureau's files are full of deletions, redactions, and falsified, fanciful, and highly edited reports generated by a narrator known as the "Confidential Informant of Known Reliability" (Robins 1992, 18), which was built up out of the testimony of paid (often unreliable) informers, some of whom were friends, neighbors, and/or colleagues of the subject.[25] Recent investigations, for example, have uncovered evidence in the FOIA files that the famous civil rights photographer Ernest Withers, who was close to many civil rights leaders, including Martin Luther King Jr., was paid by the FBI to spy on the movement he so expertly and, apparently, lovingly photographed.[26]

Even though FBI files on black artists and intellectuals are crude tools for biographical and cultural research, they are also invaluable biographical aids, enabling scholars of the Left to excavate the half-buried history of the *black* blacklist. William Maxwell's quip that "most every chapter goes better with an FBI file" (in a 2012 e-mail to the author) is a humorous but accurate appreciation of the value of these files. I have either read or have in my possession the files on Lorraine Hansberry, Alice Childress, Lloyd L. Brown, Julian Mayfield, Charles White, and Frank London Brown, which include pages of irrelevant or basic data like the subject's height, weight, address, and marital status but also produce a comprehensive and fairly accurate list of Black Popular Front organizations they belonged to, the publications they wrote for, and the activities they engaged in. Apparently Gwendolyn Brooks escaped Hoover's committees; the letter I received from the FBI says there is no record of Brooks in their files, though that does not necessarily mean a file does not exist.[27] Because Hoover decided Langston Hughes's

poems were "communistic," the bureau put him on its list as far back as 1925, even though its own informants said Hughes was not a communist. Knowing the obvious biases and unscrupulousness of Hoover and the FBI, I read these files judiciously and against many other sources, including biographical material on these figures from other archival sources, my eight-year correspondence with Lloyd Brown (1995–2003), my own literary and cultural analyses, published interviews, and the oral interviews I conducted over the past fifteen years with people close to or on the Left: Dorothy Sterling, Lloyd L. Brown, Herbert Aptheker, Esther and James Jackson, Jack O'Dell, Phillip Bonosky, Bennett Johnson, Oscar Brown Jr., Joseph Kaye, Paule Marshall, Ruby Dee, and Elizabeth Catlett. Though these state records created the threatening environment, which made everyone—even those only peripherally connected to the Left—cautious and evasive, the files also provide the evidence of the dedication of these figures in my study to political struggle and a proud record of their refusal to be completely silenced by the intimidating power of the state.

THE PORTRAIT AS METHODOLOGY

I have been inspired by the model of the communist painter Alice Neel, who said that she painted her highly individualized portraits of communists (including the one of the writer Alice Childress that appears in chapter 3) because she wanted "to show everyone what a real Communist looked like" (Allara 2000, 113). I see each individual chapter in *The Other Blacklist* as a "portrait," a way of illustrating the unique relationship between each of the artists in my study and the Left. I examine these subjects in some detail, looking at their intimate lives, their friendships, and their intellectual and institutional networks, and I try to give full attention to their sometimes ambivalent and contradictory relationships to the Left. Using archival material, oral interviews, biographies, and their FOIA files, as well as by doing close readings of their work, I piece together the traces of the Left in the lives of each of my subjects. With all five artists I make

the connections that reestablish their relationships with the Black Popular Fronts of the 1950s, ties that were lost either because these subjects deliberately distanced themselves from their leftist pasts or because of the practices of contemporary literary and cultural histories. These portraits allow me to trace the influence of the Left over a lifetime, showing that their engagements with the Left continued to affect their work and their lives long after they had distanced themselves or disconnected from a formal relationship to the Left.

Obviously, this is not an inclusive or comprehensive study. There are many more figures that could have been included under the heading "1950s black Left radicalism": Rosa Guy, Sarah E. Wright, Elizabeth Catlett, Frank Marshall Davis, Julian Mayfield, Lorraine Hansberry, John O. Killens, Paule Marshall—to name but a few. I was drawn to the five that I detail here because they allowed me to show a range of relationships with the Left. Because each was interested in formal experimentation in their work, they help prove my point that being on the Left did not preclude modernist experimentation. Through my close readings of these selected lives and works, I show the complexity of the intersection of issues of race, class, and gender among writers and artists on the Left in the 1950s. My analyses show that these individual lives and works are worth studying not only because they have been suppressed but also because they constitute a major part of the Black Cultural Front that continued to influence (some would say "dominate") black cultural production throughout the twentieth century. My hope is to continue the effort to delegitimize the demonization of communism and the Left, which ideally will encourage further investigation of other writers and artists on the Left.

LLOYD L. BROWN

Lloyd Brown's procommunist novel *Iron City* (1950) and his little-known two-part essay "Which Way for the Negro Writer?"—the first written as a challenge to Richard Wright's *Native Son*, the second written in response to

the 1950 literary symposium in *Phylon*—direct us to the contentious literary and political struggles over black aesthetics during the period of the "high" Cold War. I argue that Brown's affiliation with the Communist Party in the 1950s allowed him the freedom to reject and expose the intellectual and aesthetic constraints on black writers, especially the pressure from black literary conservatives to abandon black characters and black themes. An anomaly for the 1950s, Brown's *Iron City* focuses almost entirely and affirmatively on black characters and refuses to eliminate or subordinate racial themes. And in a period when most black writers were writing conventional realistic fiction and when only certain kinds of elite modernisms were considered authentic, Brown inaugurated what I call a black Left literary modernism using left-wing literary and cultural texts as his models for formal experimentation. The result is a remarkable novel that imaginatively integrates black folk traditions, employs modernist experimentation, and makes its central characters radical Left activists. In my remapping of literary history, I put *Iron City* in dialogue with Richard Wright's *Native Son*, to challenge the latter's status as the representative black proletarian novel and Wright as the representative black Left writer. Furthermore, I propose that Brown's essay "Which Way for the Negro Writer?" which links black writers and artists to an international leftist intellectual community and professes faith in the militancy of black literary traditions, should become the standard bearer of midcentury U.S. black left-wing literary criticism.

CHARLES WHITE

Following the interdisciplinary example of the 1950s Left, I include the visual artist Charles White, the major black leftist visual artist of the postwar period. As they were for the literary figures in my study, Charles White's associations with communism are downplayed or ignored by most of his major biographers and art historians.[28] I argue, however, that from the time White joined the WPA in the late 1930s until he left the Party in the mid-1950s, the CP supplied the institutional and philosophical support he

could get nowhere else. That institutional support helped sustain White in his commitment to an aesthetic that focused exclusively on black subjects. The main text of chapter 2 is the 1953–1954 portfolio of black-and-white charcoal drawings, *Charles White: Beauty and Strength*, originally issued by *Masses & Mainstream* in large, ready-to-frame prints as a way of making art available to working-class audiences, "who are usually unable to afford such art," according to its catalog text. Some art historians argue that this portfolio of highly representational art shows that White was under pressure to turn away from the modernist experiments that characterized his best work in the 1940s. I argue that White's determination to stick with a representational realism in his art, even though he knew that decision would mean his exclusion from the canons of "high art," produced the kind of experimentation that Arnold Rampersad (2002) associates with the work of Langston Hughes—a black modernism that is accessible, deeply racial, and rooted in an African American aesthetic.

ALICE CHILDRESS

From 1952 to 1955, Alice Childress wrote a column for *Freedom*, a Harlem- and Brooklyn-based international socialist newspaper. Childress's "Conversations from Life" column in *Freedom* featured an outspoken domestic worker named Mildred, slightly more bourgeois and more political than Langston Hughes's working-class hero Simple but clearly in the same mold, putting political and social issues in the language of a black working-class Harlemite. In the most resolutely leftist terms in her *Freedom* columns, Childress took on McCarthyism and Cold War liberalism, encouraged anticolonial struggles in Africa, and outlined a platform of labor rights for black working-class women.

But Childress was first and foremost a dramatist. Her 1950 play *Florence*, her 1951 musical drama *Gold Through the Trees*, and her 1955 Obie-winning play *Trouble in Mind* were all produced in left-wing venues and represent Childress's Left radicalism. Childress wrote *Florence* in response to the men

of the Harlem Left, who claimed that only black male issues were central to racial problems. Childress's anti-McCarthy stance runs like a thread through *Trouble in Mind*, a play in which all three of the major characters try to hide their leftist pasts for fear of being investigated. The full effect of that fear is revealed as each is shown to be unwilling to take a strong position on racial violence. In chapter 3 I analyze the unpublished play *Gold Through the Trees*, a remarkable production for its focus on issues at the heart of the Black Popular Front of the 1950s: the South African Defiance Campaign, the central role of women in political activism, the trial of the Martinsville Seven, and black involvement in underground political work. Like Langston Hughes, Childress was formulating a socially modernist aesthetic, employing in *Gold Through the Trees* a montage-like structure that combined poetry, black music, and historical event in ways that complement the play's political critique.

GWENDOLYN BROOKS

Although Gwendolyn Brooks was probably not a member of the Communist Party, she was an active part of the cast of progressives, including many communists and communist-oriented groups that formed the Black Left Cultural and Political Front in Chicago in the 1940s and 1950s. Nonetheless, except for the new scholarship on the black Left by Bill V. Mullen, James Smethurst, and Alan Wald, the biographical, autobiographical, and scholarly work on Brooks has erased all signs of her relationships with the Left. Focusing on her 1951 essay "Why Negro Women Leave Home," her 1953 novel *Maud Martha*, and the poetry in her 1960 collection *The Bean Eaters*, I argue that Brooks's writing of the 1940s and 1950s bears the "discursive marks" of leftist cultural and political influence.[29] *Maud Martha* is a self-consciously modern as well as a leftist portrayal of a young, female, dark-skinned, working-class intellectual whose experience of double consciousness is inflected by race, class, and gender. The work of black Marxist feminists such as Claudia Jones, Alice Childress, and Lorraine Hansberry, writing in *Freedom*, cre-

ated the feminist space for this political bildungsroman. Brooks paired that leftist feminist vision with her own brand of black modernism in the novel's representation of consciousness as fragmentary, signifying on "high" modernism. Focusing on *Maud Martha* and *The Bean Eaters*, I chart Brooks's radicalism from the 1930s through the 1950s, showing that it was nurtured in South Side leftist communities and was not a product of the 1960s.

FRANK LONDON BROWN

Though many of the writers at the 1959 First Conference of Negro Writers continued to represent the legacy of the Left in their fiction, I've chosen to focus in chapter 5 on the 1959 novel *Trumbull Park* by the conference participant Frank London Brown. His novel has been read only as a race-based civil rights novel; its Left history has been forgotten or ignored. The historian Sterling Stuckey (1968) was the first critic to note that Brown was creating a new narrative based on Brown's own activist engagements in progressive unions and civil rights protests. Brown's activism included participating in the desegregation of Chicago's public housing project called the Trumbull Park Homes, which became the subject of the novel. When I wrote the introduction to the Northeastern University Press reprint, I called *Trumbull Park* a "civil rights novel" because it seemed so clearly to be drawing on the Northern civil rights movement for both a subject and a method. The movement gave the novel a collective protagonist, a community of couples acting (like most civil rights activists) in spite of being fearful and unprepared. It inspired the novel's representations of black musical traditions as assisting and nurturing political action as well as images of mass protests, walk-ins, and singing demonstrators that explicitly anticipate the aesthetics of protest of the 1950s and 1960s. Such scenes and images inspired my own readings of the novel as civil rights fiction. Since then, I have begun to reconsider how this emphasis on the novel as a civil rights/racial narrative, which has largely dominated as the main critical response to *Trumbull Park*, marginalizes or indeed entirely suppresses the novel's leftist elements

and has helped obscure Brown's left-wing politics. Though I missed them the first time around, the signs of that leftist aesthetic are there in the novel's focus on a collective protagonist and on the worker and working-class solidarity, in its documentation of historical acts of racialized violence, its positive references to communism, and its internationalizing of black political struggle.

Brown's leftist politics became apparent to me only as I read his FOIA file, which was generously shared with me by the Cold War and black literary and cultural scholar William J. Maxwell. As with the other figures in *The Other Blacklist*, Brown's FOIA files are invaluable biographical sources—because FBI agents were such exemplary models of surveillance scholarship. The files reveal Brown's left-wing orientation as a civil rights activist; factory worker; trade unionist with the United Packinghouse Workers Union, a left-wing, communist-influenced, antiracist, predominantly black trade union; and supporter of women's workplace equality, all of which became central to his art as well as his politics. Furthermore, the FOIA file shows that beyond his union organizing, Brown was involved in other forms of progressive work throughout the 1950s: he gave speeches to left-wing organizations like the Midwest Conference to Defend the Rights of Foreign Born Americans, affiliated with groups like the Women's Peace and Unity Club; American Women for Peace; and the American Peace Crusade, all designated as CP fronts. At the height of the Cold War, he demonstrated against a Senate Internal Security Committee protesting the government's failure to prosecute the 1955 racially motivated murder of Emmett Till. The FBI also discovered a political genealogy for Brown, claiming that Brown's father, Frank London Brown Sr. and his wife, Myrtle L., a factory worker, were CP members for about six years, until 1945, when London Brown would have been eighteen.

Though he was a defender of Paul Robeson and apparently supported Fidel Castro's communist revolution in Cuba, Brown nevertheless expressed anticommunist views in at least one speech he gave before a prominent black real estate organization in 1959, suggesting that new black postwar prosperity may have encouraged, perhaps even required, a retreat from radicalism. On the cusp of national recognition, Brown died of leukemia at the

age of thirty-four in 1962, so we will never know how his radicalism might have played out in the coming decades of civil rights, Black Power, antiwar protests, and women's rights struggles. Gwendolyn Brooks, who knew him well, eulogized him in a poem published in *Negro Digest* in 1962: "Of Frank London Brown: A Tenant of the World"—memorializing Brown as a revolutionary "liberator," a figure not unlike Malcolm X. As the Brooks poem indicates, Frank London Brown was at the center of militant and progressive intellectual and political circles in 1950s Chicago—to his friends and comrades he was "Liberator," "Armed arbiter," and "scrupulous pioneer." As a writer and activist, he cultivated and maintained these deep connections to his local communities, but his activism also produced a larger and more radical perspective—what Brooks calls his "vagabond View"—that inspired his writing. Brown not only drew from civil rights (the side that is preserved) but also from leftist-front legacies (the side that has been forgotten) and is, therefore, a pivotal figure in remembering these political and social formations of the 1950s. His work helps us tease out where black radicalism continued in the late 1950s; where it aligned itself with or distanced itself from the communist Left; where it became the radical vanguard; where it succeeded in holding on to its values of resistant, anticapitalist, interracial, internationalist black militancy; and where it failed to adhere to those values. The project of *The Other Blacklist* is to reassemble those clues, to reattach these figures to leftist radicalism, and, in the process, to reaffirm the radical imagination and activism of the cultural workers of the Black Popular Front.

SPYCRAFT AND THE LITERARY LEFT

Given that Hoover and the FBI were particularly interested in spying on black American political activity, which Hoover always considered subversive, black intellectuals and artists were of great concern to him and his spy agency. The subjects of this chapter are the 1959 Black Writers' Conference in New York City and the selected papers from the conference published

the following year in a slim volume called *The American Negro Writer and His Roots*, edited by John A. Davis. Billed as "The First Conference of Negro Writers," it was sponsored by the American Society of African Culture (AMSAC) and held at the Henry Hudson Hotel in New York City from February 28 to March 1, 1959. Ostensibly organized to give black writers a forum for dialogue, the AMSAC conference was secretly funded by the CIA, as revealed in the 1975 Frank Church Senate investigation. Attended by both conservatives and leftists, it represents an important site of black literary debate at the end of the 1950s, a debate that was obscured by John Davis, who used his opening editorial to downplay the presence and importance of the Left. Because the published volume of conference papers omits many of the left-wing voices that spoke on behalf of protest writing, I use this chapter to reconstruct the original conference to include the presentations and commentary of Alice Childress, Lloyd Brown, Frank London Brown, John Henrik Clarke, and Lorraine Hansberry. At the beginning of the 1950s it seemed as though the conservatives would hold sway, but even in 1959, as we see from this conference, black writers and intellectuals continued to connect with the ideas and strategies that originated in the black cultural and literary Left, even as their attempts were framed and limited by government-authorized spies.

1

LLOYD L. BROWN: BLACK FIRE IN THE COLD WAR

The trouble with Negro literature, far from being the alleged "preoccupation" with Negro material, is that it has not been Negro enough.

—LLOYD BROWN, "WHICH WAY FOR THE NEGRO WRITER?"

O N FEBRUARY 20, 1962, in the vicinity of Forty-Third Street and Broadway in Manhattan, two FBI special agents approached the activist and writer Lloyd Brown, seeking his cooperation in their investigation of communist writers and artists. According to one of the entries in Brown's extensive Freedom of Information file, the agents identified themselves and asked if they could discuss "certain matters of apparent mutual interest" about the "communist conspiracy." By this time the openly communist Brown had become outraged by the attempts of the FBI to interview him and stated that he was not going to discuss anything with the FBI until he, along with the rest of the Negro race, got his freedom. He told the agents that they should be down South investigating "the deplorable conditions under which negroes [*sic*] must live." In their report of Brown's response, the agents described what must have seemed to them like a strangely incongruous reaction:

BROWN ignored this conversation and stated, "I'm just a Mau-Mau without a spear. Go ahead, call me a 'nigger' everybody else does." BROWN continued by advising the Agents to go back and tell whoever they tell that he is the meanest, rottenest s-o-b they ever met and that is the way he is going to be until he gets his freedom. [The report concluded:] In view

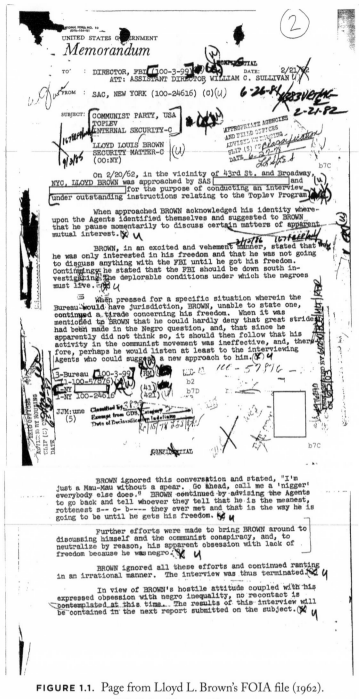

UNITED STATES GOVERNMENT

Memorandum

TO : DIRECTOR, FBI (100-3-99) DATE: 2/21/62
ATT: ASSISTANT DIRECTOR WILLIAM C. SULLIVAN

FROM : SAC, NEW YORK (100-24616) (C)(U)

SUBJECT: COMMUNIST PARTY, USA
TOPLEV
INTERNAL SECURITY-C

LLOYD LOUIS BROWN
SECURITY MATTER-C (U)
(OO:NY)

APPROPRIATE AGENCIES
AND FIELD OFFICES
ADVISED BY ROUTING
SLIP (S)
DATE

On 2/20/62, in the vicinity of 43rd St. and Broadway, NYC, LLOYD BROWN was approached by SAS and for the purpose of conducting an interview under outstanding instructions relating to the Toplev Program.

When approached BROWN acknowledged his identity whereupon the Agents identified themselves and suggested to BROWN that he pause momentarily to discuss certain matters of apparent mutual interest.

BROWN, in an excited and vehement manner, stated that he was only interested in his freedom and that he was not going to discuss anything with the FBI until he got his freedom. Continuing, he stated that the FBI should be down south investigating the deplorable conditions under which the negroes must live.

When pressed for a specific situation wherein the Bureau would have jurisdiction, BROWN, unable to state one, continued a tirade concerning his freedom. When it was mentioned to BROWN that he could hardly deny that great strides had been made in the Negro question, and, that since he apparently did not think so, it should then follow that his activity in the communist movement was ineffective, and, therefore, perhaps he would listen at least to the interviewing Agents who could suggest a new approach to him.

3-Bureau (100-3-99) (RM)
1-100-57876
1-NY (41)
1-NY 100-24616 (421)

JJM:ume
(5)

b2
b7D

Classified by
Exempt from GDS, Category
Date of Declassification Indefinite

b7C

BROWN ignored this conversation and stated, "I'm just a Mau-Mau without a spear. Go ahead, call me a 'nigger' everybody else does." BROWN continued by advising the Agents to go back and tell whoever they tell that he is the meanest, rottenest s-- o- b---- they ever met and that is the way he is going to be until he gets his freedom.

Further efforts were made to bring BROWN around to discussing himself and the communist conspiracy, and, to neutralize by reason, his apparent obsession with lack of freedom because he was negro.

BROWN ignored all these efforts and continued ranting in an irrational manner. The interview was thus terminated.

In view of BROWN's hostile attitude coupled with his expressed obsession with negro inequality, no recontact is contemplated at this time. The results of this interview will be contained in the next report submitted on the subject.

FIGURE 1.1. Page from Lloyd L. Brown's FOIA file (1962).

Source: U.S. Federal Bureau of Investigation.

of BROWN's hostile attitude coupled with his expressed obsession with negro inequality, *no recontact is contemplated at this time.*

(U.S. FBI, Lloyd Brown, 100-24616, 2-21-62; emphasis added)

This encounter with the FBI agents, who continued to trail him for years even after he was no longer associated with the Communist Party, was typical. In all FBI attempts to interview him, he was "hostile and uncooperative," and, though they continued to hound him at work, in the streets, and at his New York co-op, they eventually concluded that further contact would not be contemplated because "he was firm in his refusal to cooperate in any way" (U.S. FBI, Lloyd Brown, 2-23-67). Besides Brown's fearlessness before government spies, the incident is a remarkable for another reason. It dramatizes the emphasis in Brown's work and life on the relationship between racial injustice and political radicalism. Ten years earlier in 1951, when he published his first novel *Iron City* with the Marxist press *Masses & Mainstream*, it was so blatantly procommunist that Dalton Trumbo, one of the famously blacklisted Hollywood Ten, said that publishing that book during the Cold War was like setting a match to kerosene. For Brown, however, the novel's radicalism was not only in its normalization of communists but in its challenge to 1950s neoconservatism, which urged black writers to abandon race matters, racial themes, and social protest. In the same year as *Iron City*, Brown published his manifesto on black literature, also in *Masses & Mainstream*. The two-part essay "Which Way for the Negro Writer?" also argues vehemently for black writers to resist conservative attempts to mainstream black writing and eliminate racial protest. Brown published at least twenty-four essays and reviews in *Masses & Mainstream*, covering every aspect of black culture from jazz to civil rights to racism in psychoanalysis.[1] Between 1948 and 1952, as the journal's editor, he reviewed nearly every major book written by a black writer, including Chester Himes's *Lonely Crusade* (1947), Saunders Redding's *Stranger and Alone* (1950), William Demby's *Beetlecreek* (1950), Ralph Ellison's *Invisible Man* (1952), and Richard Wright's *The Outsider* (1953). Strangely for such a prolific and observant reviewer, Brown never wrote about Gwendolyn Brooks's 1950s publications, even though her writing is easily as politically radical as his. In his reviews Brown continually castigated black writers for

what he considered their "contempt for the working class," their "Red-baiting," and their focus on pathology in black culture. During his tenure in the 1950s as an editor at *Masses & Mainstream*, that journal published more articles by and about black writers than any other journal except for black ones, bragging in their 1952 Black History Month issue about the number of black writers in their pages.[2] Brown even shows up in the correspondence of two of his public antagonists, Ralph Ellison and Albert Murray, though, quite unexpectedly, they found themselves on his side.[3] Brown might very well have claimed the taunt he threw at his FBI investigators as the signature of his life and work: he was indeed a Mau Mau rebel, not with a spear but with his pen.

Brown was such a ubiquitous presence in literary, cultural, and political circles in the 1950s that it is hard to account for his absence from contemporary black literary history on grounds other than his left-wing politics. In my correspondence with Brown, dating from 1996 until his death in 2003, his letters describe close friendships with Langston Hughes, Alice Childress, Paul Robeson, W. E. B. Du Bois, and the *Freedomways* editor Esther Jackson—leftists all, but also, like Brown, often excised from the main currents in the African American and American literature and culture they actually helped create. Brown's literary friendships and collaborations, which are important records of African American literary history, have almost never been documented.[4]

Throughout the 1950s, Brown worked closely with Paul Robeson on the newspaper *Freedom*, reputedly ghostwriting many of the columns attributed to Robeson. He was also something of a ghost in Langston Hughes's life. He made a special effort to support Hughes when Hughes was under attack by Senator McCarthy's investigative committee, writing a rebuttal to a negative review of Hughes's work by James Baldwin in the *New York Times* (Brown 1959), but he always kept their "underground friendship" off the record so as not to conflict with Hughes's precarious peace with Senator Joseph McCarthy and the House Un-American Activities Committee (HUAC). When *Iron City* was published, Hughes telephoned to say how much he liked it and that he was sure that ten years earlier it would have been a Book-of-the-Month selection. Hughes never wrote anything about the novel publicly, though he felt that *Iron City*'s character Henry Faulcon

and Brown's own Jesse B. Simple were close kin. In 1959, when Hughes's *Selected Poetry* was published, Hughes phoned Brown to say that he wished he could dedicate the book to him. Instead he sent a copy with this private dedication on the flyleaf: "Especially for Lloyd Brown—these 30 years (+) of poetry—Sincerely, Langston Hughes."[5] Brown's procommunist politics have made it easy for critics to dismiss him. He is almost totally absent from contemporary versions of African American literary history, never cited as an influential ancestor, his writings nearly always dismissed as communist propaganda.[6] But I make special mention of these ghostlike appearances of Lloyd Brown in African American literary circles to establish that in the 1950s, even as a spectral presence, he managed to play a major role in black cultural production.

This chapter seeks to reestablish Brown's significance as both novelist and cultural critic and to show that CP aesthetics were, for him as for many radical leftists, ultimately more liberating than limiting. Writing from the Left, outside of the confines of the Jim Crow literary and cultural establishments, and with the institutional and creative support of the Party, Brown had the freedom to reject mainstream literary mandates that tried to restrict representations of black subjectivity. In direct opposition to the assimilationist rhetoric of the integration period, left-wing activists and artists like Brown challenged the very structures that defined the limits of integration, exposing the terms of analysis that made black writers into the "Other" and black writing into "The Problem." In his powerful and almost totally unknown 1951 essay-manifesto "Which Way for the Negro Writer?" he insisted that the crusade of the black neocons in the 1950s to *unblack* the Negro in literature and to aim for acceptance in the mainstream was not simply an aesthetic agenda but a response to Cold War manipulations that exerted as much ideological pressure on these writers as some claimed the Communist Party had on its members.

While the canonical black texts of the 1940s and 1950s—Ralph Ellison's *Invisible Man*, J. Saunders Redding's *Stranger and Alone*, Chester Himes's *Lonely Crusade*, and Willard Motley's *We Fished All Night*—portray the Party as a deceptive and manipulative organization using the Negro for its own opportunistic ends, Brown portrayed his communist characters as positive forces in

their communities. Brown also had Richard Wright and Bigger Thomas in mind when he wrote *Iron City*. The three politically informed working-class intellectuals—Faulcon, Zachary, and Harper, and the working-class Lonnie James—the collective protagonists of *Iron City*—were deliberately fashioned in opposition to the murderous, illiterate Bigger Thomas and meant to stand as the more representative black proletariat of the 1940s.[7] By putting Lloyd Brown's *Iron City* in dialogue with Richard Wright's *Native Son*, I show how the focus on Wright as *the* major figure on the Left distorts and minimizes the political and aesthetic value of communist influence on black literary production. In contrast to Wright, Brown embraced formal experimentation, fashioning *Iron City* out of the materials of leftist culture—documentary texts, 1930s proletarian drama, black folk culture, and even surrealism. Precisely because Brown remained faithful to the Communist Party and objected so publicly and articulately to any retreat from politically engaged art, he compels us to question those erasures that enabled this highly political decade in U.S. history to become depoliticized in contemporary African American literary and cultural histories.

LLOYD BROWN IN BLACK AND LEFTIST CULTURAL CIRCLES: "WHICH WAY FOR THE NEGRO WRITER?"

While Brown may have been ignored and marginalized by post-1950s literary critics, as editor and writer for *New Masses* between 1947 and 1953, he was a known quantity in the 1950s black and left-wing literary world. Between 1947 and 1954, Brown published more than twenty-five articles and reviews covering black literature, civil rights, race, and international issues.[8] But it was his critique of the Atlanta University–published black cultural journal *Phylon* that put him in the crosshairs of the 1950s black literary establishment. In the winter of 1950, Brown read the literary symposium that appeared in the December issue of *Phylon*, which contained one respondent after another suggesting that fiction featuring racial issues, black characters,

or black settings could not be "universal." For Brown the symposium was a rejection of blackness in exchange for the promises of integration: "It was a challenge to everything I believed in. It was as though they were trying to wipe us out. I'm all for integration, but only if it's on the basis of equality."[9] The *Phylon* editors had sent out a questionnaire to twenty-three prominent black writers and academics, asking them to respond to several—clearly leading—questions:

> (1) Are there any aspects of the life of the Negro in America which seem deserving of franker, or deeper, or more objective treatment? (2) Does current literature by and about Negroes seem more or less propagandistic than before? (3) Would you agree with those who feel that the Negro writer, the Negro as subject, and the Negro critic and scholar are moving toward an "unlabeled" future in which they will be measured without regard to racial origin and conditioning?
>
> (Atlanta University and Clark Atlanta University 1950)

Questions one and two were throwaways; what the *Phylon* editors most wanted to hear about was that "unlabeled future," which they believed would usher in the racial millennium.

In what the editors called "a mid-century assessment of black literature," *Phylon* devoted a special issue to the responses of twenty-three writers and educators to the questionnaire. The most well known were Gwendolyn Brooks, Hugh Gloster, Arna Bontemps, Langston Hughes, Robert Hayden, Alain Locke, Margaret Walker, George Schuyler, Sterling Brown, William Gardner Smith, and J. Saunders Redding. The most prominent absent voices included four well-known leftists: Ernest Kaiser, W. E. B. Du Bois, Ralph Ellison, and Paul Robeson; the one excommunist Richard Wright; and the communists Lloyd Brown and Abner Berry. Twelve of the twenty-three that were included were college professors, eleven of them on the faculty of major black universities. Ira De A. Reid, the chair of the Department of Social Science at Haverford College, was the only black professor at a predominantly white school. The symposium responses range from the archconservatism of

Gloster, a professor at Hampton Institute, to Walker's subtle left-wing radicalism, to a postmodernist poem by Hayden that critiqued the racial essentializing of the symposium.[10] The conservative voices in this issue are worth special attention because they were in the ascendancy in the early 1950s and because they became the grounds for Brown's attack.

Picking up on the direction of the third question, Gloster said unequivocally that the focus on "racial subject matter" had handicapped the Negro writer, retarded his "cosmic grasp of varied experiences," diminished his philosophical perspective, and lured him into "cultural segregation." He praised writers like Richard Wright for transcending the color line by identifying Bigger Thomas with "underprivileged youth of other lands and races," and he heralded Zora Neale Hurston and Ann Petry for producing novels with no black characters. Like many of the respondents, Gloster singled out Willard Motley for his 1947 novel *Knock on Any Door*, about an Italian youth, which, he said, "[lifts] his work to the universal plane by representing humanity through an Italian boy." As if gender somehow transcended race, Gloster praised Gwendolyn Brooks and Petry for dealing with women's issues, which he said are not racial matters, since they deal with such womanly concerns as "passion, marriage, motherhood, and disillusionment in the lives of contemporary Negro women."

Other respondents followed in Gloster's footsteps, cautioning black writers to free themselves from their "racial chains" by not writing about black characters. The novelist and critic J. Saunders Redding urged the Negro writer to register "human" rather than "racial" values by "testing them in creatures of his own imagination *who were not Negro*." Charles Nichols of Hampton Institute saw a "heartening maturity" in writers who were "not primarily concerned with Negro life" and predicted that the Negro writer was in the process of coming of age "though, happily, not as a Negro." Even Langston Hughes, whose entire literary output could be described as culturally black, found it a "most heartening thing to see Negroes writing in the general American field, rather than dwelling on Negro themes solely," and he too praised Willard Motley, Frank Yerby, Ann Petry, and Dorothy

West for presenting "non-Negro subjects" and thereby lifting their work to a "universal plane."

In his symposium essay, Alain Locke, the "dean" of African American letters, deployed the term "universal" eleven times, admonishing writers to achieve a "universalized particularity," to find a way to write about race "from the universal point of view," to write of racial life but to consider it from "the third dimension of universalized common-denominator humanity." Full of obfuscating terms and what seems like sheer terror over being left off the "universal" bandwagon, Locke's essay ends with the declaration that "outer tyrannies" like segregation, prejudice, racism, and the exclusion of black writers from the mainstream of American literature and publishing are so much a part of the past that they no longer pose a serious problem for the black writer. Abandoning his left-leaning politics of the 1930s, Locke insisted that the only things restricting black writers were "inner tyrannies"—"conventionality, repressions, and fears of race disloyalty."[11]

A telling sign of Cold War pressures and anxieties is that the symposium respondents reproduce, almost verbatim, the official State Department line that racism was "a fast-disappearing aberration, capable of being overcome by talented and motivated individuals." The journalist Era Bell Thompson wrote that integration and full equality for blacks were so close at hand that writing about Jim Crow racism should be discarded as a relic of the past. White editors, she claimed, are only interested "in the quality of a writer's work, not in the color of the skin, and black writers need only be ready to take advantage of these opportunities." "White journalism," she continued, apparently unaware of the irony of the term, "has always been open to the Negro, but never to the extent that it is today." N. P. Tillman of Morehouse College agreed with Thompson that there was no bias in the book business: "The American reading public accepts a book by a Negro now on much the same basis as it receives a book by a white author." The Fisk University professor Blyden Jackson wrote with blithe optimism, "All around the air resounds with calls to integrate the Negro into our national life." Later, the poet Sterling Brown (1951, 46) would write that the *Phylon* group had turned integration into a "literary passing for white."

Bear in mind that these calls from the symposium contributors to erase blackness and discover the "universal" subject are not signs of a postmodernist move toward hybridity and multiple subject identities. By minimizing racial identity and racial strife and promoting the image of a democratic and racially progressive United States, the *Phylon* group was offering race invisibility as a bargaining chip for American citizenship status. As Ernest Kaiser, one of the left-wing writers absent from the symposium, notes in a letter to me, the *Phylon* group was "moving quickly to establish its non-left credentials [in order to] maintain its financial support from the mainstream":

> You understand that the magazine doesn't want to embarrass the College and lose its subsidy. By 1948, the NAACP's magazine, *The Crisis*, was attacking Du Bois and Robeson. Almost all middle class black persons were becoming anti-Communist in order to save their careers. The writers who contributed to the *Phylon* symposium are all college professors who are also writers. They could see what was happening to very famous blacks like Du Bois and Robeson. They were not going left at that time.

In the March-April 1951 issue of *Masses & Mainstream*, Brown leapt into action, publishing "Which Way for the Negro Writer?" as a reply to and critique of the *Phylon* symposium. The essay served several purposes. It became a statement of Brown's theory of black literature and an opportunity for him to expose the ways Cold War ideologies were producing and manipulating the work of black intellectuals. By 1950, the policing of un-American activities and ideas by HUAC was in full sway, with the Left being Red-baited and any ideas associated with the Left, including civil rights and racial equality, discredited as communistic. As early as 1947, the attorney general had begun labeling organizations primarily involved in antiracist work "subversive," and, in hearings conducted by Truman's Loyalty Board, "advocacy of racial equality was an official justification for heightened scrutiny" of federal employees (Biondi 2003, 140). That blackness was itself considered subversive is borne out by the rhetoric of the "un-American" investigatory committees. Anyone active in an organization concerned with social or racial reform was automatically suspect. Advocating

racial equality or civil rights or even listening to a Paul Robeson recording could be grounds for having one's loyalty questioned. Witnesses in loyalty hearings were asked such questions as "Do you think that an outspoken philosophy favoring race equality is an index of Communism?" (Caute 1978, 282). Any mixing with blacks, including interracial friendships and interracial dating, could be a sign of a communist activity. When the House Investigating Committee began in 1939 to dismantle the WPA's Federal Theatre Project for alleged communistic tendencies, it was cited for having "mixed casts" and for having Negroes and whites dancing together (Mathews 1967, 265). To prove communist influence in the project, one witness said she had been pressured by her supervisor to date a Negro (Matthews 1967, 289). Any expression of discontent by Negroes could and would be interpreted as "the first step toward communism." The chairman of another anticommunist investigative committee, Senator Albert Canwell of Washington, announced conclusively, "If someone insists there is discrimination against Negroes in this country . . . there is every reason to believe that person is a Communist" (Caute 1978, 168).

Cold War rhetoric around issues of race was constructed through a vocabulary of coded terms. "Gradualism," "moderation," and a focus on racial "progress" defined the "vital center's" position on race.[12] Successful blacks like Marian Anderson and Jackie Robinson were held up as indicators of racial progress, while civil rights activity was disparaged. Walter White, the right-leaning top man at the NAACP, which was targeted by McCarthy as too cozy with communists, suggested an even more potent way to minimize the threat of blackness. In an article published in *Look* magazine in 1949 and reprinted in *Negro Digest* the same year, White advocated immediate investigation into a new scientific discovery, "monobenzyl ether of hydroquinone," which promised to make blacks white. "Has Science Conquered the Color Line?" claimed that once science perfected monobenzyl, the skin of every Negro could be changed to white. White queried hopefully, "Would not Negroes then be judged individually on their ability, energy, honesty, cleanliness as are whites?" Without even a hint of irony, White predicted that this chemical could hit society with "the impact of an atomic bomb" and conquer the color line.

None of this black-and-Red baiting surfaces explicitly in the *Phylon* issue, but Brown was politically wired to detect the ways that a seemingly innocuous phrase like "Negroes moving toward an 'unlabeled future'" signaled neither "unlabeling" nor real integration but capitulation to the right-wing assault on black resistance. As an editor at a Marxist journal where these issues were being debated openly, he and his colleagues were in the direct line of fire, but they were also freer and more willing to call things by their real names.[13] In fact, one of the reasons Brown's *Masses & Mainstream* essay should be recognized as one of the central texts in African American literary history is that it so thoroughly unmasks the coded Cold War rhetoric on race.

Although Brown could often be narrow and doctrinaire in his rigid adherence to the CP line, his reply to the *Phylon* symposium reflects those liberatory aspects of being openly communist. "Which Way for the Negro Writer?" became the ideological counterweight to the mainstream influences that inspired such docility in the *Phylon* respondents. Brown began his critique by connecting the cries for a universal perspective to American imperialism and to the domination of the white ruling class who, he said, believe that "so-called inferior cultures must be re-molded to conform to the Anglo-Saxon ideal." He insisted that "there is no contradiction between Negro subject material and Negro forms on the one hand and universality on the other" and that any notion of universality that excludes black people, black life, and black forms is simply "an acceptance of the abysmal standards of white supremacy." In opposition to the voices clamoring to eliminate blackness, Brown wrote defiantly in his essay: "Negro literature has not been Negro enough."

As part of his larger critical strategy, Brown's essay presented a trenchant analysis of the racial politics of the 1950s publishing industry. As a member of the *Masses & Mainstream* editorial staff, he was able to draw from politically and factually informed sources about "the conditions of commodity publication." To counter Thompson's claims that black writers were on an equal footing with white writers, Brown argued that the production and consumption of black literature was controlled by white capitalists and therefore that black writing was subject to their categories

and values. He pointed to the publishing record of the *New York Times*, noting that "in thirty-two pages of reviews, articles, and advertisements in the Sunday, February 4, 1950 issue of the *New York Times Book Review*, no work by a black writer is mentioned." He continued: "None of the best-sellers in the *Times* is by a Negro, nor is there any mention of Negro writers in any of the books recommended in the *Times*." In his critique of the massive 1949 three-volume *Literary History of the United States*,[14] *Masses & Mainstream*'s editor, Samuel Sillen (1949), noted that "neither Negro writing nor the Negro people merit a [single] chapter in this work of eighty-one chapters." Leveling his final attack against *Phylon*'s fantasy of mainstream acceptance, Brown reminded his readers that Atlanta University's journal *Phylon*, in which these conservatives were announcing the new day of integration, was a segregated quarterly published at a segregated university located in a state that was represented in Congress by white segregationists.

Perhaps the most striking aspect of Brown's essay is that in it he imagined African American literature in global terms and race as an international issue. The black American writer, he said, is united in the world of imaginative literature with those "writers of socialism, national liberation, and peace" including the "immortal" Gorky, Lu Hsun of China, Neruda of Chile, O'Casey of Ireland, Hikmet of Turkey, Guillen of Cuba, Nexo of Denmark, Aragon and Eluard of France—leftist writers he considered giants of the earth. In "What I Saw in Mexico," a report for *Masses & Mainstream* on his trip to the American Continental Congress for Peace in Mexico in 1949, Brown was one of the first to cite the "the two Americas," noting that, despite the number of Negroes in Latin America, the people of the Spanish-speaking Americas have been strangers to blacks in the United States. Struck by how a conservative cultural mainstream had managed to deny the internationalism of black writing, he contended that at the moment when the attention of the whole world was focused upon "Negro oppression and struggle in our country," black writers were being accused of writing about "'narrow racial issues' or *minority* questions," when in reality, he reminded the *Phylon* readers and respondents, these are the subjects that are "bound up with world issues."[15]

"HELL IN PITTSBURGH": THE MAKING
OF *IRON CITY*

As ideologically grounded as Brown was, he did not simply craft a communist version of black culture out of political pressure or from the CP's black nation thesis. Both he and Wright were black nation advocates, adhering for a time to that central tenet of the CPUSA, which from 1928 until 1935 declared blacks a national minority whose culture should be represented positively by communist and leftist writers. The Party's black nation thesis was eventually rejected by black writers as unrealistic, but its respect and support for black culture was a needed antidote to the pressures black writers faced in the 1950s to abandon black characters and racial themes.

Unlike Wright's experiences with a brutal Jim Crow, Brown absorbed an affirming sense of black culture from his early years in a black old folks' home in St. Paul, Minnesota. Born in St. Paul in 1913, the son of an African American father and a German American mother, Brown and his brother and sisters were sent to an orphanage by their father after their mother's death, when Brown was four. Because of the meager social services for blacks in St. Paul, the segregated Crispus Attucks Old Folks Home in St. Paul doubled as an orphanage. Listening to the ex-enslaved people sing spirituals and tell stories, these orphaned and quasi-orphaned Northern children heard the songs, tales, and sayings of black rural Southern folk for the first time, and Brown's early knowledge of black folk culture came largely from these elderly people, whose warmth and caring was a source of tender nurturing he never forgot. The residents of the home recognized early on that he was an extremely intelligent child and encouraged and doted on him. Though poverty and segregation existed at the home, there was none of the terror of lynching and the life-threatening forms of Southern discrimination that Wright, in contrast, experienced growing up in Mississippi. Brown encountered black folk culture in a distilled form, dissociated from the material conditions of the Jim Crow South. His earliest encounter with black folk culture, filtered through the imaginative recounting of the elders at the orphanage, was subsequently honed in the crucible of Marxist-communist

ideology and reconstructed in his fiction as a source of collective strength, humor, and defiance (Nelson 2001).

Though *Iron City* retains the sensibility of these early childhood experiences in a black community, the idea for Brown's first novel came directly from his years as an organizer in Pittsburgh and with his seven-month incarceration in the Allegheny County Jail in Pittsburgh in 1941 for trying to get communists on the ballot. The Party sent Brown to Pittsburgh because it was one of the centers of the steel industry and, as home to immigrants from Slavic countries who were sympathetic to the Left, fertile ground for union organizing. Pittsburgh also attracted the attention of HUAC. Unlike Comrade Wright, who entered the Party in 1932 via the John Reed Club, which he joined in order to become a writer (Fabre 1993, 103), Comrade Brown joined the Party in 1929, via the worker-oriented Young Communist League, to become an organizer, and, by the time he became a published writer, he was a seasoned Party operative. A devoted CP member until he left the Party in the mid-1950s, Brown did union organizing in Connecticut and Ohio in the 1930s and traveled to the Soviet Union in 1933 on behalf of the Scottsboro Nine. He was particularly dedicated to organizing garment industry workers in New Jersey and Connecticut, mainly young women who were being paid very low wages because they worked outside of the unionized areas of New York. One of his first activities in New Haven was organizing a strike of young, mostly Italian women at the Lesnow Shirt Factory where, Brown reported with a certain pride in their gallantry, the fathers and brothers of these women would not allow the women to picket and instead walked the picket line for their wives and sisters.

Brown's organizing work in Pittsburgh in the 1940s established his reputation as a writer and a radical. He set *Iron City* in Pittsburgh, which, in the 1940s, was the manufacturing home of Iron City beer and the center of the steel industry, with a reputation for union organizing. By 1947 the HUAC witch-hunt had begun in earnest in Pittsburgh, and as the Cold War historian David Caute (1978, 216) writes, Pittsburgh became "the violent epicenter of the anti-Communist eruption in postwar America" and a "hell" for radicals. In 1948 one common scare tactic used against organizers was printing the names of people who had signed a petition to nominate

the Progressive candidate Henry Wallace for president in the major Pittsburgh newspapers, insinuating that both candidate and supporters were communists. The conservative and anticommunist Catholic Trade Unionists defeated the more radical United Electrical Workers Union, and by 1950, HUAC began the trials at which the notorious FBI informant Matt Cvetic (who was the model for the informant in the novel and eponymous film *I Was a Communist for the FBI*) implicated hundreds of people who were then expelled from their unions and fired from their jobs (Caute 1978, 216). While *Iron City* is set in the 1940s, a decade before Pittsburgh's major anticommunist purge, the literary historian James Smethurst (2004) reminds us that its depiction of communists as the defenders of minorities, as union activists, and as men and women of integrity is also a response to the attacks on progressives and leftists who were gaining traction in Pittsburgh in the late 1940s and early 1950s. Brown clearly wanted *Iron City* to represent both the Party's power as well as the anticommunist attack, a reminder that Pittsburgh as "hell" for radical leftists cut two ways: as the historian Philip Jenkins (1999, 17–43) argues, the Communist Party in Pittsburgh attracted "hell" because it was especially creative, productive, well organized, and poised to become a serious political force.[16]

Brown went to trial on August 30, 1940, for distributing leaflets on behalf of progressive and communist candidates, sentenced to four months and a fine of $200, and was sent along with his comrades to the Allegheny County Jail where, according to both him and his FOIA file, he began tutoring "his seventeen fellow Communist party members" in American history and English (U.S. FBI, Lloyd Brown, 100-672, 10-9-42). While in jail Brown also met, befriended, and formed a defense committee for William Jones, a young black man on death row accused of murder. With their networks on the outside, including their wives, the jailed communists fought for a new trial for Jones and won three stays of execution, though they finally lost. Jones was sent to the electric chair on November 24, 1941 (Brown 1952).

Brown's experiences defending Jones in the Pittsburgh jail became the basis of *Iron City*. Set in the Allegheny County Jail, *Iron City* focuses on three black communists—Paul Harper, Isaac Zachary, and Henry Faulcon—convicted under the Smith Act, just as Brown and his friends were, for vio-

lating election laws when they tried to get communist candidates on the ballot.[17] The three begin a friendship with a fourth man, Lonnie James, framed by the police and sentenced to death for murder. The three black communists—each an ordinary, working-class black man brought to the Party by a desire for social, political, and racial justice—form the collective protagonist of the novel. Harper is from Cleveland, a high-school dropout working at a factory during the Depression and caring for an invalid father while educating himself by devouring library books, just as Lloyd Brown did. Zachary is a former railroad worker who migrates north when Southern white unionists start a race war to force black men off railroad jobs. Faulcon, another Southern migrant modeled on Langston Hughes's Simple character, works as a dining-room waiter and is radicalized as he tries to court the churchgoing Lucy Jackson, a political organizer working on the Scottsboro case. Convinced of Lonnie's innocence, the three communists, with the help of their wives, organize a Scottsboro-like defense committee to save Lonnie's life. Published privately by Masses & Mainstream Press, *Iron City* was sold through subscriptions, not in stores or by book clubs, which allowed Brown even more room to assert his radical ideas. But even within the relative safety of the Left, *Iron City* generated controversy. Some *Masses & Mainstream* subscribers sent the novel back and cancelled their subscriptions in fear of having a left-wing book in their possession (Bonosky 2007).

THE LIVING NEWSPAPER AS MODERNIST SOURCE

As unlikely as it might seem for a doctrinaire communist like Brown, who objected to the "surrealist horror" of Ralph Ellison's 1952 modernist novel *Invisible Man*, Brown's political radicalism actually led him to explore a range of formal experimentations in *Iron City*. Notwithstanding the claims of the literary critic Arnold Rampersad that Marxism and modernism don't mix, Brown found radical politics and formal experimentation—as long as the latter could advance his radicalism—entirely compatible. In true

modernist fashion, Brown (1949b), for example, took issue with the left-wing jazz historian Sidney Finkelstein, who claimed that jazz would have to progress from a "largely unwritten form" to "the more ambitious forms made possible by musical composition." Brown argued for the importance of modernist improvisation, insisting that "jazz is full of surprises" and he feared what would happen to jazz if "notes and bars" replaced Lester Young's "winged saxophone." In his literary productions, Brown was less consciously modernist, but he was inspired by the left-wing literary and the-atrical experiments of the 1930s Left, including the Living Newspapers of the 1930s, Popular Front documentary techniques, as well as the CP's black belt thesis, which encouraged the use of black vernacular forms. Inventing his own idiosyncratic form of literary modernism in his first novel *Iron City*, Brown crafted a novel that the cultural critic Stacy Morgan (2004, 248) calls "a hybrid product of documentary impulses and modernist literary influ-ences," showing that the protest novel could be a flexible, innovative form, one not inexorably tied to the prescriptions of social realism.[18]

Brown readily acknowledged borrowing Living Newspaper techniques for the construction of *Iron City*: "No doubt I was influenced by the doc-umentary character of WPA artistic expressions in the Thirties, such as the popular Living Theater productions which based drama on current events."[19] More than any of his other borrowings, the 1930s left-wing cul-tural production called the Living Newspapers was Brown's primary influ-ence. An offshoot of the Living Theatre developed by the Works Progress Administration (WPA) to put large numbers of unemployed actors to work during the Depression, the Living Newspaper was a kind of a travel-ing political theater, a multimedia spectacle that dramatized current events or problems as a means of provoking audiences to understand the need for action and reform of political problems (Jarvis 2000, 333). Distinctively innovative in form and intentionally theatrical, the Newspapers utilized spectacular staging techniques, including film and projection, elaborate sets, short vaudeville sketches, music, song and dance, personified char-acters, and actual documentary material from current newspaper stories and political debates. Because of the huge casts—there were often more than two hundred actors in a production—stage directions were elaborate

and at times confusing. During some performances, a character representing the "common man" would come out of the audience and demand answers to a complex situation, like decreasing military spending in order to finance public housing, and he would then be given information about causes and possible solutions. Like those that originated during the Russian Revolution of 1919, first produced by the Red Army with troupes of actors performing stories from newspapers, the WPA's Living Newspapers tried to reproduce the spirit of revolt that was carried out in the innovative forms and the revolutionary content of these Red Army productions (McDermott 1965).

One of the most successful Living Newspapers, entitled *One-Third of a Nation*, produced in both New York and Philadelphia by the Federal Theatre, dramatized the problems of slum housing, its title referring to the "one-third of the nation" affected by poor housing. The set for *One-Third of a Nation* featured a gigantic cross-section of a tenement building, which was made to collapse on the tenants at each performance and was so large that the stage had to be reinforced each night (Jarvis 2000, 333). Another Living Newspaper production that Brown remembers seeing in the 1930s, which I have not been able to locate, presented the debate over social security and challenged the claims of the Hearst newspaper chain that social security would deprive Americans of their identities by requiring them to wear dog tags, thereby instituting a totalitarian state.

Another defining quality of the Living Newspaper was its use of ridicule, macabre humor, and other vaudevillian techniques to spotlight social problems. One Living Newspaper, *Stars and Bars*, which depicted the problem of black slum housing, featured a personified Death leading Syphilis, Tuberculosis, Pneumonia, and Infant Mortality in a macabre waltz until the four diseases snatch the black children from their parents' arms and toss them offstage into the audience. *Liberty Deferred*, written by Abram Hill and John Silvera, one of only three *Living Newspapers* by African American playwrights, was never produced, probably because its racial focus was considered too controversial. It featured two couples from Manhattan, one white and one black, touring the United States to learn about black history.

FIGURE 1.2. *One-Third of a Nation* poster (1938).
Source: Living Newspapers of the WPA.

While touring Manhattan island, they learn and argue about the history and current status of African Americans, while observing almost forty scenes covering the early slave trade, the economics of tobacco and cotton production, constitutional and congressional debates on slavery, Denmark Vesey's revolt, abolitionism, Harriet Tubman and the Underground Railroad, the Dred Scott case, the Emancipation Proclamation, Reconstruction, the Ku Klux Klan, Jim Crow, and African Americans in the armed forces in World War I.

(Nadler 1995, 619)

Most of *Liberty Deferred* is representational but the ending is entirely surrealistic: a huge map of the United States appears, "covered with little doors—one for each state—out of which actors' heads pop, in blackface for the segregated states, and in white for the others" (Nadler 1995, 619). Then, a character named Jim Crow steps out of the scenes and into the frame with the two couples in order to demonstrate to them that his power to segregate extends even to New York City. In a scene called "Lynchotopia," lynching victims are "graded by the egregiousness of the violations of their constitutional rights," and the winner is the one who is dragged to death across state lines.[20]

It is critical to note this relationship between *Iron City* and these 1930s leftist cultural forms because those forms supplied both a form and a sensibility for Brown's novel not ordinarily associated with the social realism of 1940s black writers. As Stacy Morgan (2004, 41) writes, Brown's contemporaries—Richard Wright, Chester Himes, Ann Petry, William Attaway, and Margaret Walker—were deeply skeptical about the possibilities for black Americans in the U.S. capitalistic structure and represented the national landscape as "littered with irreparably fractured American dreams." But *Iron City* took on the spirit of those improvisatory leftist cultural forms. Sprinkled throughout *Iron City*, often unmediated by the narrative voice, are "documentary" pieces of evidence that require interpretation by the reader: newspaper clippings, passages from a chamber of commerce brochure, radio broadcasts, political pamphlets, taped voices from a prison wiretap, prison regulations, a script of prisoners' voices, and even an

extended postmodernist parody of *Native Son* that debunks the "scientific" claims for the authenticity of its portrayals of the black underclass. There are direct historical references to the Cold War, including the Smith Act and Red-baiting. The "conversion" stories of the three communists dramatically reenact African American labor and radical history. At one point in the novel, the narrator, like the "Everyman" of the Living Newspaper, directly addresses one of the ex-prisoners and retells the story of a mass lynching that actually took place in Georgia in 1946. Finally, *Iron City*'s utopian ending, a nonrepresentational surreal dream of Judgment Day that combines a socialist labor rally with an African American Pentecostal picnic, represents the twin urges of Brown's novel—one toward experimentation and one toward Communist Party aesthetics, both marshaled in support of black cultural agency.

IRON CITY'S MODERNIST REVISIONS

Two "documentary" scenes in *Iron City*—the railroad story and the story of a mass lynching in Georgia in 1946—illustrate the political and aesthetic effects of Brown's modernist adaptations. Like the multiple levels of the Newspaper, the railroad story told by Isaac Zachary (called Zach), a railroad worker and union man, merges autobiographical narrative, blues songs, black biblical stories, a historically based labor history, and a communist conversion narrative, all enabling Brown to transform Zach's personal tale into a collective history of black workers. In the first scene, Zach is confined to solitary for refusing to allow a racist guard to touch him. As he sits in the dark hole of solitary, the imagined sound of a switch-engine takes him back to his life in the South and to his dreams of becoming a railroad man. As Zach's vernacular voice merges with the third-person narration, the narrative recounts his climb up the railroad hierarchy from "call boy" to engine wiper, brakeman, and finally fireman, a position of partnership with the always white engineer. Like a Greek chorus, the men in the roundhouse interject warnings to Zach about the dangers of his ambitions: "*No son, not so long as*

your skin is black. And just remember this as long as you're black and live in Mississippi: there's three main things Cap'n Charlie won't 'low you to do, and that's mess with his women, vote in the elections, or drive a railroad train" (Brown 1951, 153). Ignoring these warnings, Zach climbs up the ladder to become a fireman, still with a "crazy ambition to be an engineer," until white workers set off a "strange and secret war" in Mississippi and other parts of the South (a war that lasted from 1931 to 1934 and was never covered in the newspapers), literally assassinating black men who refuse to leave their railroad jobs. Zach continues to fight until he is shot, and with the death of his dream of black equality in railroad work, he and his wife Annie Mae go north to the coal and steel town of Kanesport, up the river from Iron City. During the 1932 presidential elections, when the choice is between "one fat-faced and grim in his high choking collar, the other lean and smiling at his coming victory," someone slips Zach the poster of a white man and black man running for president and vice president of the United States. The two candidates, William Z. Foster and James W. Ford, who in fact ran on the Communist Party ticket in 1932, represent the interracial dream of brotherhood Zach could not find on the railroad. Zach's Marxist labor history conversion story ends with an image of the Glory Train, now the Communist Party Express, with equal accommodations for all people, headed for the Promised Land.

This fictionalized account of the history of black railroad workers is also a historical document, which is corroborated by Eric Arnesen in *Brotherhoods of Color: Black Railroad Workers and the Struggle for Equality*. By 1900, Arnesen writes, "blacks constituted the majority of firemen, brakemen, and yard switchmen on the Gulf Coast lines; they made up some 90 percent on the Seaboard Air line and the majority of such positions on some divisions of the Illinois Central, the Southern, and the L&N railroads in the South," and from the 1890s to roughly 1930, they outnumbered whites as locomotive firemen on Georgia's railroads, "holding 60 percent or more of these positions" (2002, 24–25). Confirming Zach's story, Arnesen says that blacks were barred from white unions and from most skilled positions as white workers campaigned for restrictions against black workers. But blacks, ironically, achieved seniority and competence in positions that whites had disdained—as brakemen and firemen. When jobs became scarce, white workers were outraged

that blacks were working while whites were being laid off, and they declared a race war, attacking trains staffed by black workers and setting off a wave of assassinations of black firemen and brakemen in the South that resulted in at least the deaths of ten blacks. This racist war against black railroad men meant that until the early 1970s, blacks were eliminated from all but the most menial railroad jobs despite years of demonstrated competence in railroad work. Arnesen makes a specific note about Brown's attentiveness to historical detail in *Iron City*, writing that the "novelist Lloyd Brown wrote accurately of Mississippi black firemen" (2002, 120).

If the integrationist discourse of the 1950s defined identity in personal terms, giving priority to the individual and to a hopeful view of U.S. democracy, Brown's railroad story is rooted in the militant civil rights discourse of the 1940s, which gave priority to a collective vision that emphasized class consciousness and a struggle against economic racism. In contrast to the familiar trope of the racist railroad journey in African American literature that generally takes place in the interior of the train, the train story in *Iron City* occurs *outside* the train car and reveals a history of black agency and black achievement rather than black humiliation and limitation. The original context for the interior train journey, provided by the 1896 *Plessy v. Ferguson* Supreme Court case, was the aborted journey of the almost-white Homer Plessy, who argued his right to a first-class seat on a Louisiana streetcar. Similar railroad scenes occur in Charles Chesnutt's 1901 novel *The Marrow of Tradition*, W.E.B Du Bois's 1903 *The Souls of Black Folk*, James Weldon Johnson's 1912 novel *Autobiography of an Ex-Coloured Man*, Nella Larsen's 1928 novel *Quicksand*, Ralph Ellison's 1940s short story "Boy on a Train," Toni Morrison's 1973 novel *Sula*, and more recently James Alan McPherson's 1998 autobiography *Crabcakes*. Though ultimately there is a collective meaning to these interior train stories, they initially focus on a relatively privileged individual deprived of respectability, agency, and individual rights. These fictional accounts of a Jim Crow train ride focus on attaining freedom of movement within the train as a "visible marker of social power and legitimacy" (Myers 2011, 16), as though autonomy and independence could be achieved by egalitarian seating arrangements ordered and supervised by white authority. Though we must remember the

example of Langston Hughes's poem "The Ballad of Freedom Train," which opens with "Who's the engineer on the Freedom Train / Can a coal black man drive the Freedom Train" (Rampersad 2002, 136), *Iron City* may be the only fictional text in black literary history that turns our attention to this historically absent site of black working-class labor history, where a *collective* and costly battle for economic mobility, equality, and dignity was waged on behalf of an entire class of black workers.

DOCUMENTING GENOCIDE, A MODERNIST TROPE

The second "documentary" scene in *Iron City* done in the style of the Living Newspaper begins with a direct address by a voice from the prison, probably the elderly Henry Faulcon, to Harvey "Army" Owens, who was incarcerated with the three communists for larceny and failure to pay alimony, a sentence that is eventually commuted so that Army can be drafted into World War II. Assuming the voice of the Everyman character of the Living Newspaper, Faulcon directly addresses Army in a three-page eulogy that predicts the events of Army's life after he leaves prison: Army will leave the war decorated with ribbons and medals and will go south to marry his sweetheart, whose sister will marry his best friend. After a double wedding ceremony, the two couples will make their way back home to live in a little town in Georgia where, some years later, on a warm spring night, a mob of white men will confront them on the road, drag them out of their car, line them up, and shoot all four at point-blank range, leaving their bodies so mutilated that they have to be buried in closed coffins at a quadruple funeral. All of this is reported in a stream of consciousness, the narrator literally spilling out the words without stopping as if overwhelmed by the savagery of the murders, the helplessness of the victims, and the chilling inevitability of Southern race terror:

It is nothing but a little old town and before you know it you can walk into the country and the road is springy and the stars are big and heavy

and the night is warm and young like the way you feel and your buddy and his wife a few steps behind just a-giggling about some secret they got but you and your wife got your own secrets too and you don't have to study none about them. Then it will be four cars stopping when the headlights find you and the white men getting out and you saying you ain't done nothing wrong but they got shotguns and they'll line you up in the ditch and kill you. Four shotguns with both barrels. You and your wife and her sister and your buddy, and the red clay will be redder where your bodies are found. . . . Your funeral, Harvey, is going to be "bigger even than the double-wedding was."

(1951, 218)

By the end of the eulogy, the narrative voice has become a collective narrator whose relationship to Army is now familial: "*Goodby, Harvey Owens. We were proud to know you, son.*"[21]

These two vignettes—Zach's railroad history and Army's lynching—serve different yet complementary functions in *Iron City.* Zach's story becomes a lesson in both the possibility of interracial worker solidarity and the recurrence of class antagonisms. Army's elegiac story serves two purposes: first to expose Southern white racism and second to point to the left-wing intertext, *We Charge Genocide,* which is Brown's source for Army's story. The lynching of four sharecroppers, Mr. and Mrs. Roger Malcolm [*sic*] and Mr. and Mrs. George Dorsey, which took place in Monroe, Alabama, on the evening of July 25, 1946, was reported in *We Charge Genocide,* a 225-page petition signed by nearly one hundred people and submitted to the United Nations in 1951 by two prominent left-leaning black intellectuals: Paul Robeson and William Patterson. Robeson led a delegation to submit the petition to the United Nations in New York, and the Civil Rights Congress head Patterson, a ranking member of the CPUSA, presented it to the United Nations in Paris. Declaring that racial violence against Negroes fit the UN definition of genocide, *We Charge Genocide* was part of the Left's effort to use international pressure to expose U.S. racism. The text immediately became an embarrassing narrative for the U.S. government, which tried vigorously to get well-known

black leaders to denounce it. There are two contemporary documentaries about the 1946 quadruple lynching: *Fire in a Canebrake: The Last Mass Lynching in America* by Laura Wexler and *Speak Now Against the Day: The Generation Before the Civil Rights Movement*, by John Egerton, both testifying, as Wexler puts it, that lynching was not obsolescent in the 1940s. Though Egerton's book includes the testimony from a man who claims that as a young boy he had witnessed the lynching back in 1946 and was terrorized into keeping silent until he was fifty-six years old, that claim is disputed by Wexler. What is even more stunning about the quadruple lynching is that it seems to have disappeared from history, even though it was widely condemned in 1946 and 1947, with protests across the country, including a rally of five thousand people in Madison Square Garden. Army's story does not end in greater consciousness but with the potency of Southern racial terror reaffirmed by the extreme isolation and vulnerability of four young lynched black bodies, thus becoming *Iron City*'s cautionary tale for those blacks that exist outside of the parameters of an organized workers' movement. Brown's deliberate juxtaposition of these two vignettes, both rooted in actual events, leads to and confirms his ultimate purpose, which is to imagine black workers harnessing their skills—along with the strength, vitality, and dignity of black culture—to the powerful organizational engine of the Communist Party.

IRON CITY'S BATTLE ROYALE WITH *NATIVE SON*

Brown's parody of *Native Son* was motivated by both a modernist playfulness and an antimodernist skepticism of psychology and psychoanalysis, and probably also because Wright's portrait of the brutal and illiterate Bigger Thomas supplied the perfect target for Brown.[22] Brown's attack on Wright in *Iron City* begins with a satirical rewriting of Dorothy Canfield Fisher's preface to the first edition of *Native Son*. Canfield Fisher, a Book-of-the-Month Club selection committee member and

a Quaker liberal, was assigned to write the preface, apparently without Wright's approval. In an attempt to psychologically diagnose the black underclass, she compares Bigger Thomas and his family to sheep and rats in a psychological experiment, concluding that "Negro minority youth," frustrated and angered by American racism, exhibit similar behavior patterns—becoming either a neurotic rat like Bigger or, like his mother and sister, acquiescent and downtrodden sheep. According to Canfield, these psychological experiments show that "personality deficiencies in Negro youth" are the result of living in one's own "intimate" culture, where acceptable standards of behavior are not developed, a view of black culture that Wright replicated in the novel. The resulting pathology can then be considered a self-inflicted wound, a "personality deficiency," not the effects of a racist society.[23]

In *Iron City*, Harper, Zachary, and Faulcon, the same kind of black proletarians who were the subjects of Canfield's investigations, began an extended riff ridiculing the Canfield preface. Harper tells the other two men about an article in the *Sunday American* covering a lecture by the "noted lecturer and sociologist" *Richard* Canfield that illustrates the causes of black delinquency. As in the original Canfield preface, Richard Canfield claims that laboratory experiments with sheep and rats show how the animals become frantic, confused, and pathological Bigger Thomases when their basic needs are thwarted. The three men then begin referring to themselves ironically as rats and sheep. Faulcon says that Brotherhood Week will have to be changed to Be Kind to Animals Week. The narrator joins in the signifying by calling Lonnie a wild rat meeting with a visitor. Brown says very explicitly in "Which Way for the Negro Writer?" that this kind of black humor is "ironic" and "ambiguous," with "a subtle and sly quality that depends for its effect upon a common understanding that comes from common experience and outlook," and, signifying on Richard Wright, he says it is always absent from the "lifeless, abject Negro-Victim caricature" (1951b, 56).

Brown's undermining of *Native Son* is most clearly seen in his construction of the character of Lonnie James. As a highly intelligent working-class man framed by racist police, Lonnie possesses the qualities

Brown felt Wright had denied Bigger, including a sophisticated understanding of the criminal justice system and a resistant spirit. In contrast to Bigger, who sits in the courtroom with his head bowed, deeply *grateful* to his communist lawyer "Mr. Max," Lonnie stubbornly refuses his white lawyer's attempts to make him plead guilty. "After what I've been through I'm not thankful about anything. Not a *damn thing*, you hear me? And I aint going to plead guilty—not for you and not for anybody else." To further emphasize Lonnie as the anti–Bigger Thomas, Brown revises the trope of the newspaper clippings. When Bigger picks up a newspaper during his attempted escape and reads the accounts of the police dragnet surrounding him, he is in effect fatalistically holding in his hands the image of his own entrapment, the map that shows the police closing in on him. On the other hand, Lonnie, who possesses, interprets, and distributes the newspaper clippings he has systematically organized to prove that the police have framed him, uses the newspaper accounts of his arrest and trial to become an agent of his own defense. He hands over his clippings to Harper in order to prove his innocence and to enlist the communists to work on his behalf, and thus, in contrast to Bigger, he draws around himself an ever-widening circle of support. From the beginning of his novel, Brown sets up an immediate sense of kinship between Lonnie and the three black political prisoners. Faulcon is surprised that Lonnie looks so much like Harper: "you and him could be kin." Harper is particularly drawn to Lonnie and begins to see him as a son. Despite Party criticism that *Iron City* was too "nationalistic," Brown insisted on representing this black working-class solidarity, creating an identification with and sympathy that makes Lonnie a far more sympathetic figure than Bigger, although it also invites the critique that Brown was intent on producing an idealized version of the relationship between the Party and the black working class. In his construction of the working-class Lonnie, framed by the white-dominated and racist criminal justice system, and of the three politically informed working-class intellectuals Faulcon, Zachary, and Harper, Brown is very deliberately positioning these four—rather than the murderous, illiterate Bigger Thomas—as the representative black proletariat of the 1940s.[24]

COMMUNIST AESTHETICS: LIBERATING OR LIMITING?

Given *Iron City*'s formal innovations—its use of mass-media discourse and documentary, its mixing of social realism with postmodern parody, its collective protagonist, and even its mild and provisional feminism—the novel challenges the prevailing view that modernism could emerge only out of estrangement from political commitment or that Ralph Ellison was the only black modernist of the 1950s (Lecklider 2012). In fact, the cultural critic Michael Denning argues in *The Cultural Front* that the documentary aesthetic of the 1930s and 1940s that Brown adapted for *Iron City* was itself a "central modernist innovation" and that, given the many kinds of innovations of Popular Front artists, the term "social realism" cannot adequately represent their aesthetics. These artists used many terms to describe their work, including "revolutionary modernism," "new realism," "proletarian surrealism," "dynamic realism," and "social surrealism." Even in the 1950s at least one reviewer of *Iron City*, J. Saunders Redding, writing in the *Baltimore Afro-American*, recognized that Brown was doing something truly innovative. The conservative Redding, who was certainly no friend of the Left, noted that Brown was pioneering in his use of what Redding called "race idiom." Referring to the way the third-person narrator in *Iron City* shares the same vernacular speech and idiom as the characters, Redding praised Brown for giving black vernacular speech an "elasticity," making it "a vehicle not only of speech (dialogue) but of narration and analysis." Virtually all of the commentators on Brown's novel since the 1990s recognize *Iron City* as an experimental novel. As I have already indicated, Stacy Morgan makes the point that Brown's "effectively crafted social realist text" constituted "not merely a mimetic reproduction of 'the real,' but rather a hybrid product of documentary impulses and modernist literary influences" (2004, 254). James Smethurst says that Brown consciously adapted left-wing literary and theatrical experiments in order to represent "a fragmented mass or multiple working class subjectivity" (2004, 5). The literary historian Alan Wald, in his introduction to the new Northeastern University reprint of *Iron City* (1994),

contends that although the plot of *Iron City* retains its commitment to realism, he sees the novel's surreal dream sequence and its references to popular culture as modernist techniques. Wald, along with many other scholars of the literary and cultural Left, also makes the important observation that black writers were often freer to explore formal experimentation because the Party, at least for a time, allowed a level of autonomy, and as he shows in *Exiles from a Future Time*, communist artists often departed from Party platforms and followed their own directions.[25] Brown confirms Wald's point about Party flexibility and says that even though he was often criticized for his politically incorrect Marxism, he was never censored nor directly pressured to write a certain way.[26]

If Saunders Redding grudgingly bestows the mantle of modernism on Brown, the black leftist Ernest Kaiser in a 1949 *Phylon* article explicitly questions Brown's commitment to a modernist sensibility. In "Racial Dialectics: The Aptheker-Myrdal School Controversy," Kaiser takes on both the liberals in the Gunnar Myrdal camp and the Marxists who followed the leading communist Herbert Aptheker for their failure to incorporate the findings of the new sciences of anthropology, sociology, and psychology into their studies of race. If the Myrdal School refused to acknowledge the significance of racism, the Marxists, with their unwavering belief that the socialist revolution would end racism, were, according to Kaiser, equally simplistic. Mainly, however, Kaiser critiques Marxists for refusing to allow black people a complicated psychology. Lumping together three well-known Marxists—Lloyd Brown, W. E. B. Du Bois, and Herbert Aptheker—Kaiser accused them all of failing to take into account "the great strides that had been made in the field of social psychology by sociologists, anthropologists, and psychologists," and he took them to task for their naïve assumption that blacks have survived American racism as "little angels even under terrific oppression." As did the two famous psychoanalysts he refers to in this essay, Erich Fromm and Karen Horney, Kaiser believed that the competitiveness of American capitalist society led to isolation and insecurity for all Americans, black and white. In particular, Kaiser claimed that blacks "as exploited workers and farmers under capitalism and as Negroes jim-crowed and segregated" were

indeed subject to certain forms of neuroses. In this article, Kaiser refers specifically to a lecture Brown gave called "Negro Character in American Literature to Contemporary Writers," which is no longer available and apparently chanted the Party line about the inviolable black psyche, and Kaiser argues that Brown, like Du Bois and Aptheker, was deliberately turning his back on the findings of modern psychology.

A closer look at the final dream sequence at the end of *Iron City* allows for a final assessment of Brown's willingness or unwillingness to depart from Marxist orthodoxy or to admit the ambiguities and uncertainties that mark life in a racist society and in a modernist text. As the novel comes to an end, Lonnie James's defense committee receives word that the Supreme Court has new evidence and will reconsider Lonnie's appeal. In this state of suspension between uncertainty and hope, the novel abandons its social realist mode and shifts to a surreal dream world. Once again, we see how *Iron City* is indebted to the stylistic techniques of the Living Newspaper. The conclusion of the Living Newspaper *Liberty Deferred*, where Jim Crow jumps out of the frame, is strikingly similar to the last scene in *Iron City*, which begins with Faulcon dreaming that he sees the Hollow, the black section of Iron City, crumbling in a "silent slow-motion disaster." One scene after another dissolves dreamlike into the next, until the Hollow is transformed into a plush green valley surrounded by a forest and a winding river unrolling through the mountains. Faulcon hears what he thinks is Gabriel's trumpet, which turns into a sound like Louis Armstrong playing "Sunny Side of the Street." Faulcon imagines a million people seated before him, and, in the tradition of the socialist speaker, he plans to proclaim the beginning of a new millennium of racial and gender equality. But before he speaks, he orders the rich white people to the rear, the black working class to the front, and women to be seated on an equal basis with men. Folk figures like John Henry and Stackalee appear in the throng along with people from Faulcon's life, who become radiantly transfigured. His reluctant lover Sister Lucy Jackson appears, "tall and black and beautiful"—and now more willing than resistant. Lonnie stands before the assembled crowd, "proud and free," as Faulcon announces that Lonnie is going to be "a thirty-game winner for the Iron City Stars," who will never be last again. With Zachary

as the engineer, the Glory Train takes off with everyone on board but Faulcon, who stays behind with Lucy Jackson. Although the surreal dream and the reference to the Louis Armstrong song suggest a comparison with the Invisible Man's drug-induced rant in a hole, *Iron City*'s dreamscape, like the endings of the socially conscious Living Newspapers, is meant as a triumphant vision of change enabled not by an individual consciousness but by the energies of black communal and socialist traditions (Smethurst 1999).

But what haunts *Iron City*'s "authentic" Marxist ending and in fact betrays Brown's underlying anxieties is the very real execution of Jones ten years earlier. Since *Iron City* is based on Jones's case, which ended with Brown and his fellow communists unable to save his life, it is impossible to read the ending of the novel without remembering the original story, especially since *Iron City* trains the reader to act as an interpreter of texts and to connect the events of the literary text to extraliterary documents. In fact, Brown provided those documents in a 1952 *Masses & Mainstream* article, "The Legacy of Willie Jones," which nostalgically reviews the letters Jones wrote to him and to the outside defense committee before his death, a set of letters pointedly given to Brown in Pittsburgh the day after a reception honoring the publication of *Iron City*. Moreover, the images of this last scene in the novel are taken from biblical and religious conceptions of Judgment Day. Brown may even be betraying the remnants of his Catholic education at Cretin High School in St. Paul, where he was probably introduced to Catholic teachings on the Last Judgment, which are very precise and detailed about the end of the world and closely match Faulcon's dream. The world will not be annihilated, according to Christian theology, but will change in form and appearance; loved ones will be reunited though transfigured into a spiritual form; trumpets will announce the event. If Faulcon's dream is about life after death, it is, ipso facto, also about death. It is, in fact, a three-page passage saturated with images of death, particularly with the image of the newly transfigured Lonnie James, "who will never be last again" and whose ghostly doppelganger Willie Jones has preceded him on the Glory Train. *Iron City*'s victorious ending is both formally and politically unsatisfying, the one place in the novel where Brown's allegiance to Party politics seems to violate his artistic vision.

In my attempts to make a final determination about *Iron City*'s aesthetic posture, I turn to a two-part article entitled "Communists in Novels" by Brown's close colleague, *Masses & Mainstream*'s editor Charles Humboldt, the man Brown said was his "principal guide as a writer."[27] As communists were being prosecuted under the Smith Act, the Party moved away from its relatively liberal Popular Front policies toward a more rigid orthodoxy, demanding a greater allegiance to Marxist principles of art—a position that seems to have been spearheaded by the cultural critiques of the arch-conservative Andrei Zhdanov. Zhdanovism demanded that writers conform to Soviet socialist realism as a model for their creative works, and its demands "ushered in a new conservative phase" of the communist movement (Hemingway 2002, 221). In effect, that phase meant producing an art that was antithetical to anything considered bourgeois culture or not in the service of the proletarian movement. Zhdanovism was also antithetical to any signs of modernism, and it mandated an art dominated by a set of political rules about the correct portrayal of communists, the dangers of formalism, and the necessity of representing "the inspiring Socialist culture of the Soviet Union" (Hemingway 2002, 208). In light of these debates over the direction of Marxist and communist art, Humboldt in "Communists in Novels" attempted to put forth careful criteria for the acceptable communist hero in fiction; his criteria walk a careful tightrope between accepting the Zhdanov hard line and encouraging full creative expression for writers. Brown was certainly at the center of these debates over whether communists were or should be "aesthetic socialists" or "revolutionary socialists" subordinating art to politics, and it is likely that on some level he was struggling with these issues as he was crafting *Iron City*.

Clearly, Humboldt was no Zhdanov. He argued for the inclusion of Freudian insights about characters and for constructing a character with "fullness," by which he meant complexity. But despite his expansive and progressive understanding of the purpose of art, he too proposed "our requirements for the Communist character." In constructing the communist hero, Humboldt declares, the writer should minimize "everything in his make-up that might alienate him from his allegiance, lessen his love, weaken his comprehension, drive him to error, desertion or renegacy [*sic*]"

and maximize "whatever sustains him, gives him intellectual clarity, expands his capacity for love and loyalty, increases his resourcefulness and energy" (62). Humboldt inserted enough qualifications into his argument to allow the writer some artistic flexibility, but in the end he admonished writers to portray communist characters who "speak the language of the working class," are able "to master the forces that overcome others," and can "resist oppression instead of being crushed by it"; in other words, he called for "artists in uniform" (Guilbaut 1984, 130).[28]

Read together, the Redding, Kaiser, and Humboldt articles underscore my contention that a leftist influence was both limiting and liberating for Brown. As Redding observes, *Iron City* is modern in its experiments with the vernacular voice and narrative style. But, as Kaiser asserts, it is antimodern in its refusal to imagine for its characters the complexities of a modern psychology. Humboldt suggests that Brown was somewhere in between, attempting to balance the rigid Zhdanovian hard line with the more flexible Humboldtian one. Brown did not abandon his attempts to create a progressive social protest novel, but his heroes in *Iron City* were correct enough to have been rated A-list communist characters.

Brown's own problematic relationships within the Party do not surface in any of his writings. He had difficulties with Party leaders, particularly Earl Browder, whose efforts to liberalize and Americanize the Party disturbed the Marxist-Leninist camp that Brown favored and resulted in Browder's ouster from Party leadership in 1945. According to Brown's friend, the well-known communist writer Phillip Bonosky, Brown "survived" Browderism and went on to support Browder's successor, William Z. Foster. Bonosky says that Brown was suspicious of the Party's efforts to push him into leadership positions he felt unqualified for and eventually came to believe that he was being used by Party leaders and refused a nomination to the Central Committee. In 1998, Brown wrote to the historian Eric Foner and included, almost gratuitously, that he knew "the CP leadership would readily distort the record for narrow partisan reasons." But he was never naïve, reports Bonosky, and so was not disillusioned by the actions of the Party leaders—including the Khrushchev revelations—though he did quietly leave the Party in the early 1960s, continuing thereafter to refer to himself as

"a communist with a small c."[29] None of this ambivalence is represented in Brown's novel or in his essays, and none of his communist characters reflect the complexities suggested by his own experiences with the Party.[30]

What I have tried to do in this chapter is, first, to reinsert Brown and the literary Left at the center of 1950s African American culture to revise the notion that this was a decade of accommodation and retreat from the militantly left-wing 1930s and 1940s and, second, to challenge the way this period is reconstructed in merely aesthetic terms—for example, as the period of "Realism, Naturalism, and Modernism," as the *Norton Anthology of African American Literature* (Gates and McKay 2004, 1355) puts it. Black literature of the 1950s is more accurately described, as Brown makes clear, as a debate with multiple voices and perspectives, arguing over black representation, over the nature and future of protest literature and the politics of form, over gender and sexuality, over communism and anticommunism, over integration versus black civil rights militancy—debates in which an embattled Left was actively involved in the production and defense of African American culture. However long Lloyd Brown has been confined to what Smethurst (2004) calls the "isolated cultural circles of the left," his novel, essays, and radical activism played a central role in the literary and cultural debates of postwar black cultural production.[31] For its unmasking of Cold War manipulations, Brown's work ought to be considered an essential counterintelligence tool for contemporary historians of black life, literature, and culture.[32]

2

CHARLES WHITE: "ROBESON WITH A BRUSH AND PENCIL"

So you're not only touching the blackness, you're touching the Left . . .

—FRANCES BARRETT WHITE, 1951

IN 1940, CHARLES WHITE completed his third large mural, *A History of the Negro Press*,[1] a nine-by-twenty-foot oil painting commissioned by the Associated Negro Press, to represent the historical progress of the black press. The mural was exhibited at the huge African American Exhibition of the Art of the American Negro, which was held at the South Side Chicago Coliseum in July 1940 to commemorate the seventy-fifth anniversary of the Emancipation Proclamation (Mullen 1999, 75). At the time White was at the Mural Division of the Illinois Federal Art Project, where he worked with two left-wing artists, Edward Millman and Mitchell Siporin. Organized by two Howard University professors—Alonzo Aden, the curator of Howard's art gallery, and Alain Locke, a professor of philosophy and major African American cultural critic—the 1940 exhibition was a milestone for the twenty-two-year-old White. He won acclaim and a first prize for his mural, which, until it was either lost or destroyed, was on display in the offices of the *Chicago Defender*.

The mural features eleven male figures engaged in the production of black newspapers. In the center of the left half of the mural are the three titans of the black press: John Russworm, the founder of the first black newspaper in 1827, *Freedom's Journal*, holds a series of broadsides spread out before him. Above him and to his left is Frederick Douglass, the founder of

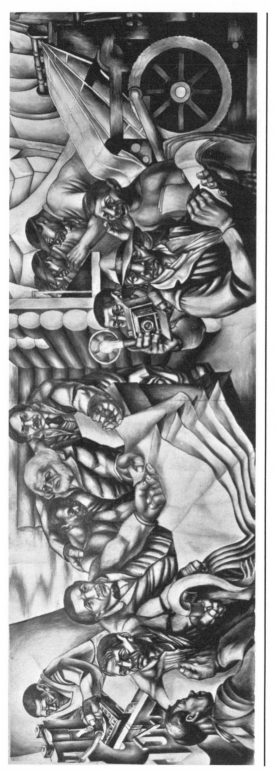

FIGURE 2.1. Charles White, *A History of the Negro Press* (1940).
Source: Photograph by Frank J. Thomas. Courtesy of the Frank J. Morgan Archives.

the 1847 abolitionist paper the *North Star*, with a full head of white hair and beard and his arm around a former slave. Centered at the apex of this triumvirate, to Douglass's right, with his signature professorial black-rimmed glasses, vest, and tie, is T. Thomas Fortune, the editor of the militant *New York Age*, founded in the early 1880s. At the bottom left is a man reading the paper and another with the torch that White often used to represent militant struggle. The four figures on the right side of the mural represent the contemporary black press. One man in a reporter's trench coat, his press pass tucked into the rim of his fedora, takes notes on a tablet. To his right a photographer holds a large flashbulb camera, and to his left is the operator of the printing press standing next to the machine that spins out the news of the day. The mural is balanced with a man setting type on the far left and the modern printing press on the right half. In this early work, the visual chronicle of the hundred-year history of the black press, White's investment in the modern is clearly on display, in the swirling lines that give a sense of deliberate but accelerating motion of progress, in the large and angular stylized hands, in the geometric lines repeated in the facial features of each of the eleven men, and in the way the history of the press is compressed into this single visual moment. But what is most modern in the drawing is the relationship between the men and the machines: the eleven men—printers, call boy, mechanics, photographer, and reporter—all are totally at ease, calmly poised before, in control of, and helping produce the forces of modernity unleashed by the machines (Clothier n.d.).[2]

White's biographer Peter Clothier was the first to call my attention to what he refers to as the mural's "stylistic contradictions," the tension between representational realism and modernist experimentation (68).[3] On the one hand we see White's modernist tendencies in the enlarged hands and arms and in the mural's theme of black progress, but the mural is clearly representational, the narrative easily accessible, the figures only slightly stylized. The mural serves as an interpretive context for understanding a decades-long interplay between White's social realism and his commitment to a modernist art. While White's critics most often situate him within an African American cultural context because of his desire to historicize and celebrate black culture, few acknowledge his affiliations

with the Left and with the Communist Party. I argue that we cannot understand White's work, especially his commitment to social realism, without considering how these "stylistic contradictions" are rooted in his dual role as artist and political activist in the context of a U.S. and an international Left, specifically during the 1940s and 1950s. If White was leaning toward more experimental forms in his work, he would eventually have to decide if and how these forms could be made compatible with the radical Left's advocacy of a democratic people's art predicated on the political potential of beautiful, realistic, accessible images of black people and black culture.

It is important to emphasize that White's commitment to a black cultural aesthetic predated his affiliation with the Communist Party. As far back as his teenage years in Chicago he describes discovering the beautiful black faces in Alain Locke's 1925 *The New Negro*, which confirmed his fascination with blackness. White's close friend, the writer John O. Killens, insisted that beyond celebrating blackness, White was intent on establishing a new aesthetic: "The people Charlie brings to life are proudly and unabashedly black folk, Africans, with thick lips and broad nostrils. Here are no Caucasian features in blackface, but proud blacks—bigger than life, in epic and heroic proportions" (1968, 451). Another of White's close friends, the artist Tom Feelings, an even more perceptive critic, adds that White's aesthetic was attentive to class as well as race:

> Though his active interest led him to draw and paint great historical figures from black history, I believe that in most of his artwork Charles White purposely chose to depict the everyday, ordinary, working-class people, the most African-looking, the poorest, and the blackest people in our ranks. The ones who by all accounts were the furthest from the country's white standards of success and beauty.
>
> (1986, 451)

In effect, White was constructing a black radical subjectivity, a visual analogue of the radical work being done by black leftist writers that would eventually force his personal and aesthetic crisis with the Left.

Publicly and privately, White espoused the ideals of Marxism, and, at least until 1956, he was involved with the institutions that the Communist Party led or influenced—associations that supported both his personal ideals and his art.[4] During his more than forty years as an artist, White created a visual archive of more than five hundred images of black Americans and black American history and culture. His portraits of historical figures including Frederick Douglass, John Brown, Sojourner Truth, Harriet Tubman, Leadbelly, and Paul Robeson have become signatures of his artistic legacy. His great murals, such as *The Contribution of the Negro to Democracy in America* (1943), *A History of the Negro Press*, and *Five Great American Negroes* (1939–1940), are almost immediately recognizable as White's work. He developed a highly respected reputation in both black and white communities because he worked to make his art more accessible—financially as well as aesthetically—to working-class people. He produced his 1953–1954 folio of six prints in a beautiful but inexpensive edition, published by the Marxist Masses & Mainstream Press. In the 1960s, he contracted with the black-owned Golden State Mutual Insurance Company of Los Angeles to illustrate their calendars in order to insure that his art would be found in black homes, restaurants, barber and beauty shops, and places where working-class blacks would see it, doing more than any other artist of his generation to put art in the hands of the black and white working class (Barnwell 2002, 84; Clothier n.d., vii).

White's focus on ordinary people, on the black worker, and on black resistance was deeply bound up with his progressive political engagements. He wrote for and illustrated the *Daily Worker* and the *Sunday Worker*, *New Masses*, and *Masses & Mainstream*, all of which nurtured his developing political activism as well as his aesthetic formation. Along with his first wife, the renowned sculptor and artist Elizabeth Catlett, he taught classes at the communist-led Abraham Lincoln School in Chicago and at the Left-led George Washington Carver School for working people in Harlem. His international travels and interactions with the Left in Mexico, the Soviet Union, and Germany helped establish his international reputation. He studied art in Mexico with the Mexican communists Diego Rivera, David Alfaro Siqueiros, and Jose Clemente

Orozco[5] and in interviews, articles, and private conversations described those collaborations as important to his growth both as an experimental artist and as an *artist on the Left.*[6] The first major critical study of his work by the communist critic Sidney Finkelstein was published in Germany by a socialist publisher. His major U.S. exhibitions in the 1940s and 1950s were at the left-wing American Contemporary Art Gallery, run by a left-wing director, Herman Baron. He met his second wife, the social worker Frances Barrett, at a camp for the children of the Left, Camp Wo-Chi-Ca (Workers' Children Camp), where she was a counselor and he taught art, and when they moved to New York in the 1950s, he and Fran were active members of the Left-dominated Committee for the Negro in the Arts.[7] In short, in the 1940s and 1950s, the critics reviewing White's work, the gallery showing his work, the publishers publishing his work, and the major biographer and critics commenting on his work were all Left-identified and nearly all aligned with the Communist Party.

While the institutional support of the Left was important in supporting an already formed aesthetic, White began, in the mid-1940s, to explore the formal techniques of modernist abstraction. Less than a decade later, as the mainstream art world shifted radically in the direction of abstraction, White embraced the socialist realism favored by Party art critics and turned away—at least during the period of the high Cold War—from his 1940s work, which had so effectively (and affectively) combined a politically charged realism with a degree of modernist experimentation. I believe that this shift precipitated a crisis for White and that, even as he appeared to be in close alignment with the Party's views on art, that crisis was expressed in his work. In this chapter I look at how crisis is encoded in his art and try to assess the assets and liabilities of White's long-term affiliation with the communist Left. With the help of the interviews White and others gave to Peter Clothier in the 1970s and 1980s, this chapter investigates, although inconclusively, how this combination of black cultural politics, modernist aesthetics, and leftist radicalism played out in White's work and life.

The second goal of this chapter is to challenge those studies that omit, obscure, or elide White's radicalism. I understand the black-Left relationship in White's life (as in others) as a complicated one of support and

conflict, anxiety and influence, love and theft, eventually resolved, at least partly, by White's move to black cultural nationalism in the 1960s. I carefully examine the tensions that develop between White and the Left during the Cold War, as leftist art critics, contending with the repressions of the Cold War, became more rigid in their ideas of what constituted a progressive and politically acceptable art practice. To some extent, this sounds like an old tale of the decline of the Left and the subsequent turn of the black left-wing radical artist to black nationalist and civil rights movements,[8] a shift precipitated by what Richard Iton (2010, 33) describes as the Left's "chronic inability to reckon with black autonomy."[9] But White's story is definitely not one of leftist manipulation and betrayal but a rarely told story of a highly nuanced, personally and professionally productive, sometimes difficult and vexed, but ultimately life-long relationship with the Left that was still vital when White died in 1979 in Altadena, California.[10]

AN ARTIST IN CHICAGO'S BLACK
RADICAL RENAISSANCE

Born in 1918 in Chicago, the child of a single mother[11]—White's father, to whom his mother was not married, died when he was eight, and his mother divorced his stepfather when he was ten—White came of age in "Red Chicago" during the 1930s, when the Communist Party had developed a broad base and become an accepted organization in the black community (Clothier n.d., 6, 27). The Chicago community activist Bennett Johnson claims that "the two most important and active organizations in Chicago's black community in the early 1930s were the policy racket and the Communist Party, the former taking care of black entrepreneurs and the latter taking care of the people who were buying the numbers."[12] It is quite clear why the Party attracted blacks in Chicago, especially during the Depression. In an industrialized city, where blacks were at the bottom of industry's discriminatory structures and were trying to organize themselves as workers, the militant efforts of the Communists to unionize,

stop evictions, integrate unions, and give positions of authority to blacks in the unions were beacons of light to the African American community. Horace Cayton writes in *Black Metropolis*, his sociological study of black Chicago, that in the 1930s when a black family feared an eviction, it was not unusual for them to tell their children to run and "find the Reds" (Storch 2009, 113).[13]

In one oral autobiography, White says that as a child he spent a great deal of time alone in the library, where he discovered the book that changed his life, Alain Locke's 1925 anthology *The New Negro*, which included hundreds of pages of literature by and about blacks, as well as black-and-white drawings and full-color portraits of famous black writers and activists.[14] Already a precocious artistic talent, White was taken with the visual aspects of this text, especially those "wonderful portraits of black people" by the German-born Harlem Renaissance artist Winold Reiss: "I'd never seen blacks quite that handsome. It blew my mind."[15] Through *The New Negro* he says he discovered an affirmation of both the tremendous artistic talent of black people and their inherent beauty and dignity. During his many solitary visits to the library, White also found a world of black poets, writers, and activists, including Frederick Douglass, Harriet Tubman, Denmark Vesey, Nat Turner, and Phillis Wheatley, so when he encountered the total absence of any black historical figures in a history class at Chicago's then mostly white Englewood High School, he was not only disappointed but confrontational. When he asked his white history teacher why these people were omitted from the history textbook, he was told to sit down and shut up (1955, 36). White experienced other incidents of educational racism; these became catalysts for his developing racial consciousness. His drama teacher told him that he could help with sets but that there were no acting roles for black students. When he was awarded two scholarships—one from the Chicago Academy of Fine Arts and one from the Frederick Mizen Academy—he was rejected by both institutions when he showed up in person to accept. All of White's biographers remark on his deepening involvement in black cultural life, and these encounters with racism must be counted as a part of that development. Finally, through the help of one of his teachers, he applied for and won a full-tuition art scholarship to Chicago's School of

the Art Institute, where he was exposed for the first time to the formal art world (Clothier n.d., 17).[16]

If White's black cultural consciousness is forecast in these school experiences, it was an alternative neighborhood school that directed him to the political and cultural Left. In 1933, when he was about fifteen, he saw an announcement in the *Defender* for a meeting of the Art Crafts Guild of the South Side, but he was so shy he first had to walk around the block in order to get up the nerve "to go to these strange people."[17] He finally knocked on the door and told them he wanted to join the art club—the Art Crafts Guild.[18] There he met what would eventually become Chicago's black progressive art community. Led by the artists Margaret Burroughs and her future husband Bernard Goss, the Art Crafts Guild was a distinctively community-based group that included visual artists, sculptors, writers, and dancers, among them Charles Sebree, Eldzier Cortor, Joseph Kersey, Charles Davis, Elizabeth Catlett, George Neal, Richard Wright, Gwendolyn Brooks, and Katherine Dunham. With little money, the visual artists worked out a plan for Neal, the senior artist among them, to take classes at the Art Institute of Chicago and then come back and teach the group what he'd learned. When the Works Progress Administration (WPA) of President Franklin Roosevelt's New Deal targeted the South Side of Chicago in 1938 for federal assistance to bolster the arts, Burroughs and Goss played a major role in the planning for a federally supported public center for black art that eventually became the South Side Community Art Center (SSCAC), which is still operative on Chicago's South Side. The improvised studios and converted back-alley garages of the Art Crafts Guild were transformed into a South Michigan Avenue mansion, remodeled by architects and designers of the Illinois Art Project, allowing poor and struggling black artists to be supported, at least for a brief time, with federal dollars.

Though black left-wing visual artists are almost always pegged as social realists, Bernard Goss suggests that the SSCAC artists were self-conscious modernists from the beginning. In a 1936 essay, "Ten Negro Artists on Chicago's South Side," written for *Midwest: A Review*, Goss writes that, having learned to read and write and to straighten our hair, and having discovered

art schools, "We became modern." In the attempt to represent this new cul-
ture, Goss says the group "practically all agree[d] silently on the doom of
Conservatism." A kind of artistic manifesto, the essay describes the SSCAC
group as artists in search of "the identity of a new culture," influenced by
Africa, by continental Europe, by the Native American Indian, and, Goss
adds, some of these new identities would be racial, some not. What they had
in common was that all felt that modernism conferred upon them a sense of
creative freedom, which Goss describes in terms that evoke the energy and
play of childhood: "that consciousness [of modernism] gives us a greater
space for romping than we had at the academic school" (18).

If the SSCAC was a wonderful social community, it was also radicalizing
for White both politically and aesthetically. When he began to take part
in the Negro People's Theatre Group at the SSCAC, first by designing and
building sets and later as an actor, he was already beginning to speak the
language of a leftist radical. He wrote to the communist writer Mike Gold
on December 28, 1940, asking Gold to include something about the "Negro
in the Theatre" in his column in *New Masses* and sharing with Gold the dif-
ficulties of trying to build an interracial, mass movement theater:

> We are trying to be a real people's theater, but our greatest difficulty is
> in attracting a mass Negro and white audience. . . . We found that large
> numbers of Negroes really wanted to see the stuff that's in the movies
> and wished to avoid having their problems as a minority group in this
> capitalistic world shown to them and solutions pointed out. Of course we
> were called radical and everything else. But our group of young people
> have grown to understand that these epithets are thrown at whosoever or
> whatsoever speaks for the working man.
>
> (Clothier n.d., 38)

White was also beginning to paint in the style that would identify him
as a man of the Left. *Fatigue* or *Tired Worker*, a Depression-era drawing
completed in 1935, when White was only seventeen years old, shows a sleep-
ing black laborer bent over a rough-hewn table, his weariness captured in
the "shoulders hunched against a sharp concern,"[19] the furrowed brow, and

his head resting heavily in the crook of his arm. The enlarged hands, which would become a White signature, the muscular shoulders and head, and the determined set of his mouth convey, even in sleep, both exhaustion and strength. The slight distortion of the natural figure indicates that White is already interested in adopting modernist techniques in his work, and, even more to the point, these expressive techniques enabled him to convey a deep sensitivity to the plight of the worker.

WHITE AND THE ILLINOIS WPA

For about three years, beginning in 1938, White worked on the WPA Illinois Fine Arts Project (WPA/FAP), moving between the Arts Section and the Mural Division of the FAP and studying Marx, Lenin, and Engels with his fellow WPA muralists, Edward Millman and Mitchell Siporin. With Millman and Siporin, he also studied the work of the radical Mexican muralists, another inspiration, particularly after White visited Mexico in 1946 and 1947, that drew him to the Left. Burroughs reports that while White worked with the WPA, he was a member of and attended meetings of both the Artists' Union and the John Reed Club, an organization of left-wing writers and artists. White remembered that black artists easily qualified for a job with the WPA because they so clearly fulfilled the "pauper's requirement" of being destitute: "You first went down to the Works Progress Admin. office. You declared yourself bankrupt, or destitute, I mean, and stated that you needed some economic aid. . . . They in turn, once having investigated and found this was true, then you were placed—they sought to place you on a job suited to your abilities and so forth."[20] White's most memorable WPA experience was the sit-down strike at WPA headquarters to protest the art supervisor's refusal to hire black artists. Although the strike resulted in police intervention and arrests, it also spawned the formation of the Artists' Union that White said eventually became very strong, and, in 1938, it formally affiliated with the Congress of Industrial Organizations (CIO).[21] According to the art historian Andrew Hemingway (2002), the leading figures in the Artists'

Union, which began as the Unemployed Artists Group within the John Reed Club in 1933, were Party members or fellow travelers, and, though their constitution claimed the group was nonpolitical, their public pronouncements about the solidarity between artists and workers, their class-inflected rhetoric about hope for a new world, and their history with the communist-aligned John Reed Clubs suggest otherwise. By this time White was seriously studying art and Marxism with Morris Topchevsky (Toppy) on the WPA and at Chicago's Abraham Lincoln School (Clothier n.d., 47). What Burroughs and other leftists called "the defense of culture"—to preserve art for the people, not for the elite—became White's mantra for the rest of his life, a commitment to a representation of black people that would counter the stereotypical images of blacks and that questioned their absence in art and to making art that spoke to and was available to the working class.

In 1941 White met and married Catlett, who had come to Chicago to study ceramics at the Art Institute and lithography at the SSCAC, and although Catlett claimed in an interview in 1984 that the communists in the SSCAC tried unsuccessfully to recruit her, she admitted to her most recent biographer that by the mid-1940s both she and White were working closely with the Party (Herzog 2005, 39). Their involvement in Chicago Popular Front organizations like the National Negro Congress (NNC), a communist-initiated organization active in Chicago; the then-progressive black newspaper, the *Chicago Defender*; the South Side Writers' Group, founded by Richard Wright; and the Abraham Lincoln School, directed by the communist William Patterson indicates that the seeds of the couple's commitment to progressive social issues and to an art focused on the black working class were nourished in these Negro People's Popular Front collaborations, so aptly described by the cultural historian Bill Mullen as characterized by "an improvisatory spirit of local collaboration, 'democratic radicalism,' class struggle, and race-based 'progressivism'" (1999, 10). White came of age in and was wholly at home with this brand of *improvisatory, collaborative, community-and-race-based* radicalism that allowed him to develop freely as an artist and as a political thinker.

As is true of the literary figures in my study, White's associations with communism and the Left have been downplayed or ignored by his major

biographers and by most literary and art historians, with the exception of Andrew Hemingway, whose comprehensive 2002 critical study identifies White's communist connections (173). References to the Left or to the Communist Party in White scholarship are often filtered through the language of anticommunism. In White's most recent biography, for example, the author Andrea Barnwell says of the Civil Rights Congress, a merger of the NNC, the International Labor Defense (ILD), and the Communist Party, that it was a "group *suspected* of affiliating with the Communist Party" (2002, 44, emphasis added), that White continued working and collaborating with other left-wing artists "*despite the danger of being affiliated* with progressives" (42, emphasis added), and that he "*sympathized* with the Communist Party's aims" (42, emphasis added), all of which suggest that White had only marginal and tenuous relationship to the Party.

In a 2008 interview, White's close friend Edmund Gordon, professor emeritus of sociology at Columbia University, offered this carefully worded description of White's leftist politics:

> He clearly identified with the Left, though he never mentioned to me that he was a member of the Party. In those days you didn't go around talking about being in the Party. I never saw a so-called Party card, but it was no secret that his politics were Left, and in his more candid moments, I am sure that he would say he believed in socialism. He certainly was very grateful to the Left for their support. When he went to Eastern Europe and the Soviet Union, I'm sure his support for that trip came from that source.[22]

The commentary on White's political radicalism suggests that, even fifty years later, White's relationship to the Party can be constructed only as philosophical and ideological affinities but that any institutional or organizational relationship to the Party is still suspect and dangerous. Nonetheless, as with all the figures in *The Other Blacklist*, those institutional and organizational ties are critical for understanding the development and direction of White's art.

THE 1940S MURAL: *TECHNIQUES USED IN THE SERVICE OF STRUGGLE*

Between 1939 and 1940, while working on the WPA, White completed three of his great murals, *Five Great American Negroes* (1939–1940), *A History of the Negro Press* (1940), and *Techniques Used in the Service of Struggle* (1940), all done as part of a progressive Popular Front agenda of expressing social-democratic ideals. But it was White more than any other progressive muralist who was devoted to inscribing black resistance in his representations of a democratic America. Besides embodying the ideals of the Black Popular Front, two of these murals—*A History of the Negro Press* and *Techniques Used in the Service of Struggle*—show White following the example of the Mexican muralists and the other left-wing WPA artists in combining formal experimentation with a vision of the black national history of struggle.

In contrast to the sense of relentless and progressive motion in *A History of the Negro Press*, White's other 1940 mural, *Techniques Used in the Service of Struggle*, depicts black struggle checked by racist brutality. *Techniques* was variously labeled *Chaos of Negro Life* (Barnwell 2002), *Chaotic Stage of the Negro, Past and Present*, and by White as *Revolt of the Negro During Slavery and Beyond*. These conflicting titles reflect the way viewers, used to the more pacific WPA style, which generally represented an America of peace, progress, and prosperity and rarely included people of color or racial strife, may have been unsettled by this raw depiction of racial violence.[23] The thirteen figures on the panel constitute a historical tableau of both black subjugation and black resistance to slavery, peonage, sharecropping, and lynching. On the far right side of the left panel a black man, bent over almost to his knees, is held in shackles and chains by a white overseer, the only figures physically separated from the others.[24] Slightly right of center a lynched body hangs from a tree that surrealistically comes up out of the ground and is blasted off at the top, with its one branch curved around to the hanged man's neck as if it has gone in search of him. In the center of the mural, as in several of White's murals, there is a black family, with a

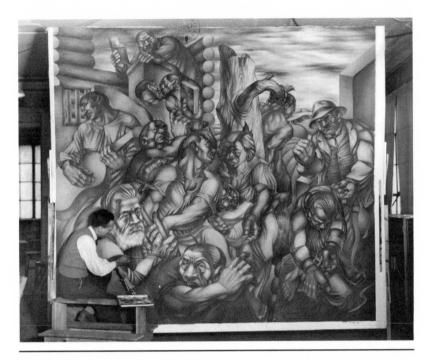

FIGURE 2.2. Charles White at work on his mural
Techniques Used in the Service of Struggle (c. 1940).
Source: Chicago Public Library, Special Collections and Preservation Division, WPA 132.

woman holding a child and next to them the man of the family, looking back in anguish toward the woman, his arms stretched out in front of him. Next to him the enlarged head of John Brown, as if looming out of history, seems disconnected from Brown's foreshortened arm, which holds a rifle and is intertwined with the hand of the black father. On the left side of the mural are figures that continue the theme of black resistance culture: a man with a guitar standing next to iron bars of a jail cell, who might suggest another leftist symbol, the folk singer Leadbelly, and another man holding up a book, a signature image White used to represent the power of literacy and education. At the very top of the triangular composition a man, perhaps a preacher, holding an open book at a lectern or pulpit, looks

down angrily on two men who are turned toward each other with questioning and skeptical looks, as if dismissing the illusions of religion. The overall narrative depicted in the intertwined and intersecting bodies is that black progress has been blocked by the forces of racism, that in the face of massive racial violence, despite the "techniques of struggle," there is no exit.

What makes White's mural exceptional is the central place White accords black people and black resistance in the narrative and its unrelenting representation of racist brutality.[25] Even though in 1940 White had not yet traveled to Mexico, *Techniques* demonstrates that the Mexican muralists' focus on social and political justice and on indigenous people, achieved through formal experimentation had already begun to influence White. The artist and former White student John Biggers specifically cites the influence of Millman and Siporin[26]—and through them, the Mexicans—on White's work. Biggers thought that the work took on "a new abstract quality, a new kind of strength as a result of working with these two guys" (quoted in Clothier n.d., 14). Not only were the Mexican artists using their art to fight for the same progressive and radical values as the artists in White's circles—against poverty, racism, and exploitation—but also, in their visions of a future, they featured indigenous blacks in prominent and powerful positions. While much of the influence of the Mexicans came to White indirectly through Siporin and Millman, we know through Burroughs and White that the political and artistic work of the Mexicans was discussed in African American community centers and that *los tres grandes* (Rivera, Orozco, and Siqueiros) were well known in the United States. Let me point out that throughout the 1950s, White never visualized black resistance in such stark, defiant, and bitter terms as he did in *Techniques*. As an example of "a marked increase of stylized features" (Clothier n.d., 60) in his work, *Techniques* exemplifies the direction that would eventually precipitate a collision course with the Left and a clear shift away from stylization toward greater representational realism. During the 1940s, however, White continued to focus on black historical themes and to pursue the methods of formal experimentation that allowed him not only to craft a distinctive style but also to communicate through visual narratives of racial injustice the power, agency, and dignity of the black subject.

THE SOUTH, THE ARMY, THE HOSPITAL,
AND THE MEXICAN EXPERIENCE

The six years of White's life from 1943 to 1949 were emotionally tumultu-
ous but professionally rewarding. In 1942 he and Catlett moved to New
York, where they both worked at the left-wing George Washington Carver
School in Harlem and, in the summer, at the leftist Camp Wo-Chi-Ca,
founded by the Furriers' Union for leftist workers and their families to sup-
port interracial cooperation. He continued his work as an editor for *Masses
& Mainstream* and the *Daily Worker*. In 1943 he received a two-thousand-
dollar Julius Rosenwald Fellowship, which he used to travel with Catlett
throughout the South, "studying and painting the lives of black farm-
ers and laborers" and visiting his extended family (Barnwell 2002, 29). He
also intended to study in Mexico, but the draft board denied his request.
In 1943 he and Catlett also went to Hampton Institute in Hampton, Vir-
ginia, where White completed the mural *The Contribution of the Negro to
American Democracy*, when he was still only twenty-five years old. In line
with Popular Front politics, the mural represented a homegrown defense of
American democracy made possible by black activism. As Rivera did with
his inclusion of a picture of Lenin on his Rockefeller mural in New York,[27]
White included a covert sign of his leftist politics. Along with the avenging
black angel and revolutionary heroes Crispus Attucks, Nat Turner, Den-
mark Vesey, Sojourner Truth, Frederick Douglass, and the runaway slave
Peter Still (who carries a flag with the words "I will die before I submit to
the yoke"), White depicted the black left-wing National Maritime Union
(NMU) activist Ferdinand Smith, who was eventually deported for his rad-
ical activism, and placed him next to Paul Robeson, whose arm, shaped like
a powerful wooden mallet, completes the mural's (and White's) revolution-
ary designs.

White's art-making came to an abrupt end when he was drafted in 1944.
He served a year in the armed forces, where he contracted tuberculosis while
he was working to stop the flooding of the Mississippi and Ohio Rivers; he
then spent two years in a hospital in upstate New York. When he appeared

to be recovered, he went with Catlett to Mexico to study and work with the Mexican artists. If the Mexicans had a powerful influence on White from several thousand miles away in the early 1940s, the year and a half that White actually spent in Mexico (1946–1947) invigorated that influence and accounts for the most politically charged and stylistically innovative art of his career. In Mexico, he says he felt for the first time in his life like a man who could go anyplace: "Nobody could care less what I looked like."[28] During this time, White began to understand what he considered the major problem in his life as an artist: the dichotomy between his political ideals and his personal artistic goals. He thought that the Mexican artists, with their studios in the streets, had solved that problem:

> So I saw for the first time artists dealing with subjects that were related to the history and contemporary life of the people. Their studio was in the streets, their studios were in the homes of the people, their studio was where life was taking place. They invited the Mexican people to come in to evaluate their work, and they sought to learn from the people. . . . They didn't let their imagination run rampant. They solved the problem of this contradiction in a collective way. I saw artists working to create an art about and for the people. That had the strongest influence on my whole approach.
>
> (Clothier n.d., 56)

The Mexican influence is especially evident in all of White's 1949 drawings, which are more overtly political and stylistically more daring than his other 1940s work. The 1949 pieces in the 1950 exhibition at the ACA Gallery include portraits of four historical figures who were staples of leftist representational insurgency (John Brown, Frederick Douglass, Sojourner Truth, and Harriet Tubman) and three historical drawings (*The Ingram Case*, *The Trenton Six*, and *Frederick Douglass Lives Again* or *The Living Douglass*), which show that expressionistic techniques were becoming part of White's stylistic explorations.[29] Let me describe two of the most well known of White's 1949 expressionistic drawings. *The Ingram Case*, which was reproduced in the *Daily Worker* along with an article, "The Ingrams

Jailed—America's Shame," focused on a prominent civil rights cause supported by the left-wing Civil Rights Congress. Rosa Lee Ingram—a widow, tenant farmer, and mother of fourteen children—and two of her sons were sentenced to death in Georgia in 1948 for the murder of their white tenant farm owner, who, she claimed, had sexually assaulted her. In White's drawing Rosa and her two sons are behind massive bars, with Rosa looking out beyond the jail cell and her sons looking pleadingly toward her, one with his arm reaching over the head of his brother as if to try to touch his mother. Hands are prominent in this drawing. One son clutches the bars with both hands, but Rosa's right hand reaches beyond the bars and is balled into a fist. Her other hand lightly touches the bar, and both arms are enlarged. The shadings of black and white on their faces emphasize both their blackness and their suffering, and the light from Rosa's eyes suggests grief and weariness. The bars of the cell seem to be laid on the bodies of these three figures, both holding them in the cell and weighing them down. But the swirling black and white lines of the mother's dress and her fists on the bars undercut the painting's sense of desperateness and suggest the tenaciousness of Rosa Ingram's fight to free herself and her sons. In response to public opinion about the harsh sentences, Mrs. Ingram's sentence was later changed to life imprisonment. Civil rights groups from the mainstream Urban League to the left-wing Sojourners for Truth and Justice fought to free Ingram, and largely because of the efforts of the CRC, the Ingrams were eventually freed in 1959 (Horne 1988, 212).

In *The Trenton Six*, done in black ink and graphite on paperboard, White features the six men who were accused of killing a white man in Trenton, New Jersey, and sentenced to the electric chair, despite a lack of evidence and proof of a frame-up and coerced confessions. Thirteen years after the near lynching of the nine Scottsboro men, the same antiblack mob violence prevailed in the northeastern city of Trenton. After the widow of the murdered man named black men as the killers, the *New Jersey Evening Times* carried an editorial entitled "The Idle Death Chair," as if black suspects automatically required putting the chair to use. Because of the efforts of the CRC and Bessie Mitchell, the sister of one of the framed men, the sentences were reversed by the Supreme Court and, in a second trial, four of the

six men were found innocent. In the midst of her fight to free her relatives, when Mitchell was asked why she turned to a group as controversial as the Communist Party, she replied, "God knows we couldn't be no worse off than we are now." In the White drawing, Mitchell is the central figure, standing in front of a barbed wire fence that encloses the six men, her enlarged hands and massive arms in a gesture of protectiveness, power, and pleading. One hand points to the men behind the fence, allowing the viewer to move past Bessie to the men who face outward at nothing in particular, as though acknowledging the desperation of their situation. Bessie's eyes are sad but determined, gazing upward as though she is capable of doing whatever is necessary to free her kinsmen. However conservative these techniques may have seemed to 1950s mainstream art critics smitten by abstraction, they represented a black avant-garde. Deployed in the service of black resistance and on behalf of left-wing causes, these images of white oppression, black anger, and leftist political agency constituted a modernist assault on the national imaginary of Jim Crow America.

A few mainstream art critics praised White's work precisely because it combined a black aesthetic with stylistic experimentation. In the *New York Times* review of his first one-man show in September 1947, White's work was described with an emphasis on form: "He paints Negroes, modeling their figures in bold blocky masses that might have been cut from granite." The reviewer also commented on the effect of merging stylized techniques with a black cultural sensibility: "Something of the throbbing emotion of Negro spirituals comes through. A restrained stylization of the big forms keeps them from being too overpowering. This is very moving work" (Horowitz 2000, 19). What White was doing in these 1949 pieces—combining stylistic experimentation with meaningful social content—was entirely consistent with the work and thinking of many socially concerned artists. According to the cultural historian Bram Dijkstra (2003, 11), these artists "link[ed] the technical innovations of modernism to a working-class thematic as part of a passionate commitment to the principles of social justice and community rather than to feed the indulgence of private obsessions." By the early 1950s, however, critics on the Left began to assess the stylizations of White's work negatively. Despite the fact that *The Living Douglass* had appeared on the

front page of the *Sunday Worker*, Sidney Finkelstein, the major art critic of *Masses & Mainstream*, found the piece problematically experimental, because, he said, the stylization of the human head and body "still lingers" (1953, 43–46), a clue that the winds of change were blowing and that White's experimentations, no matter how much they throbbed with black emotion, would no longer find favor with certain Party critics. In these 1949 and 1950 drawings, black identity is represented as an aspect of historical narrative and therefore as contingent, open-ended, and mutable. In the portraits of blacks White would formulate after 1950, he made changes in both his style and his representations of black identity that correspond with the commentary of some leftist art critics in the *Daily Worker* and *Masses & Mainstream*. The result is a representation of blackness that is far less inventive and innovative than these dynamic 1940s combinations of black subject, black resistance, and modernist aesthetics.

THE COMMITTEE FOR THE NEGRO IN THE ARTS AND THE BLACK LEFT RENAISSANCE IN NEW YORK

The changes in White's personal life in the late 1940s and early 1950s deepened his commitment to the Left. In 1946 he went through an acrimonious divorce from Catlett, who married the Mexican artist Francesco Mora, whom she met while in Mexico. White then returned to the hospital for another year of treatment for a recurrence of tuberculosis, and when Frances Barrett, the young counselor he had gotten to know at the interracial left-wing Camp Wo-Chi-Ca, came to visit him in the hospital, they struck up a friendship that eventually led to their marriage in 1950. In the love letters they wrote to each other before their marriage, there is evidence that their political commitments were part of what drew them together. Charlie wrote to Fran in 1950 that their "deep and tremendous faith in love, people, and Marxism" would be "a solid front" in their interracial marriage (Barrett-White 1994, 22).

Fran and Charlie moved to New York City in 1950 and, despite the loom-
ing McCarthy onslaught, became part of a dynamic world of leftist intellec-
tual and political activity. White was an editor at *Masses & Mainstream* and
had already had two exhibitions at the ACA Gallery, both New York–based
left-wing institutions. Major Left-led and Left-influenced unions like
United Electrical, United Public Workers Association, the Furriers' Union,
and the National Maritime Union (NMU) were all located in New York.
The communists Ben Davis and Peter Cacchione had been elected to the
New York City council, and the communist Vito Marcantonio was a New
York City representative to Congress. White worked openly on the political
campaigns of both Davis and Marcantonio, donated his art to support their
work, and was friends with major black left-wing figures like Paul Robe-
son, W. E. B. Du Bois, the CRC head William Patterson, and the NMU
vice president Ferdinand Smith. Also headquartered in New York during
this period were important and influential leftist publications like Adam
Clayton Powell's *People's Voice*, the Marxist journal *Masses & Mainstream*,
Robeson's newspaper *Freedom*, the communist newspapers *The Daily World*
and *The Sunday World*, and black left-wing organizations like the Council
on African Affairs, the CRC, and—most importantly for the Whites—the
Committee for the Negro in the Arts.

During this period, which Fran White called "this CNA time" and
"another Renaissance,"[30] the Whites made the decision to move from
Twenty-Fourth Street to 710 Riverside Drive uptown because they wanted
to be close to the black community and because "all the CNA activities
[were] uptown."[31] Founded in 1947 by Paul Robeson and others on the Left,
with the goal of "full integration of Negro artists into all forms of American
culture and combating racial stereotypes," the CNA was a militantly black,
politically Marxist, socially bourgeois, interracial cultural organization that
was, perhaps, the most successful black/Left collaboration of New York's
Black Popular Front, though it is almost totally marginalized in leftist liter-
ature except for its venomous portrait in Harold Cruse's 1961 critique of the
Left, *The Crisis of the Negro Intellectual*. Phillip Bonosky, a white communist
who started the Harlem Writers Workshop at the request of black writers
in CNA, remembers it as "our organization," but CNA's interracialism was

FIGURE 2.3. Photograph of founding members of the Committee for the Negro in the Arts (c. 1940). Left to right: Walter Christmas, Ruth Jett, Charles White, Janet Collins, Frank Silvera, Viola Scott Thomas, Ernie Crichlow. *Source*: C. Ian White and the Charles White Archives. © Charles White Archives.

certainly problematic for some. Some blacks felt that whites had no place in a black organization, and black women were often disturbed by the number of black men on the Left who were with white women (Barrett-White 1994). Nonetheless, the organization attracted a wide swath of black New York artists. The artist Ernie Crichlow was CNA chairman in 1950, and Elaine Jones, the first black timpanist for the New York Philharmonic Symphony, and Sidney Poitier were vice chairs (Barrett-White 1994, 57). Lorraine Hansberry reviewed CNA activities in *Freedom* (May 1952), and *The Daily Worker* provided extensive coverage of the CNA's activities, including its founding conference and its annual Negro History Costume Ball, a public fundraising dance where attendees dressed as figures from black

FIGURE 2.4. Photograph of a CNA awards banquet in New York City. Left to right on dais: the dancer Janet Collins; the actor James Edwards; the labor activist Thelma Perkins; Dr. W. E. B. Du Bois; Langston Hughes; the actor Fredi Washington; the visual artist Charles White; the actor Frank Silvera; the playwright Alice Childress; Lawrence Brown, the accompanist for Paul Robeson; Ruth Jett, the executive director of CNA; the historian John Henrik Clarke; one unknown woman; and the visual artist Ernie Crichlow. Date unknown (1950s).
Source: C. Ian White and the Charles White Archives. © Charles White Archives.

history. The Whites sold tickets to and attended CNA's first theatrical production held at the Club Baron at 132nd and Lenox Avenue, featuring Alice Childress's production of Langston Hughes's *Just a Little Simple* and two one-acts, Childress's play *Florence* and William Branch's *A Medal for Willie*. One photograph of a 1950s CNA event at the Manhattan Towers Hotel honoring black cultural activists shows an integrated crowd that demon-

strates that during its short history (1947–1954), the CNA was a vital part of the New York Popular Front. Seated on the dais are the honorees Robeson and Du Bois; James Edwards, star of *Home of the Brave*; Hughes, poet, playwright, and librettist; the actors Frank Silvera and Fredi Washington; Mary Lou Williams, composer and arranger; Theodore Ward, playwright; Janet Collins, dancer; Shirley Graham, writer; Lawrence Brown, composer; and Charles White, whose solo show at the ACA Gallery had closed in February of that year.[32] The CNA was not officially tied to the Party, but by 1948, when the attorney general targeted the CNA as a subversive organization, membership in the organization insured the blacklisting of several of its most famous members, including Poitier, Ruby Dee, and Ossie Davis and Harry Belafonte.[33]

One of the reasons the CNA began to excite such interest in the 1950s was that the intimate and visual medium of television appeared almost simultaneously with the high Cold War and further exposed the extent of U.S. cultural apartheid and its profound exclusion of black artists. Fran remembered that when she and Charlie got the first television set and their friends gathered at their apartment to watch variety shows, their first reaction was a stunned awareness of the deliberately discriminatory policies of this new medium (Barrett-White 1994, 55–57). In a September 1949 *Masses & Mainstream* article, "Advertising Jim Crow," which critiqued the advertising industry's racist practices, the CNA writer Walter Christmas reported that in his informal two-week survey of magazines from the *New Yorker* to the *Saturday Evening Post*, he found "a strange world" being perpetrated in U.S. magazines, one in which the words "labor" and "poverty" were absent and where blacks appeared only as smiling servants or fearful African "natives." Christmas also reported on a more systematic survey of the advertising industry done by the CNA in 1947, which estimated that of twenty thousand people in the industry, "exactly thirty-six were Negroes, for the most part used in minor capacities, mainly menial," but never represented as part of American society. Negroes were "simply not shown as a part of American life," never as "typical Americans" at town meetings, in crowd scenes, or even on Army recruiting posters (Christmas 1949, 55).[34]

LOVE AND RECOGNITION IN EAST BERLIN

In 1951, the CNA chose White to represent the organization at the World Youth and Student Festival for Peace in East Berlin as part of the Young People's Assembly for Peace, which organized the "Friendship Tour" to Europe, where U.S. peace groups would meet with other labor and peace groups.[35] White was given a gala sendoff with a cocktail party hosted by the CNA on June 27, 1951, at the ACA Gallery on East Fifty-Seventh Street, and the CNA surprised him by raising the money to send Fran, who joined him in Paris. In the twenty-eight-page interview with Clothier in 1980, Fran White describes the tour in great detail, elaborating on the political as well as personal significance of the weeks they spent in Europe and the Soviet Union. The Friendship Tour was slated to begin in Paris and culminate in the Third World Youth and Student Festival in East Berlin, but at the Russian Embassy in France, the Whites were given visas and told mysteriously one night to get ready to board a train, which took them to Le Havre, where they were met by people who took them to a Polish steamship. On board were delegations from every country, including those of the Eastern Bloc. They were picked up in East Berlin, where the entire city was given over to this two-week festival. They met the "socialist leadership" from around the world, including the famous Turkish communist poet Nazim Hikmet. They were taken to see the camps at Auschwitz. Then, as mysteriously as the appearance of the night train, fifteen out of the forty members of the U.S. delegation, including the Whites, were chosen to go to Poland and Moscow. In Moscow, they were treated like dignitaries and given exceptional hotel suites filled with fruit and wine and chocolates. They toured farms, factories, the Bolshoi Ballet, music conservatories, art galleries, and art schools. Fran White says that they were treated "royally" in the socialist countries, where even schoolchildren talked about White's work. They returned to the United States, she says in the Clothier interview, with a deepening understanding that to "bring socialism to the U.S." would require "a social movement of the country and not just a few people with the ideas," that it had to be understood as "shaped by the geography, history, and ethnic group of each specific

country." But they also faced criticism from those who "would battle him on socialist realism, because he did not find it ridiculous" (Clothier 1980–1981, 24). Fran emphasized they were both impressed with what they had seen in the Soviet Union. Charlie was especially taken with how ethnic groups were allowed to develop their own culture, and Fran was impressed by the Soviet treatment of children: "I don't care what anybody tells me about socialism," she reported. "The children were the happiest children that I've ever seen" (24). In the informal and free-wheeling atmosphere of the 1980 interview, Fran seems eager to express their elation over the enthusiastic embrace of White's art in socialist countries, but in her autobiography, published fourteen years later in 1994, that respect and admiration for socialist politics is muted or absent.

The Whites' European trip, which followed in the footsteps of Du Bois, Hughes, and Robeson, is essential in understanding the changes in White's life, his art, and his political views after 1951. Gordon says he is quite sure that the trip was sponsored by the Left,[36] which accounts for the increased attention White received from the communist press when he returned to the United States. The trip also immediately triggered White's FOIA file. In her autobiography, Fran says they were greeted at the airport upon their return by a summons to appear before the House Un-American Activities Committee and by a request from the State Department to surrender their passports. Within a few months the summons was unexpectedly withdrawn and their passports returned, but neither of the Whites was called to testify before an investigatory committee. Even so, an FBI informant kept close track of White's activities on the trip, referring to him in one file as "Charles WHITE, colored, allegedly an American citizen" (U.S. FBI, Charles White, 100-38467-5) and carefully recording the public statements White made about his experiences at the World Festival, including his amazement at the friendliness of the youth of Korea and other socialist countries. White's FOIA file also details his associations with Left-leaning or Left-led organizations, including *Masses & Mainstream*; the New York Council of the Arts, Sciences, and Professions; the Jefferson School of Social Sciences; the George Washington Carver School in New York; the *Daily Worker*; his support for clemency for Ethel and Julius Rosenberg;

his attendance at a Cultural Freedom rally to protest the banning of the prounion film *Salt of the Earth*; and his relationship with the ACA Gallery, adding that the ACA was "devoted to the work of socially conscious artists" (U.S. FBI, Charles White, NY 100-139770). According to the FOIA file, the Whites were followed closely in Moscow and were "seen at the Bolshoi Theater fraternizing with persons believed to be North Korean or Chinese Communists" (6. NY 100-102344). One section of his file, labeled "AFFILIA-TION WITH THE COMMUNIST MOVEMENT," summarizes all the reasons the FBI used to justify calling White a communist, including having "numerous books relating to Communism" and a sculptured bust of Stalin in his apartment, his "praise of Russia," and "the predominant use of red in subject's paintings" (NY 100-102344, 5). Unlike the files of Lloyd Brown and Alice Childress, a great deal has been redacted in White's file, and the constant repetition of information and the FBI's dependence on the *Daily Worker* and *Masses & Mainstream* for its reports suggest that there was little on White that could not be found in obvious and published sources. Whether or not the Whites were aware of this intense surveillance, the trip had a profound effect on White: in a speech at the Berlin Youth Festival, which was reprinted in the December 23, 1951, *Worker*, White said, "I am 33 years old and I only felt the feeling of being a real man when I was in the Soviet Union."

When Fran White tries to explain in her Clothier interview how this trip affected them both personally and politically, her statements are often contradictory, possibly an indication that even in the 1980s, their affiliation with the Left was still an area of anxiety. Clothier asked Fran about their relationship with the Party: "Party affiliation on return?" Reflecting her hesitancies, she answered both negatively and affirmatively:

No, we had been so close before the trip, yes, we wanted to bring socialism to the US. We realized in reality that it had to be a social movement of the country and not just true of a few people with the ideas. . . . All of the preaching and the literature was not going to make the change. . . . I think that when he came back was probably when he began to have differences with the communists that he knew (TOO SIMPLISTIC) [*sic*] . . .

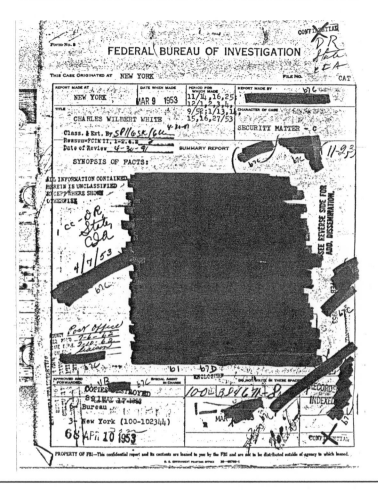

FIGURE 2.5 (a). Page from Charles White's FOIA file (c. 1951).
Source: U.S. Federal Bureau of Investigation.

you could sense that socialism was shaped by the countries, by the circum-
stances and the geography, the history, the art. . . . And then when he got
home they [other abstract artists] would battle him on the socialist realism,
because he didn't find it ridiculous. . . . I think that was one of [Charles's]
main battles with the left movement, was that you don't let the artist and
you don't let the black use their resources to determine the past.

(24–25)

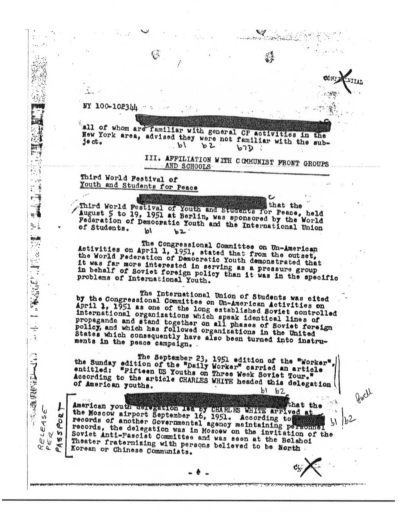

FIGURE 2.5 (b). Page from Charles White's FOIA file (c. 1951).
Source: U.S. Federal Bureau of Investigation.

In this somewhat rambling but affecting narrative, Fran tries to describe an issue that plagued many black left-wing activists: How does one craft an independent black leftist politics within the larger, mostly white-controlled Left movement?[37] She says that they had been close to Party "affiliation" before the trip but that differences surfaced when they returned, with White battling the communists on one side—who, in Fran's terms, were not allowing black artists like White to use their resources "to determine the

past"—and his artist friends on the other side, because they found social-ist realism "ridiculous" and wondered why Charlie didn't. Fran's response provides more evidence that White's conflicts with the Party go back as far as 1951, even though his public statements at the time seemed totally in line with CP doctrine. Ultimately, Fran White's interview reveals how unsettled White was both by the radical course he was taking by being openly identified with the Left and also by the Left's refusal to let "the artist" and "the black" determine their own course.[38] When she says in the interview, "*so you're not only touching blackness, you're touching the Left*" (27), Fran was describing poetically what she saw as the integration between White's political ideals and his artistic goals. But she also put her finger on another aspect of conflict for a politically conscious black artist. During the McCarthy era, blackness—or black militant activism—could be considered synonymous with the Left and therefore discredited as "communistic."

In contrast to Fran's hesitancies, White's description of the trip in his *Daily Worker* and *Masses & Mainstream* articles[39] was rhetorically and polit-ically self-assured. He said that he began to feel a sense of agreement with other world artists that "the great forward-moving tide of art was realism," despite what others were claiming as the "new." As a result of this trip, he began to "see international questions as the primary concern of all people." The American people needed to be able to identify with the African, Chi-nese, and Asian peoples, which, he said, was not only a theoretical issue for him but one that should be a part "of my actual painting and graphic work." The "character and world view of the working class, its internationalism, and optimism" would now play a major role in his work. He said that hope must be revealed even in scenes "exposing the harshness of life of the com-mon people." Most importantly, White announced that he had now chosen "realism" as his guiding aesthetic. In a December 1951 interview in the *Daily Worker*, he praised Soviet art as "the greatest in the world." In one *Daily Worker* installment, White continued to speak against "formalism," Freud-ianism, and subjective art:

"There is no longer any problem of formalism in the Soviet Union," said White. The Soviet artist stopped concerning himself with his inner

emotions, with Freudianism, a long time ago. Today his work reflects what the masses of the people are struggling for. His primary aim as an artist is to "bring out in his work the whole feeling, aspiration and goal of the masses of working people."

White continued with statements supporting socialist realism and the Party's position against formalism:

"You can't even conceive," said White, "of an art that portrays a man like Stalin who is beloved by all the Soviet people, or an heroic woman like Zoya, in terms of planes, angles, and stylization, it would be atrocious and dishonest. Besides it would be impossible to bring out the heroism of Zoya and Stalin except through Socialist Realism."

(Platt 1951b)

What ultimately encouraged the Soviet artist to reject formalism, White declared, was the close contact between the artist and the people: "All his assignments come from the people. When a piece of sculpture is commissioned for a factory and the factory workers don't like it, they let the artist know about it real quick and he has to give it another reworking." Later, as we will see from White's statements in the 1970s, he would seriously question the idea of an artist being tethered to the will of the people.

White made these statements, which aligned him with communist aesthetics—specifically with the more rigid cultural policies adopted under the hard-line Zhdanov[40] phase—at a time when he had achieved something of a name for himself in the U.S. art world. By 1952 his ACA opening had been favorably reviewed in the *New York Times*, he was the first black artist to exhibit on Fifty-Seventh Street, he was awarded a grant from the American Academy of Arts and Letters, and his painting of *Preacher* had been bought by the Whitney Museum for its permanent collection. He had produced stunning WPA murals for black colleges and universities, mounted exhibitions at galleries and universities all over the country, and had several solo exhibitions at the ACA gallery in New York. What is clear from all his narratives about his trip is that partly because of his relationship to inter-

national communism, White felt, quite accurately, that for the first time in his artistic career he had been given the kind of recognition that black artists rarely received in the United States in the 1950s.[41] He returned to the United States with "a bound volume of some of his works in hand and told a friend, 'they sure know how to put things together.'" It was, his friend and writer Douglas Glasgow commented, a "marvelous experience for him in the sense of that kind of recognition," a recognition clearly enabled by his affiliations with the Communist Left.[42]

IDEOLOGICAL REPRIMANDS AND AESTHETIC CORRECTIONS

White's growing stature in the art world was accompanied by close attention from critics on the Left. That attention was positive through the 1940s, but by the late 1940s and early 1950s, the Party began to change its position on visual aesthetics. By 1945, under the leadership of William Z. Foster and under the pressures of Cold War, a besieged Party, no longer willing to pursue the flexible strategies of the Popular Front, returned to the hard-line position that "Progressive art today, inside and outside the Soviet Union, is that of social realism." The term "realism" became ubiquitous in Party criticism in the 1950s, taking on the power of a revolutionary rallying slogan even as it remained a vague and elastic aesthetic concept. A "realistic" art pitted the Left against what was considered the "antihuman" formalism of the avant-garde, which included any kind of stylized art, abstraction, or expressionism. For the Left, the geometrical figures, vague curving shapes, and smears of paint from the abstractionists were a form of militant self-aggrandizement, a set of formal gimmicks devoid of social thought or purpose and designed to appeal to the elite, a form of pessimism that would make the individual feel helpless. Progressive artists, on the other hand, were encouraged to build up "strong hopes for the working class and present the everyday life struggles of working people. The human figure should be represented in

a recognizable form as a means of conveying inspiration and hope, not for expressing personal idiosyncrasies." The term that would encapsulate these principles was "socialist realism."[43]

As White began to change his style, leftist art critics questioned his former tendency toward abstraction and applauded his move toward social realism. In his review of a 1951 show at the ACA Gallery, the African American art critic John Pittman singled out White for avoiding "empty abstractions" and showing pride and confidence and honest directness of the worker" and specifically named White's art "socialist realism" (1951). The view that White's work before 1950 had become unacceptable surfaces in a "Symposium on Charles White," a 1954 meeting of the Voks Art Section in Moscow, March 18, 1954, reported on in *Masses & Mainstream*. One commentator, D. Dubinsky, an engraver, praises the 1954 portfolio but issues a stern warning about White's "shortcomings," which are, in his view, White's failure to represent a figure realistically. In 1955, the communist art and music critic Sidney Finkelstein, perhaps the single most important promoter of White's early career, published (in German) the first full-length critical study of White's art, *Charles White: Ein Kunstler Amerika*, with forty-three illustrations covering the 1940s and 1950s up to 1954. While Finkelstein celebrated White as an exceptional artist, he used the text to document the communist requirements for a "realistic" art. In his articles in the left-wing press of the 1950s and in his book, Finkelstein critiqued the mural *Techniques Used in the Service of Struggle* as too experimental, demonstrating the antimodernist position the Party would adopt in the 1950s.[44] Finkelstein admitted that he objected to this mural because of what he called the contradiction inherent in a style that conveys "high tension and excitement," which makes it "more difficult to disclose the inner sensitivity and psychological depth of the human beings who are the subject" (1955, 23–24). What precisely constituted "inner sensitivity and psychological depth" remained subjective and oblique.

Similarly, White was praised by Charles Corwin, the *Daily Worker*'s in-house art critic, as a progressive social artist. Then, in the middle of his February 20, 1950, review of White's show in the *Daily Worker*, Corwin inserted

a paragraph that began ominously: "We have several suggestions we would like to offer White, even as we applaud the correctness of his basic orientation." What follows is a list of corrections to White's departures from approved models of social realism. The flat, angular lines of White's figures, says Corwin, are "cold," and there is danger that his style may become "static" and meaningless. Corwin continues: "In many the characteristic mood is a tortured repose with upturned eyes and furrowed brows," and there is a danger of the picture being animated with "superficial devices." It is difficult to ferret out the covert meanings of Corwin's critique because its political and ideological undercurrents obscure what is ostensibly an aesthetic evaluation. What Corwin admits only obliquely is that this "corrective" is an attempt to influence artists who have strayed from the righteous path of socialist realism into the temptations of formalism.

In their campaign against abstract art, Party art critics—Corwin, Finkelstein, and, occasionally, the African American critic John Pittman—maintained an especially vigilant eye on White. In their comments about his work, these critics deliberately tried to direct White away from experimentalism toward realism. That pressure is particularly evident in their assessment of the drawings of Harriet Tubman and Sojourner Truth that White created between 1949 and 1951and illustrates what was being encouraged by the art critics in the *Daily Worker* in the Cold War climate of the 1950s.[45]

In White's *Sojourner Truth*, there are still traces of cubist influence in the enlarged hands that seem sculpted into blocks of wood. The figure's right hand is curved in the direction of the viewer as if in warning or self-protection; the eyes are illumined. Her left hand is raised, carrying White's signature torch (or whip), and both arms and hands are shaped like wooden mallets. Here Truth is an enigmatic figure, who might be male or female. Her face seems to emerge from her draped robe, making her seem mythical and mysterious, an avenging Old Testament prophet. The look on her face is elegiac, and her eyes are large, stern, and sad. Writing in the 1951 *Daily Worker*, Corwin found an image like this unacceptable, because of what he claimed was its *unreadability*: he called the 1949 cubist-style figure of Harriet Tubman, which is similar to the Truth drawing, "unapproachable,"

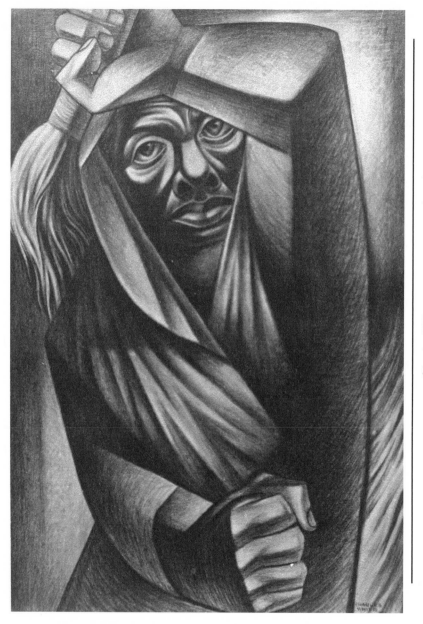

FIGURE 2.6. Charles White, *Sojourner Truth* (1949).

Source: Photograph by Frank J. Thomas, Courtesy of the Frank J. Morgan Archives.

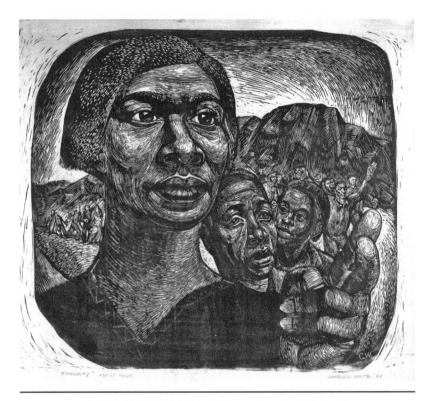

FIGURE 2.7. Charles White, *Exodus 1 Black Moses* (1951).
Source: Photograph by Frank J. Thomas, Courtesy of the Frank J. Morgan Archives.

"almost mystical," and "God-like," revealing, perhaps, his discomfort with her power.

In contrast, in *Exodus 1 Black Moses*, the 1951 Tubman is clearly female, with shortened though still stylized hair, her hand raised and pointing the way to freedom for the group of black people following her. Comparing this to White's 1949 Tubman, Corwin says, "The austere, the enigmatic, the depressed are replaced by a courageous optimism and confidence." This "approved" Tubman seemed to alleviate Corwin's anxieties and tensions created by the earlier one. The face is softer, there is the hint of a smile, and her place at the forefront of the group and her enlarged head suggest the

movement toward victory, as does a man in the background with his arms upraised. Because the face of this Tubman is more "realistically" drawn, the mysteriousness and ambiguity of images like the first Tubman and the Sojourner Truth are replaced by a triumphant image of the *Moses of her people*, a figure of comfort rather than of confrontation. For Corwin (1951), the elimination of any signs of abstraction was proof of the efficacy of the Left's corrections and of White's artistic maturity:

> White has grown much during these past twelve months, and it is in just those elements which were most criticized a year ago that White has made the most evident advance. White's subjects are again from Negro life and history, but they are more than just descriptive, for the monumentality of White's forms, allied with the style of the Mexican social painters, transforms his subjects into large symbols of oppression, the struggle and the yearning for freedom of the Negro people. There was earlier a tendency for these monumental symbols to become formalized and static. During the past year, however, White, by humanizing his forms and clarifying his content is succeeding in giving human substance to his symbols.
>
> (Corwin 1951, 11)

By the time he exhibited the third Harriet Tubman in the 1954 ACA Gallery show, White had created an image shorn of most of his experimental techniques, now taking what he called the *path to realism*, which meant representing the human figure as anatomically "correct," without expressionistic distortions. This 1954 Tubman image attempts to portray the socialist ideals of optimism and "hope for the future" rather than the bleak realities of segregation and racism evident in earlier drawings like *The Trenton Six* and *The Ingram Case* or in the earlier Tubmans. The hands are no longer the enlarged, geometric forms that resemble weapons. The eyes have a penetrating look but are not distorted. Standing next to Tubman is Sojourner Truth, who is shown in profile. Both figures wear the determined look of freedom fighters. Their beautiful and serene faces are familiar and recognizable. The suggestion of judgment, of warning, of blame in the 1949

Tubman and Truth is gone, as is what Finkelstein (1953, 20) called the "high tension and excitement" that he thought made it "more difficult to disclose the inner sensitivity and psychological depth of the human beings." While the "approved" Tubman is accessible and inviting, the "tension and excitement" of the experimental Tubman and Truth, contrary to Corwin and Finkelstein, is both revolutionary *and* modern.

In the veiled statement he issued to other progressive artists who were dallying with experimentalism, Corwin used White as both a model and a warning: "The steps which Charles White has taken this year towards the often stated ideal of social realism makes this exhibition a valuable object lesson to progressive artists and public alike as well as a very pleasant experience" (1951, 11). White seems to have been deliberately singled out to be an example. In the Corwin articles from February 1950 to March 1953, White was presented as an artist tempted by the sirens of abstraction, who, after accepting this critical advice, reaffirmed his commitment to politically approved artistic practices.

White's former student, the artist John Biggers, like many of White's artist friends, was both dismayed and perplexed with this turn toward realism: "It was almost as if he was working backward into the future . . . the early work with its marvelous abstract qualities . . . was so magnificent, he left that and went back into realism. I don't know what caused this."[46] As White himself knew only too well, the black cultural and social world was neither immune from nor unprepared to deal with the anxieties of the modern world, but he chose, at least for the brief period of the high Cold War, to work in the socialist realist art tradition, which favored those representations of black subjects that were recognizable and optimistic, rather than the dynamic, multifaceted, and psychically complex *modern* people and communities White encountered in both Chicago and Harlem. As we will see later, this period produced a profound crisis for White, but it also produced portraits of black life more complex and interesting than they seem at first glance. What I want to tease out in the next section of this chapter is the way in which the 1953–1954 portfolio reveals White's unease with the Party's attempts to control the direction of his art and the covert resistance he employed in his art to forestall that control.[47]

THE 1953–1954 PORTFOLIO:
BLACK ARTIST IN UNIFORM?

By the time *Masses & Mainstream* published the 1953–1954 portfolio, *The Art of Charles White: A Folio of Six Drawings*, White's radical departure from his earlier experimental art seemed complete. There are at least two explanations for the changes. One is that these changes were aligned with the views of art critics in White's left-wing circles, and the other is that these changes reflected White's own desires for an art that would reach ordinary people and that he could best reach that audience through realism. White's friend Bill Pajud, the art director at the Golden State Mutual Insurance Company, explained that the reason White's art was chosen for the Golden State calendar was that "Charles was the one black artist I knew who was literal enough in his drawing to be accepted by people who had not any aesthetic appreciation" (Clothier 1980–1981, 62). The portfolio of six black-and-white lithographs was sold through subscription for three dollars and through bookstores and art shops in large (13" x 18"), ready-to-frame prints, with the goal of making art available to working-class audiences, "who are usually unable to afford such art."[48] The six drawings—*The Mother*, *Ye Shall Inherit the Earth*, *Lincoln*, *The Harvest*, *Let's Walk Together*, and *Dawn of Life*—were introduced by leftist art critics, who framed the folio in almost exclusively political and nonaesthetic terms.[49] In the preface to the portfolio Rockwell Kent says that the lithographs actually transcend art and embody "peace, love, hope, faith, beauty, and dignity." In the first of two *Masses & Mainstream* articles on the portfolio, "Charles White's Humanist Art," Finkelstein equates White's shift to realism with "love for the working people."[50] In "Charles White: Beauty and Strength," the artist Philip Evergood is the only Left critic to comment on the technical aspects of the portfolio drawings, but he too sees their major achievement as the production of "happy, hopeful faces" that can "counteract the fears, the uncertainty which are to be seen in so many faces everywhere around the world today" (1953, 39). Except for the portrait of Lincoln, the drawings in the portfolio represent workers and the working class, stoic in their dignity: a mother in farm clothes carry-

ing an infant in *Ye Shall Inherit the Earth*; two muscular farm workers, both intently focused on the job ahead of them, in *Harvest Talk*; a young girl in *Dawn of Life*, her hands held up prayerfully as she releases a white dove into the sky. *The Mother* shows only the face and hands of a middle-aged woman, her enlarged hands covering nearly a third of her face and folded around a cloth as if in prayer. The weary lines around her eyes and her half smile portray the endurance of a woman who has known and survived hard times.

Taken together, the folio drawings represent a version of "the folk" intended to further the Left's goal of presenting the worker as stoic, dignified, beautiful, and, importantly, accessible. One sees here the black belt thesis deployed in visual terms—in the black proletariat as an oppressed but resistant worker, in black cultural references expressed in Christian mythology (*Ye Shall Inherit the Earth*), in the references to black spirituals (*Walk Together Children*), and in the rural settings (*Harvest Talk*). In contrast to the narrative energy and dynamism of White's 1940s image of a *Living Frederick Douglass* and the indictment of racist injustice in *The Trenton Six* and *The Ingram Case*, the folio moves away from historicized narrative to a more aestheticized version of what Richard Powell calls "the ever-ambiguous" folk (1997, 65).

Though every White biographer and critic, as well as most of his friends and fellow artists, noted the "shift" in his work after 1950, only Andrew Hemingway attributes it to White's commitment to the ideals of the Communist Party. Dijkstra argues that White abandoned expressionistic "distortions" because he realized that "genuine emotion expressed honestly and directly needed little help from technical devices" (2003, 196). Barnwell goes so far as to say that this marked shift in White's work from the "sharp angles of cubist art" to the "bold, fully articulated, rounded forms" could be attributed in part to "the romance, tenderness, and support that he found in his new marriage" (2002, 51). Barnwell does acknowledge that another possible explanation for the change may have been that White was developing "new strategies to combat the discrimination that plagued working-class people worldwide" (51), but she does not mention the fact that these "new strategies" were the ones listed in the Communist Party's art platform. These unsatisfying and in some cases far-fetched explanations illustrate the reluctance of critics to acknowledge the extent of White's communist ties.[51]

But I want to focus on two of the drawings in the portfolio, *Let's Walk Together* and *Harvest Talk*, because they disrupt the portfolio's easy legibility insisted on by Kent, Finkelstein, and Evergood and also because they complicate my own tendency to privilege White's earlier, more stylized paintings. The artist Ernest Crichlow, White's friend, says in his interview with Clothier that White, like many progressive artists, had "mixed feelings about being limited to the kind of art that was coming out of the eastern democracies at the time" (Clothier n.d., 85) and that White was concerned about this curtailment of his artistic freedom: "But you'd like to have some control over how [your art] is presented, and most of the time you don't. That was his concern" (86). Crichlow continues: White "was mainly sympathetic to that school [the Left] and I think he may have suffered for it," but, Crichlow notes, being with the progressive media had its advantages for White's work: "I think it's widely known and you'd have to give a large credit for that to the progressive media, and in the various ways they spread his work internationally" (86). Crichlow's view that White's turn toward realism was a "curtailment of artistic freedom" points to White's dilemma—of being both enabled and confined by leftist networks. But at least two of the drawings in the portfolio, precisely because their meanings are ambiguous, can be read as White's deliberate and coded resistance to the pressures of the Left. I believe that a close reading of these two drawings, *Let's Walk Together* and *Harvest Talk*, supports my argument that White's struggles with the Party's designs for a politically inflected art were expressed covertly in his art.

Though the drawing *Let's Walk Together* was used in leftist publications to signify protest and black unity, nothing in the drawing confirms the relationship of the seven people in the drawing or their purpose for being together—are they a family, a union, a group of friends? Is this an informal gathering or a planned event? Is there any evidence that they are actually walking? While White shows off his elegant draftsmanship in the hauntingly beautiful faces of these seven black people, he insured that the purpose of this gathering would not be easily accessible. The young man in the foreground left is dressed in a worker's jacket, pants, and a cap and, because he is front and center, appears to be the main figure. But the main figure of what? The matronly woman on his left, dressed more formally, has

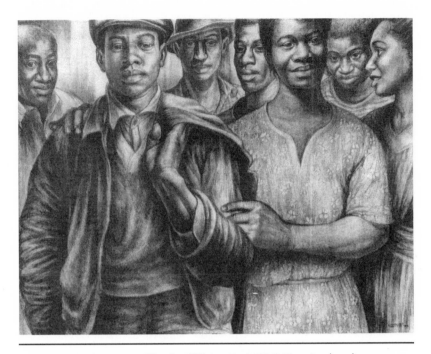

FIGURE 2.8. Charles White, *Let's Walk Together* (1953).
Source: C. Ian White and the Charles White Archives © Charles White Archives.

her hand on his arm, and an older man, the only one directly engaging the viewer, rests his hand on the young man's shoulder, as if in some kind of support or recognition. If, as Smethurst suggests, the older man is the figure of the folk singer Leadbelly, then his hand of support on the younger man's shoulder is White's coded gesture of affiliation with the Left.[52] The cropped drawing gives little clue about these figures. Two of the men are wearing hats and appear to be workers, but the women's dresses are of softer, more delicate material that might be appropriate for a church event. All look expectant but uncertain, as if tamping down any unwarranted optimism. But optimism about what? Only one figure, the middle-aged man on the far left with his hand on the shoulder of the young man, looks directly at the viewer, but his expression is skeptical, as if to challenge any attempt to decipher the drawing's meaning. Five of the figures are facing forward

with their eyes focused down or slightly away from the viewer, so that they do not visually engage the viewer. The woman on the far right faces away from the viewer and toward the group with a slight enigmatic smile, which further reinforces the sense of the intimacy and privacy of the group, leaving the viewer to speculate on what, other than their racial identity, might constitute the group's unity. John O. Killens (1986, 452) suggests the many different and even prophetic meanings this drawing elicits: "*Walk Together* would appear to prophesy the heroism of Rosa Park and Ed Nixon and Martin Luther King, Jr., and Ralph Abernathy, of fifty thousand black folk who walked together hand-in-hand in the Montgomery bus boycott, some three or four years ahead of the time it happened." What's important here is that the drawing invites multiple interpretations, superseding the insistence of leftist critics that meaning had to be clear and unambiguous, and, ultimately, the drawing betrays, at least subversively, White's continuing modernist inclinations.

Harvest Talk is an even better example of White's coded intentions in the portfolio. White had most probably seen in Richard Wright's 1941 *Twelve Million Black Voices* the Farm Security Administration photographs of rural poverty taken by Marion Post Wolcott. He chose as a model for his drawing the one captioned in Wright's book, "The bosses send their trucks for us." In the photograph, a group of impoverished white and black day laborers in rural Florida wait in line to be paid for their day's work. The figures in the photo are placid, as though awaiting their fates as well as their paychecks. It is almost impossible to read any emotion on their faces or in their bodies. They are fastened to the task at hand—collecting their wages—and, apparently disconnected from one another—perhaps just tired—as all look straight ahead, no one engaged in conversation. In the car nearby is a white man, probably one of the bosses, who looks on at the crowd impassively, with a slight suggestion of threat should anything get out of control.

If the intention of 1930s documentary photography was to register visually the brutal impact of social and economic oppression, White had something else entirely different in mind. Obviously engaged by the image of the worker, White lifted one figure, the tall black man wearing a fedora and car-

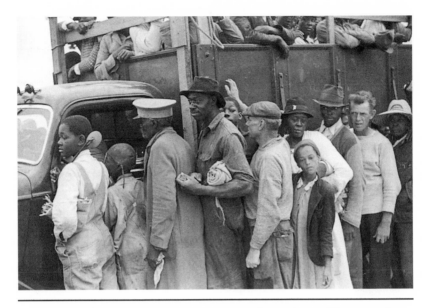

FIGURE 2.9. Migrant workers waiting to be paid, near Homestead, Florida. Marion Post Wolcott, Farm Security Administration photo.
Source: Farm Security Administration.

rying a small package in one arm, out of the photograph, out of the isolation and locked-in space of the crowded line, and onto the open rural landscape of *Harvest Talk*. The man on the right in the drawing so closely resembles the man in the Wolcott photograph that he is undoubtedly White's model. White incorporates the same folds in his shirt, as well as the worn fedora atop his head. In both photograph and drawing, the man's left arm is bent at the elbow at a ninety-degree angle, his right hand is enclosed in his left, and he wears a steely-eyed look of determination, but the farmer's overalls are gone, and the facial expressions of White's men suggest freedom fighters, not farmers. Whatever the farmer in the Wolcott photo was holding has been omitted; he is now empty handed, his two hands meeting each other in a gesture that portends but does not disclose his intentions. The two men are shown standing together, facing outward as wheat and trees wave in a strong wind, both seemingly unfazed by the brewing storm. The two men

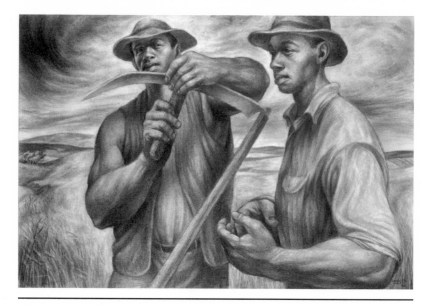

FIGURE 2.10. Charles White, *Harvest Talk* (1953–54).
Source: C. Ian White and the Charles White Archives, and the Art Institute of Chicago.
© Charles White Archives.

in this drawing, perhaps brothers, possibly cultivating their own land, are in stark contrast to the people in the photograph, sandwiched together in a line that is directed by the invisible presence of a white boss. The powerfully muscular arms of both men are only slightly exaggerated, almost approximating the size of the man's in the photograph.

What appears to be a farm setting in the White drawing is deceptive. No crop, barn, or farmhouse is pictured, and the scythe being sharpened by the second man is an anachronism since by the 1930s farmers would have used tractors for harvesting, not hand-held scythes. What looks like a sharpening blade might also be a hammer, so White may be covertly suggesting an image of hammer and sickle. Moreover, if visual representation has been a historically problematic for the black subject and black artist, *Harvest Talk* points to sound as another possibility for black expressiveness and resistance. Despite its title, whatever "talk" has taken place

between these two men is now over. Both men are looking into the distance, not at each other, and neither is speaking. Sound is represented in the drawing as the threatening storm and the sharpening of the anachronistic scythe—an ominous sound, as if the "harvest talk" White meant to convey is the sound of black insurgency that, in my reading, probably included his own.[53] The ominous *sounds* of a brewing storm and a sharpened scythe enable a rereading of the drawing as far more subversive and "modern." In such a representation, the black working class cannot be viewed as idealized symbols but as modern workers with a complex psychology. Read in relation to the Wolcott photograph, *Harvest Talk* is not a utopian depiction of a proletarian ideal but a challenge to the domination of the workers in the photograph.

Given his desire for an art that transformed the representations of black people and addressed racial inequality, it seems that White chose both strategically *and* out of conviction to remain with the Left. Nonetheless, a story in Horace Cayton's 1965 autobiography *Long Old Road* reveals White's private ambivalence about the Party's influence on his work. Cayton narrates an encounter that occurred around 1956 between White and a white leftist playwright named Rollo, which reveals White's open animosity toward the Left. Cayton's recounting of the incident begins with Rollo claiming that the Left was "making real progress on the Negro question" (386). White's volatile response surprises but gratifies Cayton, who by the mid-1950s had become anti-Left. According to Cayton, White replies that the sit-ins, boycotts, and freedom rides going on in the South are evidence of a "new Negro movement" that has no need of left-wing leadership. White continues: "The only revolution I believe in is a Negro movement. . . . I'm sick of this working-class jazz and sick of white leadership, too, for that matter. . . . Left-wing-leadership? That went out with the war, thank goodness" (386). Aside from the fact that Cayton's retelling of this incident is highly interpretive, the narrative reflects White's allegiance to the new black militancy generated by the 1955 Montgomery bus boycott under the leadership of the young and charismatic Martin Luther King. It also verifies my suspicion that beneath White's outward acquiescence he chafed at the restrictions he felt under the leadership of the white-controlled Left.

ABSTRACTION'S POLITICS VERSUS POPULAR FRONT AESTHETICS

White's turn to social realism is particularly surprising given that he was at the center of a massive shift in the art world in the late 1940s as abstract art became hegemonic.[54] Though art historians dispute this characterization of abstract art as "hegemonic," even the language used to describe the ascendancy of abstract art in the late 1940s and early 1950s reveals how massive a change was taking place. Abstract art was said to have "swept into the lead," its practitioners "swarming all over the stage," "dazzling" the art world and "dominating" the New York art scene," sweeping social realism, it was hoped, into oblivion. The art historian Bram Dijkstra labels the move to abstraction as "The Corporate Take-Over of American Art" and reminds us that the erasure of the social realism of the WPA was literalized when thousands of pieces of WPA art, many by prominent artists, were discovered in 1943 lumped into dirty bundles in the back room of a second-hand bookshop on Canal Street in New York City (2003, 9). In this period of abstraction's ascendancy, White's decision to turn to socialist realism was viewed by other artists as a "decline" and by some as "ridiculous." Clothier says that White must have also heard the fashionable forces of abstraction call to him as an artist who sought to achieve recognition beyond his already achieved distinction as a "Race artist." However, White also felt strongly that part of his larger mission was to represent what he referred to as "his people," and he came to accept that modernist abstraction produced art that could reach only a few people, whereas he wanted to create an art that black working people could understand.[55]

Even the popular black magazine *Ebony*, hardly known for its devotion to high modernism, did its part to elevate modernist abstraction and discredit social realism. Adding its own unique spin to avant-garde art's disdain for content or meaning, *Ebony* insisted, in an unsigned April 1958 article, "Leading Young Artists," featuring twenty-four mostly avant-garde African American visual artists, that the elimination of a racialized subject was necessary in order for blacks to be accepted as an "integral, representative

part of native American art." With striking similarities to the integration-ist rhetoric of the *Phylon* symposium eight years before, the *Ebony* article asserted that by moving away from the black racial subject, artists like Jacob Lawrence, Eldzier Cortor, Romare Bearden, Charles Seebree, and Marion Perkins had "carried the Negro painter's historical effort to lift himself out of the racial category" a little further toward achieving stature as "American artists of the first rank." Ironically, as the art historian Richard Powell relates in his study of modern black artists, in 1947, more than ten years before the *Ebony* article, several major black artists, including the black abstractionist Romare Bearden, had convinced the International Business Machines Cor-poration "to abolish all racial references in the catalogue of their art collec-tion," hoping that such a move would further the integration of black artists in the mainstream art world, an effort that Powell (1997, 105) says totally backfired: When Harold Rosenberg, "one of Abstract Expressionism's most articulate spokespersons, was asked in the 1960s to name a few of the lead-ing African American artists, he allegedly brushed off the request, saying he did not know of any."

What was paramount for White, even more than the Party loyalty expressed in these changes in his work, was the obligation he felt to make his art accessible to "simple ordinary people" like his mother, who, unlike his artist friends who were "getting excited" by it, could not understand his experimental work. In the Clothier biography, White uses language that accepts the Party's rejection of abstraction and its emphasis on form:

> I began to see around me the beginning of the development in Ameri-can art of a braking [*sic*] away from clarity in the ideas into the realm of obscurity in terms of ideas . . . after I had worked out the idea of what I wanted to say, [I] began to devote myself to the question of the placing of shapes, the placing of lines, to dealing with the question of space in an abstract sense until finally what eventually would wind up was where the form was predominant over the content [*sic*].

Clothier asks, "Why were you so influenced by the form? Did you consider that modern?" White responds:

No, it wasn't that, I was trying to achieve power, power, strength and I felt that in order to achieve certain strength, you exaggerated certain forms out of proportion that you made lines that were strongly diagonal [*sic*], for instance, and sacrifice the realistic shape of the thing for the sake of making up a thing exaggerated and therefore the emotional power it seemed to me was more ajar. But mother reacted to this, and I found more and more that very simple ordinary people who saw my work was [*sic*] a little more confused by it and the intellectuals, my artist friends and writers and musician friends were all getting excited about it. So there's a contradiction here.

(20)

The word "power" seems to have a dual meaning for White: first, of trying to acquire personal power through his manipulation of form, and second, of the emotional impact of his art on the viewer. Though neither is an undesirable goal for an artist, White admits that he was trying to distance himself from both, confessing that he, too, in a quest for power, had been obsessed with issues of form over content. What was paramount for White, even more than the Party loyalty expressed in these changes, was the obligation he felt to make his art accessible. But it is hard to accept White's conclusion that drawings like *The Trenton Six, The Ingram Case, Frederick Douglass Lives Again,* or the 1949 *Harriet Tubman* would have been too powerful or beyond the imaginative capacity of black viewers, since even the least educated among them was used to negotiating on a regular basis with the sophisticated powers of state-sanctioned racism, not to mention the sophisticated dissonances and complex rhythms of black music.

BEYOND THE SILENCES OF THE COLD WAR

After his move to California in 1956, White moved away from any close association with the Party, though his FOIA file continued until 1968. He was hired to teach at the Otis Art Institute in Los Angeles and became

chair of the Drawing Department in 1977. While at Otis, White did a series of interviews in which he spoke more openly about his work. Sorting through the public and private statements he made during these last years of his life sheds light on his complicated relationship to the Party and to social realist art. In this more "open" time, White begins what I view as a kind of downloading of his repressed feelings about the political pressures of his Left period on his art.

In a 1970 interview with an Otis student, five years after a 1965 black militant protest on the campus known as the "March uprising," the student tells White that representational art is considered by the teachers at Otis as art that "belongs with the old ladies [at] art fair[s] doing flower pots," that an artist cannot make a valid statement any more if he studies the anatomy of the human figure and incorporates that into his art. Responding to the student, White does not defend his artistic choices to the student but relates a story about his meaningful encounters with abstract artists in the late 1940s. After the war he lived in Greenwich Village for nine years and got to know and to "establish a certain rapport" with the artists destined to become famous as abstractionists—Jackson Pollock, Adolph Gottlieb, Franz Kline, and Willem de Kooning. Despite his own representational focus, he tells the student, he was dealing with very difficult formal problems and was "fortunate" to have these associations.[56] I quote his comment to the student at some length because it has never surfaced in any article on White and because he is more candid and reflective about his artistic struggles in the 1970s than he was, or could have been, in the 1950s:

> We [White, Pollock, and de Kooning] used to get drunk together, and I found that a great deal of their thinking rubbed off on me. A great deal of their exploration at the time—now they were not that well known at that time, they were mostly known amongst artists and admired amongst artists, certainly Jackson Pollock was sort of half way ignored for a long [time]—and DeKooning, but it helped me considerably in my growth to be exposed to these guys, to be able to see what they were doing and hear what they were thinking, on a one-to-one basis. It enlightened me tremendously. It broadened my horizons, not necessarily in what my goals

were, because my goals were pretty well laid out for me in terms of what I wanted to do. The form for me was there, ready. But I began to study where a Franz Klein [*sic*] was at—and I began to find that Franz Klein could help me in his formal resolution of problems . . . and he was an invaluable teacher for me, and he still is. Unfortunately, artists who deal in the representational can sometimes be very, very one-sided. They can only see and appreciate that which is living where they are.

White tells the student that he finds the work of the modernists Mark Rothko, Jasper Johns, and Roy Lichtenstein "exciting." "Our tastes," White says, "are very catholic, that is to say, broad and inclusive." And he says that he is always dealing with formal problems, "and most of these problems are very abstract." Nothing in his *Daily Worker* or *Masses & Mainstream* statements in the 1950s suggests that he had "a certain rapport" with the very modernists who would have been anathema to the Party intellectuals or that he thought he had anything to learn from them about "formal resolution of problems."

In another interview done in the 1960s or early 1970s, White seriously questioned his former role as a social protest artist:

What is important to me is that studio . . . that is important, that is the key thing at the moment I'm doing it. That is the most important thing. What I feel. Not what other people feel. I don't even care how they react even when I'm sitting in that studio creating something. That's important to me. It's my only means of trying to understand myself. I tried to and I found out a few things. I took part in movements. I took part in organizations, active roles in organizations. I traveled. I exchanged ideas, philosophies, thoughts. I got into fist fights almost with people over ideas. And then along in later years, I found that art was my only means of understanding myself, my only means of gaining any depth was for me to find it out in that studio, to find out what was going on inside me.[57]

In contrast to his earlier insistence on the masses of people judging his work, White says that in later years, he found that "art was my only means

of understanding myself, my only means of gaining any depth was for me to find it out in that studio, to find out what was going on inside me." In striking contrast to what he professed as a leftist social protest artist in the 1940s and 1950s, he concludes that the artist does not and cannot represent the masses:

> *He's not a mass figure. He's not a Reverend King or Abernathy. He's not any of these political figures. His is a lonely job. He sits in a studio. He is the sole producer, judge, evaluator, everything of his work of art. It takes no other people, like a play. It is not a collective effort of many people to put on a finished product. The artist is a lonely figure.*

I italicize these comments to emphasize what a shift they represent from the political statements White made in the 1950s. When we look at White's life in the circle of the South Side Community Art Center, with the WPA, teaching in the Abraham Lincoln and George Washington Carver schools, working with the CNA in New York, or as an editor on the staff of progressive journals like *Masses & Mainstream*, we see the artist joined with others who shared values, community, a lively social world, a devotion to important social and political ideals, and a belief that through their political and cultural work they could transform the world. It may be that White's later determination that "the artist is a lonely figure" is as much a commentary on the loss of these sustaining coalitions, collaborations, and united fronts of the 1940s and 1950s as it is about transformations in White's personal artistic journey.

Yet even after the Whites moved to California in the mid-1950s and away from the leftist circuits of the radical 1940s and 1950s, these Popular Front ideals and practices still remained. As he had done in his early work as part of the Left's crusades to free Rosa Ingram and the Trenton Six, White indicted the U.S. criminal justice system in his late 1960s work with the *Wanted Poster* series, which used pre–Civil War posters advertising slave auctions and rewards for runaway slaves to portray the plight of contemporary African Americans. In 1970, when the neocommunist political activist Angela Davis was arrested and charged with involvement in a murder-kidnapping

plot, White contributed one of his lithographs, *Love Letter I*, to be used as an image in the literature protesting Davis's incarceration. The image was made into a postcard and one sent to Governor Ronald Reagan.[58] One of the last notices in White's FOIA file records indicates that friends from the Communist Party and the Left in California were gathering to support him. Dalton and Cleo Trumbo sold land to the Whites in Pasadena for a nominal sum of money. When the Whites were short of funds, their old CNA friends—Harry Belafonte and Sidney Poitier—made loans and contributions to the Whites and purchased White's art.[59] Even the collection of personally designed, Left-inflected Christmas cards the Whites received over many years, from Harry and Eugenie Gottlieb, Lila and Anton Refregier, Gwen and Jake Lawrence, Langston Hughes, Neville Lake, William and Sophie Gropper, Dalton and Cleo Trumbo, Philip and Julia Evergood, and Paul and Essie Robeson—cards Fran saved all of her life—represent on an intimate level the continuation of a Left community in White's life.[60] One FOIA file reports that there was a great deal of concern from Party members in California about "WHITE'S health condition" and says that "the Party" feels responsible for him. The informant adds that "the Negro comrades" especially feel quite strongly that caring for White is "a responsibility of the movement" and suggests taking up a collection to establish a "sustainer fund" for him. In another FOIA entry, the informant at the April 1958 meeting of the Southern California District Communist Party of Los Angeles says that the members were urged to support an upcoming exhibition of White's work because, as the informant reports, "WHITE was one of us." It is fitting that White's lifetime commitment to represent a complex black subject, which was enabled by the public support of a leftist community, should end here in this intimate circle, with his left-wing comrades joined together to support the artist, this time with personal acts of love and loyalty.[61]

3

ALICE CHILDRESS: BLACK, RED, AND FEMINIST

America in 1956, baby. . . . Communist? Black?
You only needed to whisper it once.

—SARA PARETSKY, *BLACKLIST*

We are all going to suffer much more until we wake up
and defend the rights of Communists.

—ALICE CHILDRESS, *CONVERSATIONS*
FROM LIFE, 1952

IN 1950, WHEN Alice Neel, a well-known visual artist and a publicly involved communist, added the writer Alice Childress to her portraits of communists, nearly all of them white and male, she was acknowledging Childress as one of the most important left-wing women of the 1950s (Allara 2000, 112). Neel's portrait of Childress is almost completely unknown, but it is one of the clues that I have followed to uncover Childress's leftist identity, and I return at the end of this chapter to speculate on what it reveals about Childress. Despite her fairly open traffic with the Left, including the Communist Party, Childress has almost never been considered in the context of the organized Left.[1] Unlike her literary Left counterparts Richard Wright, Ralph Ellison, and Langston Hughes, all highly visible in black literary and Left studies, Childress, who remained openly connected to the Left throughout the Cold War and for six decades produced an aesthetics that reflect her radical politics, has only recently been included, though still

only marginally, in postwar African American literary canons, and never as a radical leftist.[2]

Yet from 1951 to 1955, the period of the high Cold War, she contributed a regular—and, in some instances, procommunist—column to Paul Robeson's international-socialist newspaper *Freedom*, maintaining close ties with Robeson even when many others were running fast to distance themselves from him. Her radical musical *Gold Through the Trees*, performed at the left-wing Club Baron in 1952, was infused with the Harlem Left's international consciousness, which asserted a relationship between U.S. racism and colonialism.[3] Her 1955 Obie-award-winning play *Trouble in Mind*, though it was produced in the mainstream theater, is permeated with images of the blacklist. Blacklisted herself by 1956, Childress appealed to her friend, the top communist Herbert Aptheker, who helped her publish her novel *Like One of the Family* with the procommunist International Publishers. Even the plays and novels she published between 1966 and 1989 continue that radical perspective, though in more nuanced and subtle forms. Her 1966 play *Wedding Band*, produced off-Broadway in 1972 and then as a primetime special on ABC in 1974 (starring the acclaimed Ruby Dee), critiques conservative notions of race and integration that had infiltrated black culture during the Cold War 1950s, as we saw in the 1950 *Phylon* symposium. In *A Hero Ain't Nothin' but a Sandwich*, a 1973 novel about a thirteen-year-old heroin addict, which became a feature film in 1978 starring Cicely Tyson and Paul Winfield, the historical figures cited as models for the young main character are Marcus Garvey, Paul Robeson, Harriet Tubman, Malcolm X, W. E. B. Du Bois, Martin Luther King—and Karl Marx. Childress's final two novels, one in which the Left figures prominently as part of the main character's political education and the other structured by Cold War imagery, show the continued importance of the Left in her work. Highly reticent about her affiliations with the Left, Childress's fiction, drama, and essays—and her extensive FBI file—constitute the only record we have of an extended relationship between a black woman writer and the organized Left.

TO : Director, FBI (100-379156) DATE: JAN 2 6 1953

FROM : SAC, New York (100-104258)

SUBJECT: ALICE CHILDRESS
SM-C

The above captioned individual is the subject of a
security investigation in the NYO. Information to date
reflects ALICE CHILDRESS has been a member of the CP since
1951 and during that year was an instructor at the Jefferson
School of Social Science. The subject has also been affiliated
with the following groups since 1950:

The Frederick Douglass School, The American Peace
Crusade, Civil Rights Congress, Teachers Union, Congress of
American Women, Sojourners for Truth and Justice, New Playwrights,
May Day Parade, National Council of the Arts, Sciences and
Professions and the Committee for the Negro in the Arts.

Investigation in NY further revealed that the subject's
b7C husband is [] who is []

[]

- These facts are being submitted to the Los Angeles
Division for information purposes.

1-Los Angeles

ALL INFORMATION CONTAINED
HEREIN IS UNCLASSIFIED
DATE 4/10/80 BY SP-5 RSG/RJ

NY 100-104258

The "Daily Worker" of September 27, 1951, page 2,
column 5, describes a "Women's Mass Meeting, held at the
HARRIET TUBMAN Center, 290 Lexington Avenue. ALICE CHILDRESS
was a member of the Committee for this Mass Meeting which
was initiated by BEULAH RICHARDSON, who called on the women to
go to Washington on September 29, 1951 to talk to President
TRUMAN and inquire why WILLIAM L. PATTERSON, National Executive
Secretary of the Civil Rights Congress was cited for contempt
of Congress and why W. E. B. DUBOIS was indicted as a foreign
agent.

[] was a member of the Harlem Branch
of the Civil Rights Congress according to the information
furnished by Confidential Informant [] on September 20, 1951.

b2
b7C The Civil Rights Congress has been cited by the
b7D Attorney General as coming within the purview of Executive
Order 9835.

[] of known reliability, advised on February 12,
1952 that ALICE CHILDRESS was one of the sponsors of the
"Negro History Week Celebration," which was to be held at the
HARRIET TUBMAN Memorial.

Confidential Informant [] of known reliability,
advised that a Negro History Week Celebration was held on
February 12, 1952, and that a Symposium was also held, which
was sponsored by the Greenwich Village, Chelsea, Yorkville,
and Columbus West Side Compass Club of New York Communist
Party.

[] said it was held in the Manor Casino, 121 East
11 Street, New York City. ALICE CHILDRESS spoke on the subject
entitled, "The Negro Woman - Yes - Yesterday and Today." In
this speech she urged that a fight be made for Civil Rights
f[]

[]ily Worker" issue of February 28, 1952, page 8,
[] that PAUL ROBESON'S newspaper, "Freedom" would
[]g Star Nite on February 28, 1952 at the Golden
[] Street and Lenox Avenue. This article
[] CHILDRESS was scheduled to appear on the

- 4 -

FIGURE 3.1. Page from Childress's FOIA file (1953).
Source: U.S. Federal Bureau of Investigation.

CHILDRESS'S FOIA FILE AS
LITERARY HISTORY

While Childress was evasive about her left past, her FOIA file is unambiguous. Far more enterprising and thorough than most literary historians, the "confidential informant of known reliability" reported carefully on Childress's political activity from 1951 to 1957, even offering some analyses of Childress's literary productions.[4] We learn from her FOIA file that Childress taught dramatic arts at the communist-influenced Jefferson School of Social Science; spoke at a rally for the blacklisted Hollywood Ten in 1950; walked in the annual communist May Day Parade; sponsored a theater party to benefit the progressive United Electrical Workers Union; joined the campaign to repeal the Smith Act; entertained at an affair given by the Committee to Restore Paul Robeson's Passport; sponsored a call for a conference on equal rights for Negroes in the Arts, Sciences, and Professions; raised money "for the benefit of the South African Resistance Movement"; and was one of the founders of the Sojourners for Truth and Justice, a movement for Negro women against lynch terror and the oppression of Negro people—all of which were designated "subversive" activities by the FBI (Goldstein 2008). The agent/informer reported on Childress's publications in *Masses & Mainstream*, the *Daily Worker*, and *Freedom*, and on her work with the left-wing Committee for the Negro in the Arts, an organization Childress helped initiate. The institutions that Childress was closely associated with during the fifties—*Masses & Mainstream*, Club Baron, the Jefferson School of Social Science, *Freedom*, Sojourners for Truth and Justice, the American Negro Theatre, the Committee for the Negro in the Arts—constituted a major part of the Harlem Left, a cultural front that shaped Childress's personal and public life and continued in Harlem throughout the 1950s, long after the "official" Popular Front was considered dead.[5]

There are conflicting accounts about Childress's relationship to the Communist Party (CPUSA), and her official membership in the Party cannot be verified with any certainty. In 1950, the FBI identified her as a member of the Harlem Regional Committee of the Communist Party. But, according

to her friend Lloyd Brown, an open communist in the 1950s, Childress tried to keep her left-wing affiliations hidden so as not to handicap herself as a writer and as an actor, and he believed that Childress deliberately refused to join the Communist Party, "making it a point to be a nonmember who could do as she pleased" (phone interview with the author, October 2002). Another source (Sterling 2003) says that Childress actually was a Party member and that she attended Party meetings in a unit in New York with his wife, an actress. The cultural historian James Smethurst (2012) offers this explanation for the ambiguousness of Childress's CP connections: "Another reason Childress might have remained a non-member in the 1950s is that the infrastructure of the CP in Harlem was in great disarray due to the effects of McCarthyism, factional infighting, and a number of leaders going underground. Some members of the Harlem section of the CP said it was hard even to find a representative to whom you could pay your Party dues." Childress's writings leave a number of clues that she was familiar with and may have been a part of the Party in Harlem, and Lloyd Brown maintained that there were only "technical differences" between Childress and Party members: "She was with us on all important issues" (2002). Whatever her official status with the Communist Party, Childress did not acquire her FOIA file and her leftist credentials by shadowing Robeson, as some critics have suggested, but because of her own extensive, well-earned political résumé (Harris 1986, xxvii).

RECONSTRUCTING CHILDRESS'S LEFTIST PAST

When critics rediscovered Childress in the 1980s, she seemed to be retrievable only within the boundaries of race and gender, neatly confined to the categories of "liberal," "feminist," "race militant," "didactic black activist," even "sentimental realist" (Harris 1986; Jennings 1995; Schroeder 1995, 334). One writer, improbably, accounts for Childress's devotion to working-class characters as the result of her modest beginnings as a self-supporting

high school dropout—all of which are accurate, if limiting, descriptions. In groundbreaking biography of Childress, La Vinia Delois Jennings does not mention Childress's left-wing politics, but even in the 1990s, very little had been documented about Childress's political leftist past.[6] Thus it is understandable that in her analysis of Childress's 1952 play *Gold Through the Trees*, which is virtually a textbook of 1950s Harlem leftist politics, Jennings (1995, 5) attributes the play's political viewpoints to Childress's "personal encounters with racism in America and her heightened sensitivity to apartheid in South Africa." What we know now is that the play was produced in leftist venues (Club Baron), that it was reviewed in left-wing papers (*Daily Worker*), and that its anticolonialist and antiracist themes were hallmarks of the black Left. The signs of the Left in Childress's play *Trouble in Mind*, which was produced in the midst of the high Cold War, are more difficult to detect, a sign that Childress's leftist politics were a growing liability and that she was savvy enough to employ camouflage. The play's racial issues—the 1955 Emmett Till murder and "the turbulent civil rights movement" (27) took center stage for most critics, but images of the HUAC and McCarthy investigations are woven throughout and structure the entire play. In her 2006 introduction to Childress's novel *A Short Walk*, which she wrote after Childress's relationship to the Left had been fairly well documented, Jennings describes Childress's early writing career as "concurrent with the early years of the United States' civil rights movement, the black liberation movement, and the women's liberation movement" (6), thus omitting the entire leftist context for the work Childress produced from 1949 to the 1960s.

If Childress's left-wing politics are hard to pin down, some of the blame can be laid on Childress herself. She began revising her personal history with several autobiographical essays written in the 1980s, specifically a 1984 essay "A Candle in a Gale Wind." In this essay she constructs herself as a loner, inspired to write about the masses because of her own personal experiences and determination, citing slavery, racial discrimination, her family and personal history, and her self-determination to explain her proletarian concerns—with no reference to the Harlem Left or Karl Marx.[7] She says she moved beyond "politically imposed limitations," teaching herself to "break rules and follow my own thought," which may be an indirect

reference to her ability to resist both Party ideology and the conservative mainstream. Although there is an oblique reference to McCarthyism in her admission that she was subjected to "a double blacklisting system," she maintains throughout the essay the pose of embattled loner, declaring that "a feeling of being somewhat alone in my ideas caused me to know I could more freely express myself as a writer." She explains her affinity for "the masses" as a totally apolitical attraction to "losers": "I turned against the tide and to this day I continue to write about those who come in second or not at all—the four hundred and ninety-nine and the intricate and magnificent patterns of a loser's life."[8]

"A Candle in a Gale Wind" is a far cry from Childress's earlier essay "For a Negro Theatre," first published in the Marxist journal *Masses & Mainstream* in February 1951, then reprinted with an enhanced Marxist title in the communist *Daily Worker* as "For a Strong Negro People's Theatre." Written and published during her years working at the American Negro Theatre, this essay represents the closest Childress ever came to a public declaration of her leftist identity. Not only does Childress's title mimic the ways that the term "the people" was used by radicals in the 1930s and 1940s to signify the working classes,[9] but the *Daily Worker* reprint is accompanied by a professionally done head shot of the glamorous thirty-something Childress that suggests she must have been comfortable being published in a communist-identified venue. The essay also reveals the always evident hesitancies and fissures in Childress's relationship with the Left, which she believed helped her maintain the political and artistic independence. She says in the essay that she came to accept the notion of a "people's theatre" after a "heated discussion" with the black radical left-wing playwright Theodore Ward, with Ward arguing that there was a "definite need for such a theatre" and Childress, despite her own long relationship with the American Negro Theatre, expressing the fear that a separate theater for Negroes might become "a Jim Crow institution." That she was never entirely comfortable with the discourses of the Left becomes clear as the essay sets forth her own distinctive brand of black-centered left radicalism. Without committing to Ward's vision—she agrees only that she "understands" his position—Childress proposes a "Negro people's theatre" that will first of all combat the racist practices of mainstream

theater: black students limited to "Negro" roles, white students never asked to perform black roles, black culture and history ignored, American blacks denied access to their African heritage, only those techniques developed by white artists recognized—a catalog that leads her to hope that a people's theater will devote serious study to "the understanding and projection of Negro culture." Her vision of this new theater is multicultural, black-centered, and internationalist: it will, she says, be concerned with the world and possessed of the desire "for the liberation of all oppressed peoples." The "Negro people's" theater will take advantage of "the rich culture of the Chinese, Japanese, Russian and all theatres," and it will study "oppressed groups which have no formal theatre as we know it," because, she says, *We must never be guilty of understanding only ourselves*" (63).

What makes the essay so important is that it shows Childress in the process of adapting and revising the cultural and political imperatives of the Left, something she would do for the rest of her creative life. Childress envisioned her audience as a politically sophisticated black working class: "domestic workers, porters, laborers, white-collar workers, people in churches and lodges . . . those who eat pig's tails, and feet and ears . . . and who are politically savvy enough to watch to see if some foreign power is worrying the rulers of the United States into giving a few of our people a 'break' in order to offset the propaganda." For Childress, "*the* people" was a racialized "*my* people," a phrase that, in the more doctrinaire period of the 1930s, might have earned her a reprimand for putting race before class solidarity. Departing even further from the Left's working-class emphasis, Childress also claims as "her people" those who drink champagne, eat caviar, and wear furs and diamonds with a special enjoyment "because they know there are those who do not wish us to have them." Childress's brand of radicalism did not separate her from the fur-wearing or fur-aspiring black middle class because her experience of U.S. racism was more deeply felt than interracial class solidarity. At one of the CNA's writers' workshops, when Paul Robeson suggested that Childress might improve a story about black workers by bringing in a union, she told him she couldn't make that story believable because she didn't know of any unions fighting for the rights of her people (Bonosky 2009, 34). In a letter she wrote to Langston Hughes in

1957, Childress took Hughes to task for his stereotyping of the black middle class as "snobbish strivers" and told him that she could very well "do without" his radical Left poems like "Move Over Comrade Lenin" and his "strained reference[s] to the 'workin' class," because they did not ring true to her as a "real reflection of Negro life" (Childress 1957).[10]

Yet Childress's racialized radicalism did not separate her from leftist radicals or from interracial work. The models she cites for this new theater at the end of her essay were three of the most radical cultural groups of the 1950s, all of which she was involved in—Harlem's Unity Theatre, the CNA, and the interracial New Playwrights theater group (where Childress was a board member), formed by the communist Mike Gold, the blacklisted screenwriter John Howard Lawson, and the left-wing writer John Dos Passos, the latter two organizations listed prominently on the FBI's Security Index.

Given the evidence of Childress's close ties to the Left and to the Communist Party, I use this chapter to reread her literary, cultural, and political work to show how her idiosyncratic radicalism allowed her to incorporate black cultural traditions and a critique of race, gender, and sexuality with the radical international-socialist views of the Harlem Left. If Ralph Ellison used his writings in the Cold War 1950s to "wrestle down his former political radicalism," as Barbara Foley (2010, 2) argues, Childress was wrestling in the opposite direction, moving from the more overt social protest of her early radical work to the subtle and complex leftist sensibility most evident in her 1966 play *Wedding Band*. As I show in chapter 1, the 1950 *Phylon* symposium's dismissal of protest writing and its efforts to exclude blackness and race issues as not sufficiently universal gained traction in the 1950s under Cold War conservatism. Childress's black internationalism and black radicalism was deployed to repudiate those restrictions, allowing her to explore more expansive and complex ways to represent black subjectivity, an example of what Alain Locke meant when he claimed during his short-lived radical period that "a Leftist turn of thought" can produce "a real enlargement of social [and I would add *aesthetic*] consciousness" (quoted in Wald 2001, 277). I trace the development of Childress's social and aesthetic consciousness, first through her own biography and then through her two Cold War productions, the 1952 play *Gold Through the Trees* and her columns

in *Freedom*, which were the basis for her 1956 novel *Like One of the Family*, and, finally, through three post–Cold War productions, her 1966 play *Wedding Band* and two novels, *A Short Walk* (1979) and *Those Other People* (1989).

CHILDRESS'S HOMEGROWN MARXISM

As her friends' testimonies and her own writings attest, Childress was an idiosyncratic leftist, and that was surely encouraged by her unconventional grandmother. Born in Charleston, South Carolina, in 1916, Childress moved briefly to Baltimore after her mother and father separated when she was five, and then to New York (they lived on 118th Street between Lenox and Fifth avenues in Harlem), where she was raised by her maternal grandmother Eliza Campbell, a relationship she considered one of the most "fortunate" things in her life, according to Elizabeth Brown-Guillory (quoted in Maguire 1995, 249). Formally uneducated and the daughter of an enslaved woman, Childress's grandmother introduced her to New York culture, from art galleries to Harlem churches; cultivated her imaginative life; and nurtured her desire to write, telling Alice, even as a young child, to imagine stories about the people and places they encountered and to write down her important thoughts so that they could be preserved (Maguire 1995, 49). She attended elementary school in Baltimore and junior and senior high school in New York City and credits many of her teachers for encouraging her writing. The New York City high school she attended, Wadleigh High School, was founded by Lydia F. Wadleigh, an early crusader for education for girls; as the first high school in New York for girls, it may have been another place that encouraged her independence. Her grandmother's interest in her cultural education may have pushed Childress to do some amateur acting, and her FOIA file reveals that she was active in theater as far back as junior high school with the Urban League and with the Negro Theatre Youth League of the Federal Theatre Project (U.S. FBI, Alice Childress, 100-379156, March 20, 1953). If Childress was working or acting in the Negro Youth League, then she was almost certainly exposed to radical politics, an affiliation that

suggests she was formed politically at an early age by her associations with the Left as well as by grandmotherly influence.

After both her mother and grandmother died in the mid-1930s, Childress was left on her own and forced to leave high school after two years. Because Childress was notoriously reticent about revealing her private life, we know very little about her between 1935 and 1941 (Maguire 1995, 31). However, we do know from several biographical sketches that she supported herself working at odd jobs as a machinist, domestic worker, saleswoman, and insurance agent (J. Smith 2004, 295). Childress (then Alice Herndon) married Alvin Childress, also an actor, most famous for his role in the 1950s *Amos 'n' Andy* television show, with whom she had one child, Jean, in 1935. She also continued acting in leftist community theater. One chapter in her novel *Like One of the Family* indicates that she was quite familiar with the FTP and the project actors. In one conversation with her friend Marge, the character Mildred discusses the "Negro problem" films of the late 1940s and reminds Marge that the Federal Theatre years (1935–1939) were a kind of golden age for black actors: they played in productions including *Turpentine, Noah, Sweet Land,* and *Macbeth.* Mildred's familiarity with the productions and actors of the 1930s and 1940s indicates that her author may have been a part of the project, but Mildred stops Marge from talking about the Federal Theatre because Mildred fears people will find out their correct ages, a relevant comment for Childress because, like Mildred, she was hiding her real age, claiming 1920 rather than her actual birth date of 1916 (Maguire 1995, 31; Jennings 1995, 1).[11] The Federal Theatre closed in 1939 under accusations of "un-American propaganda activities" most probably earned because of its prolabor stands, its progressive politics on social issues, and its interracial casts.

In 1941, two years after the close of the Federal Theatre, Childress joined the American Negro Theatre, founded in 1939 by the actor and blacklisted revolutionary trade unionist Frederick O'Neal and the writer Abram Hill, to identify and encourage blacks in theater.[12] In the vision of O'Neal and Hill, the ANT, following in the progressive path of the FTP, was organized as a cooperative where actors, playwrights, directors, and stage crew would work cooperatively and, in contrast to the professional theater, "[share]

expenses and profits" and develop artists and plays for the black community. The ANT operated for the first five years of its existence in the basement of the 135th Street branch of the New York Public Library, which seated 125 people, eventually adding the Studio Theater to train young artists, two of whom—Sidney Poitier and Harry Belafonte—became internationally known.

Childress spent the next eleven years at the ANT, working usually four nights a week, as demanded by ANT policy. Because the ANT operated like an arts academy, Childress had the opportunity to perform all the roles in the theater, including playwright, director, manager, actor, stagehand, and even, at one point, union negotiator. Her life in the 1940s was almost entirely consumed by the theater. She learned how to erect sets, coach new actors, do makeup, design costumes, and direct shows, and, whenever she could get a role, she acted in off-Broadway theater (Jennings 1995, 3). Along with fellow actors who started at the ANT—Ruby Dee, Ossie Davis, Poitier, and Belafonte—she starred in several of ANT's most popular productions, eventually landing a part in the all-black cast of *Anna Lucasta*, ANT's first big-time commercial success. Written by the Polish-American playwright Philip Yordan, *Lucasta* was originally about a Polish family, but, with Yordan's permission, the play was revised by Abram Hill for a black cast, and it was the all-black ANT production that caught the attention of producers, who took it to Broadway in 1944 for 957 performances, earning Childress a Tony nomination for her role as the prostitute Blanche (Branch 2010). Poitier, Childress, Dee, Davis, and other ANT members joined the traveling company of *Lucasta*, which toured the Midwest and East Coast. The young, self-identified "left of center" Poitier suggests in his autobiography that it was on this long road tour that Childress became his political mentor: "She opened me up to positive new ways of looking at myself and others, and she encouraged me to explore the history of black people (as opposed to 'colored' people). She was instrumental in my meeting and getting to know the remarkable Paul Robeson, and for that alone I shall always be grateful" (2007, 121–122). By 1955, the traveling four—Poitier, Dee, Davis, and Childress—would all be blacklisted for their close associations with Robeson, the Committee for the Negro in the Arts, and the ANT. When

Lucasta was made into a Hollywood film in 1958, starring Eartha Kitt, Sammy Davis Jr., Rex Ingram, and Frederick O'Neal, the part of Blanche was given to the unknown Claire Leyba, and Childress was passed over for the role for which she had garnered a Tony nomination, most likely because of her left-wing associations.

In 1951, the same year that Childress became a regular columnist for *Freedom*, her husband Alvin, now an instructor at the ANT, was offered the role of Amos Brown, the philosophical cab driver in the controversial *Amos 'n' Andy* television series. Both Alice and Alvin were making very little money, so a television role meant the possibility of hitting it big, but it also meant both a physical and, eventually, an ideological separation. Alvin was working on the West Coast in the glamour world of Hollywood, and Childress was working in New York with the ANT and with the people at *Freedom*, all of whom were highly critical of *Amos 'n' Andy* for its demeaning portrayal of black culture. Childress has said very little about their divorce, saying only that the marriage "was just something that shouldn't have been" (Branch 2010). She was, however, so adamantly opposed to Alvin's decision to stay in the series that she announced publicly at a forum on black playwrights held at the University of Massachusetts–Amherst in the late 1980s that she had divorced him for taking the *Amos 'n' Andy* role. As we will see in the "Spycraft" chapter, Childress was as firm in her rejection of the CIA as she was about her husband playing in *Amos 'n' Andy*.[13]

GOLD THROUGH THE TREES

In 1952, Childress produced her most clearly identifiably leftist play, the radical musical *Gold Through the Trees*, and staged it in a cultural context so radicalized that it immediately caught the attention of the FBI. Almost without exception the commentary on *Gold* has ignored its radical implications, but, if literary historians missed the significance of the play, the FBI certainly did not. The FBI report was extensive, observing that on May 20, 1952, *Gold* would be produced by the left-wing Committee for the Negro

in the Arts to benefit the left-dominated Civil Rights Congress (the CRC bought out the house for one performance), that the play would be performed at the progressive-interracial Club Baron at 437 Lenox Avenue at 132nd Street, and that it was reviewed favorably by Lorraine Hansberry in the left-wing newspaper *Freedom* and by Lloyd Brown in the Marxist journal *Masses & Mainstream*. As the leftist affiliation of each of these institutions and individuals shows, by the early 1950s Childress was fully embedded in the Harlem Left community, which supported the play as it ran for two months until, according to Childress, the leads were hired away to do the European tour of *Porgy and Bess*.

Childress's experiment with radical musical theater came the closest to providing what Michael Denning says in *The Cultural Front* was missing in other Popular Front musicals: a marriage of dramatic narrative, left-wing politics, and African American music. Countering Denning, Smethurst insists that a worthy precursor to *Gold* certainly must be Langston Hughes's *Don't You Want to Be Free*, which combined dramatic historical narrative, leftist politics, and African American music, and Childress was certainly familiar with Hughes's theatrical work. Experimenting formally, Childress composed the lyrics and orchestrated the music and dance for the show, incorporating Ashanti dance, a Bantu love song, West Indian shouts and songs, drumming, and African American blues and gospel singing to accompany the play's historically based, politically left-wing dramatic sketches that trace the history of African peoples from ancient worlds to the 1950s. If its sweeping coverage of thousands of years of history compromised dramatic unity, there were nevertheless three scenes of real dramatic power in *Gold*.

Act 1 features the fugitive Harriet Tubman working with two other women in a Cape May, New Jersey, laundry in 1852 to earn money for her underground trips. One scene in Act 2 is set in a prison, where a young man is on trial for the rape of a white woman in Martinsville, Virginia, in 1949. Based on the actual trial of the Martinsville Seven, the scene is narrated through the voice of the man's mother and ends with the singing of the plaintive and politically charged "Martinsville Blues," written by Childress. A woman narrator introduces the last act with a powerful monologue on

the brutalities of colonialism, which sets up the final scene: South Africa in the 1950s, as three young activists meet to plan their part in the South African Defiance Campaign.

Two of the sketches in *Gold*—the Harriet Tubman scene and the scene in South Africa—are stories of reluctant activists discovering in collective resistance the courage to be involved in an underground movement, and these mirror Childress's own political life in the 1950s. The Tubman scene is particularly notable in that respect: it features two women, Celia and Lennie, working with Tubman in the laundry at a luxurious seaside Cape May resort helping her earn money for her trips to the South to rescue enslaved people. According to the historical record, Tubman followed a pattern of seasonal migration, earning money doing domestic work in the North during the spring and summer and then heading south in the fall and winter, "when the nights are long and dark," to execute her raids on slavery. Celia has become despondent over the heavy laundry work and fearful of their mission: she says the idea of working for the underground "sound so good in the meetin' where it was all warm and friendly," but she has begun to realize the dangers of being involved with a wanted fugitive. In a powerfully affective speech to encourage Celia to remain committed, Harriet uses the body as a tropological site, telling Celia to imagine that the broken skin on her knuckles is warm socks and boots for an escaping man or woman and that the cuts made by the lye soap is a baby that will be born on free soil. Trying to explain to Celia the transcendent feelings of crossing into both physical and psychological freedom, Harriet tells her that when she crossed that line, "There was a glory over everything. The sun come like *gold through the trees*" (7). The civil disobedience of these three women may certainly have been a disguised reference to Childress's own underground work, since by 1952, according to her friend and leading communist Herbert Aptheker, who had gone into hiding, Childress too had crossed the line into subversive and illegal activity. Aptheker told me in an interview that during the worst days of the McCarthy period Childress let him use her uptown apartment for meetings with underground communists. This could have meant a jail term for Childress. Since this is not mentioned in her files, I conclude that the FBI never discovered the full extent of Childress's radical politics.

The Martinsville section opens with a monologue by the mother of one of seven young black men accused of raping a white woman in Martinsville, a case that became a major cause for the Left when the Left-led Civil Rights Congress began mass public protests for the repeal of the death sentences and linked the CRC's fight for the lives of the seven men to the constitutional rights of the CPUSA. Unlike the Scottsboro case, there was no question that Ruby Floyd had been brutally raped, that all seven men had been present, and that at least four had apparently participated in the rape. Desperately trying to avoid another Scottsboro, Virginia authorities produced "procedurally fair trials," but there was, nonetheless, the lingering smell of Scottsboro: All blacks were dismissed. There was an all-white and all-male jury in all seven trials. Confessions were obtained without benefit of counsel, and some of the men may have been intoxicated at the time of their confessions. The jury in one case took only half an hour to sentence the defendant to the electric chair. In the largest mass execution for a single crime in U.S. history, all seven men were executed on two days, February 3 and 5, 1951, despite the mass protest of the CRC.[14]

The mother in *Gold* narrates her son's life through memories that show she had already anticipated the inevitability of trauma in his life. When he toddled out into the road as an infant, or caught his finger in his wagon, his screams prefigured the harm she knew she would be unable to prevent. Once he is older, those fears are realized as the young boy inadvertently tries to pay at the white counter in the grocery store and has to be whipped into submission to segregation. At the end of her monologue, the mother cradles an imaginary baby in her arms, and a single spotlight is turned on the face of a man, now behind bars singing "The Martinsville Blues": "Early one morning / The sun was hardly high / The jailer said, Come on black boy / You gonna lay down your life and die. / Lord, Lordy, Lay down your life and die." A second verse is sung by the condemned man to his mother, and another is directed to "Miss Floyd," the white woman whose rape is the cause of his death sentence. At the end of the "Martinsville Blues," the singer counts slowly to seven, inserting dramatically after each count the names of the seven executed men, a chant much like the one in Langston Hughes's *Scottsboro Limited*, where the count is to eight for eight of the nine Scottsboro men

sentenced to death. The Martinsville section was not only an elegy for the dead but a song of protest made possible because of the Left's activism that first fought to preserve the lives of the Martinsville men and then provided the space to lament the injustice of their fate.

Gold's final scene, set in apartheid-era South Africa, is introduced by the narrator in a monologue that calls attention to the way the body of the colonized becomes the raw material for the productions of empire, showing again the Harlem Left's deep consciousness of colonialism's ties to European and American interests:

> And the ships that had sailed away with gold and ivory returned to Africa laden down with German muskets, British and Portuguese guns . . . French weapons . . . and American blasting powder. . . . These weapons were for the purpose of hunting elephant. . . . Oh . . . yes. . . . They did hunt elephant. . . . Seventy-five thousand a year . . . and every pound of ivory cost the life of one African. . . . And I heard the delicate strains of the *Moonlight Sonata* played on that same ivory.

At the end of the monologue, three young South African revolutionaries are shown meeting in a shanty in Johannesburg where they make plans to join the rebellion against the apartheid laws. John, his friend Burney, and Ola, the woman he loves, speak to one another of their personal experiences with apartheid history, citing the pass laws, the mine accidents, the compulsory labor policies, and the prison farms they have endured, but they also report on the encouraging news of a new alliance among African, Indian, and Coloured, all demanding repeal of the "special laws." In a scene taken directly from the African issue of *Freedom*, Burney recalls the time that African women lay on the ground, forming a human carpet in the road to prevent police trucks from taking their men to jail. John announces that the campaign of passive resistance will begin on April 6, the anniversary of the arrival of the first Dutch settlers, with mass demonstrations and protests against the pass laws. The three say goodbye to one another, fully expecting to be imprisoned or killed, but with the knowledge that "through the resistance the world will have to move" (act 2, 7).[15]

According to the historian Penny von Eschen, activists like W. E. B. Du Bois, Alphaeus Hunton, Robeson, and, we must add, Childress deepened their insistence on the place of Africa in the consciousness of the Harlem Left with their support of the Defiance Campaign, knowing full well that this was a dangerous match-up (1997, 116). In the midst of the production of *Gold*, the Harlem Left experienced the full brunt of repression: The Council on African Affairs's director Dr. Hunton received a one-year jail sentence for contempt for refusing to divulge the names of contributors, Robeson's passport was withdrawn, Du Bois was arrested and indicted for trying to get signatures on a peace petition, and Childress was unable get her work published in the mainstream press (Plummer 1996, 191). Very shortly after the 1952 production of *Gold*, members of the theater committee, under the pressures of McCarthyism, "'panicked' and padlocked the door of the Club Baron themselves" (Duberman 1988, 703n29). Nonetheless, they all retained their commitment to linking African and African American struggles and foregrounding leftist political causes that Childress makes explicit in *Gold*. If the underground in Ellison's *Invisible Man*—a far more celebrated 1950s black literary production—was a site for self-induced psychological paralysis, Childress's black undergrounds were scenes inspired by a militant black international diasporic consciousness that imagined strategies for action, not retreat. In her focus on the outlaw Harriet Tubman, the Martinsville protest, and South African revolutionaries, Childress was not only drawing from the well of Left symbols, she was continuing her quest to represent blacks outside of the narrow, limited images of blacks in the American imaginary of the 1950s (Schaub 1991, 104; Schrecker 1998, 375–376).[16]

CHILDRESS, *FREEDOM*, AND CLAUDIA JONES

In contrast to the autonomous self she constructs in her 1984 autobiographical sketch, all of Childress's work is permeated with images of community. In the essay she wrote for *Freedomways* in 1971 about her life as

a writer on Paul Robeson's newspaper *Freedom*, she situated herself at the center of a culturally cohesive black left-wing community, with Robeson working in the offices at 53 West 125th Street, alongside the dynamic, young communist editor Louis Burnham. The building also housed the Council on African Affairs, with offices occupied by Alphaeus Hunton and W. E. B. Du Bois. As she narrates, Childress imagines herself as a kind of roving camera, watching "Paul taking visitors to the offices of Du Bois and Hunton," hearing their "deep and earnest conversation about Africa" (1971, 272). She remembers actors and musicians and neighborhood "Harlemites" dropping in to talk to Robeson, Eslanda Robeson introducing young artists to Burnham, Du Bois sitting in his office making a plan to complete his dream of *The Encyclopedia Africana*, and a twentysomething "Lorraine Hansberry typing a paper for Robeson." Childress shared an office with Robeson, Hunton, Burnham, and Hansberry, where she wrote her monthly "Conversations from Life" columns for *Freedom*, one of the most popular features in the paper (Childress 1971, 272–273).

In this idyllic memoir, Childress omits the very Cold War history she was a part of. Once Robeson was blacklisted, the paper was unable to raise the funds to carry on and published its final issue in 1955, but Childress stayed with *Freedom* until the very end. She wrote more than thirty columns called "Conversations" that featured Mildred Johnson—an outspoken domestic worker, Harlemite, and spiritual cousin to Langston Hughes's Jesse B. Simple. Speaking in the first person, often to her friend Marge, usually a silent listener, other times to her white employers, and sometimes directly to the reader, Mildred speaks on a range of subjects, from the importance of Negro History Month to South African independence struggles.[17] Mildred is more of a consciousness-raising device than Hughes's Simple, but like Hughes, Childress gave Mildred strong ties to the black community, an ease with vernacular speech, and a militant racial perspective, all intended to create an identification between Mildred and her working-class black readers. In 1956, Childress revised and expanded her "Conversations" and turned them into the novel *Like One of the Family*, and because critical attention has always focused on the novel, these antecedent texts—the *Freedom* columns—have been ignored, excising in the process another connection between Childress

and the Left. Failing to trace the Mildred stories back to these Popular Front columns, critics could not situate the author or her protagonist in the context of Cold War politics and were easily led into limiting Mildred Johnson to race woman or "sassy black domestic" (Harris 1986). It is important, however, to read the Mildred monologues as they first appeared, not isolated in the autonomous and static text of the novel but as texts produced in the midst of Cold War tensions, in a left-wing newspaper, dramatically transformed by their dialogic relationship to the other stories and writers in the paper.

In the January 1954 issue, for example, Childress joined Robeson and the other *Freedom* contributors to launch an attack on the antiblack subtext of the HUAC and McCarthy witch-hunts. Mildred calls McCarthyism a form of legalized terror in which everyone from the Army, to the post office, to ordinary housewives was being investigated, and she predicts, "we are all going to suffer much more until we wake up and defend the rights of Communists." Throughout the column, Childress/Mildred puts the major ideas of the paper in the language of an ordinary person in the community, trying to get them to understand the McCarthy purge as an effort to suppress thought and dissent that will affect them: they will have to "raid the libraries and remove all books that the ruling body in the land deems unfit . . . suppress all movies that they think unfit . . . close off every avenue they think unfit and put away or do away with all people who have such ideas, close all churches and social groups that hold such ideas these ideas and purge every home in the land to root out such ideas." In another "Conversation," again deploying Mildred as her political spokesperson, Childress affirms her support for Robeson, who by 1954 was under attack. When cautioned by a white employer that her involvement with Robeson will only cause her trouble, Mildred relates a folk tale about Old Master and his slave/servant Jim, with the subtext that "trouble" for the enslaved is rooted in the racism of Old Master. Revising the meaning of "trouble," Mildred ends the tale by saying, "Somebody has made trouble for me, but it ain't Paul Robeson. And the more he speaks the less trouble I'll have."

There is another reason to read Childress's Mildred stories in a Left context. It brings to light an important collaboration between Childress and

Claudia Jones, the secretary of the Communist Party's National Women's Commission and, at age thirty-five, the highest-ranking black woman in the CPUSA. Not only was Jones a substantial presence in the black leftist Harlem community, but in 1949 she published, in the leftist journal *Political Affairs*, an important essay about black working-class women, "An End to the Neglect of the Problems of the Negro Woman," which I believe helped inspire Childress's Mildred character (Davies 2008, 79). No one has documented the relationship between Childress and Jones, but they almost certainly knew each other. They traveled in the same leftist-progressive circles in Harlem and knew many of the same people.[18] According to the *Freedomways* editor Esther Jackson, Jones lived with Lorraine Hansberry when she first came to New York, and Childress became active with the Harlem Committee to Repeal the Smith Act at the same time that Jones was being threatened with deportation under the Smith Act. Born in Trinidad and raised in Harlem, Jones was a part of the group called the Sugar Hill Set, a group of artists and intellectuals in Harlem that included Hansberry, the Robesons, Langston Hughes, and Childress (Dorfman 2001). After being deported under the Smith Act, Jones died in London in 1964 at age forty-nine and, in honor of her political work, was buried in Highgate Cemetery literally to the left of the grave of Karl Marx.[19] The focus on Robeson in Childress's life and work has obscured this radical left feminist influence on the construction of the Mildred character.

Jones argued that black women, as the most oppressed group in America and the least organized, were the most deserving of attention from the Left and should be at the center of leftist theorizing and strategizing about labor issues. Instead, she wrote, progressive leftists were guilty of "gross neglect of the special problems of Negro women." With facts gathered from the U.S. Department of Labor, Jones set out to catalogue the evidence. Black women, she wrote, represented the largest percentage of women heads of households, having a maternity rate triple that of white women, and they were paid less than white women or men and were excluded from virtually all fields of work except the most menial and underpaid, namely domestic service. As domestic workers, black women were not protected by social and labor legislation nor covered by minimum wage legislation. Working in

private households, they could be forced to perform any work their employers designated, sometimes standing on corners in virtual slave-market style with employers driving by and bidding for the lowest price. Despite these real-life roles black women were playing as workers, mothers, heads of households, and protectors of their families, Jones showed that the media continued to portray them as "a traditional mammy who puts the care of children and families of others above her own." The conditions in Negro communities that resulted from those disparities in income and employment were, Jones wrote, with a sure sense of irony, an "iron curtain."

In "An End to the Neglect of the Problems of the Negro Woman," Jones also took her critique to those private spaces where discrimination against black women by progressives went unremarked. She cited instances where white women progressives called adult black women "girls," or complained that their maids were not "friendly" enough, or drew the line at social equality, or, on meeting Negro professionals, asked if they knew of "someone in the family" who could take a job as a domestic (60). While leftist critics often cite Mike Gold's story of a black woman who "could dance like a dream" (quoted in Maxwell 1996, 91) as evidence of the Party's integrationist stance, Jones tells the story of black progressive women at social affairs being rejected for not meeting "white ruling-class standards of 'desirability'" like light skin, discovering that discrimination existed even on the dance floor, where neither white nor black men were filling up their dance cards (60).

Freedom began monthly publication in November 1950 and ran until August 1955, when it folded from lack of funds and under Cold War pressures.[20] Its editor was Louis Burnham, an open communist, and appearing regularly were columns by Paul Robeson, Eslanda Robeson, Du Bois, Victoria Garvin, Yvonne Gregory, Hansberry, and Childress. It sold for ten cents an issue, one dollar for a year's subscription, and followed a consistent format, with the motto of the paper under the masthead pointing to the internationalist-socialist focus of the paper: "*Where one is enslaved, all are in chains.*" Each issue had front-page news followed by information about union and civil rights activities. Paul Robeson's column, "My Story," started off each issue on page 1 and often linked the various stories to Robeson's personal activities.[21] The third page usually focused on inter-

national news and emphasized solidarity with people of color around the
world. There were regular contributions both by and about Robeson and
Du Bois. While gender was not as consistently raised as race, class, peace,
and international solidarity, there was an understanding that gender was a
separate and important issue. Both Childress and Hansberry, who became
an associate editor after one year, and other contributors, including Beu-
lah Richardson (later Bea Richards), Charles White, Shirley Graham Du
Bois, Thelma Dale, Lloyd Brown, and the labor leader Vicki Garvin and
at least fifteen other women labor activists helped shape the paper's black-
leftist-feminist viewpoint.[22]

Childress made an enlightened, politically conscious Mildred the center
of her narrative, as if to show, as Jones had pointed out, the possibilities of
leadership in the very women white and male progressives were exclud-
ing. In one extended narrative on the importance of hands, Mildred pays
tribute to working people by focusing on the physical labor required to
bring the objects of everyday use into existence—from the tablecloth that
Mildred says began in "some cotton field tended in the burning sun," to the
nail polish her friend Marge is using. When Mildred encounters a woman
who is angry at "them step-ladder speakers," a reference to Communist
Party's tradition of street-corner speeches, she gives a sermon on the value
of "discontent" that introduces her readers to the Left's contributions to
their social welfare: "Discontented brothers and sisters made little children
go to school instead of working in the factory," and "a gang of dissatis-
fied folk" brought us the eight-hour workday, women's right to vote, the
minimum wage, unemployment insurance, unions, Social Security, public
schools, *and* washing machines. In her excellent introduction to the 1986
reissue of *Like One of the Family*, the literary historian Trudier Harris cor-
rectly identifies the signs of Mildred's radicalism. Harris says that Mildred
confronts racial injustice, eradicates symbols of inequality, fights for labor
rights, advocates collective resistance, and "radically violates every sort
of spatial boundary." Harris concludes that Childress's militancy can be
traced to Nat Turner, Frederick Douglass, Sojourner Truth, and Harriet
Tubman. Since Childress was alive in 1986 and not eager to be identified as
a leftist, it may have been prudent to attribute her politics to nineteenth-

century radicals, but that again elides Childress's left-wing politics and misses Mildred's twentieth-century Marxism. With the Mildred character articulating the issues in Jones's essay, Childress and Jones and Mildred were the three most important voices on the Left theorizing and representing black women workers in the 1950s. Contrary to the critics who reduced Mildred to a "sassy black domestic" or ignored Childress's radical leftist profile, Childress meant for Mildred (like Jones and herself) to be a voice that provided black women with a theory of labor rights, authorization for dissent, and a language to speak against injustice; in other words, a bona fide woman of the Left.

BEYOND THE BLACK POPULAR FRONT:
A *WEDDING* BANNED

With the CNA and the *Freedom* family disbanded, she and her friends under surveillance, blacklisted, jailed, Red-baited, and/or deported,[23] Childress began writing her 1966 play *Wedding Band: A Love/Hate Story in Black and White* in a period of crisis.[24] When the journal *Freedomways* was founded in 1960, as the successor to *Freedom*, Childress, along with her compatriots on the Left—Louis Burnham, W. E. B. and Shirley Graham Du Bois, Charles White, John O. Killens, Lorraine Hansberry, Elizabeth Catlett, and Margaret Burroughs—joined the editorial staff, a clear signal that they were still willing to be identified with the Left. While the journal was dedicated to continuing the internationalist-socialist aims of *Freedom*, it also reflected a spirit of black radicalism that allowed them to remain engaged with the Left and give priority to black struggle. *Freedomways's* founders were so intent on maintaining "both the reality and appearance of black control" that they refused to ask the leading white communist Herbert Aptheker to join the editorial board, "adamantly" insisting that the journal be organized and run entirely by African Americans.[25] For black leftists who were increasingly distrustful of white-dominated institutions, the highly inspirational influence of the Southern civil rights movement

led by Martin Luther King Jr. and the emergence of the charismatic black nationalism of Malcolm X made the transition from "the Robeson era" to the civil rights era (Iton 2010, 61) almost a necessity.

Even as black activists made this transition, very few left any documentation of the internal conflict created by this move. Two of Childress's generation who did produce such documentation are the actor and activist Ossie Davis and the excommunist activist and writer Hunter (Jack) O'Dell. In a private letter written in 1964 to his long-time friend, the black communist William (Pat) Patterson, published in 2007 by Davis's wife actor Ruby Dee, Davis describes his anguished decision to move away from the Left, a departure triggered by a conflict over plans for the memorial for Du Bois, which Davis viewed as an example of the white Left trying to contain black authority. He begins by reminding Patterson of his sincere and long-term allegiance to the Left even when it was dangerous: "I was on the outside with Robeson and Du Bois." Including his dear friend Pat in his list of heroes, he writes, "My heroes were Hunton, Davis, Patterson, Robeson and Du Bois." Nonetheless, Davis says he now understands that it is necessary to break away from "Great White Papa," and, in the full-dress rhetoric of black nationalism, he concludes that at this moment of the ascendancy of the "Negro struggle," the Negro people are now the "vanguard" and must break away from the Left in order to discover "our own separate manhood and dignity" (205). In his 2000 essay "Origins of *Freedomways*," O'Dell describes a similar epiphany. By the mid-1950s, O'Dell writes, "the mechanisms of the Cold War State were now in place"—loyalty oaths, the Attorney General's Subversive List, investigative committees, Red Squads in police departments, blacklists—and then, he writes, "along came Montgomery—one of those moments of awesome significance" that demonstrated the power of community action and the "joyful spirit of unselfish commitment" mobilized around a proposition with universal appeal: "Better to walk in dignity than to ride in humiliation" (5). O'Dell realized that joining Reverend King in black movement politics was a kind of redemption from the increasing isolation of the Left. Reading Davis's letter for the first time in 2009, O'Dell said that his own feelings about the decision to leave the Communist Party and join King's

movement echoed Davis's. That was such a necessary and organic shift, he admitted, "I wasn't even torn about it."[26]

Childress made no such dramatic pronouncements about leaving the Left, and, though she was deeply affected by the fervor and challenge of the new civil rights movement, she did not become closely identified with either King or Malcolm X, as Davis and O'Dell did. In an unpublished nonfiction piece called "Harlem on My Mind," Childress left no doubt that her continuing interest in radical political change would take a blacker and more internationalist direction. In her notes for this piece, she mapped out a black historical trajectory for her future work that included the formation of the Student Non-Violent Coordinating Committee, Fidel Castro's postrevolutionary stay at Harlem's Hotel Theresa, Rosa Parks's defiance of segregation laws, and "the birth of a baby in the West Indies" named Frantz Fanon, who, she writes, was "destined to call for a black revolution that would be studiously read by Harlemites, Africans, West Indians, and South Americans." As these unpublished notes indicate, Childress was intellectually engaged in the fierce political currents of the early 1960s, but her typically iconoclastic response to this new era of black political struggle was *Wedding Band* in which she imagines "the indigenous current of black militancy" in the figure of a Southern working-class black woman and situates that woman in an intimate relationship with a working-class white man (Singh 2005, 184).

Not unexpectedly, black nationalists openly reviled *Wedding Band*. Childress's close friend, the writer and fellow leftist John O. Killens, writing twenty years later, came close to calling her a race traitor for portraying a black woman loving a white man:

Childress's other writings seemed to have a total and timely relevance to the Black experience in the U.S. of A.; *Wedding Band* was a deviation. Perhaps the critic's own mood or bias was at fault. For one who was involved artistically, creatively, intellectually, and actively in the human rights struggle unfolding at the time, it is difficult, even in retrospect, to empathize or identify with the heroine's struggle for her relationship with the white man, symbolically the enemy incarnate of Black hopes and aspirations. Nevertheless, again, at the heart of *Wedding Band* was the

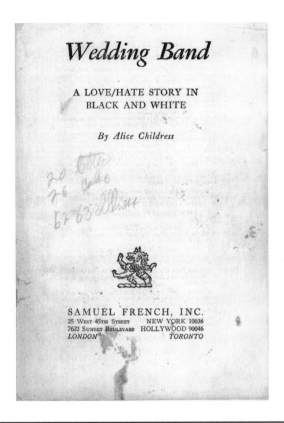

FIGURE 3.2. Cover of Childress's *Wedding Band*,
published by Samuel French.
Source: Copyright © 1973 by Alice Childress. Used by
special permission of Flora Roberts, Inc., and Samuel French, Inc.

element of Black struggle, albeit a struggle difficult to relate to. As usual,
the art and craftsmanship were fine; the message, however, appeared out
of sync with the times.

(1984, 131)

Wedding Band so unnerved Killens that he conflated Childress (the writer
involved in artistic struggle) and her main character Julia (the heroine

struggling in an intimate interracial relationship), reflecting the anxiety among black nationalist men over interracial desire between a black woman and a white man (Childress 1973, 8).[27]

I want to challenge the view that *Wedding Band* was a "deviation" from Childress's earlier commitments and that her message was out of sync with the times" and show that her earlier investments in radical black leftist politics also animate this play.[28] Childress clearly had the contemporary moment in mind as she constructed a play that turned 1950s integrationism on its head. In what the historian Penny von Eschen calls a new "rewriting of race and racism" and the cultural historian Nikhil Pal Singh calls the race project of the "U.S. race relations complex," Cold War liberalism, in reaction to the leftist radicalism of the 1940s, reinterpreted race as a psychological disorder rather than a system of economic, political, and social structures and practices connected to the subjugation of minority peoples all over the world. In opposition to the Left's analysis of racism as located in systems of domination—slavery, colonialism, and imperialism—racism could now be understood in the metaphor of a "disease," or an aberration, or the personal "prejudice" of unenlightened individuals, which could be overcome by talented, motivated, educated blacks with a "fighting spirit" (Von Eschen 1997, 153–159). Postwar civil rights militancy, with its emphasis on the black worker, its focus on the relationship between racism at home and colonialism abroad, and its advocacy of black equality, was being conveniently and systematically replaced by the integrationism of the 1950s or what the communist Ben Davis called derisively "a new race discourse of individual success stories," which were designed to undermine the militancy of the fight for jobs and freedom for the masses of blacks.[29] At the same time that racial integration was being hailed as a sign of Negro progress, integrated unions, with their strong record of antiracial work, were being decimated by anticommunist hit squads, and interracial relationships and support for Negro equality were being designated un-American by government investigative committees. With the black radical Left weakened by investigative committees, blacklists, subpoenas, arrests, and jail terms, racism became domesticated, diverted into Cold War narratives of racial progress and individual achievement. *Wedding Band*'s focus

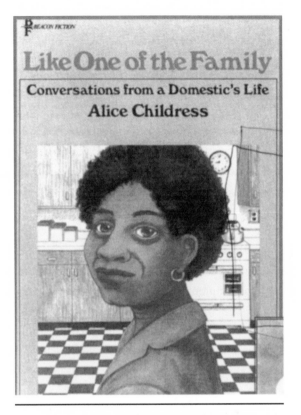

FIGURE 3.3. Cover of Childress's *Like One of the Family*,
Beacon Press ed. (1986).
Source: Art by Leslie Evans with permission from Leslie Evans.

on the collective and on community solidarity and black protest, its critique of white race privilege and American nationalism, and its skepticism about the possibilities of interracial alliances contested these State Department–authorized versions of integration and questioned the entire project of Cold War-styled integration.[30]

Wedding Band opens on Julia Augustine's first day in an unnamed small black South Carolina community, where the back porches and backyards of several houses are contiguous, bringing Julia together with three other black women and their families: Mattie and her lover October, who is

away in the merchant marines, and their daughter Teeta; Lula and her adopted son Nelson, a soldier home on leave from the army; and Fanny, the owner of all these little backyard houses. Julia, a thirty-five-year-old, working-class seamstress, living in domestic service away from family and friends, has moved here, hoping that this community will accept—or at least tolerate—her relationship with a white man, Herman, a forty-year-old German American baker, whom she meets when she buys bread in his small bakery. In South Carolina they cannot be legally married, but Childress depicts their union as binding and stable and as ordinary as any ten-year-old marriage. At their private anniversary celebration, Herman gives Julia a wedding ring on a chain since she cannot wear it publicly. By focusing on a ten-year-old union, Childress dispensed with the major premises of the conventional interracial love story—passing, sexual seduction, titillating courtship, erotic sex, the exotic other, effectively de-eroticizing the romance plot so as to focus on the politics of an interracial love affair. Childress seems to have anticipated the 1967 Supreme Court decision *Loving v. Virginia*, which denounced laws banning interracial marriage not as private infringements but as public acts of violence that confined, excluded, and violated entire black communities (Childress 1967, 17–21).[31]

At the end of the first act, Herman falls ill with influenza in Julia's house, triggering the public implications of their interracial relationship: it is against the law in South Carolina for a white man to be found living—or dying—in a black woman's house. Though the love story between Julia and Herman is foregrounded in the film version of the play, the stage version (and my reading) centers on Julia's interactions with the people in this backyard community (Maguire 1995, 53–54). When Julia wants to call the doctor for Herman, Fanny warns her that the entire community will be punished if Herman is found in her house. Mattie and Lula will lose their jobs, Nelson will not be able to march in the parade, and the doctor will file legal papers. As Fanny warns her: "That's police. That's the work-house. . . . Walk into the jaws of the law—they'll chew you up" (act 2, scene 1, 35).

Julia and Herman are thus forced to encounter the public racial history they were able to evade when Julia lived in isolated places, but, more impor-

tantly, in this new black community, Julia experiences the collective troubles and racial anger that make their former evasions impossible. Their relationship—now mediated by the material conditions of this impoverished black community and incidents of racial consciousness raising that form the central action of the play—is a set up that allows Childress to present her very carefully constructed intellectual arguments about race, class, gender, and collective responsibility.

Significantly, Julia's first public act in this new community is to read Mattie's letter from October. When Mattie, who cannot read, asks Julia to read the letter from October, Julia's voice merges with October's as he relates his encounters with racism in the military: "Sometimes people say hurtful things 'bout what I am, like color and race" (19). And it is Julia, not October, who thus hears and participates in the call-and-response with Mattie's defiant vernacular: "Tell 'em you my brown-skin Carolina daddy that's who the hell you are" (19). Later, Lula tells Julia about the time she got down on her knees and played the darky act in a segregated courtroom in order to keep her son Nelson off the chain gang. Unschooled in the ways of racial resistance, Julia responds in a voice of class-based gentility: "Oh, Miss Lula, a lady's not supposed to crawl and cry," and Lula, disdaining Julia's airs, retorts: "I was savin' his life" (57). In a clear repudiation of Killens's accusation of race disloyalty, Childress (1967, 20) says she was also intent on representing a strong black male voice to counteract the usual paradigms of interracial stories: "The colonel's sweetheart never seemed to know any men of her own race, and those presented were usually slack-kneed objects of pity. This caused me to see an admirable black man in the center of the drama, one who could supply a counterpoint story with its own importance, a man whose everyday existence is threatened with the possibility of a life and death struggle." In the most charged encounter between Julia and this community, Nelson comes home smoldering in anger over being attacked by Southern whites for wearing his uniform in public, remembers Julia's white lover, and narrates a bitter parallel tale of interracial sex: "They set us on fire 'bout their women. String us up, pour on kerosene and light a match. Wouldn't I make a bright flame in my new uniform? . . . I'm thinkin' 'bout black boys hangin' from trees in Little Mountain, Elloree, Winnsboro" (41).[32]

Julia's encounters with Mattie, Lula, and Nelson enable her to find a "racial" voice, which she uses to end the silences Herman has imposed on her.[33] It is also important to note that in these encounters between Julia and Herman, whiteness becomes a racial category, and the racial gaze is rerouted and focused on white race privilege. In the past, when Julia would begin a sentence with "When white-folks decide," Herman would insist that "white" be deleted: "people, Julia, people" (28). When she reminds him that his mother once accused him of loving a "nigger," he chastises her for remembering something that was said seven or eight years ago (25). Herman says he only wants "to leave the ignorance outside," not to allow difference to threaten their love, even as his own racialized descriptions of Julia as "the brown girl" who is like "the warm, Carolina night-time" reaffirm his privileged status as the unmarked, universal subject (41). He insists that his folks, struggling German Americans, plain working-class people, looked down upon and exploited by elite whites, cannot be blamed for slavery or segregation. His father laid cobblestone walks until he could buy the bakery where Herman makes a meager living: "What's my privilege . . . I'm white . . . did it give me favors and friends? . . . nobody did it for me . . . you know how hard I worked. We were poor. . . . No big name, no quality" (61). With only a tenuous hold on their white American identity, Herman's mother Frieda and sister Annabelle, in an attempt to ward off wartime anti-German attacks by other Americans, have flags flying in the front yard, red, white, and blue flowers planted in the back, and a "WE ARE AMERICAN CITIZENS" sign in their front window (24). Although Herman is disgusted by their jingoism, he admits that his father joined a Klan-like organization, and he can still recite the racist speeches of John C. Calhoun he learned as a child (he does so while he is delirious with fever). Despite this history, Herman insists that their lives are essentially personal stories disconnected from race. Julia tells him she does not blame him for the past but for the silences he has imposed on her: "For the one thing we never talk about . . . white folks killin' me and mine. You wouldn't let me speak. . . . Whenever somebody was lynched . . . you'n me would eat a very silent supper. It hurt me not to talk . . . what you don't say you swallow down" (62). When Herman defends his father as a hard-

working man who "never hurt anybody," Julia answers him in the present tense—"He hurts me"—undercutting Herman's evasion of responsibility for a system that continues to privilege him and his family and to hurt Julia. In a newly freed voice, she rejects Herman's description of her as "not like the rest" and claims a collective identity: "I'm just like all the rest of the colored women" (61).

Childress had already begun to critique postwar interracial stories in her *Freedom* column "About Those Colored Movies," where she exposed the interracial films *Pinky* and *Lost Boundaries* as duplicitous attempts to evade the larger issues of economic and political inequalities by foregrounding black anxiety and helplessness.[34] We might consider that the near-universal acclaim for Hansberry's *Raisin in the Sun* in 1959 was at least partly attributable to its optimistic portrayal of black progress toward integration and that *Wedding Band*'s insistence on confronting the violence and repressed traumas of our "decidedly interracial history," rather than romance or Negro progress, was not likely to go down as easily with a public being prepped for a decidedly rosier racial story (Singh 1999; 2005). Childress, however, set her interracial romance on the terrain of power, represented in large part by the oppositional interactions between Herman and Julia. Herman says it's "the ignorance," and he wants to leave the ignorance outside, as if there were an "outside" where white supremacy and black inequality did not exist. Julia insists on erasing that imaginary line, and "disturbing the peace" with her narratives of black struggle and a history grounded in racial discrimination and domination.[35] Herman's ownership of the bakery, his insistence that white remain an unmarked category, and his geographic mobility literally and symbolically represent racial privilege; Julia's enslaved ancestors, her sexualized brown skin, and her vulnerable homelessness are a sign of her status as the racialized other; thus, *Wedding Band* becomes an analogue to, and a powerful critique of, the racist construction of U.S. racial subjects.[36] But my larger point here is that *Wedding Band*'s portrayal of white racial violence and privilege, its focus on the working class and on communal responsibility, and its rejection of the Negro progress story are evidence of the oppositional leftist politics that informed Childress's political thought and creative production.

Wedding Band marks Childress as a writer of both Popular Front and Cold War cultures. We can read the play as an allegory of Childress as an artist and leftist activist at the end of the 1950s. Her character Julia is a fancy seamstress and thus, like Childress, a working-class black woman artist. As the playwright's notes indicate, Julia moves into the center house in this small black community, where "one room of each house is visible," placing her under continual surveillance by all the neighbors (Childress 1966, production notes 5). Fanny, the landlady, does, in fact, spy on her when she is alone with Herman, and she informs on Julia to Herman's family. Considering that during the McCarthy investigations, any kind of interracial connection was tantamount to declaring one a communist, there is another overlap between Childress and Julia. For being involved interracially, Julia is blacklisted by both whites and blacks, and, under South Carolina law, her interracial relationship, like Childress's communist affiliations, was criminalized. Herman's death at the end of the play, as well as his inability to relate to anyone in this black community, signals that their interracial alliance has proved neither safe nor enduring, and Julia hands her wedding band to Mattie, saying, "You and Teeta are my family now" (64). It is not too much of a stretch to see this scene as Childress questioning the interracial alliances of the Left and attempting to establish, as she did in her work after 1966, a deeper sense of connectedness with black community and black culture. Keep in mind, however, that at the end of the play, Julia remains both insider and outsider, and Childress refuses any claim that Julia can become "authentically" one with the "folk." Even as Julia asserts a spiritual unity with the people in this Southern community, the wedding band on a chain, her ten years with Herman, her status as a skilled seamstress, and her ability to speak for the community preclude any easy identification with that community. Once again we see how much Childress's work is influenced by her involvement with the Left. As she did with her Mildred character in the pages of *Freedom*, she recast the militant-intellectual-worker as a woman; she represented the reconnection of that figure with the folk community as partial, difficult, and provisional; and, most effectively, she drew from the Left's uncompromising critique of 1950s race liberalism as a powerful source of literary and cultural self-determination.[37]

CHILDRESS'S LEFT LEGACIES:
A SHORT WALK AND *THOSE OTHER PEOPLE*

Even in her final two novels published in the 1970s and 1980s, a leftist sensibility is evident in Childress's representation of black subjectivity. Her 1979 novel *A Short Walk* continues the oppositional politics and aesthetics of her earlier work.[38] Whatever her ambivalence about the Left's inter-racial focus, her final literary productions suggest that that she believed that interracial struggle, so central to leftist politics, was crucial to political empowerment. An episodic and impressionistic bildungsroman, *A Short Walk* traces the life of Cora James from 1900 to the end of World War II. That time frame allowed Childress to insert a positive representation of the Communist party, replaying the Left of the Depression 1930s, when the communists organized interracial Unemployment Councils, challenged segregation, and fought evictions, making historic gains for the Party in black communities. In contrast to the eviction scene that appears in several black texts—most famously Ellison's *Invisible Man*, which depicts com-munists as strange and duplicitous outsiders—Childress uses the evic-tion scene in *A Short Walk* to normalize communists. Cora describes the encounters between the evicted blacks and the communist activists as part of an interactive and personal relationship:

> Folks from the Communist Party come around after the marshall leaves, knock the lock off the apartment door and move the people back into their place. Makes the landlord mad cause he has to pay the marshall each time for putting things out. The neighbors chip in and buy contain-ers of beer for the Communist Party and also bring odds and ends of food to make up a "welcome home" party for the evicted.
>
> (281)

Using the affective and intimate terms of an insider familiar with commu-nist culture and practice, Cora describes the Communist Party as an orga-nization with naturally occurring disagreements and misunderstandings as well as with affective bonds between blacks and whites.

After the eviction, Cora's friend Estelle invites her to a communist cell meeting, which she attends at first with trepidation, only to discover that a so-called cell is merely someone's flat where there are readings and discussions of politics and an exploration of real antagonisms between blacks and whites. At one meeting when a Negro comrade is angered because a white comrade acts high-handed and uses many unnecessarily big words, Party leaders initiate a discussion about the problems of white chauvinism, a phrase used by the Communist Party. When they show Cora two booklets on *The Woman Question* and *The Negro Question*, Cora challenges the way gender and race are subordinated to issues of labor: "I asked why the word *question* was in it at all," because, she says, when they deal with the issue of unemployment, they don't refer to it as "*The Unemployment Question*" (290). Though Cora is frustrated by the Party's hesitancies on these issues, she defends communists to a friend who charges that they are just trying to use black people: "'What the hell you think the Republicans and the Democrats doin with us?' She [Cora's friend] fell out laughin. 'Yeah,' I said. 'They can show Communists what usin is all about!'" (290). At a Christmas party given by Cora's friend Marion, both black and white communists join in the celebration, bringing their guitars, singing work songs, and attempting "to put social meaning to the blues" (299).

In a departure from most mainstream African American literature prior to the twenty-first century, *A Short Walk* openly represents queer sexuality. Childress ends the novel with a homosexual cross-dressing performance by Cora's friend Marion, who wins the first prize at the cross-dressing Hamilton Ball, an expressive and colorful spectacle where no one can tell the difference between women and men and where whites and blacks of all classes mingle in open defiance of official norms. As a novel that violates hegemonic prescriptions about sexuality, class, race—and the Communist Party—*A Short Walk* might arguably be considered Childress's most oppositional and radical text (Washington 2007, Higashida 2009).

In her final literary production, *Those Other People*, a young-adult novel about a young, white, gay male computer instructor that Childress published in 1989, she returned again to issues of interracialism and leftist politics,

which for her always seemed to be paired. In this novel Childress extended and revised the lessons of the Harlem Left Front, which was relatively inattentive to issues of sexuality, by putting queer sexuality at its center. The novel is constructed in a *Rashomon*-style plot, in which all the characters are given a point of view, though it is mainly told through the perspective of the main character, Jonathan Barnett, a gay teacher at a small-town high school. Once Jonathan witnesses a sexual assault on one of the female students by another male teacher, he becomes the target of an antigay community trying to suppress the story of the assault. He finds an ally in one of the black students, Tyrone Tate, who is trying to resist the elitism of his upper-class parents and to fight the small-town bigotry of the mostly white school and town. Tyrone's militant uncle, Kwame, becomes an important mentor, handing out lessons about black pride and a racial analysis that undercuts the bourgeois values of Tyrone's parents.[39]

Images of McCarthy-era surveillance and containment structure the novel. While Jonathan wavers between revealing his sexual identity and testifying against the teacher, school and community officials attempt to protect the accused teacher, and anonymous callers threaten to reveal Jonathan's sexual identity if he testifies. The people in the school community try to avoid being summoned to testify under oath, knowing that this controversy can ruin reputations, cost jobs if they have their "name and face on television," or even incur physical reprisals (162). At considerable risk to his reputation, Uncle Kwame secretly obtains the tapes Jonathan needs to support his testimony and slips them to Jonathan. Jonathan's decision to reveal his sexual identity and to testify against the attacker is thus enabled by a militant black activist. All of "those other people," joined together in collective resistance, replay practices of solidarity and courage that were a critical aspect of the interracial Harlem Front. Obviously, memories of the McCarthy-HUAC witch-hunts were never far from Childress's consciousness, and in this final literary text, she offered this legacy to her young-adult readers, the next generation: an example of political struggle modeled in large measure on the "radical resistance culture" of the Left, through which an interracial front resists the power of a repressive state.

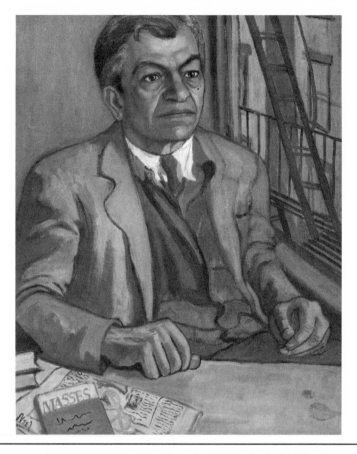

FIGURE 3.4. Alice Neel's portrait of Mike Gold (1952).
Source: © The Estate of Alice Neel, courtesy of David Zwirner, New York/London

ALICE CHILDRESS AND ALICE NEEL: PORTRAIT IN AMBIGUOUS RED

Childress turns up in yet another leftist community. From the 1930s through the 1950s, the painter Alice Neel began her portrait gallery of communists because, she said, in the face of the demonizing of the Party, she wanted "to show everyone what a real Communist looked like" (Allara 2000, 113). She

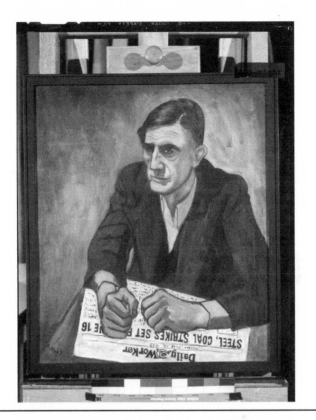

FIGURE 3.5. Alice Neel's portrait of Pat Whelan (1935).

Source: © The Estate of Alice Neel, courtesy of David Zwirner, New York/London; and the Whitney Museum of American Art. © The Whitney Museum of American Art.

included Childress in this gallery, but that painting is so different from her portraits of white leftists it seems at first to be another misreading of Childress. Neel represents three white communist men—Pat Whelan, a waterfront organizer; Art Shields, a labor journalist; and the writer Mike Gold—in almost archetypal leftist terms.[40] Whelan and Shields are shown seated in front of a neutral plain background, at their desks, brows furrowed, eyes intensely focused. Whelan's hands are closed in defiant fists, and Shields's are hooked purposefully in the loops of unbelted trousers. Their angular, lean bodies express a kind of intensity that suggests their political commitment.

FIGURE 3.6. Alice Neel's portrait of Alice Childress (1950).
Source: © The Estate of Alice Neel, courtesy of David Zwirner, New York/London.

Neel's 1952 portrait of Gold shows him at his desk with a copy of *New Masses* in its red cover and an issue of the *Daily Worker* open to his column "Change the World." Even Neel's 1970s portrait of a radical white woman activist Irene Peslikis signifies her politics. Peslikis is dressed in jeans and a black tank top, seated in an armchair with one arm thrown casually over the top of the chair to reveal a hairy armpit, "her aggressively undemure pose and unsmiling face [casting] Peslikis as a serious-minded radical," a point underscored by the title of the painting, *Marxist Girl*.[41]

FIGURE 3.7. Left to right: Herbert Aptheker, Ewart Guinier, and Alice Childress at Kraus Thompson publicity event for the publication of the first five volumes of the collected works of W. E. B. Du Bois, published by Herbert Aptheker (1975).
Source: Courtesy of Bettina Aptheker.

Neel depicted Childress in profile, seated on a cushioned chair gazing out of a window—most probably in Neel's studio. She is wearing a dark blue formal, strapless dress and a large gold medallion around her neck, appearing regal and distant (looking a bit like Queen Elizabeth, one commentator suggested) and racially indeterminate. Behind her on a delicate red table is a pitcher of yellow flowers, suggesting a bourgeois woman of comfortable means. Instead of the three-quarter or full pose of her white subjects, Neel painted Childress in profile so that we cannot read her face, and in costume so that her social self seems entirely fictionalized. Looking for some sign of Childress's radicalism in the portrait, I considered that Neel may have intended for the swatches of red in the painting—the red table behind Childress, the red hat perched on her head, red lipstick, red

chair, and red nail polish—to signal her leftist politics, but there is certainly nothing else in the painting that does.

What we must finally conclude is that Childress's portrait in costume actually makes Neel's case—that you can't tell a communist by looking— that identity, including Left identity, is multiple, complex, contradictory, and performative, a point supported by Alan Wald's (2001) critical study of the midcentury communist movement, which reminds us that the Left was full of contrarians like Childress and Neel who refused to conform to orthodoxy. Neel, who loved to play with contradictions, quite cunningly captures the complex, idiosyncratic Childress, who never fit in any grooves, who in her six decades of radical resistance and cultural and political work stayed firmly with the Left—on her own terms—putting black working-class women at the center of her work and portraying them as leftist activists and thinkers when the conventional image of the Left was a white man.

Childress's radical politics may have earned her place in Neel's canon, but it cost her (along with the Harlem Left) an official place in the canons of African American literary history. Although, as with other leftist writers, Childress's work is often dismissed by critics as mere social protest, and although Ralph Ellison is generally the only 1950s black writer granted the mantle of modernist, I argue that Childress and other left-wing writers and artists of *The Other Blacklist* were also experimenters—social modernists, to use Michael Denning's term (1996)—and that their formal and social experimentations were, particularly in Childress's case, enabled by their leftist political grounding. As one of the most prolific writers of the Harlem Left, Childress demands that we rethink what is lost when we label the period 1940 to 1960 "Realism, Naturalism, and Modernism" and omit the Black Left. For one thing, it means that we cannot take account of how the repressions and intimidations of the Cold War constructed the literary and cultural production of that period. It means obliterating the dynamic political organizations and cultural productions of the Left. It means that we lose the links between the Left militancy of the 1930s to the 1950s and the black militancy of the 1960s and 1970s. It also means that we lose one of Childress's most important aesthetic contributions: she reset the meaning of the trope of the "underground," reimagining it as both the discursive and the actual space of political resistance.

4

WHEN GWENDOLYN BROOKS
WORE RED

But I have judged important the very difficult creation
of poems and fiction which even a century ago were—
and are now—bearers of a hot burden.

—GWENDOLYN BROOKS, *NEGRO DIGEST*, 1966

WENDOLYN BROOKS CAME of age as a writer in Chicago when the Communist Party had already established a militant presence and voice in support of black civil rights. However minimal her early left-wing political affiliations might have been, scholars of the literary Left identify Brooks at the center of the Chicago Negro Left Front in the 1940s, which the literary historian Bill Mullen (1999, 10) describes as "independent of the Communist Party but largely symbiotic with its popular front objectives and aspirations." Although Brooks was probably never a member of the Communist Party, there are always a fair number of communists and leftist radicals dotting the landscape in the reports of her cultural and social activities in the 1940s and 1950s. The literary historian James Smethurst (1999, 165) situates Brooks within most of the important cultural networks of the Left—from the Left-led National Negro Congress and the League of American Writers to the Left-influenced South Side Community Art Center and the Left-led United Electrician and Machine Workers Union and to the left-wing editors and writers who promoted her early career. Even the black nationalist poet and critic Haki Madhubuti, though he disparages its significance, acknowledges that the Left was at least a brief stop on Brooks's career path: "She was able to pull through the old leftism of the 1930s and 1940s and concentrate on herself, her people and most of all

her 'writing'" (2001, 82).[1] The consensus among scholars of the Left is that Brooks was a part of a broad coalition of mainly black artists, writers, and community activists who were making their own history of radical black struggle, which exceeded, transformed, and expanded Communist Party–approved aesthetics but cannot be divorced from its influence and support. What I hope to show in this chapter is that in her work of the Cold War 1950s, mainly in her 1953 novel *Maud Martha* and in several poems in her 1960 poetry volume *The Bean Eaters*, written in the late 1950s, Brooks managed to balance a black leftist political sensibility with an investment in modernist poetics that produced, during the Cold War 1950s, what I call, with some caution, her leftist race radicalism. I am pursuing this course for many reasons, the first in answer to Brooks's own call to poets to remember the past, no matter how controversial or problematic: "Think how many fascinating human documents there would be now, if all the great poets had written of what happened to them personally—and of the thoughts that occurred to them, no matter how ugly, no matter how fantastic, no matter how seemingly ridiculous!" I am therefore piecing together these fragments of Brooks's leftist past, much of which she herself left unrecorded. I want to show her work as an example of the long left-wing literary radicalism that, especially for Brooks, extended into the 1970s and has been dwarfed by the attention to her black nationalist period, which seemed to require severing all connection to a left period in which she was a central player.

BROOKS IN THE CHICAGO BLACK POPULAR FRONT

Brooks's own statements, particularly in her first autobiography, *Report from Part One* (1972), have erased or masked signs of her relationship with the Left.[2] The friends and colleagues she socialized with in the 1940s and 1950s—artists and writers like Elizabeth Catlett, Charles White, Ted Ward, Langston Hughes, Margaret Taylor Goss (later Margaret Burroughs), Frank Marshall Davis, Paul Robeson, and Marion Perkins—leftists, com-

munists, and fellow travelers—are remembered in one-and-a-half pages in *Report from Part One* as "merry Bronzevillians," with no reference to their politics; they may be party guests and partygoers but never Party members. Consider how Brooks carefully parses her political leanings in an essay about Bronzeville she contributed to the 1951 issue of the mainstream magazine *Holiday*. Though she covers a wide range of issues of black life in Bronzeville, beginning with the stories of the economically depressed and the consequences of poverty on children, she opens with a critique of the assumptions underlying the term "Bronzeville": "something that should not exist—an area set aside for the halting use of a single race." In "another picture of Bronzeville," she depicted the exciting parties there, specifically noting that she did not mean the "typical" black bourgeois ones, which she called, ironically, "soulless," but the "mixed" parties that included whites and blacks. Though, as in *Report One*, she does not label them politically, many of the guests, like the host, the sculptor Marion Perkins, were avowed communists or deeply Left enough to be considered fellow travelers: Ed and Joyce Gourfain, Willard Motley, Margaret and Charles Burroughs. Joyce Gourfain was a former lover of Richard Wright, and both Gourfains knew Wright from their days in the John Reed Clubs; both were certainly Communist Party members.[3] Both Margaret and Charles Burroughs were close to the Party, and Brooks hints at that in *Report One*, describing Margaret's radicalism with a dictionary definition: "then a rebel, [who] lived up from the root" (1972, 69). Lester Davis, named in the Brooks article as a Chicago teacher, photographer, and journalist, was also at the time the executive secretary of the Chicago Civil Rights Congress, a position that would have gone to a CP member or close ally. Richard Orlikoff was a leftist attorney who defended an Abraham Lincoln Brigade member against HUAC. Also there were the African American physicist Robert Bragg, later a member of the faculty of the material science department at Berkeley, and his wife Violet. In the oral interview Bragg did for the Berkeley archives, describing himself as "a closet radical," he speaks of his attraction to communism and his early friendship with Brooks, probably through the NAACP Youth Council. The only reference Brooks makes to the politics of these mostly leftist merrymakers is a series of ironic and mocking comments that imply

but downplay the political tenor of their conversations. In her signature elliptical commentary on their conversations, Brooks reports that "Great social decisions were reached. Great solutions, for great problems" were debated over "martinis and Scotch and coffee" (1972, 68). In the photograph that accompanies the front page of the *Chicago* article, Margaret Burroughs is shown strumming her guitar "for her artist-writer friends," and Brooks, who may well have been in that audience, was, as we see from these alternative "reports," at least for a time in the late 1940s and early 1950s, quite comfortably situated within the intimate circles of these Chicago Marxist bohemians.

One of the major Brooks biographers, her friend George Kent, insists that Brooks was too thoroughly "attached to the certainties of her upbringing, Christianity, and reformist middle-class democracy" to have espoused radicalism, but even he admits that she was within the orbit of the Left artists and writers during the 1940s. In her apprenticeship years, Kent notes that Brooks joined the NAACP Youth Council, which he says was "the most militant organization for black youth except for organizations of the Left" (1990, 42). As a Youth Council member, Kent says Brooks was spirited along by the more politically engaged members, such as her friend the artist and writer Margaret Taylor (later Goss, then Burroughs), who, along with Brooks, joined in antilynching protests, marching along with the other protesters through the streets of Chicago, wearing paper chains around their necks to symbolize the racial violence of lynching (44). That protest became the catalyst for one of Brooks's earliest social protest poems. Margaret Burroughs, a lifelong friend, lists Brooks among the organizers of the one-day "Interracial South Side Cultural Conference" in 1944, which included Burroughs herself, as well as other black leftists—the poet Frank Marshall Davis, the sculptor Marion Perkins, *Negro Story*'s editor Fern Gayden, the playwright Ted Ward—and the white radical artists Sophie Wessell and Elizabeth McCord. According to the cultural historian Bill Mullen, when Burroughs recorded her recollection of the conference, she referred to all of its participants as *progressive*, which she said in a later unpublished letter to Mullen meant "Left wing to Communist," which, apparently, included Brooks (1999, 101–102).

Despite her friendship with Burroughs, Mullen says that Brooks "escaped" identification as a writer on the Left, and he reads Brooks's 1940s poetry as maintaining a skeptical and anxious distance from the political and cultural currents of the Left, as Brooks herself did. While I have not been able to locate any FOIA file on Brooks, the FBI had her in its sights. In the FOIA file of her friend Burroughs, agents accused Burroughs of introducing Brooks to the Left-led National Negro Congress and the National Labor Council and trying to radicalize her friend: "Margaret would later find that the FBI had kept a file on her beginning in 1937 and had labeled her as one of those attempting to influence Gwendolyn politically" (Kent 1990, 55).

I am not trying to turn Brooks into a communist, but I insist that her left-wing connections are an important part of her biography and essential to understanding the trajectory of her creative work. Like both Mullen and Smethurst, I am skeptical of any version of Brooks as political ingénue tagging along on Burroughs's more radical coattails. Whatever her motivations for deflecting attention to the story of her early leftist political life, she sustained a number of leftist affiliations in the 1940s that furthered her literary career. She was mentored by leftist writers and editors, including Edwin Seaver, a founder of the Marxist journal *New Masses* and a former literary editor of the *Daily Worker*, who included work by Brooks in his *Cross Section* anthologies in the middle and late 1940s (Smethurst 1999, 165). Another important left-wing connection for Brooks during the 1940s was the communist-led League of American Writers, formed when the CP disbanded the John Reed Clubs. In his memoir of the League, Franklin Folsom, the league's executive secretary and a communist, lists Brooks in his memoir as a member, along with Langston Hughes, Richard Wright, Arna Bontemps, Countee Cullen, Frank Marshall Davis, Ralph Ellison, Margaret Walker, and the openly communist Ted Ward and Claude McKay, all of whom would have been considered on the Left in the 1930s and 1940s (Franklin 1994, 75). By her own account, Brooks was deeply involved in the South Side Community Art Center (SSCAC), a center of the Chicago black Left, where she studied poetry and modernism under a white mentor, the poet and "upper-class rebel" Inez Cunningham

FIGURE 4.1. Photo of Gwendolyn Brooks,
"A Gathering at the South Side Community Art Center" (1948).

Stark (Melhem 1987, 9). Lawrence Jackson notes that she moved in intellectual crowds with a number of leftists: Ted Ward, Fern Gayden, Davis, and Edward Bland, all former members of the South Side Writers Club, which had been founded by Richard Wright in his communist days (206).[4] When Harper's asked for Wright's recommendation for Brooks's first volume of poetry, he wrote back to the editor Edward C. Aswell, on September 18, 1944, recommending the book highly, asking for one long poem to unify the collection. He also recognized and confirmed the poems' engagement with a Marxist aesthetics that demanded a focus on black cultural and communal life: "They [the poems] are hard and real, right out of the central core of Black Belt Negro life in urban areas" (cited in Fabre 1990, 185). When she turned to autobiography in *Report from Part One*, Brooks represented her life in the 1940s and 1950s in terms of marriage, children, poetry, and parties, the only clue to her leftist life being the communists, leftists, fellow travelers, and radicals who attended those parties. If Brooks

was simply naïve, and I doubt that she was, she certainly took her early political life seriously enough to deflect attention away from her substantial ties to the Left.

BROOKS'S EARLY LEFTIST POETRY

If we document Brooks's writing career from the late 1930s during her Negro Popular Front period, rather than starting with her first published volume of poetry in 1945, the early traces of the Left in her writing are evident. In 1937, when she was just twenty years old, Brooks submitted her first poem, "Southern Lynching," to the NAACP journal *Crisis*, which, in line with 1930s Popular Front politics attacking racism, produced features on lynching in almost every issue in the 1930s. Published in the same year that Burroughs was allegedly "radicalizing" Brooks and when Brooks was engaged in antilynching protests, the poem is aligned, in theme and tone, with Negro Popular Front politics. In this poem, there is none of the detached narratorial consciousness that Smethurst describes as characteristic of Brooks's poetry of the 1940s and 1950, almost no sign of the narrative distance and indirectness of her later style. The narrator describes the lynched body in detail: dried blood on rigid legs and long / Stiff arms," the still open eyes stare as "merry madmen" laugh and sing. The poem also anticipates Brooks's use of irony in its intertwining of the bloody body, the lynchers singing, and the image of the soft pale evening darkening, with its night-breeze "flow[ing]" and the "first faint star" glowing "coldly" above the "strange and bloody scene." The desecration of the body is complete when one of the lynchers "treats" his young child to "a souvenir / In form of blood-embroidered ear." But the poem ends with the focus on another "youngster," the son of the murdered man, waiting for his father's return:

> Back in his hovel drear, a pair
> of juvenile eyes watch anxiously
> For a loved father. Tardy, he!

Tardy forever are the dead.
Brown little baby, go to bed.

Here the speaker's focus on the grisly details of the lynching scene allows no distance between the speaker, the victim, and his attackers, and, in typical social protest style, the speaker's emotional investment also demands the reader's empathy and moral outrage. I can find no evidence that Brooks ever referred to this poem in her commentary about her work or in her public readings. As a kind of Brooksian representational history, however, Brooks's lynching poems help mark the the movement of her work from leftist social protest to modernist formalism, as "Southern Lynching" is clearly in the vein of 1930s social protest. Two other lynching poems, "The Ballad of Pearl May Lee," from her first published volume, *A Street in Bronzeville* (1945), and "A Bronzeville Mother Loiters in Mississippi. Meanwhile a Mississippi Mother Burns Bacon," from *The Bean Eaters* (1960), based on the lynching of the fourteen-year-old Emmett Till, suggest the modernist directions of her work. In both of these later poems, which she regularly included in her public readings, Brooks is thoroughly modernist, revising a conventional form—the ballad—and offering a feminist slant that takes on the almost always absent viewpoint of the woman victim. "Mississippi Mother" is told from the point of view of the wife of one of Till's killers, herself a mother of two small children, somewhat stunned by her new role as the wife of a child killer. Emmett's mother, Mrs. Mamie Till Bradley in real life, "loiters" as the Bronzeville mother throughout the poem, the mother of the killed boy, the image the white mother cannot ignore.

"The Ballad of Pearl May Lee" was first published in the left-wing *Negro Quarterly* in 1944 (Jackson 2010, 205) edited by communist Angelo Herndon and Ralph Ellison in his proletarian days. The poem takes the viewpoint of the black woman whose lover is lynched because of his involvement with a white woman and includes the almost inadmissible representation of the black woman's sexual jealousy and desire to be avenged by her lover's murder. As Jacqueline Goldsby (2006, 1–4) has so superbly argued in *A Spectacular Secret: Lynching in American Life and Literature*, the Pearl May Lee lynching poem shifts the focus of the conventional lynching story in several

crucial ways: it is set in the North, it narrates the black woman's anger over her lover's desire for "the taste of pink and white honey," and it protests not white racial violence but a black man's desire for white and light-skinned women, which, in this case, has put Pearl's lover in the crosshairs of a white lynching mob. Yet, even as the Pearl May Lee and "Bronzeville Mother" poems challenge the admittedly masculinist protest tradition, both recall and revise the politics of the cultural Left that brought racially instigated lynching to the foreground and made it a centerpiece of leftist protest. These markers of Brooks's indebtedness to the 1930s (and 1940s) Left still remain in her work, but these connections have disappeared from nearly all Brooks commentary, including her own.[5]

The great and irretrievable loss is that we will never have Brooks's own probing exploration of her place in a community of literary and visual artists committed both to social change and to formal experimentation within the community-based orientation of the Chicago Left Cultural Front. That community made the Chicago Negro Cultural Front a particularly hospitable climate for an artist interested in combining artistic experimentation and a radical black perspective. Many of the friends and colleagues with whom she socialized and worked, such as the visual artists Elizabeth Catlett and Charles White and the writers Langston Hughes and Margaret Burroughs, labored to balance their political and social concerns with formal experimentation. They did so with varying degrees of success and, in the case of White, against leftist resistance to modernist experimentation. Brooks was more fortunate. Her first book of poetry was reviewed by a socially conscious leftist imagist poet, Alfred Kreymborg, who managed that balancing act skillfully in his own work and recognized Brooks's own attempts. Kreymborg published a rave review of *A Street in Bronzeville* in the Marxist journal *New Masses*. Calling the volume "original, dynamic, and compelling," "one of the most remarkable first volumes of poetry issued in many a year," and "a rare event in poetry and the humanities," Kreymborg praised Brooks's ability to "regard her people objectively in the face of every temptation to plead a cause in which she is deeply involved" (1945, 28). Repeatedly remarking on Brooks's "technical skill" and "inventiveness," Kreymborg flew in the face of Marxist orthodoxy, which disparaged 1950s

art criticism as valuing "chic esthetic forms" and "formal gimmicks" that did not "inspire 'progressive thinking' and revolutionary social change" or "strong hopes for the working class."[6] Kreymborg's timing was auspicious: the review was published when formal experimentation was still seen favorably by *New Masses* critics and just before the ascendancy of socialist realist orthodoxy in the early 1950s.[7] Brooks responded to the review in a 1945 letter to her friend and leftist activist-writer Jack Conroy, saying that she had been "very fortunate" in the reviews of the volume, specifically citing Kreymborg's review: "There was a very generous one in *New Masses*, September 4, by Alfred Kreymborg." The year 1945 was a very good one for socially conscious imagist poets like Kreymborg and Brooks, and it was a moment when Brooks could and did bask in this recognition and acclaim from the Left.[8]

ERASING THE LEFT

Why, then, besides Brooks's own reticence, has her relation to the Left been so difficult to establish? In considering this question, I am quite aware of the cultural amnesia that developed in the 1950s as the Cold War made it dangerous to acknowledge ties to the Left.[9] That amnesia was not only restricted to the "disappearing" of various poets or groups of poets but also, as Smethurst notes, applies to our ability to think or rethink the legacies (and contexts) of poets, for example William Carlos Williams, Hughes, Brooks, Kenneth Fearing, Muriel Rukeyser, Margaret Walker, and Robert Hayden, all of whom were part of the Left Popular Front in the 1930s and 1940s. For a number of reasons, Brooks's "occluded" relationship to the Old Left is more difficult to tease out than that of most of the African American literary Left, some of whom have unusually open past and present ties to the Left and others who left behind obvious clues. But if Brooks has "escaped" identification as a writer influenced by the Left, that misconception has been most effectively facilitated by the saga of Brooks's 1967 "conversion" to black nationalist radicalism (Smethurst 1999, 151)—a conversion tale that I

believe to be apocryphal and misleading—and that, most problematically, required the rewriting of her earlier left-wing radicalism. Brooks's more public movement toward black cultural nationalism in the 1960s and the elision of her connections to the Left have helped veil these earlier political affiliations and partly explain the dull conventionality of Brooks's autobiographical narratives. I argue that in our failure to appreciate Brooks's connections to the leftist cultural front of the 1940s, we also lose a sense of the innovative relationship Brooks forged in her work between a Left-inflected ideology and a modernist formal poetics.

The "rewriting" of Gwendolyn Brooks's post-1950s political life by critics and reviewers reads as follows: *an apolitical Brooks, having been highly esteemed and richly rewarded by the white literary establishment for her early work, is baptized into black cultural and political nationalism by the young black militants she meets for the first time at the Second Black Writers Conference at Fisk University in 1967; having rejected her earlier connections with and submission to the white liberal consensus, she discovers her blackness and her radicalism within the (masculine) arms of Black Power and black nationalism.* Brooks herself promoted this story in her 1972 autobiography *Report from Part One*, describing the 1967 conference in almost mythical terms as an "inscrutable and uncomfortable wonderland" where the "hot sureness" of the black radicals "began almost immediately to invade" her and her new "queenhood in the new black sun" qualified her, finally, to enter "the kindergarten of new consciousness."[10]

While Brooks undoubtedly perceived the black consciousness movements of the late 1960s and 1970s as life changing, as they were for many blacks of that period, the continual and uncritical recitation of the "conversion" narrative disconnects Brooks from her earlier political contexts and, indeed, even from her own remarks *at* the 1967 conference. Brooks's immersion in the baptismal waters of the '67 conference may have *eventually* caused her to reevaluate the relationship between her art and African American political struggle, but during her time at the conference she held firm to her earlier position, rejecting what she called "race-fed testimony" in art. In her prepared presentation at the conference, Brooks acknowledged the importance of race in black art: "every poet of African extraction must

understand that his product will be either italicized or seasoned by the fact and significance of his heritage. How fine! How delightful!" But, she insisted—and this was said while she was still *at* the conference, "I continue violently to believe [that] whatever the *stimulating persuasion*, poetry, not journalism, must be the result of involvement with emotions and idea and ink and paper" (quoted in Kent 1990, 199). In what might be considered a statement of her own poetic credo and a modernist restatement of Du Bois's double consciousness, she argued for the "double dedication" of black poets, addressing the "two-headed responsibility" they must have in order to respond to the "crimes" they cover but also to the "quantity and quality of their response to those crimes."

Brooks eventually expressed her annoyance with these pronouncements about the "change" in her work. In a 1983 interview with Claudia Tate, when asked if any of her early works assume an "assertive, militant posture," Brooks says emphatically, "Yes, ma'am. . . . I'm fighting for myself a little here because I believe it takes a little patience to sit down and find out that in 1945 I was saying what many of the young folks said in the sixties" (Tate 1983, 42). Later in the same interview Brooks repeats that she is "fighting for myself a little bit" as she moves to reshape the critical readings of her early work. Still later she says she is "sick and tired of hearing about the 'black aesthetic,'" because "I've been talking about blackness and black people all along" (45–46).[11]

THE EVIDENCE OF THE LEFT

But if Brooks's ties to the Left can be discerned in the friendships she developed, in her social life, and in her affiliations with Left organizations, what is less clear and more important is how to chart these ties in her work. Despite public statements that distance her from the politics and aesthetics of the Left, I argue that Brooks—like Hughes, Frank Marshall Davis, Melvin Tolson, Lorraine Hansberry, Julian Mayfield, Sarah E. Wright, John O. Killens, and many others that are rarely connected to the Left—

was influenced by the aesthetics of the Popular Front and that we can see that influence most clearly in her struggling over the problem of how to negotiate a relationship between social realism and modernist experimentation. Brooks's attempt to balance social concerns and modernism aligns her with other quite devout leftists, many of whom had "similarly complicated relationships" to "high" modernism.[12] Contrary to conventional accounts of artists on the Left, many felt that they had to balance their political and social concerns with the problems of realism versus formal experimentation. As I have shown in chapter 2, White faced these issues in the 1950s as the Communist Party began to take a more rigid stance in their demands that art adhere to principles of socialist realism. The painter and sculptor Elizabeth Catlett, on the other hand, more easily accommodated her social and political concerns with modernist art techniques, almost certainly because of her location in Mexico among Mexican muralists—Diego Rivera and Francisco Mora (her second husband)—whose communist politics did not preclude modernist experimentations. In *Rethinking Social Realism: African American Art and Literature, 1930–1953*, the cultural historian Stacy I. Morgan traces the way modernist innovation runs through the work of all the writers traditionally associated with social realist traditions. While these social realists—among them the poets and writers Frank Marshall Davis, Ann Petry, Robert Hayden, Lloyd Brown, and Gwendolyn Brooks and the visual artists Charles White, Elizabeth Catlett, and John Wilson—were intent on representing social change in their art and using art for social change, they were also experimenting with modern forms. In fact, as Morgan shows, African American visual artists exposed to the new media and materials through the Federal Arts Project were given their first opportunity for experimentation.

Reading Brooks back into a leftist political and artistic community enables us to track the continuities and discontinuities in her political and aesthetic development rather than being force-fed the tale of her sudden and unprecedented conversion to blackness and radicalism. As the cultural historian James Smethurst shows in *The New Red Negro*, a superb analysis of the relationship between black writers, formal experimentation, and Popular Front cultural agendas, Brooks's concern with issues of class, race, and

gender oppression marks her as someone working in Popular Front tradi-
tions (Smethurst 1999, 179). With the aid of the lens of a slightly Left-tilted
political biography, we can see that she was working out the formal and
thematic issues that were important to many black Popular Front writers:
how to represent the African American vernacular voice; how to represent
African American working-class and popular culture; how to incorporate
both high literary culture and social protest; and how to represent class, race,
gender, and community. These are the signs of what Bill Mullen (1999) calls
the "discursive marks" of the cultural and political Left. Even if, as Mullen
insists, they are in coded and revised forms, they provide the evidence that
Brooks's political commitments were being formed at least three decades
before 1967.

BROOKS'S 1951 LEFTIST FEMINIST ESSAY: "WHY NEGRO WOMEN LEAVE HOME"

In March 1949, five years after some of her closest encounters with the
Left, Brooks was on her way to being recognized as a major poetic voice.
She published a second book of poetry, *Annie Allen*; received an excellent
five-page review by Stanley Kunitz in the magazine *Poetry*; and, in 1950,
won the Pulitzer Prize for that volume, the first African American to win
the award. At some point during the years 1947 to 1950, Brooks separated
from her husband, Henry Blakely, also a poet, and had to consider how she
would manage financially with a young child, son Henry Jr. (Melhem 1987,
82). By 1951, she had reunited with Henry and had a second child, Nora.
At thirty-four years old and, perhaps, with the memory of that separation
and what it meant to be an economically dependent wife, she published
the essay "Why Negro Women Leave Home" in the March 1951 issue of
Negro Digest. It dealt with the inequalities facing black married women at
home and at work. Under the bright lights of mainstream fame and praise,
Brooks's left-wing connections were hardly noticed, so it is not surprising
that this little-known essay was never connected to the 1940s Communist

Party debates over women's issues, not even by leftist feminists.[13] As Kate Weigand (2001, 100) argues in *Red Feminism*, the Party took a progressive stand on black women's rights, arguing for black women's permanent access to industrial jobs and protection against all forms of discrimination. In Party literature and in Party-sponsored educational forums, the Party featured articles about black women's history, and in Left-organized schools, classes taught by progressive black women like Lorraine Hansberry, Claudia Jones, and Charlotta Bass focused on black women's achievements and struggles, with the aim of empowering black women and making them central to the Party (109). As Weigand sums it up, "Communist leaders pushed rank-and-file members [especially in the 1950s] to act on their belief that all progressive people had a personal responsibility to support black women's struggles and to welcome black women into the movement with open arms" (111). Communists, often those in black-dominated unions, worked to improve wages and conditions for black women workers, especially domestics, and to denounce the male chauvinism of left-wing writers and activists during the 1940s and 1950s that ignored these issues. Left-wing unions also had a hand in promoting black cultural production. The left-leaning United Electrical and Machine Workers Union, through the efforts of the black Chicago communist Ishmael Flory, funded the prize given by the journal *Negro Story*, a prize Brooks won in the 1940s (Smethurst 1999, 165).

Brooks cites a number of reasons in this essay that Negro women were considering leaving their marriages, among them gold-digging husbands, in-law interference, male impotence, and their husbands' affairs with other women (or men). But the central emphasis of the essay is on the liberating experience of a woman going to work during the war, earning her own income and experiencing "the taste of financial independence":

> her employer handed her money without any hemming and hawing, lies,
> rebukes, complaints, narrowed eyes—and without telling her what a fool
> she was. She felt clean, straight, tall [a description Brooks would use later
> for Maud Martha], and as if she were a part of the world. She was now "a
> fellow laborer," deserving of respect and tact.

The language and rhetoric of the essay has the rhetorical ring of the communist movement's position on the "Woman Question," which hammered on the "triple exploitation" of black women, challenging them to "guard against male supremacist behaviors, to adopt egalitarian gender roles, and to live out their politics in their day-to-day lives at work, in their interpersonal relationships and at home" (Weigand 2001, 113). These subjects were most ably theorized by the high-ranking black communist Claudia Jones in her ground-breaking 1949 essay "An End to the Neglect of the Problems of the Negro Woman," which also challenged the failure of white communists to put their theories into action. In the left circles of *Negro Quarterly*, the South Side Cultural Art Center, the National Negro Congress, or hanging out with her friend Margaret Burroughs, Brooks might very well have read Jones's article (Weigand 2001, 113).

But, in critical ways, Brooks's essay departs from the radical leftist critique that emphasized issues of unionization, class inequalities, solidarity with other women, demands for changes in the workplace, and the ultimate goal—freeing women for political struggle. Brooks was more interested in casting her acute eye on the psychological abuses in marriages and partnerships that do not often surface in politically left-wing material. Brooks lists the things a financially independent woman is able to do: buy a pair of stockings without her husband's curses, buy her mother or father a gift without his hysterically shouted inquiries, take a college course or buy her child an overcoat without having to plan a strategic campaign or confront his condescending handout. She is aware of the emotional and psychic cost to women of staying in loveless or disappointing marriages because of financial dependence on their male partners. Despite what leftists might have considered the bourgeois concerns of the essay, Brooks calls for men to treat women as "fellow laborers" in language that evokes the politics and practices of the Left. "Why Negro Women Leave Home" begins to chart Brooks's ironic relationship to the Left. Yes, she would draw on the language and ideology of the Left, but always in her own idiosyncratic, racialized terms. She could not assume the privileged positions of a white leftist feminist as empowered agent, nor could she assume the role of protector of black women in the industrial unionized workforce. She was a writer, a poet,

an aspiring working-class black intellectual woman, a figure that could only be seen as anomalous in the 1950s, as her working-class women neighbors reminded her.

MAUD MARTHA: BLACK LEFTIST MODERNIST FEMINIST NOVEL OF THE COLD WAR

Brooks began working on her first (and only) novel, *Maud Martha*, as early as 1944, and, with the help of Guggenheim awards in 1946 and 1947, submitted the manuscript, which her editor at Harper's rejected as "too hampered by a self-consciousness more suited to poetry than prose" (Melhem 1987, 80). More submissions and rejections followed until final acceptance in 1953. Originally entitled *American Family Brown* and constructed as a series of poems, the novel still demands to be read as one would read a highly complex, tightly structured poem. Composed of thirty-four short, imagistic chapters[14] that rely on a combination of stream of consciousness, interior monologue, free indirect discourse, dreamscapes, chapter headings that frame and order the narrative, and cryptic and unresolved chapter endings, it represents a black urban landscape not as realist landscape but as imaginative space, an allegorical landscape. Each chapter is filtered through the poetic, highly perceptive, sometimes claustrophobic self-consciousness of a black female subject. As the novelist Paule Marshall reminds us, *Maud Martha* is the first American novel in which a dark-skinned, working-class black woman with a complex interior life appears as a main character (see Washington 1987, 403–404). Closely paralleling Brooks's life, the novel covers Maud's life from age six or seven until she is in her late twenties, roughly from 1924 to 1945. Brooks described the novel as a hybrid, part autobiography and part fiction: "Much that happened to Maud Martha has not happened to me—and she is a nicer and better coordinated creature than I am. But it is true that much in the 'story' was taken out of my own life, and twisted, highlighted or dulled, dressed up or down" (Brooks 1972,

191). The final chapter, "back from the wars!" is fairly optimistic, with Maud, though disillusioned with marriage (the domestic war), awaiting her soldier brother's return from the war and contemplating the birth of her second child—scenes that were based on Brooks's own experiences.

MAUD MARTHA AS "GHETTO PASTORAL"

Though there are now several leftist revisionist studies of Brooks's poetry, *Maud Martha* is nearly always read as unattached to any prior left-wing contexts. The cultural historian Michael Denning suggests three reasons for not seeing its radical possibilities: its lack of an "explicit 'political' narrative," its "ethnic or racial accents," and the Left's failure to recognize the changing nature of the "working-class author" (1996, 235). Critics did not read a highly intellectual black woman—either author or subject—as an "authentic" representative proletarian. Brooks was identified as a black writer or a woman writer, not as a working-class writer—and *Maud Martha* did not seem to fit (and, in fact, did not fit) the requirements of the conventional proletarian novel. The critic and writer Lloyd Brown, for example, a prolific reviewer of black writers for the left-wing press throughout the 1950s, made no mention of Brooks's work.[15]

In an insightful and expansive theorizing of fiction he calls "ghetto pastorals," Denning shows that Brooks's 1953 novel fits quite comfortably in the black cultural Left—as a novel with the proletarian outlook and by a writer socialized in a working-class family and community (as Brooks was) but aspiring to an intellectual life. Like other writers of the ghetto pastorals (Richard Wright, Tillie Olsen, Philip Roth, Jack Conroy, Hisaye Yamamoto, and Paule Marshall, to name a few) Brooks is resistant to old forms, dissatisfied with the demands of naturalism, and increasingly drawn to experimental modernist fiction. Struggling for independence from the realism and naturalism of the novel, these writers needed a form, Denning argues, that could accommodate the contradictions of their lives: the geographic and psychological limitations of ethnicity or race, their uncer-

tain and enigmatic futures during a still-segregated Cold War era, and the changing nature of their working-class lives (1996, 230–258).[16]

While I am in agreement with Denning on *Maud Martha*'s leftist identity, I find myself throughout this chapter in an ongoing and as yet unsettled dialogue with Bill V. Mullen, specifically with his reading of Brooks's poetry before the publication of *Maud Martha* as more likely to exemplify a flexible and less militant definition of the leftist cultural front.[17] Mullen situates Brooks, as I do, at a moment after the war when black and white radicals alike could envision and expect critical and commercial success, thus experiencing along with those prospects "troubling uncertainty about the myriad dilemmas facing black American writers, activists, and cultural workers after the war" (Mullen 1999, 179). Mullen contends that Brooks inserts "stopgap measures" in her poetry that critique capitalism but do not enable radicalism, in some cases producing characters who have no way to apprehend or form the kind of collective resistance that might have been available in the radical collective of the South Side Community Art Center. The stasis that is characterized by employing "Prufrockian" (Mullen's term) modernist themes of alienation and dislocation, images of passivity, and paralysis and stalled progress does not evoke the militant resistance of a traditional leftist politics; instead, these modernist effects register Brooks's "ironic relationship" to the black cultural politics of the Chicago Front. While keeping Mullen's reservations in mind, I maintain that Brooks's critique of race, gender, and class in this novel, written at the height of Cold War repression, is a sign of radicalism, and I am inclined to agree with the literary scholar John Gery (1999), who says that Brooks's use of parody "to convey the deep ambiguities facing those who live in black ghettos" is a "politically aggressive" and radical move. As Gery notes, we have to read her radicalism in this novel in the ways she combines modernist formal devices with subjects usually alien to modernism to expose "the very rhetorical structures of thought by which those oppositions stubbornly persist" (54).

Brooks establishes Maud's working-class status in language designed to emphasize Maud's finely tuned aesthetic sensibility. Her childhood home has "walls and ceilings that are cracked," tables that "grieved audibly," doors and drawers that make a "sick, bickering sound, "high and hideous radiators," and

"unlovely pipes that coil beneath the low sink" (Brooks 1953, 180). Although her parents are buying the house, where they have lived for fourteen years, the family waits in fear to see if Maud's father, a janitor, as Brooks's father was, will be able to extend the mortgage from the Home Owners' Loan Association, staffed and owned, no doubt, by whites in this Jim Crow world. What she desires and fears losing is not simply homeownership but "the "shafts and pools of lights" that create the "late afternoon light on the lawn," "the graceful and emphatic iron of the fence," "the talking softly on the porch." As teenagers in the early 1940s, Maud earns ten dollars a week as a file clerk, and her sister Helen, fifteen dollars a week as a typist (176), salaries that were several dollars below the minimum wage, which, in 1940, was forty-three cents per hour. As a married woman, Maud and her husband Paul move into a third-floor furnished kitchenette apartment, as Brooks did, two small rooms with an oil-clothed covered table, folding chairs, a brown wooden ice box and a three-burner stove, only one of which works, and a bathroom they share with four other families. The roaches arrive; the "Owner" will not make any changes; the couple will have to be satisfied with the apartment "as it is." Maud's disappointment with husband and marriage is the logical and inevitable adjunct to the gray, drab, and unsatisfying conditions of the home Paul is able to provide, so different from the traditions of "shimmering form, hard as stone" she had imagined for herself. As she thoroughly examines the ways in which working-class poverty erodes a marriage relationship, Brooks's social concerns, aesthetically rendered, pervade the entire novel.

What distinguishes Maud from other black proletarian fictional characters is that she is a developing intellectual as well as being a proletarian; she is familiar with both working-class poverty and with more intellectual and academic pursuits. Maud makes specific references to the allure of such university literary canons as Vernon Parrington's three-volume study of American literature, *Main Currents in American Thought*, a fixture in U.S. graduate schools in the 1940s and 1950s. When Maud refers to "East of Cottage Grove," that same racial dividing line between black and white that confines Bigger Thomas in Richard Wright's *Native Son*, it is not mainly in terms of physical space. Seen through the eyes of Maud's second beau, David McKemster, east and west of Cottage Grove signify

the cultural, intellectual, physical, and imaginary spaces of black limitation and white control that thwart the desires of an aspiring black intellectual, including herself, though she specifically names her "second beau":

> Whenever he left the Midway, said David McKemster, he was instantly depressed. East of Cottage Grove, people were clean, going somewhere that mattered, not talking unless they had something to say. West of the Midway, they leaned against buildings and their mouths were opening and closing very fast but nothing important was coming out. What did they know about Aristotle?
>
> (44-45)

McKemster aspires to college, to moving away from the South Side, to an intellectual life where he would not only read Parrington's *Main Currents in American Thought* but could toss it around carelessly as one would a football—as he assumes privileged whites do. McKemster's desire for access is undercut by his marginalized existence on Chicago's South Side. He is ashamed of his mother, who takes in washing and says "ain't" and "I ain't stud'n you." With ironic emphasis on the elitism of the word "good," the narrator tells us that McKemster wants a good dog, an apartment, a good bookcase, books in good bindings, a phonograph with symphonic records, some good art, those things that are "not extras" but go "to make up a good background" (188). In striking contrast to Carl Sandburg's tributes to the lustiness, power, and dogged vitality of the Windy City, the narrator (always through Maud's consciousness) informs us that McKemster's life on the South Side is not "colorful," "exotic," or "fascinating" but a place where "on a windy night" he (and perhaps Maud too) feels "lost, lapsed, negative, untended, extinguished, broken and lying down too—unappeasable" (187). The poet and literary scholar Harryette Mullen reminds us that here Brooks is employing the rhetorical device of synathroesmus, which consists of piling up adjectives, often as invective, to modify a noun.[18] Buried under this stack of adjectives, McKemster seems to lose any intrinsic qualities and is psychologically demolished by that overwhelming accumulation of negating modifiers until the final adjective. The final term, "unappeasable," shifts

the tone to focus on the need and desires of the "loser" rather than on his state of abjection, thus saving him from total annihilation. If Bigger's crude references to white power structures more accurately describe the effects of white racial power and black powerlessness, Brooks's critique is aimed partly at McKemster's own pretensions but most severely at the integration ideologies of the Cold War 1950s, which promoted the notion that as blacks achieved sufficient intellectual and cultural weight they could become candidates for integration, even as the economics of segregation were rigidly maintained. Clearly, however, this narrator knows the meaning of and how to deploy synathroesmus and thus how to assert her own power.

Chapter 24, "an encounter," the second David McKemster chapter, almost certainly meant to suggest the story "An Encounter" in James Joyce's *Dubliners*, aligns Brooks with a quintessential modernist. Following the pattern of the other thirty-three chapters, the chapter is elliptical, about six pages long, narrated almost entirely in free indirect discourse, and focused relentlessly on Maud's interior reactions, ending abruptly without conclusion or resolution. Now a young married woman and mother, Maud runs into McKemster on the campus of the University of Chicago, where they have both gone to hear "the newest young Negro author" speak. When McKemster sees two of his white college friends, he proposes that they go to one of the campus hangouts, and out of sense of obligation invites Maud, whom he introduces formally as "Mrs. Phillips" to his "good good friends." McKemster and his friends proceed to carry on a conversation, which the narrator, channeling Maud's inner thoughts, describes caustically as "hunks of the most rational, particularistic, critical, and intellectually aloof discourse" (272), into which they weave words like "anachronism, transcendentalist, cosmos, metaphysical, corollary, integer, monarchical" (274), words noted by the third-person narrator but intended to represent Maud's resentment as outsider as well as her own private satisfaction that she too knows these terms.

The entire encounter is constructed around the question the young white woman (nicknamed Stickie) poses about the young Negro author they've come to hear: "Is he in school?" The question is subtle, posed in the argot of the college insiders, and intended to consolidate their intellectual supe-

riority. It is such a loaded question that, before it can be answered, the narrator intervenes, inserting after Stickie's question a veiled reference to the William Carlos Williams "red wheelbarrow" poem: "on the answer to that would depend—so much." Here Brooks's reveals her own knowledge of modernism and her critique of it. She adds a dash between "depend" and "so much" as if to alert the reader that she is quoting from and also rewriting the Williams poem. Remember that the poem depends on a series of material images: "a red wheel / barrow / glazed with rain / water / beside the white / chickens." But there's no concrete image in the Brooks chapter—the question evokes the elitism and snobbery through which people like Maud are excluded or included. The chapter suggests that the young woman's question, "Is he in school?" allows these insiders to consolidate their power, giving them the power to measure the young Negro writer's importance—for insiders both in and outside the text.

David answers "Oh, no," and, assuming authority, assures his audience that the young Negro author "has decided" that "there is nothing in the schools for him," that though he may be brilliant, may have "kicked Parrington or Joyce or Kafka around like a football," "he is not rooted in Aristotle, in Plato, in Aeschylus, in Epictetus"—the classical traditionalists. ("As we are," the narrator adds.) This interaction is channeled through Maud's interior consciousness in order to convey Maud's feelings of displacement in the university world and the coded terms by which her outsider status is conveyed. In this case, "so much depends" not on our appreciation of the material objects of the physical world as in the Williams poem but instead on our ability to read and critique the assumptions of hierarchical categories and vocabularies of exclusion. What we do know is that Brooks intended these narrative techniques to represent a protagonist "locked out" of white/male/upper-class traditions. Deliberately reversing the godlike powers typical of male narrators and claiming her own insider authority, Brooks is also critiquing the male-dominated naturalistic tradition, in particular the social realism of texts like Wright's *Native Son*—and *Twelve Million Black Voices*—with its reliance on representations of a static black collectivity.[19] The language of gesture in *Maud Martha* forces us to develop our skills of observation and to learn to read a face or gesture without the privileged

access sanctioned by realistic traditions—as one is required to read Joyce or Williams. Her silence here may indeed require us to read back to the accumulated injuries she has endured as a black female working-class intellectual throughout her life, as the chapter ends abruptly with a single-sentence, unmediated comment by the narrator: "The waitress brought coffee, four lumps of sugar wrapped in pink paper, hot mince pie." On the other hand, what Maud has ordered replaces silence with her hot awareness (and perhaps even her own assumptions of a modernist smackdown of her so-called betters) of both the confectionery condescension at the table and her own disguised, repressed (minced) anger (275).[20]

MAUD MARTHA ROUGHS UP THE SMOOTH SURFACES OF COLD WAR CULTURE

Brooks was working both sides of the political divide in the 1950s. As I have indicated in the first part of this chapter, Brooks developed as a writer and activist in the leftist circles of the South Side Community Art Center while working with a group of black writers and artists committed both to social change and to formal experimentation. Beginning in 1941, their poetry instructor was Inez Cunningham Stark, "an elegant upper-class rebel from Chicago's 'Gold Coast,'" a modernist poet herself and board member at *Poetry*, who obviously helped send Brooks in modernist directions (Melhem 1987, 9). The minutes of the 1944 board meetings of the SSCAC, where Brooks was apparently workshopping her first novel, suggests that Brooks, now formally committed to a modernism in her poetry, was working out her method and intention for her first attempt at writing a fictional narrative. As the minutes indicate, the class was working that year on fiction concerning personal interracial relations, and Brooks is specifically mentioned:

> The attempt is being made in these [meetings] to present the psychological story, to show what is in the minds of the persecuted or the persecuting if [*sic*] Jim Crowism is depicted, to get inside the mental conflict

which is set up individually by this thing called race. A number of new writers are developing in this group, two men working on their first novels, a journalist or two, and the winners of both first and second prizes for poetry in this year's Midwest poetry awards, one of whom, Gwendolyn Brooks, has her first book of poetry, A Street in Bronzeville [*sic*], released this last month by Harpers Brothers.[21]

At the same time that she was workshopping at the leftist SSCAC, where race and modernism comfortably coexisted, Brooks was also negotiating with her white editor, Elizabeth Lawrence, and readers (probably white) at Harpers, as she tried, from 1945 to 1951, to get her novel accepted. Lawrence conveyed to Brooks the readers' discomfort with Brooks's treatment of race: "One reader liked the lyrical writing but was disappointed by the sociological tone and patent concern with problems of Negro life" (quoted in Melhem 1987, 81). Though Brooks proceeded to make changes, her editor continued to express concern about her representations of race: "It was proposed that the unpleasant experiences with whites be balanced by a positive encounter to justify the hopefulness she [Maud Martha] retains" (83). Lawrence thought that the hopefulness in the novel should be tied to Maud's "positive" experiences with whites rather than to Maud's growing awareness of and resistance to racism. In the final letter of approval for publication, Lawrence used the coded term "universal" to warn Brooks against too much emphasis on racial issues and "possible stereotyping of whites" in her future writing: "She hoped that the poet's future work would have a universal perspective" (83–84). Lawrence suggested another change that confirms her biases. In the chapter where Maud is reading, Brooks had originally chosen a book by Henry James, one of Brooks's favorite models for writing fiction, but Lawrence called that selection "improbable," so Brooks changed it to the more popular and less highbrow *Of Human Bondage* by Somerset Maugham. We might call to mind here that Brooks meant for her protagonist to be a racially marked, working-class, modern intellectual. Brooks was well aware of the way Lawrence was coding race, but, rather than softening her racial critique, she instead inserted a series of racially marked chapters. I argue that she was deliberately refusing the Cold

War consensus on race—that black writers should minimize racial identity and racial strife in an effort to achieve "universality."

The editor's pressure on Brooks to soften her racial critique has to be understood in the context of late 1940s and early 1950s race liberalism. In her remarkable study of U.S. postwar racial change, *Represent and Destroy: Rationalizing Violence in New Racial Capitalism* (2011), the cultural historian Jodi Melamed critiques the ways that new postwar racial orders, which she calls "official antiracist liberalism," emerge during the Cold War, ostensibly to promote racial equality but in actuality to serve as technologies "to restrict the settlements of racial conflicts to liberal political terrains that conceal material inequalities" (xvi). Meant very clearly to repress and supersede the race radicalism(s) of the 1940s, "official antiracist liberalism" operated to stymie race radicalism and to substitute an official race order that would ignore material inequalities, restrict the terms of antiracism, promote "progress" narratives, and, in my terms, depoliticize antiracist work. Melamed argues that literary texts, often under the guise of protest narratives, were deployed to do this kind of race neutralizing—first, represent; then, destroy. As many scholars of the Cold War make clear, this kind of liberal antiracism sold well in the era of Cold War containment, anticommunism, McCarthyism, HUAC investigations, and FBI spycraft. As I show in chapter 5, the CIA was operating domestically as well as internationally to carry out its policies of containment and repression, diligently and deviously infiltrating and manipulating African American cultural institutions. Cold War ideologies, often disseminated through the culture industry, permeated every facet of American life, particularly the media. In the massive drive to insure and justify the elimination of left-wing dissent, anticommunism was successfully installed as a permanent feature of U.S. democratic ideals to undercut political radicalism further.

Considering Melamed's argument that literary texts were also purveyors of racial containment, there is even more reason to appreciate *Maud Martha* as politically radical. Certainly, Brooks refused African American optimism about racial progress. Taken together, the thirty-four chapters in *Maud Martha* form a textual indictment of the "Negro progress narrative," as chapter after chapter reveals Maud's discontent, impotence, and anger

over Chicago's racial regime: she endures and repulses a racial slight at the millinery shop (a potent reminder of black women's treatment in downtown department stores during Jim Crow); a white saleswoman tries to make a sale in the black beauty shop and inadvertently says, "I worked like a nigger to earn these few pennies"; when Maud goes to work as a domestic during the Depression, her upper-class employer treats her like a child; at the World Playhouse, she and her husband Paul experience themselves as "the only colored people here"; on the campus of the University of Chicago, she encounters the elitism of university whites and blacks; and, finally, in that revered public spectacle of 1950s hegemonic whiteness—visiting Santa at the downtown department store—she finally recognizes and voices her stifled rage when the white Santa dismisses her little daughter. In what may seem only a minimal expression of her anger, she revokes his cultural title and authority: "Mister . . . my little girl is talking to you." The entire city, from the downtown department store to the university campus, serves up ammunition for Maud's racial critique, producing a militant rhetorical analogue to the black Left's militant 1940s campaigns to "desegregate the metropolis." If the culture of the Cold War was designed to produce smooth surfaces for U.S. consumption—images of domestic family tranquility with the woman's place in home and family, good wars, and the harmony of racial integration, interracial cooperation, and black docility—*Maud Martha* disrupts on every front.

BEYOND THE 1950S: THE LEFT IN
THE BEAN EATERS

Brooks submitted the manuscript of *The Bean Eaters*, her third volume of poetry, to Harpers in December 1958, and the editors "enthusiastically" accepted it for publication (Melhem 1987, 100). The black nationalist poet and critic Haki Madhubuti dismissed *The Bean Eaters* in his 1966 essay on Brooks with one line, "*The Bean Eaters* is to be the last book of this type," inferring that Brooks's subsequent poetry would mark the beginning of her

political and racial consciousness. Brooks herself dubbed the book her "too social" volume because it had almost immediately been identified as "politically" charged—even "revolutionary," and she had a hard time getting it reviewed (Madhubuti 2001, 87; Brooks 1983, 43). In fact, Brooks says that *The Bean Eaters* was a "turning point 'politically,' its civil rights poems and its pointed critiques of class prejudice and racial violence so startlingly different from her earlier work that the reviewer for *Poetry* wrote that it had too much of 'a revolutionary tendency' and was too 'bitter'" (Brooks 1983, 43).[22] Brooks's biographer Melhem notes that fully one-third of the thirty-five poems in *The Bean Eaters* were "distinctly political" (1987, 102).

In view of the political directness of *The Bean Eaters*, it is stunning that so many of Brooks's critics insisted that she became "political" only after 1967 and that her poems from the 1940s and 1950s were apolitical and directed at a white audience. In *The Bean Eaters*, written during the 1950s and published in 1960, Brooks initiates all the themes that critics associate with her black nationalist period. Moreover, she goes beyond the category of race to include issues of gender, class, and war. Brooks's subjects in *The Bean Eaters* are nearly always black and working class, and her relationship to these subjects compassionate, though, as always, Brooks's use of an ironic, mocking voice makes it impossible to draw any easy conclusions about the aims of her critiques (Gery 1999, 44–56). Beyond that compassion is her determination to expose the way conventions of respectability, Christian norms, racism, and classism dominate and oppress working-class and racialized subjects. Her subjects in *The Bean Eaters* are as follows: an elderly devoted couple eating their beans in "rented back rooms" and fingering the mementos that bespeak a life of poverty and lifelong faithfulness; the racial and class violence directed at a young couple who make love in alleys and stairways; the Chicago black working class drinking their beer in the establishments once an enclave for the rich; Emmett Till, "a blackish child / Of fourteen, with eyes too young to be dirty" and a mouth of "infant softness"; the pool players who live in urban ghettos, expecting short and brutal lives; the homemaker Mrs. Small, trying to manage breakfast for her six, an abusive husband, and the payment for the (white) insurance man; the "brownish" girls and boys of Little Rock, caught in a storm of race hatred from the white mothers; "those Lovers of the Poor"

who "cross the Water in June," "Winter in Palm Beach," and cannot endure an actual encounter with the poor; the emptiness of middle-class consumption; Rudolph Reed dying in order to protect his family and home from white racial violence; and, finally, an antiwar poem that critiques the war aims of generals, diplomats, and war profiteers and assails the people's desire for war. I list these subjects in some detail as further proof of the political, racial, and class issues Brooks took on in her 1950s work.

I conclude this chapter with a discussion of three poems in *The Bean Eaters* that bear the signs of Brooks's leftist poetic sensibility, two of which make specific references to the Left. The first, entitled "Jack," I assume to be about Brooks's leftist radical friend Jack Conroy, and the other, "Leftist Orator in Washington Park / Pleasantly Punishes the Gropers," the only poem in which she actually makes a direct reference to the Left. Almost nothing has been written about Brooks's long-term friendship with Conroy, identified by the literary and cultural historian Alan Wald (2001, 269) as "pro-Communist" or a "fellow-traveler." That friendship—both literary and personal—is established in the letters between the two written between 1945 and 1983. Conroy's biographer Douglas Wixon says Brooks met Conroy at the South Side Community Art Center. Alice Browning, a student in Conroy's writing class, asked for Conroy's help when she started *Negro Story*, and Brooks was there at Browning's house for meetings with Conroy (Wixon 1998b, 426n37). Conroy's close relationships with and support of black writers are almost unprecedented. His friendship with the black writer Arna Bontemps spanned twenty years and produced several collaborative works, including the 1945 social history of black migration, *They Seek a City*, as well as several books for children. He seems to have been a ubiquitous presence and a beloved friend and colleague among black writers, including Bontemps, Browning, Frank Yerby, Willard Motley, Melvin Tolson, Frank Marshall Davis—and Brooks.

The letters between Brooks and Conroy begin in 1945, shortly after the publication of her first volume of poetry. In the first letter of September 14, 1945, which is mentioned above, Brooks confides in Conroy that she is pleased with "a very generous" review of *A Street in Bronzeville* in *New Masses*. Brooks's greetings change from "Mr. Conroy" in the 1945 letter to

FIGURE 4.2. Gwendolyn Brooks presents the Literary Times Award
to Jack Conroy (1967).
Source: Photo courtesy of Douglas Wixson.

"Jack" in subsequent letters, as their friendship deepens.[23] Wixon says that
"Gwendolyn Brooks (among others) was a frequent guest at the parties given
by Jack and Gladys on Green Street" (1998b, 462). In a letter from 1962, Con-
roy asks Brooks to autograph *Maud Martha* and *A Street in Bronzeville* and
confides in Brooks about the troubles getting his books published because of
his blacklisting:

> The trouble is they [his books] were translated and published freely sev-
> eral years ago and I was never paid anything. In Russia they had a huge
> sale. Now I see the Russians are willing to pay American authors, and
> I have put Pfeffer on the trail of my lost rubles. Don't know whether I
> ought to accept them or not, for McCarthy is not dead but only sleepeth.
> Besides, Eastland and Walters seem to have taken over where the Repub-
> licans left off.[24]

In another letter remarking on Brooks "rusticating" at the writers' retreat Yaddo, Conroy says he is going to look in on her husband Henry Blakeley while Brooks is gone.[25] Later in 1967, Brooks, by now a Pulitzer Prize–winning poet, presented Conroy with the first Literary Times Prize, praising him for "his aid and encouragement to young writers and his overall contribution to American literature, particularly his novel *The Disinherited*" (Wixon 1998b, 482), which she called a "classic." Brooks obviously felt an extraordinary sense of kinship with Conroy. She admired his devotion to the working class; his unpretentiousness; his wariness of ideology; his multicultural, multiracial friendships and collaborations; and his love of parties. While nothing in these archives proves that Brooks was a Party member or even that she could be considered on the Left in the 1940s or 1950s, this friendship, almost totally undocumented in any critical or biographical work and strangely unremarked on in Brooks's own work, is further evidence that Brooks was no stranger to the Left.

Since the poem "Jack" appears to be about someone Brooks knew, and since it reflects qualities one might associate with Conroy, I read the poem as a description of Jack as a kind of secular saint. It opens with a typical Brooks irony, appearing at first to honor Jack in religious terms, calling him a man of "faith." Knowing, of course, that Conroy was a Marxist, Brooks has revised "faith," inserting instead an economic metaphor: he is not, the first line tells us, "a spendthrift of faith" but one who carefully doles out his faith with "a skinny eye," waiting to see whether or not that faith is "bought true" or "bought false":

> And comes it up his faith bought true,
> He spends a little more.
> And comes it up his faith bought false,
> It's long gone from the store.

Not religious in any sense of a formal creed, this man's "faith" is an ethic of integrity based on an ideal of justice whose results must be observable, not on the abstractions of traditional notions of "faith." After Conroy's death, Brooks took a trip to his hometown, Moberly, Missouri, where he moved

in 1965 after leaving Chicago, to give a talk about him. Wixon discusses the visit in his biography of Conroy and says it clearly demonstrated Brooks's close ties to her friend (1998, 482).

In addition to this poem dedicated to an openly leftist radical, Brooks's Left-inflected "Leftist Orator in Washington Park / Pleasantly Punishes the Gropers," suggests her familiarity with scenes in Washington Square Park, where militantly black and Left soapbox orators regularly spoke. As a result of the demographic changes following World War I, when African Americans moved into the area, Washington Square Park became a site of racial tension and conflict in the 1920s and 1930s, and by the late 1950s, the park had become the (un)official dividing line between the black South Side and white Hyde Park (Brooks 1983, 41). Bill Mullen notes that Washington Square Park, bordering the Black Belt, had a long reputation as the "South Side's public flashpoint for speeches and demonstrations by black Garveyites, Communists, unionists, and other radicals," (Mullen 1999, 67), and, in the early 1930s, it attracted thousands of blacks to hear its political speakers, even some black women speakers.[26] According to the cultural historian Brian Dolinar, in the late 1950s, when Brooks was writing *The Bean Eaters* poems, the park would have attracted a mostly black audience.[27] There are stories of large Garvey parades in Washington Park, and the black historian Hammurabi Robb gave soapbox oratories there.[28] Brooks might have known the park as a black cultural site because it is specifically named in Richard Wright's novel *Native Son*, when Bigger Thomas drives the drunken Jan Erlone and Mary Dalton around Washington Park as part of their desire to experience black space. As Jan and Mary embrace, Bigger "pulled the car slowly round and round the long gradual curves" and drove out of the park and headed north on Cottage Grove.[29]

In Brooks's poem, the leftist orator acknowledges that he or she is engaged in a thankless and hopeless task, trying to fire up the audience in this "crazy snow," an audience that is rushing to get out of the cold, fearfully aware that "the wind will not falter at any time in the / night." At the beginning of the poem, the speaker is compassionate toward these listeners, the "Poor Pale-eyed" (not "Pale-skinned"), knowing that they "know not

where to go." Aware of his (or her) own ineffectiveness, the orator seems resigned to the reality that he cannot offer enough inspiration to compete with the wintry weather or reach this audience of "gropers" with a vision capable of stirring them. Speaking in the voice of a religious prophet, however, he blames their indifference on more than simply a need to get in out of the cold, but also on a failure of vision: "I foretell the heat and yawn of eye and the drop of the / mouth, and the screech / Because you had no dream or belief or reach." While the poet understands these "gropers," like the folks in Brooks's "kitchenette building," as people under the harsh and insistent material realities of their lives, the speaker's sympathy is for the leftist orator, who is committed to remaining out in the cold trying to reach the people, and perhaps she even shares the orator's desire to punish them "pleasantly" for their obstinacy. Even if the "thrice-gulping Amazed" listeners are not entirely indifferent to the speaker's message, the pattern of threes in the poem ("thrice-gulping"; "the heat and yawn of eye," "the drop of mouth," and "the screech"; "no dream or belief or reach"; "were nothing," "saw nothing," "did nothing") points perhaps to the three denials of Christ by Peter and a harsher rebuke of the crowd as not only indifferent and preoccupied but also as betrayers of themselves and of a larger cause. As the orator tries to reach a reluctant and indifferent audience, it is striking to note that the narrator's sympathy is evoked for both the unheeding crowd and the determined but ineffectual "leftist orator."[30]

We can only speculate about what is actually said by the leftist orator, the "I" of the poem, in his address to the Washington Park crowd, since his actual speech is unnarrated, but he speaks in several registers that would appeal to a black audience—as a political voice, as the voice of a religious prophet, and as the poetic voice. In her reading of the poem, Brooks's biographer D. H. Melhem assumes that the audience is white and that the orator is castigating them for their apathy and lack of conviction (1987, 118). But in the late 1950s, the park would have been a predominantly black or interracial gathering center and that audience almost certainly not entirely white.[31] Moreover, Brooks deliberately employs *whiteness* to refer to the weather and thus anticipates then forestalls any easy identification with race. In Brooks's critique, the "Pale-eyed" listeners seduced into indifference

and complacency and unwilling to act, is a recurring theme in her poetry and not necessarily racially inflected.[32]

Two more poems from *The Bean Eaters* I read as representative of a "Left" political sensibility because they show Brooks's profound alignment with those disadvantaged by class and race. The first poem, entitled with Brooksian irony "A Lovely Love," is about the first sexual experience of two young people whose lives are such that the encounter takes place in an alley or stairway. The poem opens with an imperative: "Let it be alleys. Let it be a hall . . . Let it be stairways and a splintery box." Rather than the imaginative space of the conventional sonnet where love is accorded dignity and meaning, the space these lovers occupy for their illicit love creates a disturbance: it is a place that "cheapen[s] hyacinth darkness," where there is "rot" and "the petals fall."

The elegiac mood and bitter wisdom of the poem are created by the speaker addressing her or his lover, speaking of the way their love affair is cheapened not by their lovemaking but by ugly "epithet and thought" thrown by those "janitor javelins" that "rot" and "make petals fall." As she has done repeatedly throughout this period of her "high" modernist experimentation, Brooks revises a high modernist form—the sonnet—to critique those traditions and to give to the poor the trappings of poetic form.

The speaker, however, is resistant to the defamation of her experience, and to honor that experience, she (or he) endows it with the elegance and fragrance of "hyacinth" (the "hyacinth darkness that we sought"). The speaker, small enough to be "thrown" down, then "scraped" by her or his lover's kiss and "honed" as one would sharpen a tool, is not caressed in this encounter. Nonetheless, the act entails more than the awkward and inadequate moves of a young lover; he or she smiles away their "shocks" in an attempt to be reassuring, and the poem shows that both these inexperienced young people have been unsettled by their sexuality. In the third quatrain, the speaker compares this love and the possible birth it might produce to the birth of Christ and, in a caustic comparison, names Christ's birth "that Other one," charging religious myth with both irrelevance and otherness: this Cavern is not the mythic cave of the Christ child, and there are no "swaddling clothes," no "wise men," and no blessed birth. The birthright of

the lovers is only the feeling that they must run before they are caught, probably by those people whose "strict" rules, both religious doctrine and social norms, would condemn their lovemaking in alleys and stairways: "Run / People are coming. / They must not catch us here / Definitionless in this strict atmosphere."

There is another reference in the couplet to the strict conventions of the sonnet form. By its repeated references to those public, dark, and indecent locales, the poem, like the couple, violates the *lovelier* love traditionally associated with the sonnet. In this space outside of conventions, the couple is "definitionless," without standards or traditions reserved for those "lovelier loves" sanctioned by myth, convention, and poetic traditions. So, what to make of the title, "A Lovely Love," and the opening tag "Lillian's" beneath the title of the poem? Is this poem a tribute to someone named Lillian and to Lillian's "lovely love," perhaps her first sexual experience? Brooks is, of course, subverting the traditions that have historically omitted girls (and boys) like these two.

In a conversation with the literary critic Aaron Lecklider, I became aware of the gender ambiguity of the poem. Since the only gender signifier is the reference to "Lillian's" that prefaces the poem—the poem invites a queer reading, with the two young lovers possibly a same-sex couple. Under the terms of a homophobic culture, two gay lovers would also be labeled "Definitionless." This lexicon of deviance and transgressiveness in the poem suggests that in pushing against the boundaries of respectability Brooks may have intended to align the poem with sexual as well as class deviance in the narrator's embrace of the two lovers. I would argue that a queer reading of the poem is further evidence that Brooks was clearly capable of the political *deviance*, boldness, and indifference to conventional norms required for an embrace of the Left.[33]

"The Ghost at the Quincy Club" is a companion poem to "A Lovely Love," with Brooks again taking on the issue of class and the "dark folk" omitted from, marginalized by, and discarded by white patriarchal traditions. The Quincy Club is an old upper-class establishment, a genteel social club of "Tea" and "Fathers," owned and dominated by the white male elite that excluded black and Jewish folk, where the African American DuSable

Museum is now located. The poem opens with a vision of the past, with one of the genteel ("Gentile") daughters of the former Quincy Club fathers drifting down the staircase and wafting into the halls of "polished panels" in their "filmy stuffs and all."

The poet-narrator is blunt and sarcastic, sneering at these "Gentile" daughters turned, presumably by their fathers, into "filmy downs," "filmy stuff," "Moth-soft" and "off-sweet"—ephemeral, insubstantial, and easily snuffed out. Their "velvet voices" are described here as moving almost as though directed by a metronome ("lessened, stopped, rose")—that imposes on them an exact and precise rhythm. The enjambment between the first and second line in this stanza forces the "velvet voices" to give way to the "Rise" of the "raucous Howdys," those new raw sounds that now, with energy and swagger, perhaps with vulgar curse, challenge and replace the old, the privileged, and the white. In the current arrangement of things, "Tea and Father" are replaced by "dark folk, drinking beer."

Both of these poems enact a kind of leftist recoding of the spaces of Brooks's Chicago. She rejects the *soft*, the *off-sweet*, the *demure*, the very image often imposed on her own autobiographical persona. One could read these final lines as Brooks's silent, suppressed political voice—raw, raucous, challenging, vulgar, and coarse, rejecting the old order just as the cultural Left tried to do.

Black left-wing cultural workers were under intense pressure by 1953 (the same year that Brooks's friend Langston Hughes was summoned to appear before McCarthy's Senate Investigative Committee) to distance themselves from radical left-wing affiliations. I place Brooks as both an insider and an outsider in the Cold War literary realm, a writer aiming for literary recognition, perhaps even insider status, but also writing a novel and poetry that subverts the conservative racial politics of the Cold War 1950s. She was not immune to the allure of mainstream success. Along with the publication of *Maud Martha*, Brooks had been selected by *Mademoiselle* as one of its ten "Women of the Year." In 1949, she received the Pulitzer Prize, and, in 1957, she was selected by the Jesuits of Chicago as one of their hundred outstanding Chicagoans, to celebrate their hundred-year anniversary of the Jesuits in Chicago. In a *Chicago Times* article, she is listed for the award as "Mrs.

Gwendolyn Brooks Blakely, poet and author." In the *Times* photograph Brooks is attired in a white formal gown, seated in the center of the front row along with the civic leaders, businessmen and women, social workers, labor leaders, lawyers, authors, an opera impresario, philanthropists, sports leaders, scientists, and educators. Dr. Percy Julian and Dr. Roscoe Giles appear to be the only other blacks in the photo. The entire issue with photograph, which Brooks kept all of her life, is saved in the Brooks archives at the University of California, Berkeley. On the front page of that issue, Brooks wrote in her signature, strong, bold handwriting, "*Save This Always.*"

I understand Brooks's black nationalism as essential to the development of her aesthetic and critical to her own political formation, and perhaps it was Brooks's expiation for what she considered writing for a white audience. But this chapter underscores the problem of dismissing or marginalizing the radical politics in this earlier work. Let me illustrate with an example from the marginalia Brooks appended to an article in the December 1970 issue of the black left-wing journal *Liberator*. In an editorial entitled "Big Brother," the editor Daniel H. Watts rejected the surging tide of black nationalism, arguing that "the rhetoric of Black Power was becoming a 'gospel' of authentic blackness that Watts said ignored the "very nature of our diversity" and could result in our "becoming slaves to an inhuman institution called oneness." The one thing we don't need, pleaded Watts, is "an Orwellian Black Brother." Brooks was obviously incensed by this editorial, as is clear from the double marginalia she wrote on the side and at the bottom of the page. In her large bold handwriting, she demanded, "How about an Orwellian Big Black Brotherhood," using the same term Ellison used to signify the Communist Party in *Invisible Man*. In double underlining, she wrote, "We can't afford indulgence in this 'diversity' stuff *right now*. It had better be 'oneness' *right now*"—with quotation marks around "oneness." We see here Brooks's commitment to the black power nationalism of the 1970s, which did indeed often attempt to suppress difference under the guise of black unity and, in many instances, either celebrated or tolerated the male dominance and homophobia often associated with nationalism.

Brooks's public embrace of black nationalism has certainly helped obscure and undermine the power of her earlier political commitments

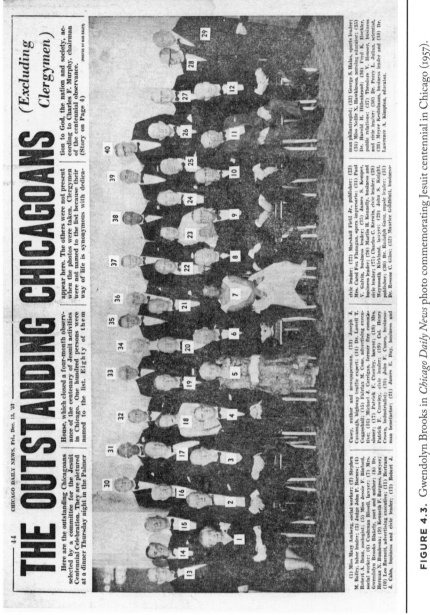

FIGURE 4.3. Gwendolyn Brooks in *Chicago Daily News* photo commemorating Jesuit centennial in Chicago (1957).

Source: Courtesy of the Bancroft Library, University of California, Berkeley

and aesthetic innovations. Both *Maud Martha* and *The Bean Eaters* suggest something of what we lose in the dismissal of Brooks's pre–black nationalist writing. The body of work Brooks produced in the 1940s and 1950s, formally challenging in ways that create new meanings, is informed by many categories of critique, not just race; it is proletarian, militantly race and class conscious, feminist, and antiwar, open to all forms of diversity, rejecting the kind of ideological rigidity that produces the "oneness" she later advocated. Brooks herself insisted for years that black writers have all kinds of wonderful material in black life to work with, but that they, like all writers, have to create and work with formal elements—in her words, they have to "cook that dough." The effort to do that hard work—to struggle with language, to create something "linguistically and stylistically" beautiful, meaningful, and challenging, should never have been dismissed as writing for white folks or a kind of racial shortcoming. In the final analysis, we must take our cues from Brooks's own political and aesthetic defense of her early archive, offered retrospectively in 1966: "but I have judged important the very difficult creation of poems and fiction and essays which even a quarter of a century ago were—and are now—bearers of a hot burden." That burden surfaces in Brooks's hot, militant, and leftist, poetic vocabulary and style.[34]

5

FRANK LONDON BROWN: THE END OF THE BLACK CULTURAL FRONT AND THE TURN TOWARD CIVIL RIGHTS

How, then, should American literature deal with these people, crushed for centuries beneath an insufferable weight of exploitation, calumny and derision, yet always rising, their presence and their struggle ever mocking the strident pretensions of the nation?

—LOUIS E. BURNHAM, *THE GUARDIAN*, 1959

I wanted to make it hip to be socially conscious.

—FRANK LONDON BROWN, 1960

N ORDER TO reevaluate black Cold War literary production at the end of the 1950s, I turn to a little-known novel, *Trumbull Park*, by another Chicagoan, Frank London Brown, published in 1959. If Ralph Ellison's 1952 novel *Invisible Man* was the quintessential black Cold War text of the early 1950s, distinguished for its high modernism and its disillusionment with the Left, then Brown's novel, a politically engaged and formally innovative form of social protest, might be considered the representative black Cold War text at the other end of the 1950s (Schaub 1991, 94). Deeply immersed in and defined by the cultural and political collisions of that moment—civil rights coalitionism, insurgent black nationalism, Left interracial alliances, and FBI surveillance—*Trumbull Park* forces an engagement with the literary and cultural politics of the Cold War 1950s.[1]

The cultural and literary historian Alan Wald was the first to suggest that, given Brown's connections with a radical union and the publication of his novel during the period of McCarthyism, *Trumbull Park* should be read as a black Cold War text (1995, 488). Spurred by this nudge from Wald and by the discovery of Brown's FBI file, I began to look more closely at Brown's radical politics and to read the novel not in the limited register of his civil rights activism but in the light of his leftist radical résumé, as a reflection of the tensions of the late 1950s between civil rights, black nationalism, and the radical Left, tensions all too evident in Chicago black politics. As the literary historian Bill V. Mullen reminds us in the conclusion of *Popular Fronts*, his study of Chicago's black Left, by the 1950s and 1960s, black/Left alliances were already showing these tensions: "(white) big labor, the Communist Party, and the Old Left were challenged and in many ways superseded by civil rights coalitionism, insurgent black nationalism, and interracial alliances under black political leadership" (1999, 202). As we will see from a close reading of his FBI file, Brown's political life and his work reflect this eclectic mixture. He was active in civil rights, in nationalist circles, and in radical groups, and all of these elements percolate in his novel, colliding and conflicting in some cases, overlapping and intersecting in others.

Brown's radical politics probably began as far back as his years at Roosevelt College, known in the 1950s as "The Little Red Schoolhouse" because of the many left-wing activists there, where he met and became friends with the former congressman Gus Savage, Harold Washington (the first black mayor of Chicago), and the community activist Bennett Johnson, among others. The Roosevelt group pursued its nationalistic aims through the Chicago League of Negro Voters, which whites were not allowed to join, although periodically, according to Johnson, they worked with the white Left. The group insisted on calling themselves "progressives" because, Johnson says, "leftist" automatically meant communist, and "we were not Communists. We were progressives."[2] Both Johnson and Brown worked closely with communists like Ishmael Flory and Claude Lightfoot, who were staples of the Chicago communist Left.[3] Whatever political label he favored, Brown was active in several unions and, most importantly, served for two years (1954–1955) as program coordinator for Chicago's District 1 of

the UPWA, described in all accounts as vibrant and eclectic: a left-wing, communist-influenced, antiracist, black-led trade union that worked on behalf of black women's equality and was one of the few CIO-led unions that refused to purge communists from its ranks,[4] consistently producing cooperation between the nationalists and the Left (Halpern 1997, 241).[5]

With this history in mind, we might be able to see *Trumbull Park* as a cultural, historical, and formal hybrid bearing a complicated mixture of the political traditions that help produce the novel's aesthetics. Whether or not critics were astute enough to recognize them, the signs of literary and political Left are everywhere in the novel. The novel's focus on collective political struggle, its documentary-style depiction of racialized violence and black resistance, its focus on and identification with the worker and working-class solidarity, its oblique references to political surveillance, and its call to unite U.S. civil rights battles with global struggles against white supremacy represented by the 1955 Bandung Conference are literary strategies closely linked to the proletarian fiction of the 1930s and to the antiracism of the black cultural front narratives like the short stories Ellison wrote in the 1940s. They display some affinity to the racial and ethnic focus of what Michael Denning calls the "ghetto pastorals." Denning describes the ghetto pastoral as a form of proletarian literature that was part naturalist fiction, part pastoral tale of the ethnic working class, usually without a focus on topical political events and generally written by writers who had grown up in the working class (1996, 230–258). Thus Gwendolyn Brooks's 1953 novel *Maud Martha* fits the pattern of the ghetto pastoral more closely than Brown's novel, which focuses on political struggle, but both Brooks's *Maud Martha* and *Trumbull Park* bear signs of these cultural and literary traditions of the Left, although neither text has ever been considered within leftist literary traditions. I read Brown's novel as part of a more expansive and flexible social protest aesthetics, one produced and inspired, at least in part, by his leftist affiliations, which I document through his newly discovered Freedom of Information Act (FOIA) file. What I hope to show is that, even in the late 1950s as the Left was crumbling under the onslaught of McCarthyism and the word "communism" had clearly become a pejorative, black writing continues to be influenced by leftist cultural strategies and ideologies, thus

reflecting how deeply the cultural aesthetics of the Left permeated African American cultural production, even as the Cold War critics and those of later generations tried to separate black and red.[6]

The idea for *Trumbull Park* (1959) was born when Brown and his wife Evelyn moved with their two children to Chicago's Trumbull Park Housing Project in April 1954, just a month before the *Brown v. Board of Education* Supreme Court decision. The historian Sterling Stuckey[7] says in his review of the novel (1968) that Brown was motivated to write by his experience of the "new militancy in the North," encouraged by two important Supreme Court decisions, which set the stage for the battle in Trumbull Park.[8] By 1954, the Chicago NAACP, buoyed by the 1948 Supreme Court decision against racially restrictive housing covenants,[9] had targeted Trumbull Park for integration. Though the Brown family was motivated by a personal decision to find affordable housing for their growing family, Brown was no stranger to political activism. He was an organizer in the left-wing United Packinghouse Workers Union and active in civil rights and nationalist organizations. Even when he was gravely ill with leukemia in the summer of 1961, he joined the wade-in at Chicago's Rainbow Beach on Lake Michigan to protest the policy barring blacks from swimming there. In an interview after the publication of the novel, he was explicit about the nationalist aims of his novel, describing his main character Louis "Buggy" Martin as a kind of Everyman who could encourage black political change: "If I could get the Negro reader to identify himself with this man, then, at the end of the novel, the reader would be sworn to courage—if the trick I tried to pull on Negro readers worked" (Brownlee 1960, 29).

The novel is narrated in the first-person by Louis "Buggy" Martin, an airplane factory worker who, as Brown did, moves to Trumbull Park with his wife Helen and two daughters. Motivated by the desire and need to get out of a tenement apartment, and with the assistance of the Chicago Housing Authority, the Martin family (like the Browns) joins several other black families to integrate the project, but they are completely unprepared for the intensity of racist violence. With almost total autobiographical consistency, the events in the novel closely align with the historical facts recounted in Arnold R. Hirsch's (1995) extensive investigative article "Mas-

sive Resistance in the Urban North: Trumbull Park, Chicago, 1953–1966."
With the tacit approval of the police and housing officials, who made no
arrests and did little to stop the harassment, whites carried on psychologi-
cal warfare against the black families, throwing bricks, stones, and sulfur
candles through their windows; congregating on street corners in hostile
groups; putting out hate sheets; and making it dangerous for black families
to use any community facilities, including stores, parks, and churches. The
mobs were so threatening that blacks were required to sign police logs to
get in and out of their apartments and had to be driven by armed police
escort, in filthy police wagons, to points of safety beyond the projects, where
they could then board public transportation. For the entire three and a half
years the Martins (like the Browns) lived in Trumbull Park, white mobs did
everything in their power to make life unbearable for the black families and
to sabotage the desegregation effort. At night the mobs set off explosive
devices, which went off in three-to-five minute intervals with flashes and
deafening thunder. The jazz musician Oscar Brown Jr. reported that when
he visited the Browns during this time, the only person who didn't jump
at every explosion was the Brown's newborn infant: "The new baby was so
acclimated to the sound that she apparently thought the world exploded
every three minutes."[10] The Brown family fought the battle for Trumbull
Park from 1954 to 1957, until Brown's wife Evelyn was pregnant with their
third child, a boy who died forty-five minutes after he was born, which
Evelyn blames on the stress of those years. Noting the irony of being called
"communists" and "un-American" by the white mobs that assaulted them
daily and nightly in the project, Evelyn wrote in her memoir of this period:
"We were more American than anyone, and we were being attacked by
people wearing long dresses and babushkas, calling us 'niggers' in a foreign
accent" (Colbert 1980, 1–4).[11]

Since several other black families joined the Brown family in this strug-
gle, Brown was compelled by the actual experiences of the Trumbull Park
protestors to resist the single-protagonist story and to create the novel's col-
lective narrative focus. The seven real-life couples involved in desegregating
Trumbull Park are portrayed in the novel, probably accurately, as a distinctly
unorganized, contentious group whose political positions range from not

wanting to offend whites to planning to arm themselves and shoot whites on sight. For the first several months, the couples live in terror and shame, all of them reluctant to challenge the mobs, which, with the collusion of the police, gather around their homes at night, chanting racial epithets and detonating explosives. In response, the couples initially board up their windows, eat in silence, and sleep in fear. They are forced to ride in and out of the projects in police wagons and sign log books every time they enter or leave, as if they are the ones guilty of a crime. Finally, with each one of the characters encouraging the others, the men and women together, almost in counterpoint, collectively perform their first acts of defiance: Helen begins, shouting to the police that they will meet whenever they want and without permission. Buggy's voice follows hers, Ernestine backs Helen up, Arthur and Mona join them, and then Nadine and Terry. These unlikely "soldiers of Trumbull Park" gradually become emboldened: Ernestine leads the way out of the house through "the ring of uniforms and plainclothes," refusing to sign the log books despite police threats. In the claustrophobic confines of the housing project, the main character and his family learn to stand up to white mob violence, those lessons of leadership and courage enabled entirely through collective struggle.

After Brown's death in 1962 at age thirty-four, *Trumbull Park* fell into obscurity. (Brown wrote only one other novel, *The Myth Maker*, which was published posthumously in 1969.) Out of sync with the literary integrationist moment and too early to be a part of the Black Arts Movement, *Trumbull Park* remained out of print until its 2005 publication in the Northeastern University Press series edited by Professor Richard Yarborough. Although there are many reasons for *Trumbull Park*'s obscurity, we must acknowledge that writers who championed social protest, as Brown did, were almost surely writing themselves and their work into obscurity, victims, they would be called, of a naïve faith in ideology and in the efficacy of literature as a political and cultural weapon. The social protest tradition represented by Richard Wright was written off as an "exhausted mode" (Gates and McKay 2004, 1360) contaminated by its relationship to Marx, Lenin, the Communist Party, race, and the absence of high modernist technique. If we understand the 1950s as a Cold War standoff between

the United States and the Soviet Union, which made acceptable the government repression of liberals and leftists, of thought as well as acts, of speech and the written word, then it is easy to see that it was a short walk to subscribing to the official conservative line (also known as the liberal anticommunist line) that art should be free from any social, political, or historical context. In one of the most moving personal accounts of this period, the author and, more importantly, publisher Andre Schiffrin writes in his memoir *A Political Education: Coming of Age in Paris and New York* that there has never been any real calculation of the extent, damage, and terror of postwar persecution of liberal thought: progressive bookstores were bugged and forced to close, the mail of ordinary Americans was intercepted, J. Edgar Hoover spread a steady diet of (often false) information to newscasters and newspapers, the left-wing press disappeared, writers and filmmakers were blacklisted, unions were destroyed, and nearly every mainstream publication in the United States became wise to what was acceptable to the FBI and the State Department and published accordingly. Schiffrin concludes: "all learned to accept and internalize the lessons of McCarthy" (2007, 98–103).

Those lessons were well learned by the scions of the elite literary establishment, who dominated 1950s literary culture and helped facilitate the 1950s turn from social realism to a conservative modernist aesthetics, a story that has been rehearsed many times and is more complicated than I can present here. Suffice it to say that one of the casualties of Cold War politics was literature or films that too aggressively engaged social, racial, and/or political concerns. Literary productions that rose to the top of the mainstream charts exhibited the qualities approved of by the New Critics—complexity, irony, paradox, and ambiguity—which became the measure of literary value. Social protest was presumed to have none of these, and *Trumbull Park*'s deep concern with race and civil rights would have marked it as too tightly tethered to political issues and not eligible for consideration by the New Critics.[12] As Harvey Teres notes in his study *Renewing the Left: Politics, Imagination, and the New York Intellectuals*, ignoring race and the political and cultural life of African Americans was standard procedure "from the 1930s to the 1960s" for a major New Critical literary journal like *Partisan*

Review as well as for "nearly every other white publication in the country" (1996, 213).

Black cultural critics were also of this Cold War cultural mindset. At the First Conference of Negro Writers in 1959 and in the earlier *Phylon* symposium in 1950, several major black critics suggested that the elimination of black characters and racial concerns was the price of the ticket into the mainstream. In his two early essays, "Everybody's Protest Novel" (1949) and "Many Thousands Gone" (1951), James Baldwin borrowed liberally from the code words of the New Criticism to claim that "only within this web of ambiguity, paradox, this hunger, danger, darkness, can we find at once ourselves and the power that will free us from ourselves" (1949, 1701). Looking for complexity and ambiguity in all the right places, Baldwin established his solid standing in New Critical discourse and helped pound another nail in the social protest coffin (1949, 1699). Ralph Ellison's National Book Award–winning *Invisible Man* was measured worthy by its embrace of New Critical aesthetic values and by its distance from social protest. What the cultural historian Andrew Hemingway says in his study of visual artists on the Left applies equally to literary artists of the 1950s: the barrier between critical success in the cultural mainstream and doing socially committed art became "impermeable" (2002, 146).

Still, in the civil rights atmosphere of the late 1950s, the Cold War cultural machines were no longer quite so powerful as they had been in the early and mid-1950s. Brown's first novel garnered a fair amount of literary attention in important literary and cultural venues and was reviewed in major newspapers and magazines. The *New Yorker* called it a "vigorous and exciting first novel." The South African writer Alan Paton, the author of *Cry, the Beloved Country*, wrote a featured review on the front page of the April 12, 1959, *Chicago Tribune* Sunday book supplement, claiming that *Trumbull Park*, though it would shame white Americans, was a story of courage and not hatred. Van Allen Bradley, the literary editor of the *Chicago Daily News*, praised both the author and the publisher for the courage it took "to bring this book into being" (1959). Even in parts of the South the novel was enthusiastically received. Writing for the *Montgomery Alabama Advertiser*, Bob Ingram (1959) said that though

the story was fictionalized, its "feeling of white against black" was "too real not to be true."

Langston Hughes (1959) praised the new author in *Jet* for writing about "his own people"—"their warmth, their humor, their language, their blues"—with love and for documenting racial struggle.[13] When the Chicago poet Gwendolyn Brooks, who knew Brown well, eulogized him in a poem published in *Negro Digest*, "Of Frank London Brown: A Tenant of the World" (1962, 44), she imagined him in nationalist terms as a religious mystic and a prophet of righteous fury, not unlike Malcolm X. While Brooks dropped hints of a more expansive political view in her description of Brown as a "tenant of the world," reviews of his novel viewed it almost solely as a civil rights/nationalist text.[14] Indeed, the images in the novel of marching, singing black protestors and white-black integration battles seem to demand a reading of the novel as a civil rights/racial narrative, and such scenes and images inspired the initial swell of critical interest but created something of a critical bind for the novel as well. Along with Brown's self-proclaimed commitment to progressive black activism and to social protest writing, commentaries about *Trumbull Park* that could not or would not evaluate the novel as ideologically nuanced and/or formally innovative sealed the novel firmly within the confines of U.S. racial protest fiction.

I suggest that understanding *Trumbull Park* as a lens through which to read the anxieties and ambivalences produced by the Cold War can help us confront our amnesia about that period. I propose a multilayered reading of *Trumbull Park* that shows us how to read this and other black texts of the Cold War, which are often submerged under the all-purpose heading of "social protest."[15] As a text produced at the cultural crossroads when the institutions of the Left were crumbling under the pressures of McCarthyism, as the civil rights activism of the 1950s was struggling to emerge, and as the powerful coalitions of the civil rights and black nationalism were activating, *Trumbull Park* responds to a complex cultural and political moment. The Cold War mafia was playing a serious game of hardball, and these pressures had serious consequences. After Langston Hughes was chastened by McCarthy's investigative committee in the spring of 1953, he hurried that following summer to remove all references to the most famous

American Negro intellectual W. E. B. Du Bois from his collection of biographical essays *Famous American Negroes*. In return for his complicity and silence, as we learn from his biographer Arnold Rampersad, Hughes was allowed to "survive on acceptable terms as a writer" (2002, 229–231). Later that decade, the FBI dropped in to review a production of Lorraine Hansberry's 1959 play *Raisin in the Sun* and reported in her file that the play had passed bureau inspection—*Raisin* was not communistic, the agent reported, but by the time the play opened several controversial scenes had already been scuttled.[16] Paule Marshall, the author of the 1959 novel *Brown Girl, Brownstones*, was mysteriously summoned to the State Department as late as 1965 for a "briefing" before being approved for a cultural tour of Europe with Langston Hughes. She found herself in a Kafkaesque scene, seated in front of a desk on which the State Department official had placed Marshall's "extensive" FOIA dossier, containing, Marshall discovered, "a detailed account of my involvement in every political organization to which I had ever belonged" (2009, 5–6). Brown is representative of many politically engaged black writers of the late 1950s—trying to construct a resistant black subjectivity and an oppositional cultural critique but also vying for mainstream acceptance, all while trying to maintain a safe distance from the very left-wing radicalism that inspired their work.

BROWN'S FBI FILE

It is impossible to imagine that as he began writing *Trumbull Park* Brown could dismiss or ignore the bureau's threatening implications, with its freedom to invade his private life as well as its power to destroy his reputation and censor his writing. We will never know the extent to which Brown's FBI encounters influenced the literary politics of *Trumbull Park*, whether they induced what Maxwell calls "FBI-provoked defining prerevisions" (2003, 62), but we do know that he consistently thwarted the agents with his unwavering civil rights dedication and his noncommittal statements about communism. Reading Brown's novel alongside his FOIA file does

offer, however, an interpretive strategy for deciphering the novel's tensions. Brown creates a plot that seesaws back and forth between a black civil rights–centered narrative and one that is inflected by but constantly backgrounds its black leftist cultural front politics. The FOIA file makes it easier to spot this juggling act in the novel. What I want to do first is to examine these tensions by looking at *Trumbull Park* and Brown's FBI file as interactive texts that, taken together, reveal the novel's conflicting aims. I will first provide a brief synopsis of Brown's FOIA file, then closely read four scenes in which Brown stages a rhetorical confrontation between an emergent black nationalism and left-leaning politics, which I call the novel's dueling radicalisms. These duels enact the very tensions I refer to earlier—between civil rights coalitionism, insurgent black nationalism, and left-wing interracial alliances, each of the four scenes producing the novel's palimpsestic traces of black-Left alliances.

Notwithstanding the FBI's nefarious record of trying to turn leftists into enemy spies, Brown's FOIA file, which William J. Maxwell, the pioneer scholar of black spycraft textual studies, generously shared with me, underscores my claim that Brown was a man of the Left. If the leftist cultural front was constituted, as Bill Mullen argues, as a "coalition of liberals, radicals, trade unionists, farmers, socialists, blacks and whites, anti-colonialists and colonized," (1999, 3) then the only group missing from Brown's coalition was farmers. Brown's FOIA file, dating from March 21, 1956, presents an extensive résumé of what the FBI considered his "subversive" activities with peace activists, union organizers, the foreign born, civil rights protestors, communists, and dangerous periodicals. Among those activities cited were his membership in the NAACP, his work as union organizer for the UPWA and later for the progressive Textile Union, and his one-year subscription to the communist paper *The Worker*. Additionally, the bureau cited Brown's membership, including his signing of the nominating petition in 1950, in the Progressive Party—a group the FBI considered in league with the Communist Party.[17] The suspicion that Brown may have been a communist was raised several times in his file, with no firm evidence except that the description of "a Negro male, 27-years old, active in the NAACP, member of the Packinghouse Union, and reader of Communist daily paper,

'The Worker,' [*sic*]" listed on the CP registration of the Illinois-Indiana CP District, matched Brown's.[18]

The FBI informant also caught Brown's speeches at meetings of the Midwest Conference to Defend the Rights of Foreign Born Americans on May 4 and 17, 1955, where he was recorded as stating that his union would work for the repeal of the infamous 1950 McCarran Act that gave the attorney general the power to investigate "un-American" activities. Brown attacked the McCarran Act in particular for its use against those unions whose "most active union members are of foreign birth," an attack the FBI would surely have considered "subversive" for its support of unionists *and* foreigners (U.S. FBI, Frank London Brown, 13). The informant added on May 19, 1955, that Brown had stated in his speech that "everyone, whether they be foreign born or native, should enjoy the Bill of Rights and action should be taken to arouse the public and inform them of the dangers within the Walter-McCarran Law [*sic*]" (14). The peace groups Brown was affiliated with—the Women's Peace and Unity Club, American Women for Peace, and the American Peace Crusade—were all designated by the FBI as fronts for the CP. Another report shows Brown speaking on March 26, 1957, at the International Women's Day Dinner and Program at the Kenwood-Ellis Center, sponsored by the "Communist front" WPUC.

The FBI file supports my claim about the links between Brown's civil rights activism and leftist radicalism, since Brown used this meeting to detail what he called the "unbearable" conditions at Trumbull Park. According to the report, Brown went even further, arguing, in an obvious reference to his Trumbull Park ordeal, "that members of a minority group receive no protection while going to and from work, and that they were insulted and assaulted frequently and [he] further stated that the United States could not condemn other nations for discrimination of races when this nation restrains Negroes, Chinese, and Mexicans under police rule" (28). What is important for my purposes is that this FOIA file, however venal the motivations of the FBI, is the only document that gives us a sense of the extent of Brown's left-wing radicalism. The FBI even uncovered a politically radical genealogy for Brown. According to the files, Brown's father, Frank London

FIGURE 5.1 (a). Pages from Frank London Brown's FOIA file (1957).
Source: U.S. Federal Bureau of Investigation.

Brown Sr., was a "Solderer in the Tin Copper Ware Union 758 of the radical Mine Mill Workers Union, CIO Branch South Side-Washington Park; 5th Ward, Cook County." It asserts that he and his wife, Myrtle L., a factory worker, were CP members for about six years, until 1945, when Brown Jr. would have been eighteen.

CG 100-30890

anyone else. It was pointed out to BROWN that the CP is usually quick to capitalize on a situation such as that described.

BROWN was asked if he would be willing to aid the FBI, at which BROWN stated that he did not want to do so due to the fact that inasmuch as he is primarily concerned with supporting his family through his job as Organizer for the Textile Workers' Union of America and, with becoming a writer, he felt he could give none of his time to any other activity. He stated that he has just finished writing a book on the Trumbull Park situation and if published, will devote more time to writing.

BROWN went on to state that he felt that the FBI had failed him in 1955 and because of that, he was not willing to help the FBI in 1957, even if he felt so inclined to do so. He elaborated on the point by stating that in 1955 he had brought to the attention of the FBI and other Federal and local agencies what he thought to be the injustice of the Trumbull Park situation. He stated that the Federal agencies failed to come to his aid.

The limitations of Federal jurisdiction were then explained to BROWN by the agents whereupon he stated that he now could understand why no aid came to him and realized now that such a situation can only be altered by an act of legislation.

BROWN added as an afterthought that his personal answer to overcoming "Trumbull Park" is to become personally wealthy for in that way the color lines fall.

BROWN was very cordial and listened attentively during the entire interview, which lasted approximately three hours.

Due to the fact that BROWN had another engagement, the interview was terminated with the suggestion that the agents contact him again soon thereafter, in order to further elaborate on the reason why his aid to the FBI could be very valuable to the United States.

- 2 -

FIGURE 5.1 (b). Pages from Frank London Brown's FOIA file (1957).
Source: U.S. Federal Bureau of Investigation.

What may have been the final straw for the FBI's security sensitivities was a demonstration on October 7, 1955, at the U.S. Customs House in Chicago, where Brown was "one of approximately 37 persons" protesting a session of the subcommittee of the Senate Internal Security Committee, which was investigating the sending of communist propaganda through the mails. The informant "Chicago T-1" (the twenty informants in Brown's

CG 100-30890

BROWN stated that he was sur
interview would not change his mind ar
that he would not appreciate another i
then departed with the request that B....
in strict confidence.

Evaluation:

It is the opinion of the agents that BROWN
will always rationalize every aspect of his life henceforth
in the light of "Trumbull Park." BROWN was receptive to
the remarks of the agents and was courteous, exhibiting
no hostility whatsoever during the interview.

Factors precluding a reinterview are:

BROWN's seeking to publish his book and
continuing his writing pursuits, and his completely
apathetic attitude toward the Communist exploitation
of the Negro.

No further interview is contemplated at this
time because with this attitude, BROWN is completely
unreceptive to further discussion.

- 3 -

FIGURE 5.1 (c). Pages from Frank London Brown's FOIA file (1957).
Source: U.S. Federal Bureau of Investigation.

FOIA file are numbered T-1 to T-20) reveals that Brown was one of the people carrying signs in the demonstration reading, "This committee should investigate Mississippi," "Mississippi is the real threat to internal security," and "Senator Eastland, who killed Emmett L. Till?"[19] As these protest signs make clear, Brown was motivated by the racial inequalities reflected in the hypocrisy of a Senate investigative committee powerful enough to mount

a national and international campaign of surveillance of communists but unable to end (or even properly investigate) racial terror in the South,[20] or, for that matter, in Chicago. This 1950s picket demonstrates the existence of a powerful civil rights/radical Left coalition, but the singular racial focus of the protest signs may also foreshadow the instability of that unity. The FBI, however, did not draw any fine distinctions between radical civil rights activists and radical leftists. Brown's picketing of the Senate investigative committee led directly to the FBI's decision on November 6, 1956, that "FRANK LONDON BROWN be placed on the Security Index."[21] Another undated report cautioned that the investigation of Brown should be "assigned to mature and experienced agent personnel, and care should be taken so as not to give the impression that the Bureau is investigating the labor union activities of ———," the names blacked out.

Brown's FOIA file, dated from 1955 to 1957, was in the works before he began writing *Trumbull Park*. He might not have been aware of the extent of his FBI surveillance, which prevents me from reading the novel as an extensive dialogue with the "F.B. Eyes," as William J. Maxwell so effectively reads Claude McKay's work.[22] However, Brown was contacted by the FBI for an interview, and his skillful fencing with the FBI in this particular report may have been the pilot for the scene of FBI surveillance that appears in the novel. On May 22, 1957, with Brown safely out of Trumbull Park, which the FBI considered the potentially embarrassing territory of unleashed black rage, bureau agents contacted Brown near his new home (at 308 West Ninety-Fifth) and informed him that they were interested in "the subversive infiltration of unions as is being conducted by the Communist Party (CP)." Brown invited them into the house, where they questioned him about his knowledge of CP activity; he claimed to have none. They warned him of CP tactics and asked if he would be willing to "aid the FBI." Brown's answers are at first evasive, then more direct, but always cagey. At first he says he is primarily concerned with supporting his family through his work as organizer for the Textile Workers Union of America and that his aim is to become "personally wealthy," for in that way "the color lines fall." When asked if he could aid the FBI, he refuses, saying that he could not spare the time from his writing and that, furthermore, "the FBI

had failed him in 1955" when he "brought to the attention of the FBI and other Federal and local agencies what he thought to be the injustices of the Trumbull Park situation." Because of that, even if he had felt so inclined to help the FBI, "he was not willing" to do so in 1957. The agents apparently believed that they had explained to Brown's satisfaction why the FBI could not have intervened in Trumbull Park, and the report blithely assumes that "he could now understand why no aid came to him and realized now that such a situation can only be altered by an act of legislation" (2). Throughout the three-hour interview, Brown was "very cordial and listened attentively." He was "receptive to the remarks of the agent and was courteous, exhibiting no hostility whatsoever during the interview" (3). The agents do seem dismayed about Brown's "completely apathetic attitude towards the Communist exploitation of the Negro" and correctly conclude that the fight to desegregate Trumbull Park was a defining moment in Brown's life: "It is the opinion of the agents that BROWN will always rationalize every aspect of his life henceforth in the light of 'Trumbull Park.'" The report says that Brown terminated the interview, saying, "He would not appreciate another interview." The report ends: "BROWN is completely unreceptive to further discussion," indicating in so many words that he would never be a Communist Party member "inasmuch as the Communist Party could do nothing of value for him in order to help him advance financially or socially or in his fight for equal rights for people of his race" (2). As with comments he made in the *Chicago Defender* after the publication of *Trumbull Park*, the FBI interview suggests an ambivalent posture on Brown's part that makes it difficult to assess whether his anticommunist comments were motivated by desires for upward mobility or were a serious critique of the Left's problematic relationship to black activism—or if they were simply a maneuver to avoid censure. On the other hand, though these files often supply informative biographical material, one always has to read FOIA files skeptically, as potentially unreliable, biased, and deceptive, but one also has to read Brown as both character and author in the FBI text, a seasoned political operative dedicated to black struggle, bitter about the lack of FBI support for the black families facing white mobs in Trumbull Park, producing for the "F.B. Eyes"[23] his own equivocal, mocking, and subversive performance.

READING FBI FILES AND *TRUMBULL PARK*
AS INTERACTIVE TEXTS

Throughout *Trumbull Park*, the direct links between black cultural aesthetics and the discourses of the literary Left are always undercut as Brown dances around these signs of the novel's associations with the Left and the Communist Party. Throughout the novel, Brown uses black vernacular cultural forms—blues, jazz, black vernacular speech—as signs of opposition and as a vehicle for producing class and race consciousness. This fusion in *Trumbull Park* of black vernacular culture and political struggle might be considered, metaphorically, the soundtrack for what is known as the black belt thesis. Adopted in 1928 by the international Communist Party as "The Comintern Resolution on the Negro Question in the United States," the black belt thesis argued that blacks in America constituted a "community of culture," sharing language, territory, economic life, and psychological makeup, and this thesis explicitly designated blacks in the American South as "an oppressed nation" with the "the right of self-determination."[24] While the Communist Party's notion of an African American nation rising up within the American South was never a realistic political goal (and in fact was ridiculed by many African Americans),[25] the potentialities of an organized black community—particularly one that celebrated black culture and history—excited many of the leading black intellectuals of this era. African American writers of the 1920s, 1930s, and 1940s, including Langston Hughes, Richard Wright, Ralph Ellison, and Chester Himes, who were affiliated in varying degrees with communism, saw the possibilities for black cultural advancement in this embrace of black cultural forms.[26] As part of a leftist effort to embody a unified black community, black artists on the Left increasingly represented black vernacular culture in their texts through the incorporation of folklore and a celebration of jazz and the blues, believing that this kind of collective consciousness, which had its source in black cultural traditions, could create the potential for political action. One example of the influence of the black belt thesis in Brown's novel is the staging of the final walk-in scene, when the Trumbull Park group refuses to ride in the

safety of the police vans but decides to stand up to the white mobs. Narrated as a collective chant, the walk-in scene features its main character—an "ideologically transformed" urban industrial worker—united with the other Trumbull Park protestors, belting out a Joe Williams blues song that enables their political resistance. Thus, while the novel's credentials as a civil rights text seem never in doubt, *Trumbull Park* is also invested in producing a narrative born of left cultural values.

But if Brown aligned his work with traditions of social protest, his novel breaks with the formulas of social realism as defined by Richard Wright in the 1930s and 1940s. Despite the similarities with Wright in the novel's examination of class exploitation and urban racial violence and Wright's presence in Chicago leftist culture in the 1930s and 1940s, neither Wright nor *Native Son* appear as anything but faint traces in Brown's literary and cultural framework, and neither is cited by Brown as a literary or political influence (Graham 1990). In contrast to *Native Son*'s Bigger Thomas, *Trumbull Park*'s major black characters are several black working-class married couples based on the original Trumbull Park protestors. Over the course of their desegregation battle, they move from racial shame and fear to their first acts of political militancy, from experiencing blackness as inferiority to manifesting its power to inspire political action—a clear departure from Wright's bleak naturalism. Brown was conscious of his role as a modern, if not modernist, writer, consulting books on writing and citing artists as diverse as Gwendolyn Brooks, Fyodor Dostoyevsky, and Thelonious Monk as influences. Brown credits Monk as a modernist model because of the "daring in execution in his work," specifically citing Monk's conscious experimenting with combining "traditional blues and abstract bop as two features of a really different music," a strategy that Brown tried to emulate with "jazz-oriented language" in his fiction (Brownlee 1960, 30). There are several places in the novel where music is an emotional or psychological barometer of a character's interior life or where it is used to signify or inspire collective action (Graham 1990).[27] At other points in the novel, Brown departs entirely from conventional narration. In a remarkable scene about halfway through the narrative, the narrator disrupts his own male-privileged narrative voice, explicitly questioning the way he has represented

women up to that point, after which the novel shifts its focus to women as political activists. Like the musical avant-gardist and in contrast to what is typically considered social protest, Brown plays with and occasionally dispenses with conventional realism, a technique he would probably attribute to his lessons from Monk. He often read his short stories on the radio to jazz accompaniment to capture that spirit of improvisation in his fiction because, he said, "I wanted to make it *hip* to be socially conscious" (quoted in Brownlee 1960, 30).

Let me return here to the four scenes I call scenes of "dueling radicalisms," each of which juxtaposes black cultural or political nationalism and an image of leftist interracial radicalism but refuses the implications of the latter. In the midst of the racial turmoil the families have endured, Buggy is listening to a church radio program and finds in the exuberance of the black church music an unusual sense of connection with Southern black culture (which seems straight out of the CP's black nation thesis), a much-needed antidote to the racial hatred he is experiencing in Trumbull Park:

> I felt happy in my bones, like I had just been sent a message from home. From home? I don't know from where. Maybe from the South; maybe from the past; maybe from those people I used to see in Helen's father's Negro history book, with that thick, bushy hair fixed up there some kind of way, and those thick curly moustaches, and that proud look that's just beginning to get back in style.
>
> (223)

These pictures from the Negro history books conjure for Buggy both those public portraits of nineteenth-century black leaders like Frederick Douglass, with "bushy hair" and "that proud look," and also contemporary black nationalists, complete with Afro hairstyles and militant politics. Moreover, Brown's nationalism surfaces throughout the novel, especially in the narrator's comments on the beauty of black faces. Buggy's descriptions of Helen are as political as they are poetic: "Deep dimples in her cheeks looking like great comma marks. Eyebrows like black rainbows curving around those deep-set night-time eyes, looking brown then black, and nothing but soul

in them" (122). In another passage describing both Helen and her mother as having "rich-brown skin" and "coarse, glossy hair" (221), the intent to counter the negative images of black skin and hair is obvious. On a larger political level, Buggy's statements of solidarity with the few black police officers allowed to patrol Trumbull Park is another instance of both his and Brown's nationalist intentions. One black policeman is described as "tired and pained and wrinkled with some way-down-deep misery" (140), and, almost against his will, Buggy is forced to acknowledge their shared history: "I knew that it was my misery, that his misery was mine. There was something in that tired face that was kin to me" (140).

But even as Buggy tries to solidify his somewhat tenuous sense of black consciousness with images of black militancy, the novel shifts abruptly in the next chapter to a meeting between Buggy and Arthur, another black resident, and Mr. O'Leary, a white Trumbull Park neighbor, who, Arthur says, has something they both need: "Knowledge, Daddio, knowledge. Mr. O'Leary's got it" (234). Mr. O'Leary turns out to be a true white ally, attacked by the Trumbull Park mobs that view him as a "nigger lover," thus forcing Buggy to revise his feelings about whites: "Here was a man who was white, who had to put wooden boards against his window just as Arthur had" (235). O'Leary gives the two men information about the larger plot behind the Trumbull Park battle, explaining how speculators were manipulating the riots and planning to turn the Trumbull Park projects into a private investment, charge blacks higher rents, and exploit black labor: "There are no accidents in society," he tells Buggy, and, in his refusal to accept the status of universal (white) American, he too claims his noncitizenship: "where is my America, boys? I'm seventy-three years old. And I'm an outcast, for trying to be an American." The chapter ends with a moving image of O'Leary as a kind of revised American icon. He is depicted standing in the doorway as Buggy and Arthur leave, holding a kerosene lamp to light their way out into the night, "that lamp lifted high in his old hand—a perfect target for anybody who wanted to throw anything in his way" (244). The image of the Statue of Liberty as a left-wing white radical lighting the way for black civil rights activists does double duty, suggesting the ironic revision of an American democratic icon and the image of interracial solidarity.

Mr. O'Leary never appears again, and the courage of the black residents is enabled mainly within the context of the family and the black community; nonetheless, that struggle is affirmed throughout the novel by these gestures of support from allies like O'Leary.[28]

Buggy's personal experience with O'Leary is replicated on a larger scale in the novel's representation of a protest march on City Hall in support of Trumbull Park's desegregation. Though the novel gives credit to "the Negro Businessmen's Society" for planning the march, the protest march on Trumbull Park that was organized in October 1955 by the NAACP is described in the investigative article as comprising a broad coalition of activists, attracting five thousand participants from labor, religious, and civic organizations, including thousands of packinghouse workers. Though the FOIA informant may have been conflating the CP and the left-leaning United Packinghouse Workers Union, which was actively involved in the desegregation of Trumbull Park, the FBI reported that the Communist Party "has a project in force now to agitate on the Trumbull Park situation" (U.S. FBI Frank London Brown 14). The march described in the novel has all the elements of this kind of coalitional politics. Several characters applaud the march as an example of mass action from "the old days" (Brown 1959, 337). Singing "We Shall Not Be Moved" and even improvising some of the stanzas, a large diverse crowd of demonstrators marches to City Hall, carrying picket signs, some wearing badges that read "Picket Captain." Brown's description of the protestors draws explicitly on images of progressive organizing: "there were people in line who were dressed up; there were people wearing jackets from unions; there were old ladies with cloth coats and babushkas. . . . Negro men, Negro women; white men, white women, Mexicans; all sorts of people." Buggy wonders to himself: "*Where had they come from? Why were they there? They didn't even know me. Why were they so concerned?*" (339). As a black airplane factory worker in the mid-1950s in one of Chicago's unionized plants, Buggy would, of course, know who these people were, as Brown obviously did. When someone gives him a picket sign to carry, Buggy says it "seemed like they had rehearsed all this somewhere before," suggesting that both he and Brown have memories of the sources of this mass protest. Given Brown's position as a UPWA organizer during this period, and that

Brown himself had organized and participated in such protests, Buggy's naïveté about the political meaning of a demonstration, in which a multiracial, unionized, working-class collective is joined in mass protest against social injustice, is another instance of the text attempting to maintain an ideological neutrality that disguises its left-wing contexts. Moreover, while there were actually two demonstrations against the Trumbull Park mobs during the desegregation effort, one sponsored in May 1955 by the "Negro Chamber of Commerce" and another by the militant Chicago NAACP in October, the novel attributes its march to a fictional "Negro Businessmen's Society," which sounds too suspiciously like the "Negro Chamber of Commerce," as if Brown is again trying to shift his allegiances from leftist political action to black capitalism.

In another instance of the tension between black civil rights nationalism and leftist interracial radicalism, the novel implicitly rejects the latter. One of the women in the Trumbull Park group, Mona Davis, is asked by "some kind of businessmen's society" to speak at the Greater Urban Church (a stand-in for Chicago's Greater Metropolitan Church) to enlist community support for the Trumbull Park resistance. This scene frames political anger in a collective, public space that is reminiscent of civil rights imagery with "white-robed men and women sitting in the choir box" and speakers orating in the call-and-response tradition of the black church. The preacher begins the meeting with a sermon about "the evil forces that feed on discord among the working men and women of our great nation!" The sermon shifts, almost immediately, into both Christian and Marxist messages, but it headlines the more obvious rhetoric of left-wing interracial proletarianism. The preacher denounces the forces that would "turn Negro against white," "brother against brother." Calling for the congregation to recognize that "our white sisters and brothers" will suffer when "they allow themselves to be fooled into breaking ranks with us" and that they will one day discover "who is really responsible for white slums, white unemployment, white hopelessness, white despair!" (329), the speech reflects the interracial, working-class politics of the leftist cultural front. But the black church crowd and Buggy are unmoved by these images of black and white working-class unity, and Buggy responds: "There weren't too many amens after these last words. The

day this big man talked about seemed too far off for any of us to see, too far off to me to make going back to Trumbull Park any easier. I couldn't see any of the twisted faces in the mobs out in Trumbull Park waking up and discovering any enemy but me and my folks" (329).

In contrast to the preacher's failed sermon, Mona's speech to the church crowd has both men and women crying. She movingly retells the stories of white violence and black heroism in Trumbull Park, ending with a defiant pledge that "it will take more than bombs and mobs to get us out of Trumbull Park," which sets off an uproar from the church, "Say it louder! Say it louder!" (Frank London Brown anticipating James Brown). The chapter ends with the church audience shouting their support for Mona's speech, completely upstaging the preacher's earlier homily on interracial solidarity. While one goal of the dueling radicalisms is to show women as political actors, the main result is to showcase the inadequacy of the Left's articulations of working-class unity—a signal of Brown's own reluctance to endorse the Left fully. In this key moment, however, the novel's internal split becomes obvious: civil rights activism trumps interracial labor solidarity. One has to note, however, the irony of the text's avant-garde representations of black women, given that it also second-classes the Left, which advanced the most progressive policies and ideas on women's equality. The CPUSA, the left-wing National Negro Labor Council, and leftist unions like the UPWA produced major initiatives for black women's equality in the workforce, even while black women's issues were absent from mainstream 1950s civil rights discourse. In fact, Brown's friend, the unionist Oscar Brown Jr., reported in an interview that "the resolution to increase black female leadership and to recruit more women into the union [the UPWA]" was "at the heart of what was being done by the Packinghouse Workers Union."[29]

The novel ends with the Trumbull Park "walk-in" when Buggy and his friend Harry refuse to ride in the police wagons, choosing instead to walk into TP facing the mobs. Helen initiates the walk-in by singing out the first line of a Joe Williams blues, *"Ain't nobody worried!"* and Buggy answers with the next line, *"And it ain't nobody cryin'!"* This call and response serves as a counterpoint to the taunts of the white crowd. When Buggy imagines them calling out "We dare you to walk, nigger!", he sings out a line from the

song and imitates Joe Williams's "long hip strides": "*Noooooo-body wants me. Nobody seems to care!*" Finally, when Buggy and his buddy Harry have made their way through the mob without backing down, the words come pouring out, with Harry joining in. These defiant *black and blues* resistance of the Joe Williams song creates an antiphonal relationship between music and action, much as it did in many civil rights demonstrations. The contrast with the self-induced paralysis of Ellison's protagonist at the end of *Invisible Man*[30] is significant. The invisible man sits in his well-lighted and newly desegregated underground, high on reefer or sloe gin, contemplating the meaning of his invisibility as he vibrates in his solitary cave to the sounds of Louis Armstrong's paean to black invisibility: "*What did I do to be so black and blue?*"[31] In contrast, *Trumbull Park* ends with this small, courageous act of resistance, enabled by communal support and the vernacular energy of Williams's blues. Inscribed in italics on the final page of the novel—"*Every day, every day . . . Well, it ain't nobody worried, and it ain't nobody cryin'*"—the words of the song are unmediated by any character, so that the blues voice, the characters' voices, and the authorial voice are collapsed into one, an example of the novel's formal and thematic commitment to collective action.

We must remember, however, the way this antiphonal chant borrows from another feature of left-wing literary experimentation from the 1930s and 1940s—the mass chant popularized by the Workers Theater in the 1930s and 1940s. As the literary critic James Smethurst points out, the mass chant often occurred at the end of a Workers Theater production to represent "a fragmented mass or multiple working class subjectivity [coalescing] into a relatively unified consciousness" (2004, 4). In two prominent Popular Front adaptations of the mass chant, Clifford Odets's *Waiting for Lefty* and Langston Hughes's 1937 revolutionary "poetry-play" *Don't You Want to Be Free*, Odets's play ends with the cast—and generally the audience—chanting together, "STRIKE, STRIKE, STRIKE," and Hughes's ends in a chorus singing "FIGHT, FIGHT, FIGHT." The singing represents a newly emboldened collective, a resistance to white supremacy, and a new psychological spirit. Thus *Trumbull Park* represents once again the novel's investments in simultaneous gestures toward both civil rights and black popular front aesthetics.[32]

If we push back to the scene in the novel that immediately precipitates the "walk-in," we see the pervasive thread of leftist culture continuing to animate the novel's vision. In the penultimate chapter of *Trumbull Park*, the novel abruptly and, seemingly haphazardly, inserts a reference to the 1955 conference of African and Asian nations held in Bandung, Indonesia. Trying to encourage Buggy to continue their resistance, Helen tells him that she has heard a radio story about Bandung, where, she says, "a whole bunch of colored people from all over the world—Africa, India, China, America, all over—are getting together to figure out how to keep from being pushed by all the things that are happening in the world . . . how to do some pushing themselves, how to make the wagon go the way they want it to go" (412). But not only does she connect their struggle to the larger international network of leftist political activism represented by the Bandung Conference; she also connects it to the Southern push for desegregation, by immediately adding that this same kind of "pushing" is going on in the South: "the radio talks about how down South Negroes are pushing, trying to get the Supreme Court to outlaw segregation in schools. Everywhere everybody is doing something—everybody but us, Buggy" (412). Bandung also represents Helen's refusal to settle for the bourgeois lifestyle that the new postwar prosperity seemed to promise blacks: "I don't want a Lincoln or even a fur piece like some people have. I just don't want to sit by and watch life pass me by without doing *something* about it" (412). Immediately after this conversation, Helen and Buggy begin their plans for the dramatic and dangerous walk-in, as if finally freed by envisioning Bandung as the lifeline enabling them to break from the limited *nationalism* of a U.S.-based integration struggle.[33]

The Bandung reference is thematically important, even though it is included tangentially and even though Helen is allowed to misleadingly include "America" among the invited nations, when the United States was "pointedly" not invited.[34] The twenty-nine nations that convened in April 1955 at Bandung were an anticolonial, antiracist coalition representing nearly all of Asia and six countries of Africa; the reference signals the novel's global awareness of liberation movements. The Bandung allusion also suggests that these Chicago nationalists were concerned with international

issues, and, to that end, they formed ad hoc alliances with civil rights groups as well as with the interracial Left.[35] Helen's reference to Bandung, which expressly links "the soldiers of Trumbull Park" to an international, anticolonial gathering of nonwhite people, is even more telling considering that by the end of the 1950s, Cold War politics had effectively disconnected the mainstream civil rights movement from Bandung's internationalizing focus on the colonization of people of color (see Von Eschen 1997).

TRUMBULL PARK'S REVERSE SURVEILLANCE

In one chapter in *Trumbull Park* Brown inserts a covert allusion to FBI surveillance practices, indicating that he was capable of his own undercover strategies and, as Maxwell asserts about Claude McKay, may have been intentionally writing back to the FBI. In this chapter a "mysterious white man" named Hiram Melange visits Buggy's Trumbull Park home at a moment described in the narrative as a moment of stasis, when nothing "frantic" or unusual is happening (276). Melange jokes that his name means "hodgepodge," though Buggy doubts that it is his real name and wonders how he knows everything about the Trumbull Park incidents, including Buggy's position as the leader of the protests. He carries with him a letter that Buggy says "looked like it was from the Attorney General," a letter informing Melange that "you [i.e., Melange] are not a Communist." Buggy is stunned: "Here is a cat that's so twisted he don't know what he is—has to ask somebody else what he is, and then carry papers around with him so he can prove to other folks what he is—or isn't" (279). Melange, a card-carrying noncommunist, is further discredited by the text's description of him as man with a "great smile on his big red face," hair like that "limp silky blonde hair you usually see on white actresses and models," a man who uses the term "Nig-groes," sounding like Buggy's foreman at work, saying something that is "half nigger, half Negroes" (277). Thus the depiction of Melange as an untrustworthy performer and his self-description as a "hodgepodge" suggest that Brown means to out him as an undercover agent, like the

agents interviewing him; it seems straight out of his FOIA file. There is further confirmation of his suspicious status when Melange confesses that he has come to warn Trumbull Park families not to let "these forces ruin the beauty of the magnificent courage you're showing out here!" (280). Those "forces," Melange informs his increasingly incredulous audience, are "the Commies, of course!" Melange is totally undercut in this depiction of him as duplicitous and ineffectual, but no one in the group confronts his status as a possible government agent. At the end, the Trumbull Park men assail him only because of his racial insensitivities. When Buggy asks him, "And when has your wife ridden a patrol wagon?" (279), Melange is momentarily stunned by the reality that the black people, including women, are subjected to such indignities. Nothing more is said about the implications of Melange's visit in this chapter—nothing to indicate that Brown's own scrutiny by the FBI might provide the insight missing in this chapter, and nothing to indicate how the interviewees react to this attempted intimidation. The chapter points to Brown's awareness of the power and ubiquity of surveillance even as it casts the putative FBI figure as inept. But the novel never pursues the implications of this surveillance, what it means for the Trumbull Park civil rights struggles, how it affects Buggy's political decisions, or how it might inform or impede the direction of his political work. Refusing to bring to the surface the implications of Hiram Melange's visit may have been another way for Brown to avoid identification with the Left, as if the novel's silence about an FBI threat could insure its escape from the "tarnish" of communism—black insurgency could be tolerated so long as it was not red.

BROWN WRITES FOR THE *DEFENDER*

When Brown began writing for the Chicago *Defender* after the publication of his novel, his newspaper articles show him moving away from, even undercutting, his leftist affiliations. We might well ask why a civil rights, radical union activist should disable his connections with the Left.

There are several answers. In the mid-1950s, as many black leftist activists moved toward the civil rights movement, among them Julian Mayfield, Jack O'Dell, Charles White, and Alice Childress, they found the experience of their newfound black cultural consciousness, middle-class mobility, and political independence from the Left quite exhilarating. In *Black Is a Country: Race and the Unfinished Struggle for Democracy*, Nikhil Pal Singh prompts us to remember that black political and intellectual activists had many reasons at this moment for their ambivalence toward the organized Left: "Black struggles," he argues, had come to possess a vibrancy that no longer required external mediation" (2005, 119). But we also need to read the Chicago nationalists' reluctance to use the word "leftist" and Brown's political disavowals as signs of Cold War anxiety. As the cultural historian William J. Maxwell persuasively argues in his study of the FBI's obsessive interest in black literary production, there was nothing the FBI feared more than African American political resisters linking up with the Left. In Maxwell's words, such a coalition constituted "the dead center of the radical intersection that the FBI most feared, the crossroads where African American resistance bargained with the devil of world communism" (2003, 41). The intersection of the Cold War and civil rights, as Mary Dudziak and Penny Von Eschen, among others, argue, meant that civil rights groups had to make clear that their reform efforts were within the bounds of "acceptable protest" and not connected to the Left or the Communist Party or in any way threatening the "Americanness" of the struggle (Dudziak 2002, 11). And Brown was certainly aware, as one chapter in his novel indicates, that he was under surveillance by the FBI. I suggest, however, that the blindness to Brown's left-wing radicalism and the Cold War implications of *Trumbull Park* also reflect the unexamined discomfort of Brown's readers and critics with black and red alliances. I am in agreement with Denning that when we encounter texts with racial or ethnic inflections—"ghetto pastorals" and proletarian Left models (1996, 235)—we tend to overlook and are encouraged to overlook these traces of the Left: in other words, the "black" narrative trumps the proletarian one. The tensions of Brown's novel are therefore both historic and discursive: they are first embedded in the cultural and political moment as the civil rights movement collides with an increasingly

nationalist politics, which also collides with—or in Mullen's term, "supersedes"—the Left, which is under national threat. These tensions are then reenacted in *Trumbull Park* and then again in the critical responses to the novel that refuse to acknowledge or do not recognize its leftist leanings.[36] Brown's publication of *Trumbull Park* with the conservative Regnery Press and the public Cold War–inflected speech he gave to the well-heeled Dearborn Real Estate Board the same year his novel was published signify that the balancing act between nationalist concerns, leftist politics, and an emerging black conservatism had by 1959 become a delicate and precarious enterprise.[37] Once his novel was published, Brown began to appear more often in the pages of the *Chicago Defender*, both as writer and subject, during the very years that the *Defender* was flaunting its anticommunist credentials and adopting the politics of what A. Philip Randolph called "black Americanism"—in other words, interpolating blacks into the American national narrative. At the May 19, 1959, banquet for the real estate board, Brown gave a manifestly Cold War speech, as reported on in the *Defender*, that distanced him from the progressive pluralism and class consciousness of the Black Popular Front and from the aims of 1940s civil rights militancy. In this speech, Brown declared that the battle over racial violence was a "duel to the death" between the two adversaries, Soviet Russia and the United States. Having now recast the United States as the defender of democracy and minority rights, he asserted, "we are locked in combat with Soviet Russia to test whether our system of democracy is superior to their system of dictatorship" (Brown 1959). Sidestepping the continuing spectacles of U.S. racial violence as well as international racial violence supported by U.S. policies and practices (the support of South African apartheid, for one), Brown argued that by showing our system of government superior to the Soviets, by outproducing and outmaneuvering them, Americans could defeat the "bigots and tyrants who have a vested interest in keeping their feet on the minorities' necks." This argument, which presumes (or pretends) that "bigots and tyrants" and "the U.S." are separate and oppositional entities, defies the reality of Brown's own recent experiences trying to integrate a housing project that was segregated with the support and collusion of the federal government.

Surprising and troubling given Brown's radical union work, his public defense of Paul Robeson, his collaborations with people on the Left, and his celebration of the Cuban Revolution, the speech echoes the increasingly anticommunist politics of the *Defender*, which throughout the 1950s began to parrot the FBI's position on "subversives" and to support the U.S. government's description of world politics. In 1955, the *Defender* columnist Louis E. Martin denounced the communists Benjamin Davis and Robeson for being too "intoxicated" by communism to recognize its danger to black Americans. He then explained that communism failed to take root in black communities because "*everything the Negro ever dreamed about is right here in the United States and he has always felt that if only racial discrimination were eliminated this would be Utopia.*" I italicize this passage not because I think it represents Brown's politics but to indicate how smoothly anticommunism was being interpolated into civil rights discourse. In contrast to the *Defender*, the editorials in Robeson's *Freedom* throughout the 1950s relentlessly exposed the parallels between U.S. racial violence and South African apartheid as well as the role of the United States in fomenting international racial exploitation. Whether Brown's anticommunist speech was merely tactical or, less likely, actually represented a genuine political change of heart, it articulated an untenable position for a black radical labor and civil rights nationalist. In another example of Brown trying to juggle his political allegiances, he journeyed to Cuba in 1959 during the height of the Cuban Revolution, and, though he was there ostensibly as a neutral reporter, his friend Bennett Johnson recalls that he spent "his daylight hours with Batista supporters, and his nights with adherents of Fidel Castro" and Johnson maintains quite resolutely that "[Brown] was, without a doubt, sympathetic with Fidel Castro."[38]

Bill Mullen describes the end of the 1950s as a moment when the possibilities of "sustained progressive or radical black cultural work" of Chicago's Negro People's Cultural and Political Front were also being undercut by the emergence of a growing black entrepreneurial and consumer class" (1999, 202). Adam Green (2007) argues that black Chicago entered into modernity during the 1940s and 1950s, becoming modern market consumers ambitious for and to some extent constituted by their participation in the new consumer

economy. As a newly successful writer working for the glossy picture magazine *Ebony*, posing with movie stars, and contemplating a movie deal for his novel, Brown was firmly positioned to enter Chicago's black middle class. In the three-page spread in the black picture magazine *Sepia* celebrating the novel's release, Brown was shown in shots at home with his wife and daughters; in his study writing; at Chicago's Val-Jac African art shop, where artists and writers congregated; and at a cocktail party discussing his book, as it was "heading toward the best seller list," with film star Lana Turner. In the article's cover photograph, he is standing on the steps of a downtown Chicago federal building, dressed impeccably in a lightweight summer business suit and dark tie, holding a leather briefcase as though about to enter his office. We might recall here the scene from just a few years earlier captured in Brown's FOIA report, which also describes him standing in front of a federal building in downtown Chicago not with a briefcase but holding aloft a protest sign that denounced the government investigation being held there and, as his file indicates, courting FBI reprisal.

Although Brown seems to be dancing around his associations with the Left and the CP, we may be able to understand, through a figure like Brown, how diverse and sometimes conflicting affiliations shaped a nationalist consciousness. In his history of the UPWA's relationship to Martin Luther King Jr. and civil rights, the historian Cyril Robinson reports that there was an important practical reason black UPWA organizers did not fall for anticommunist rhetoric: "Why didn't the charges of communism make much difference? The people who were most vociferous in pushing that line, looking under every bed for a red—black folks didn't get caught up. We wanted to get free. We didn't care who helped us. The vast majority of organizing came from blacks and they would not be stopped by ideological warfare" (2011, 39–40).

Brown's friend and his predecessor as program coordinator at UPWA, Oscar Brown Jr., verifies Brown's strategic political alliances with communists. While he insisted that the union was not communist when Frank London Brown was program coordinator, Oscar Brown said that the UPWA and London Brown "worked well with left-leaning people like Charlie Hayes, Leon Beverly, and Sam Parks."[39] In addition, Oscar Brown

himself was sent by the union to organize support for the Trumbull Park families, so there was at least one official and known communist in the Trumbull Park struggle. In the FOIA file on Frank London Brown, the informant, "Chicago T-20 . . . advised on December 23, 1957, that he had known FRANK BROWN Jr. personally while he was District Number 1 Program Coordinator of the United Packinghouse Workers of America Union, and that the persons with whom he had contact considered him to be a 'left winger.'"[40] Oscar Brown confirmed this assessment of London Brown's leftist political leanings: "[I] tried unsuccessfully to recruit Brown to the Party; he didn't join but he was very left."[41]

It may be that *Trumbull Park* is, finally, less about suppressing the Left than about Brown trying, against the odds, as it turns out, to fashion an eclectic leftist, interracial, international black nationalism out of a potpourri of political ideas and practices he felt would advance the cause of black liberation. Weaving back and forth between a black nationalist focus on identity and political resistance and a commitment to the crossracial radical democratic aims of earlier cultural front aesthetics, *Trumbull Park*, as well as Brown's life story, might best be seen as acts of negotiation between the conflicting formations of public and counterpublic spheres that included black cultural nationalists; multiracial political and cultural fronts; antiracist, interracial radical unions; the commercial publishing industry; black consumer culture; and the omnipresent F.B.-Eyes. In the final analysis, however, enough of the improvisatory politics and aesthetics and resistant black consciousness of Brown's Cold War generation, though up against the formidable repressive power of the last three forces on that list, would remain to enkindle some sparks in the next.

6

1959: SPYCRAFT AND THE BLACK LITERARY LEFT

*So dear friend, I must perhaps go to jail. Please at
the next red-baiting session you hear . . . remember
this "Communist."*

—LORRAINE HANSBERRY, "LETTER TO
EDYTHE," 1951

*You scratch a black man in the Communist party
and you're going to find a black man.*

—JULIAN MAYFIELD, INTERVIEW WITH
MALAIKA LUMUMBA, 1972

WITH THE EXCEPTION of Chicagoan Gwendolyn Brooks, all
the writers of *The Other Blacklist* were gathered at the Henry
Hudson Hotel in New York City in 1959 to participate in what
was billed as "The First Conference of Negro Writers." Held from Friday,
February 28, to Sunday, March 1, 1959, the lavishly funded three-day confer-
ence was modeled after the Presence Africaine conferences of the Paris-
based Society of African Culture and sponsored by an offshoot of SAC, the
American Society of African Culture (AMSAC), whose stated goal was to
facilitate "links between culture and politics in Africa and America" ("The
American Society of African Culture and Its Purpose"). The following year,
selected papers from that conference were published in a slim volume, using
the conference theme as its title, *The American Negro Writer and His Roots*,
and edited by AMSAC President John A. Davis, a professor of government

at the City College of New York.[1] As Davis stated in his preface, the broad purpose of the conference was "to assess [the progress of Negro writers] and their relationship to their roots," with "roots" suggesting only a slight nod toward the "Africa" in AMSAC's self-description, since all the participants were American.[2] Just as a questionnaire had shaped the 1950 *Phylon* symposium a decade earlier and steered its participants into a narrow self-reflection, the AMSAC "roots" theme was designed to circumscribe and limit the speakers, obscuring a contentious debate that emerged at the conference between the conservative integrationists (also known as anticommunist race liberals) and the leftist radicals. The resulting book, which omits, edits, and marginalizes the comments and speeches of some of the most radical speakers at the conference, both subdues those debates and becomes, I will argue, another example of the imaginative and ideological battles over representing race in the Cold War 1950s.

I began *The Other Blacklist* to challenge the ways African American literary and cultural histories have downplayed, ignored, minimized, or omitted the influence of the Communist Party and the Left in African American cultural practice of the "high" Cold War 1950s. In doing so, I have tried to correct the tendency in African American studies to treat communism and the Left as pejorative or irrelevant or to confine the Left's influence on black writing to the 1930s and 1940s. It is especially important to avoid the amnesia that McCarthyism, the FBI, and the CIA have promoted. At a time when being on the Left or in the Communist Party guaranteed literary extinction, the writers and visual artist of my study—and, in this chapter, the outspoken Left speakers at the AMSAC conference—continued to articulate a leftist aesthetic and politics. They challenged State Department–authored versions of integration. They furthered the resistant traditions of the Black Popular Front and the 1940s civil rights movement. They spoke up loudly, clearly, and often in support of a literature and politics of social protest and, in the process, supplied a political and aesthetic vocabulary for the Black Arts Movement of the 1960s and 1970s.[3]

Since few scholars have taken up the task of a revisionary history of this conference, the task I have set for myself is to piece together as much as possible of the original AMSAC conference, looking behind the scenes

and between the margins at the original speeches, the photographs, and the political and cultural contexts of the conference, which, I argue, show how the published volume was reconstructed to align smoothly with AMSAC's political agenda. When the entire conference is studied, including the missing speeches and comparing the published volume with the conference presentations, we can see that it was clearly a site of ideological contest. This comparative interpretive strategy allows us to reread the conference and the published volume (and ultimately 1950s black literary history) as a three-way dialectic between an embattled internationalist Left (represented by John O. Killens, Julian Mayfield, Sarah E. Wright, Lofton Mitchell, Frank London Brown, Alice Childress, and Lorraine Hansberry) determined to advance black cultural and political self-determination; a conservative flank (Saunders Redding and Arthur P. Davis), promoting narrow national definitions of integration and race; and U.S.-government sponsored spy operations (John Davis, the CIA, the FBI, and Harold Cruse, working undercover), authorized to monitor and contain black radicalism.[4]

The signs of that struggle—between conservatives, liberals, radicals, and government spies—are embedded in the AMSAC conference, but the task of interpreting these signs is challenging. Nearly the entire original cast of players in the AMSAC conference, with the exception of William Branch and Samuel Allen, died before I completed my study. Some of the conference speeches were rewritten for the *Roots* volume, and, at least in one case, an entirely different paper was submitted to the published volume. With the exception of Hansberry, original drafts and revisions of conference presentations are, as far as I know, not available.[5] Documentation of the conference planning and organization is spotty and sparse. Some of the most prominent black writers, including James Baldwin, Robert Hayden, and Paule Marshall, whose first novel, *Brown Girl, Brownstones*, was published later that year, did not attend the conference. Harold Cruse says that Ralph Ellison refused to attend because he wanted to avoid Killens, who had written a negative review of *Invisible Man*.

Langston Hughes spoke on "Writers: Black and White" with a double-voiced irony and barely concealed bitterness that distanced him from his former militancy, perhaps the result of his earlier shakedown by McCarthy.

He tried to caution writers that the publishing industry is a crass, commercial, white-controlled enterprise that sees blackness through the eyes of commerce and partly through its own racism, a perilous and unpredictable course for black writers to navigate. A black writer, Hughes insisted, must work harder and write better but still will not be able to count on the success white writers expect. Replicating the crazy contradictions of race, he ends with this final paradox: "Of course, to be highly successful in a white world—commercially successful—in writing or anything else, you really should be white. But until you get white—write." There would be no appearance by the highly sought-after writer Richard Wright, who was invited to come from Paris to give the keynote but eventually declined, so Hansberry, just three months away from her spectacular Broadway success, agreed to fill in for him.

It is important to take into consideration the silences and self-censorship of the left-wing participants, who did not openly identify as Left or communist. Moreover, as Langston Hughes reminded the audience, there were no black literary journals of the 1950s where these debates could have been expanded and explored in greater depth; thus we are, to some extent, confined to and dependent on these limited articulations provided by the published volume of the AMSAC proceedings. But one of the great values of the volume is that it allows us to tease out and foreground the leftist ideas and positions presented at the conference, and since, as I argue throughout this book, it is those ideals and ideas that encouraged political and aesthetic freedom for black writers, we are lucky to have the AMSAC archives, however tarnished by editorial emendations and CIA snooping.

FRAMING THE 1959 CONFERENCE IN THE *ROOTS* VOLUME: EDITING OUT THE LEFT

The epigraphs by Mayfield and Hansberry that open this chapter suggest that 1959—the year of the AMSAC conference—represented a crossroads moment for black leftist writers. In contrast to 1959, Hansberry in 1951

was so far to the left that she was fully prepared for and expected to go to jail. But by 1953, with the Red Scare intensifying, Hansberry left her position at Robeson's newspaper *Freedom* and applied for jobs at various publications, including the *New York Times*, cautiously referring to *Freedom* in her application as "a small cultural monthly" and listing her position there as associate editor at a "New York Publishing company" (Hansberry n.d.). When Hansberry's 1959 hit play *Raisin in the Sun* opened on Broadway, even her FBI informant could find no evidence of communist thought and concluded in the report, "The play contains no comments of any nature about Communism as such but deals essentially with negro [*sic*] aspirations" (U.S. FBI, Lorraine Hansberry, February 5, 1959). In the next few years before her death in 1964, Hansberry, like many black leftists, was drawn to the civil rights movement and in 1964 wrote the text for the civil rights pictorial volume *The Movement: Documentary of a Struggle for Equality*. Mayfield became a communist in 1956, even as its top leaders were going underground, because he considered the Communist Party the most radical organization he could join. But he also felt strongly that black nationalism, which was at the core of his radicalism, existed in uneasy tension with his leftist affiliations. For Mayfield neither the U.S. Left nor the U.S. civil rights movement was revolutionary enough: the communists of the 1950s were a problem because, in contrast to the 1930s, they "had no real effect on the black community," and civil rights organizations were because they had turned away from the militant strategies of the black freedom struggles of the 1940s (Mayfield 1970). Tensions between blacks and the Left were exacerbated in the late 1950s as the Left suffered major setbacks under the Red Scare and McCarthyism and as many black intellectuals and activists were increasingly drawn to the black freedom movement. Complicating these issues for the leftist radicals at the AMSAC conference is that AMSAC and the conference were funded by the CIA, and many of the participants suspected as much. The conference thus became a forum where these tensions were played out and where, contrary to conventional notions of a quiescent 1950s, the black Left squared off against the conservative integrationists, prefiguring—and helping produce—the black cultural militancy of the 1960s.

Despite assimilationist visions and CIA collusions, the conference organizing committee that President Davis assembled was strikingly left wing, a strategic choice that the cultural historian Lawrence Jackson maintains was a brilliant tactical move on the part of Davis to camouflage AMSAC's covert politics (2007, 721). Davis chose the left-wing novelist and Harlem Writers Guild director John O. Killens to chair the organizing committee, and Killens stacked the committee with his friends, including Mayfield, the leftist historian John Henrik Clarke, the progressive playwrights William Branch and Loften Mitchell, and the leftist writer and activist Sarah E. Wright. The conference also included a number of left-wing writers as speakers or panelists, including the playwright Alice Childress, the Chicago novelist and union organizer Frank London Brown, the recent McCarthy target Langston Hughes, and the playwright and activist Lorraine Hansberry. Though they may have been in the minority, the conservatives were well represented by the Howard professor Arthur P. Davis and the writer-scholar Saunders Redding, who were prepared to scrap any vestiges of social protest, which for them was rife with overtones of Marxist social consciousness and racial militancy.[6] The leftist lineup became a major concern for at least one ex-communist, Harold Cruse, the author of the Left-bashing *The Crisis of the Negro Intellectual*, who drafted several pages of neatly typed notes, apparently for Killens, entitled "AMSAC Writers Conference Notes" (n.d.), in an effort to displace what he called the "Marxist oriented sphere of cultural activities" of the conference. Though there is no evidence of Cruse having any final say over the program, he warned Davis that the "lineup reflects too heavily the point of view which is known to be favorable to those white leftwing" and that it would give the impression "that AMSAC also agrees officially with this point of view in literature and racial politics." Cruse then proposed that Childress, Mayfield, Mitchell, and Branch should be shifted about, dropped, and replaced so that a panel on social protest and its discussion of the topic "more democratically reflects a broader cross-section of views" (Cruse n.d.).

In light of Cruse's warnings to Killens, it is not surprising that, when John Davis created the *Roots* volume, he edited out the lively and controversial panel on social protest, specifically the papers in support of social

protest given by Alice Childress and Frank London Brown. The only evidence we have of that panel is in the paper given by Loften Mitchell, which refers specifically to "the panel on social protest" and the controversy it produced. Because the final *Roots* volume does not correspond to the conference organization, I have not been able to determine the exact format of the conference, but the table of contents in the *Roots* volume indicates that the speeches covered the following topics: "The Negro Writer and His Relationship to His Roots," "Integration and Race Literature," "Marketing the Products of American Negro Writers," "Roadblocks and Opportunities for Negro Writers," and "Social Responsibility and the Role of Protest." In a further neutralizing of the Left, Davis opened the volume with a preface promoting one of the hallmarks of Cold War ideology—that racial troubles are disappearing: "It is a tribute to both the Negro writer and America that this problem [black writers writing for a non-Negro audience] is being resolved, although much remains to be achieved" (iii). Davis added that the

FIGURE 6.1. Photo of Lloyd L. Brown and Louis Burnham at AMSAC conference (1959).

Source: Courtesy of the Moorland-Springarn Research Center, Howard University.

goals of black writers were "being true to their roots, accomplished and universal in their art, socially useful, and appreciated by a significant public." Of course, the leftist writers at the conference argued that black writers, if they followed Davis's list, risked becoming socially acceptable and politically irrelevant or, as Mayfield put it in his talk, on their way "into the mainstream and oblivion." Davis did not refer to that debate. In another example of the manipulations and omissions behind the scenes of the published volume, Lorraine Hansberry's closing address, arguably the most radical speech of the conference, was excluded from the final *Roots* volume and not published until 1971 in *The Black Scholar*. Davis also omitted John Killens's "Opening Remarks," which Killens's biographer Keith Gilyard (2010, 141) says "echoed [the radical leftists] W. E. B. Du Bois, Paul Robeson, and Alphaeus Hunton," with Killens proclaiming that "the American Negro's battle for human rights mirrored the broader struggle of colored peoples throughout the world against colonialism."

Surprisingly, Davis included a series of photographs, including some taken at the conference, that testify visually to the presence of the Left. On the opening pages opposite the title page, under the caption "The Many Postures of the American Negro Writer," there are six candid snapshots of William Branch, Frank London Brown, Sarah E. Wright, Langston Hughes, and a group picture with several participants and John Davis at the conference. At the bottom right-hand side are pictures of the two open communists, the writers Lloyd Brown and Louis Burnham, neither of whom was invited to speak, listening intently to the proceedings (Burnham with one hand shielding his face from the camera). They were apparently sought out deliberately by the roving camera, since there are several different shots of them in the AMSAC files, though neither was featured on the program. The six members of the "Conference Planning Committee" are shown in headshots on the following page, looking dignified and serious. There are two pages of photographs at the end of the volume: Richard Gibson, a black expatriate writer, shown with the civil rights leader Arthur Spingarn; Alice Childress giving the paper that was omitted from the published volume; a group picture with Saunders Redding, Arna Bontemps, his son Paul, Irita Van Doren (the influential book editor of the

FIGURE 6.2. Photo of Lorraine Hansberry giving keynote address at
AMSAC conference (1959).

Source: Courtesy of the Moorland-Springarn Research Center, Howard University.

New York Herald Tribune), and Spingarn. Filling one-eighth of the page
at the bottom is a picture of the missing "Panel on 'Protest Writing,'" with
the American flag conspicuously displayed in the center. Finally, on the
last page, under the highly ambiguous and self-congratulatory caption "The
Conference Closes with a Note of Success," there are three photographs
that point to the importance of Lorraine Hansberry's presence: one shows

FIGURE 6.3. Photo of Lorraine Hansberry at the AMSAC conference (1959).
Source: Courtesy of the Moorland-Springarn Research Center, Howard University.

her standing before a lighted podium, giving the closing address; one is a group shot with four men—Hughes, Redding, John Davis, and Bontemps; and, finally, the last is a photograph of the audience at the "closing session," where Hansberry received a standing ovation for the speech that was omitted from the publication.

These photographs certainly document the existence of the AMSAC conference and its participants, but they also subtly manipulate our view of the conference. As Shawn Michelle Smith (2004, 7) observes, a photographic archive is never neutral:

> Even as it purports to simply supply evidence, or to document historical occurrences, the [photographic] archive maps the cultural terrain it claims to describe. In other words, the archive constructs the knowledge it would seem only to register or make evident. Thus archives are ideological; they are conceived with political intent, to make specific claims on cultural meaning.

In this case, many of the photographs—particularly the formal portraits—are so staid that the book looks like a Chamber of Commerce brochure. In all of the images, the men are in suits and ties, dressed formally for what is clearly a downtown affair. Unless we know the subjects' affiliations with the Left, the photographs obscure the conference's radical tone. The AMSAC photographs, then, can be read as both a historical record of the event and as evidentiary traces that hint at what is hidden, manipulated, or distorted in the written text.

BLACK WRITERS AND THE CIA

With these political-literary debates in mind, I want to turn briefly to the relationship between the CIA and AMSAC.[7] By 1959, the Central Intelligence Agency's infiltration of American cultural institutions had been operating for more than nine years. Through its major propaganda vehicle, a front called the Congress for Cultural Freedom established in 1950, their mission on one front was to counter the Soviet Union's programs of cultural propaganda; a second aim was to conduct "cultural warfare" in order to discipline American art and artists for the work of Cold War culture. As the British journalist and CIA historian Frances Stonor Saunders (1999) reports, the Congress for Cultural Freedom (CCF) maintained offices in Paris and Berlin as well as in the United States, operating under a structure that mirrored that of the Communist Party—involving fronts, spy networks, clandestine money transfers, committed ideologues, and fellow travelers. Fronts like the Farfield Foundation were fairly easy to set up: "a rich person, pledged to secrecy, would allow his or her name to be put on letterhead, and that would be enough to produce a foundation" (1999, 127). The foundation would then funnel money to approved organizations, essentially employing a spying network, ostensibly to expose the dangers of totalitarianism, while exporting the culture and traditions of the free world (126). At some point during the 1950s, all of the major foundations—Ford, Rockefeller, and Carnegie—operated as "funding cover" for CIA funds (135), and

Ford and Rockefeller, specifically, according to Saunders, "were conscious instruments of covert US foreign policy" (139). By the early 1960s, Stoner reports that Ford had funneled about seven million dollars to the Congress for Cultural Freedom (142).[8]

The extent of CIA operations in U.S. culture, the magnitude of its influence, and its expansive reach into literary, musical, and visual arts is, in Stoner's estimation, astounding. Over seventeen years, the CIA pumped "tens of millions of dollars into the Congress for Cultural Freedom" (1999, 130). With fronts like the Farfield Foundation, the Norman Foundation, and *Encounter* magazine in place, the CIA proceeded to sponsor art and sculpture shows and literary debates and conferences in Europe and the United States. They published the anticommunist essay collection *The God That Failed* and sponsored an arts festival in Europe, which the French communist press labeled U.S. "ideological occupation." In the visual arts, there were collaborations between the CIA and private institutions like the Museum of Modern Art. The CIA contributed to art exhibits in Europe and organized cultural festivals through the CIA-sponsored Congress for Cultural Freedom, establishing the CCF as "a major presence in European cultural life" (107). The presence of the CIA and the involvement of major figures in the art and literary worlds and government officials, all connected with and supported in some way by the CIA, make it impossible to overlook the fact that the CIA was a major force in U.S. culture throughout the 1950s and 1960s.

But, according to Hugh Wilford (2008), the CIA appeared to have had its greatest effectiveness in literature, where "the link between modernism and the CIA appears clearest," especially "in the covert subsidies to little magazines such as *Partisan Review*" (116). In his extensive study of the CIA's relationship to AMSAC and black literary work, Wilford shows that AMSAC was "the CIA's principal front organization in the African American literary community," intended, Wilford asserts, to ensure that black political thought would stay firmly within the boundaries of acceptable forms of anticommunism (200).

Wilford identifies two CIA concerns behind its involvement with AMSAC. The first was to ensure a flow of information about the emerg-

ing independence movements in colonial dominated countries, especially in Africa, and to steer these emerging independence movements away from communist influence. The second was to counter growing civil unrest in the U.S. South, sparked by white resistance to the civil rights movement. This unrest was being broadcast throughout the world and used by the Soviet Union to score propaganda victories against the United States as the site of racial violence against blacks. The U.S. State Department was looking for—and found—blacks willing to advertise a positive view of U.S. race relations to counter the images being shipped abroad of dogs attacking children in Birmingham and white adults heckling children trying to go to school, but the government's promotion of African American intellectuals was most certainly contingent on their distance from the Left (Wilford 2008, 199; Plummer 1996).

On February 20, 1975, the *New York Times* reported that the Manhattan-based Norman Foundation, a CIA front, had directed $50,000 to the American Society of African Culture. Many members of AMSAC were suspicious that the CIA might be involved in it, but that did not deter them from participating in the organization. With offices in New York in the tony East Forties (where other CIA front offices were located) and a spacious Fifth Avenue apartment "for use as guest quarters" (Wilford 2008, 206), AMSAC had the CIA's signature written all over it. As "money flowed in" for AMSAC operations like annual conferences, festivals in Africa, book publications, and expenses-paid travels to Africa and Europe, it would not have been hard to figure out those connections.[9] William Branch said that members wondered where all the money was coming from since no one was asked to pay dues or asked to sponsor any fundraising events. Branch (2010) says that the rumors began almost immediately: "For a number of years there were those of us who had suspicions about the money supporting the organization. We were told it was coming from various foundations. Certainly it was not coming from the members because there were no dues." In a letter in the AMSAC files at Howard University's Moorland-Spingarn Collection, the Boston University sociologist Adelaide Cromwell Hill reported that she remembered the exact time and place that someone suggested CIA sponsorship of AMSAC, and she makes clear that CIA

involvement was intentionally not documented (cited in Wilford 2008, 213). When Yvonne Walker, one of AMSAC's staffers, was interviewed, she reported that she was surprised that she had to be checked by the FBI and required to swear an oath of secrecy. Although Davis denied the link to the CIA, Walker says, "Dr. Davis informed the CIA on everything that was going on," and she was sure that "they [the CIA officers] helped to steer some of the plans" (quoted in Wilford 2008, 214). Although Davis, as well as the other officers on the Executive Board, knew about the CIA connections, he never acknowledged his connections with the CIA or its sponsorship of AMSAC, even after they were established by the *New York Times*.[10]

The leftists at the conference were not under any illusions about AMSAC's funding. During a break in the conference, Lloyd Brown chatted with his long-time friend Langston Hughes at the hotel bar, remarking, "With its ample supply of free drinks of the best brands, the sponsors seemed very well funded." Hughes replied, "By somebody with a *whole* lot of dough." Brown responded, "Yes, and he can print all the money he needs." Hughes merely shrugged and asked Brown if he planned to go along to the upcoming conference in Africa, also sponsored by AMSAC. But Brown had not been asked to go, "for the same reason I had not been asked to be one of the speakers—my long association with Paul Robeson" (1996 interview with author). And, he might have added, his open membership in the Communist Party. The AMSAC sponsor, Brown noted, "appeared from nowhere and vanished the same way" (1996), but, of course, these issues surfaced again in the 1970s when AMSAC was named in the Senator Frank Church report as a CIA-funded organization.

What must be addressed is the effect of CIA influence during its unimpeded seventeen-year campaign to control U.S. culture and, more specifically, the black literary and cultural Left. Wilford (2008, 116) wonders "how writing might have developed in Cold War America without the 'umbilical cord of gold' that united spy and artist," a reflection that has implications for the direction of African American writing in the 1950s and 1960s and specifically for the First Negro Writers Conference. Any reading of the conference, then, must account for how the speakers, the conference program, and the published volume, directed and edited by Davis, were influenced by the

presence and power of U.S. government spies and, even more to the point, how African American literary and cultural production of the 1960s and beyond continued to be shaped by these collaborations.

THE LEFT VERSUS THE "NEW NEGRO LIBERALS" AT THE AMSAC CONFERENCE

A close reading of the conference is telling.[11] Conference participants discussed a number of issues for black writers—from how to write for the mainstream to how to form autonomous institutions—but the dominant issue of the conference was the role of protest literature in this new era of "integration," an issue clearly radioactive in the climate of the 1950s because protest writing had been associated with the Left and with a militant critique of American democracy and race.[12] Those who favored "integrationist poetics" (Houston Baker's term for those who advocated assimilation rather than black nationalism) objected to protest in both formal and historical terms, defining it as synonymous with the naturalism of Richard Wright, as placing an excessive focus on racial problems, and sometimes simply as the inclusion of black characters as subjects. Their antiprotest position was, of course, buttressed years before by James Baldwin's brilliantly argued attack on Wright and naturalism in the 1951 essay "Many Thousands Gone" as well as by the Cold War aesthetics that had demoted social realism and naturalism in favor of a modernist (nonracialized) aesthetic. Ironically, that position was also supported by Wright himself in 1957, in a lecture he delivered in Rome, "The Literature of the Negro in the United States," in which Wright—the former communist—optimistically predicted, on the basis of the 1954 Supreme Court ruling against segregation in education, that African American writers would move into the mainstream and turn away from "strictly racial themes."[13]

Whereas Lawrence Jackson (2010) says that the AMSAC conference was a clear signal that "the old guard was giving way and that the future generational conflict" would find its definition in the language of "assimilation versus black nationalism," I read its integrationist stance as heavily favored

in 1959, since the members of the "old guard" had the winds of anticommunism, the Cold War liberal consensus, U.S. global superiority, and CIA interventions at their backs. The old guard's integrationist politics are perhaps most ably demonstrated in Arthur P. Davis's *Roots* essay. Davis—a professor at Howard, a Southerner, an eighteenth-century British literature specialist, and one of the authors of the pioneering 1941 anthology of black literature, *The Negro Caravan: Writings by American Negroes*—was in his early fifties in 1959 and one of the old guard. He castigated the protest tradition as unnecessary and burdensome in this new "spiritual climate" of integration, presumably ushered in by the 1954 *Brown v. Board of Education* decision. Davis declared, prematurely as it turns out, that, with the *Brown* decision, the enemy had capitulated, and so the black writer could no longer "[capitalize] on oppression" (35). Thus he urged writers to drop this "cherished tradition" of protest, abandon "Negro character and background," "search for new themes," "emphasize the progress toward equality," "play down the remaining harshness in Negro American living," and move "towards the mainstream of American literature" (39). Segregation, he predicted, will pass, like the "Inquisition or the Hitler era in Germany," and then black writers will be able to "write intimately and objectively of our own people in universal human terms" (40). Without using the term "modernism," Davis cited two modernists, Melvin B. Tolson and Gwendolyn Brooks, as examples of black writers working in "the current style," which he said he admired because they did not, in his opinion, engage protest aesthetics but feature middle-class characters and stress life "within the group," not "conflict with outside forces" (37). To authorize his stand against protest poetry, Davis cites Allen Tate's Anglocentric backhanded praise of Tolson, who, Tate had written, represents "the first time . . . a Negro poet has assimilated completely the full poetic language of his time and, by implication, the language of the Anglo-American poetic tradition" (39). Davis's misreading of Brooks, Tolson, and Tate is instructive. Both Brooks and Tolson were leftist modernists, and neither would have sanctioned Davis's position on social protest nor considered Tate's comment a compliment.[14]

A fellow traveler in Davis's ideological camp was the scholar-critic Saunders Redding, a professor at the historically black Hampton Institute

in Virginia; the author of several books of literary criticism, two autobiographies, and the 1950 novel of black alienation, *Stranger and Alone* (a precursor to Ralph Ellison's *Invisible Man*); and one of the founders of a tradition of African American literary criticism. Additionally, and surely of great import to Redding, he was a member of the editorial board of the Phi Beta Kappa journal *American Scholar*. As Redding contributed regular columns on black literature for the Baltimore newspaper *Afro-American*, he became, according to his biographer Lawrence Jackson (2007), "the most widely read black literary critic in the US."

In the speech Redding submitted for the *Roots* volume, he presented black literary history as a steady evolution from old traditions set by leaders like Booker T. Washington, through the "artiness" of the Harlem Renaissance and the political "alienation" of communism, to a final resting place in *universality*, a concept, he said, that will enable the black writer to understand his relation to a *common human identity* (8). With this view of racial history as inevitable forward progress, Redding minimized racism as "the actions of a few men," producing "insupportable calamities for millions of humble folk" (2), and he predicted that when black writers throw off their fixation on race, they would be able to ascend to the towers of "universality," where, presumably, all white writers resided, swaddled in that all-embracing but elusive *humanity*. In his recent work on black intellectuals of the 1940s and 1950s, Jackson argues for understanding Redding as a far more complex thinker than his AMSAC essay reveals, a sophisticated critic who, Jackson says, embraced a range of positions: "a modernist impatient with older patterns of race relations," a bourgeois with a desire for mainstream approval, and a race man who valued black racial traditions (2010, 718).

However, that sophistication and subtlety was not on display in his comments at the AMSAC conference. In that limited forum, Redding was lofty and erudite, showing off his impressive knowledge of literary history and hinting at but failing to elaborate his position that black American writers were part of a "complex and multifarious" American culture and were, therefore, only *American* writers. In what appears to be the speech he originally gave at the conference, published in 1964 as his "Keynote Address," Redding much more explicitly states his controversial position

that there is no separate African American cultural tradition and that American literature is the "bough" and American Negro literature merely the "branch." In a point that would have been even more problematic for the AMSAC audience, Redding maintained that much of American Negro literature was supported by "pathogenic" forces that created in the American Negro writer "illnesses," "self-hatred," "a lavish imitation," and "preoccupation with man's doom rather than with man's destiny" (283). Small wonder, then, that Redding retracted this essay and submitted the tamer version to the *Roots* volume.[15]

The leftists at the conference, who appear to have outnumbered the opposition, objected to both the spirit and the letter of the speeches given by Davis and Redding. Despite their numbers, however, we must remember that the Left carried the burden of Cold War repressions, and their presentations are, not surprisingly, full of coded terms and silences. To make sense of those, we need to keep in mind the precarious position of the black Left in 1959. By that year the institutions that had supported black left-wing cultural production had been decimated through all sorts of Red Scare tactics, chief among them being named to the Attorney General's List of Subversive Organizations (AGLOSO), a totally arbitrary list that allowed the attorney general to declare an organization suspect without any legal proceedings. One of the most effective and innovative leftist cultural organizations of the 1950s, the Committee for the Negro in the Arts, was dead in three months after being designated "subversive" by the AGLOSO (Goldstein 2008, 67). Robeson's pioneering leftist newspaper, *Freedom*, which gave Lorraine Hansberry her start in journalism, featured Alice Childress's popular "Conversations from Life" columns, and generally covered and reviewed cultural work on the Left, was disbanded in 1955 under Cold War pressures. The theater committee of the Club Baron, where Hughes, Childress, and Branch had produced plays, was closed in the 1950s because of the threat of a McCarthy investigation. Blacklisted writers including Childress, Sarah Wright, and Mayfield were unable to get their work published for a time in the 1950s. Hughes was called before a Senate investigation committee and forced to disavow his leftist writing. Just a year before the conference, the FBI tried to get Sarah Wright fired from her job as a bookkeeper in a

printing firm, advising her employer that Wright was known as "an admirer of Paul Robeson," her husband, Joe Kaye, said in an interview. (Her boss refused to fire her, even though he was anticommunist.) We might also consider another reason for the Left's circumspection: both AMSAC and its lavishly funded conference were sponsored by CIA funds funneled through a phony setup called the Norman Foundation. Given CIA surveillance, along with blacklisting, congressional investigations, arrests, and deportations carried out during the 1950s, it is not surprising that these writers couched their leftist positions in carefully guarded terms.[16]

If there was anything writers on the Left understood well, it was that these debates over protest literature and over representations of black subjectivity were State Department–authorized strategies to determine the kind of black literary production that would be sanctioned and promoted in the era of Cold War containment. The left-wing speakers rejected the conservatism of Redding and Davis because that conservatism prescribed a racial, political, and aesthetic litmus test for black writers. In view of the 1960s Black Arts Movement, however, the Left seems to have won the day. But while the leftist writers argued hotly for the continuing importance of protest literature, they failed to examine the implications of the term social protest, presenting it as though its meaning were stable, unitary, and self-evident. Along with external pressures felt by the Left, the fundamental problem with the Left's support of a protest tradition was that they did not or could not define it in formal terms. So a term like "social protest" floated around the conference, acquiring different meanings each time it was used. The conservatives, on the other hand, were armed with concrete and detailed reasons for rejecting and discrediting protest writing. The leftist speakers seem particularly stumbling in their efforts to defend social protest and social realism, perhaps because of the political implications of social protest and the climate of the Cold War. But perhaps the speakers on the Left were simply reluctant to formulate a formal orthodoxy. For the leftist writers at the AMSAC conference, social protest was a flexible term, reflecting the kind of pugnacious stance they assumed in their defense of black writers' freedom to explore black subjectivity in all its dimensions. In actual fact, they did not impose any formal requirements on writers and did

not insist on some form of (Richard) Wrightian naturalism. Their own work ran the gamut from modernism to social realism.

The opportunity to debate the importance of protest literature at the AMSAC conference was particularly important, given that in the late 1950s there was no progressive or black cultural journal where these issues could have been debated more extensively and that white publications, including the putatively liberal journal *Partisan Review*, ignored black writing and racial issues almost totally.[17] Together the three AMSAC participants— Mayfield, Wright, and Hansberry—constituted the progressive wing at the conference, each of them resisting the domination of the conservatives and trying to carve out an autonomous and politically progressive space for black writers. All three were close to or members of the Communist Party at one time. Mayfield was, at the time, a thirty-year-old novelist and radical activist; he had joined the Communist Party in the mid-1950s, when the Party was at its most endangered. Unfazed by its decline, Mayfield considered it "the most powerful, radical organization" that he could join, and he remained active with the Party and the Harlem Left throughout the 1950s.[18] Sarah Wright said later that the only reason she did not join the Party is that no one asked her. Her husband, Joe Kaye, identified himself in an interview as an active communist and described Wright as deeply involved in events sponsored by the Communist Party as well as in organizations that openly supported Party causes. Hansberry joined the Party as a student at the University of Wisconsin (Anderson 2008, 264).

Mayfield took on the conservatives, arguing in his paper, "Into the Mainstream and Oblivion," that integration into the mainstream constituted "oblivion" for the black writer. Mayfield directly addressed the panel on social protest, rejecting the claim that social protest "had outlived its usefulness" because the Negro artist was on the verge of acceptance into the American "mainstream," a word, Mayfield noted with sarcasm, heard repeatedly at the conference (30). Mayfield began by examining the political use of the word "integration" as a ploy for "completely identifying the Negro with the American image" (30). In a direct challenge to Davis's integrationist stance, Mayfield says that for the black writer "to align himself totally to the objectives of the dominant sections of the American nation" would

be to limit himself to "the narrow national orbit," accepting uncritically all that the American nation-state stands for. Urging black writers to remain critics of the nation, sensitive to "philosophical and artistic influences that originate beyond our national cultural boundaries," Mayfield was the only speaker at the conference to place black writers in an international context and to identify the transnational Cold War politics behind the increasing emphasis on integration:

> Now, because of a combination of international and domestic pres-
> sures, a social climate is being created wherein, at least in theory, he [the
> Negro] may win the trappings of freedom that other citizens already
> take for granted. One may suggest that during this period of transition
> the Negro would do well to consider if the best use of these trappings
> will be to align himself totally to the objectives of the dominant sections
> of the American nation.

> (31)

Though Mayfield's talk drifts off at the end into a pessimistic and inept con-clusion about the black writer remaining in "the position of the unwanted child," he came the closest of any of the presenters to exposing the Cold War politics behind AMSAC and the coded meanings behind the conser-vatives' rejection of social protest.

In her presentation, the thirty-year-old activist Sarah E. Wright, whose 1955 experimental poetry volume *Give Me a Child* and her critically acclaimed 1969 novel *This Child's Gonna Live* have been nearly erased from black literary history, echoed the radical critiques of Alice Childress, Mayfield, and Hans-berry. The integrationists, she maintained, supported a "dominant [white] aesthetic [that] does not accommodate the judgment, values, or needs of the Negro people, let alone the Negro writer." Wright's focus on the "aesthetic" and her critique of the New Criticism are important. While Wright addressed a number of practical issues—like getting black books into public libraries and urging black artists to use political pressure to get schools and libraries to purchase and use books by black authors—she was the only speaker to deal with the politics of aesthetics and the only one besides Mayfield to connect

these issues to Cold War politics. She argued that it was crucial to understand how the construction of "protest" writing was manipulated by the politics of the academy, and she specifically implicates the theories of the New Criticism in Cold War strategies. Black writers, she asserted, "should expose those standards of aesthetics which are often deliberately, but more often unwittingly, conceived to destroy artistic vitality. The new critics' plea for self-contained writing that will cause readers to move only within the experience of the composition must be recognized by Negro writers as a force destructive of rational relations to life" (63).

Wright made explicit the assumptions of the New Criticism that art must be (or could be) divorced from the political or the social, that it could be, in other words, a "self-contained aesthetic object" distinguished by qualities of complexity and ambiguity that mock the simplistic and moralistic aims of protest writing. Arguing clearly as a leftist, Wright identified this idea of art as "destructive" and pointed to the need for an alternative aesthetic, naming the Left-influenced Harlem Writers' Guild of New York City as "an inspiring example" of the type of forum necessary to aid black writers in "formulating a meaningful aesthetic." But it is worth noting that the conservatives at the conference had the institutional-theoretical support of the New Criticism, which, as Smethurst (2012, 3) reminds us, "had by this time completely dominated literary studies in U.S. academia, giving them a coherent aesthetic underpinning that the intellectual-artistic Left did not have." Wright's critique had little forcefulness since it had no equivalent systematic theoretical support. Her valiant efforts to discredit the reigning aesthetic-theoretical Mafia was like carrying a thimble of water to a forest fire.

THE MISSING HANSBERRY
KEYNOTE ADDRESS

In keeping with his well-deserved reputation for iconoclasm and personal vendetta, the historian Harold Cruse claimed in his 1967 book *The Crisis of the Negro Intellectual*, typically without any documentation, that Lorraine

Hansberry's keynote presentation at the AMSAC conference was so "inappropriate" it had to be omitted from the published volume. Cruse may have been right that the radicalism of her speech, though it might seem subdued to a contemporary reader, was too far to the left for editor Davis. Robert Nemiroff, Hansberry's ex-husband and estate manager, says that the speech was omitted because Hansberry did not edit it in time for publication, which seems an unlikely explanation for excluding the keynote address by the star of the black literary world. It seems more likely that Hansberry's use of terms like "white supremacy," her critique of 1950s civil rights strategies, and her direct references to the Cold War, lynching, the 1955 Bandung Conference, and "paid informers" so alarmed Davis and his CIA sponsors that he used the excuse of her tardiness to ban the speech.

The text of the speech—ultimately published more than a decade later in *The Black Scholar*—makes clear that Hansberry was not simply targeting the conservatives in her remarks. Instead, she seems to have been aiming at the larger audience of anticommunist liberals, whom she addresses indirectly, referring to a conversation she had with "a young New York intellectual, an ex-Communist, a scholar and a serious student of philosophy and literature" who is cynical about any possibility for political change. I take Hansberry's entire speech to be a refutation of the claims that art and ideology must be kept separate—the "end of ideology" position of disenchanted postwar liberal intellectuals.[19] She began the speech with the simple assertion that all art is "social," by which she meant *ideological*, and by attacking the mainstream media—including film, television, theater, and the novel—which, she says, were intent on masking their own ideologies. In a bulleted list, she named the "illusions" that the mainstream media perpetuate while claiming to be ideologically neutral:

- Most people who work for a living (and they are few) are executives and/or work in some kind of office;
- Women are idiots;
- People are white;
- Negroes do not exist;
- The present social order is here forever, and this is the best of all possible worlds;

- War is inevitable;
- Radicals are infantile, adolescent, or senile; and
- European culture is the culture of the world.

In other words, Hansberry's list critiques the media for producing an ideology that promotes whiteness as normal, represents blacks as Other, discredits radicalism, and defines culture from an Eurocentric perspective.

Hansberry was not advocating a simplistic reverse ideology that would represent black life in a positive light. She challenged the Negro writer to reject the cultural values of "white supremacy" that devalue black speech and black expressive production, but she also insisted that the black writer should fearlessly present "all of the complexities and confusions and backwardnesses of our people"—including the "ridiculous money values that spill over from the dominant culture," "the romance of the black bourgeoisie," and "color prejudice" among black people.

Hansberry's leftist politics are most apparent in her prescient critique of 1950s civil rights strategy. While she passionately remembered "the epic magnitude" of fifty thousand Negroes in Montgomery, Alabama, and nine small children trying to go to school in Little Rock, Arkansas, she challenged what she considered the "obsessive over-reliance upon the courts, [and a] legalistic pursuit of the already guaranteed aspects of our Constitution," which, she said, "preoccupies us at the expense of *more potent political concepts*." Like Mayfield, Hansberry reminded her audience that the Left's pre-*Brown* (the *Brown v. Board of Education* Supreme Court decision of 1954) racial justice struggles, built out of a coalition of trade unionists, civil rights organizations, left-wing groups, and communists, were focused on economic inequities and labor rights, not on "a simple quest for integration" (Biondi 2003, 7) set into motion by the *Brown* decision. The socialist aims of these earlier civil rights movements were, in Hansberry's words, "more potent political concepts" constituted to insure "vast economic transformations far greater than any our leaders have dared to envision" and "equal job opportunity, the most basic right of all men in all societies anywhere in the world."

In *The Lost Promise of Civil Rights*, one of the most trenchant critiques of the NAACP's pursuit of desegregation in education, the legal historian Risa

L. Goluboff (2007) essentially vindicates Hansberry's (and Mayfield's) criticism of the political limits and ideological constraints of the NAACP's litigation strategy. As Goluboff shows, when the NAACP "channeled [their] legal energy" exclusively toward fighting the harmful effects of discrimination in public school education, they turned the energies of civil rights struggle away from its earlier focus on labor rights, insuring that "psychologically damaged schoolchildren and the state-sponsored segregated school [would become] the icons of Jim Crow" (2007, 4; see also Von Eschen 1997). But there were a few, like Hansberry, Mayfield, Childress, London Brown, and Wright, who were willing in 1959 to critique what had become by the end of the 1950s the Cold War orthodoxy on race, on civil rights, and on African American cultural work. Going still further, Hansberry seemed to be dropping hints of the collusion of artists with the CIA, another possible reason her speech was jettisoned: "And until such time [as these changes are realized], the artist who participates in programs of apology, of distortion, of camouflage in the depiction of the life and trials of our people, behaves as the paid agent of the enemies of Negro freedom" (138). Connecting black racial issues to an international context, Hansberry said that she would tell the people of Bombay, Peking, Budapest, Laos, Cairo, and Jakarta (referring to the Bandung Conference and the Hungarian uprising against the Soviet Union) that Negroes are not "free citizens of the United States of America," that her people do not "enjoy equal opportunity in the most basic aspects of American life, housing, employment, franchise," and that "there is still lynching in the United States of America." Briefly referring to the Red Scare in her own life, Hansberry said that she was the victim of a physical assault motivated by both the "racial and political hysteria" of the Cold War, a war she called "the worst conflict of nerves in human history."

As we can see from the numerous handwritten revisions she made on the original copy of this speech,[20] Hansberry was stitching together the mosaic of political concepts that constituted the black cultural and political Left in the 1950s, showing it as an articulate and incisive vision of the black freedom struggle. It is striking after reading this speech—for years only available in the 1971 issue of *Black Scholar*—to turn to the final page of the *Roots* volume and to the photograph of Hansberry standing before a well-lit lectern and

speaking into a rather large microphone before a very large audience, which gave her a standing ovation. The photograph is a surprising reminder of the absence of her remarks from that published volume. If, as Gilyard (2010, 142) notes, Hansberry spoke more militantly in this speech than she allowed any of her characters in *Raisin in the Sun*, it may have been that the Henry Hudson Hotel, even under CIA surveillance, was, ironically, a more receptive space for that militancy than the theaters of Broadway.

THE CONFERENCE'S AFTERMATH

AMSAC, as I have shown, had unquestionably derived major sustenance from the "umbilical cord of gold" provided by the CIA. In his 1971 memoirs, Julian Mayfield began to contemplate uneasily the willingness of the black Left to be less than vigilant about the largesse derived from their relationship to AMSAC. He was disappointed with the nationalists at the conference for so easily making a truce with the AMSAC establishment and wrote to the politically and culturally progressive *Black World* editor Hoyt Fuller in the early 1970s, confessing to Fuller in a soul-searching moment that there was only one of his colleagues on the Left who consistently questioned that relationship and refused to accept the perks being offered:

> Lest someone else hasten to point it out, I should confess here that apparently both Hoyt Fuller and I, along with a lot of others, worked unwittingly for the C.I.A. when we were members of the American Society of African Culture, AMSAC. In those innocent years, there was only one writer I knew, Alice Childress, who demanded to know where the money was coming from, and consistently stayed away from those fine receptions/and boat rides for [Leopold] Senghor, [Jaja] Wachuu and the like.[21]

In a letter to John Henrik Clarke, Mayfield again remarked that Childress's singular example continues to disturb, pushing him to consider the price to be paid by those who willingly allowed themselves to be innocent dupes:

How it works, I don't know, but I am reminded of those pretty days when we were being sponsored by AMSAC, and, to the best of my knowledge, only Alice C. [Childress] asked, "Where is all the money coming from." When at a joint lecture at Boston in 1961, I reminded Sauders [*sic*] Redding of our C.I.A. connection, he didn't seem to know anything about it. Now that I have to do R. Wright [Richard Wright] more thoroughly, I realize that, like the poor, the F.B.I. and the C.I.A. are always with us. The problem is what happens when they send in the bill.[22]

Even though these are private musings, Mayfield is one of the very few writers willing to admit his complicity with the CIA. Certainly, as we see in the Frank London Brown chapter, the desire for inclusion and normalcy made it more difficult for black artists to critique white supremacy, especially when it came in the "pretty" disguises of what Nikhil Pal Singh calls "the material and symbolic nets of funding and prestige" (2005, 151). Despite that, Mayfield was at least willing to contemplate the bill that would come due and what it would cost him. In the epilogue, I turn briefly to Mayfield's creative work, specifically his 1961 novel *The Grand Parade*, to see if and how he was able to resolve these tensions. Mindful of what James Smethurst and Alan Wald call "the continuities" of radical politics and poetics that paved the way for the militant writing of the 1960s, I look at how he represented and expanded protest writing and continued to produce a "black literary Left." While I am also interested in asking how his left-wing literary and cultural orientation may have enabled or inhibited formal experimentation, I am most interested in how black Left radicalism's powerful critique of the conservative politics of the Cold War 1950s, gave artists like Mayfield the freedom to resist conservative notions of integration and race that energetically sought to limit expressions of black subjectivity.

EPILOGUE: THE EXAMPLE OF JULIAN MAYFIELD

*Think how many fascinating human documents
there would be now, if all the great poets had written
of what happened to them personally—and of the
thoughts that occurred to them, no matter how ugly,
no matter how fantastic, no matter how seemingly
ridiculous!*

—GWENDOLYN BROOKS, 1938

W E CAN ONLY wish that Gwendolyn Brooks had heeded her own words and allowed some of the ghosts of her Cold War past out of the closet. When she and the others of her generation of black leftist activist-artists looked back on the history they helped make, they were reluctant to tell the story of their part in creating it. Some were communists and some weren't, but if they stood up against McCarthy's witch-hunts, HUAC investigations, and Smith Act and McCarran act reprisals against the Left, or even if they merely supported causes identified with the Left, they could count on being blacklisted and harassed. Even though African American artists on the Left produced many of the major themes and forms of African American cultural production from the 1930s to the early 1950s—a radical protest tradition—African American cultural histories have often helped obscure their contributions by erasing or evading Left history or by foregrounding the negative stories of the Communist Party.

The new scholarship on the black Left, deeply researched and theoretically smart, has advanced our knowledge and understanding and begun to reverse those practices of erasure, but what is still missing, and what I

long for, are the personal testimonies of black leftists who were there in the midst of the activist 1940s and the Cold War 1950s, the kind of eye-witness testimony and private reflections that they tucked away to protect themselves from further intimidation and reprisals.[1] The editor and left-wing activist Esther Jackson writes, "People wonder why these things aren't known," but she, like many others, also hesitated to admit her communist ties, in part because red-scare tactics can be and still are used to menace them and their families (interview, March 30, 1998). In an effort to correct what she calls "this silencing of history," the historian Gwendolyn Midlo Hall wrote me an e-mail blistering the *New York Times* for denying the communist affiliations of the visual artist Elizabeth Catlett in their 2012 memorial tribute:

> That *NYTimes* article [April 3, 2012] about Elizabeth Catlett's ties to the Communist Party is absurd claiming she was persecuted because her ex-husband was a member of the Communist Party but she was not. I knew her very well when we lived in Mexico between 1959 and 1964. She was a member of the Communist Party throughout her life in both the USA and Mexico. She is all over my FBI files as the liaison between the US refugees from McCarthyism (including Dalton Trumbo) living in Mexico and the Mexican Communist Party which is absolutely true. In fact, she helped me get articles about Robert F. Williams' flight from the FBI in Mexican newspapers, which helped Rob and Mabel Williams and their two sons escape to Cuba via Mexico. She was not only a great artist she was a very influential Communist. Her husband Francisco (Pancho) Mora was also a Communist as were most of the great artists and mural-ists of Mexico. It is past time to put a stop to this silencing of history and accept what communists did to empower the exploited of the earth dur-ing the twentieth century.

The exasperation we hear in Hall's insistence on Catlett's leftist history underscores the reason there are only a few autobiographical accounts of the black Left and so few willing to allow us access to the personal, intimate, and multivalent stories of their experiences of being on the Left during the

Cold War. Such imaginative narratives of the self might help undermine the knee-jerk reaction that paints communism as demonic and communists as traitors, but we also see the dangers of such revelations—consider the red-baiting discourse that continues alive and well in 2012, with ridiculous attacks on the current U.S. president as a "socialist" or, worse, "a communist."[2] Nearly every figure I interviewed for *The Other Blacklist* was hesitant about using the word "communist," including Catlett herself.[3]

In this epilogue, I return to a figure who appears briefly in chapter 6, Julian Mayfield, one of the speakers at the 1959 AMSAC Black Writers conference and the most outspoken about his radical affiliations. Mayfield left several autobiographical sketches, among them an unpublished interview and a semiautobiographical 1961 novel, *The Grand Parade*, both of which describe Mayfield's radical life and serve as an alternative vision of communism that counteracts those of disaffected communists like Richard Wright. As a thirty-year-old novelist and radical activist living in New York City, Mayfield joined the Party in the late 1940s because he considered it "the most powerful, radical organization" he could join, even though he felt that he had missed the great moment of the Party's power in the 1930s. In a seventy-five-page interview given to a young student, he brilliantly evokes the passion that Party involvement inspired and honestly explores his disappointments. He says the Party attracted people like him "who were young, idealistic, and who were looking for a place in which to change American society as drastically as possible." Nothing, in his estimation, came close to the Party for that kind of revolutionary change (1970, box 552-21). He was proud of the work he did in the Party on the big campaigns to free the Martinsville Seven, Willie McGee, and Mrs. Rosa Ingram and in trying to fight the execution of the Rosenbergs.[4] In contrast to most communist conversion narratives, Mayfield says that he was disappointed with the Party because it was "not revolutionary enough." When the Party leaders were arrested and pleaded innocent, Mayfield says the tragedy was that they were indeed absolutely innocent—"we never conspired to overthrow the government" (552-18). "Our energies went into trying to reform American society as it is constituted now," and, in the end, Mayfield believed, "we had no—no real effect on the black community" (552-17).

Like many other black leftists, including Jack O'Dell and Ossie Davis (see chapter 5), Mayfield left the Party because he felt that his black nationalism would always exist in uneasy tension with his leftist affiliations, and he felt compelled to switch his energies and loyalties to black struggles. That break from the Party is reimagined as the central event in the life of his main character, Alonzo (Lonnie) Banks, in *The Grand Parade*. There are several reasons for the importance of this novel. First, it spotlights the moment in the 1950s when the black Left, including Mayfield, moved away from communism and toward the emergent civil rights movement. Another reason for its importance is its delineation of the emotional and psychic cost of renouncing the Party, a move that is fraught, for a dedicated radical like Lonnie, as it was for Mayfield, with a sense of failure and loss. In its representation of the Party as a flawed but critical and effective organization, *The Grand Parade* recalls and revises Wright's version of leaving the Party and shows how caricatures of the Communist Party and anticommunist censorship narrowed the range of black political critique. The novel is also unique in its examination of the political maneuverings of the 1950s integration movement. In *The Grand Parade* the integration movement is depicted as a collision of political interests vying for power: liberal politicians, black political activists, white racist groups, and, of course, government spies, renamed in the novel, with intentional irony, the BS, or Bureau of Security. Finally, the novel performs something rare in autobiographical accounts of black ex-communists: it very specifically cites the example of Soviet oppression under Stalin as a reason for Lonnie's departure from the CP, a critique that radicals were often reluctant to raise because it played into the anticommunist discourse. As Alan Wald notes in his review essay "'Triple Oppression' to 'Freedom Dreams,'" "Even among those African Americans who departed the Party, in 1956 if not earlier, the horrible facts of Stalinist oppression are never cited as a reason for the separation—the books report only grievances around lack of attention to anti-racism or personal gripes" (*Against the Current*, January/February 2013, 25).

We get a rare view of the Communist Party in *The Grand Parade*. Lonnie describes his life in the Party as rich, full, exciting, exhausting, and intellectually challenging. Above all, it is a meaningful life in community, with Lonnie serving in the important position of educational director. Signaling

1956 and the Khrushchev revelations about the Stalinist regime, the novel begins with Lonnie's ouster from the Party for refusing to retract a report called "The Americanization of the Communist Party of the U.S.A." Citing the Khrushchev report on Stalin's atrocities, the report urges the CPUSA to call for "ideological and tactical independence from the Soviet Union" and to "repudiate the Russians whenever they were wrong just as it did the United States." Lonnie's report is considered anathema, and he is ejected from the Party for refusing to retract it (147). Though he stands on principle, he understands the enormity of his decision. He is relinquishing his dream of rising in the Party to become a member of the National Committee and ending a long-enduring relationship to a community of comrades: "*He was out of the Party.* The realization struck Lonnie with full force as he opened his eyes. The knowledge was so awful in its enormity that he was certain he would never be able to live with it" (121). I know of no other narrative that describes with such emotional power and honesty the pain of being "cast out of the Communist family," of losing what the Party had meant to someone being absorbed in struggle, invigorated by the Party's intellectual demands, and supported by one's comrades.

Despite the nuance and power of Mayfield's narratives, the communist conversion narrative we are most likely to encounter is Wright's 1944 autobiographical "I Tried to Be a Communist," which was reprinted in 1948 in the CIA-financed volume *The God That Failed*.[5] The CP that Wright describes is composed of venal, distrusting, anti-intellectual blacks jealous of his intelligence. When he is eventually brought up on trumped-up charges of being an "unhealthy element" (134), Wright "stands alone" before a Party that is secretive, underhanded, corrupt, domineering, and vicious. In the end Wright is thrust out of the Party and feels the sense of isolation and loneliness that Lonnie experiences, but Wright concludes that he must follow his own path—to "hurl words into this darkness and wait for an echo." Wright's self-portrait, the writer with the singular ability "to send other words to tell, to march, to fight, to create a sense of the hunger for life," is an image of the "exaggerated self"—to paraphrase the literary critic Robert Stepto's term—alienated from the Party hierarchy but woefully unconcerned with the rank and file.

In contrast to Wright's noble solitariness, Lonnie is standing at the end of *The Grand Parade* in the midst of a crowd of black demonstrators prepared to engage in a fight for the right of black children to integrate the public schools. In what is clearly an elegy for the Left, Lonnie remembers at this point in his life the ability of the communists to organize and lead mass struggle and the example they set of courage. Lonnie's greatest regret is knowing that the loss of the Communist Party insures that some of the greatest organizers and fighters will not be a part of the civil rights struggles: "*At last there was a real mass struggle among the Negroes but the Communists had been scattered to the four winds*" (366–367).

The novel's examination of the school integration struggle ends with another scene that illustrates the value of the radical traditions I've identified throughout *The Other Blacklist*. Focused on the young girl Mildred as the central figure in the integration struggle, this scene pays tribute to the way a leftist perspective could spot the tricks played by race liberalism's ostensible benevolence. Mildred is depicted at her new school listening intently to the principal's welcoming address. She sits among her classmates silently promising herself that she will earn A's in all her subjects so that she can prove her ability. In the final line of the novel—"and Mildred sang with all the rest"—Mildred is shown standing and singing with abandon, along with all the other students, "My country 'tis of thee / Sweet land of liberty" (448). This is clearly a scene Mayfield intended not to champion the nation's grudging acceptance of the Mildreds of America but as bitter political commentary on integrationist ideology. One can only understand this scene if we see it as Mayfield's critique of race liberalism: the black girl, studying and singing for legitimacy, has been assigned her role as the newly racialized and restigmatized integrated subject, now retooled for the modern integrationist narrative.

This scene and this novel constitute the ending of *The Other Blacklist*. Like Mayfield, the five artists of *The Other Blacklist* countered the conservative integrationist narratives of the 1950s that reinforced rather than subverted white supremacy. They were able to do so because their art and activism was rooted in the militant discourses of the 1940s civil rights movement and in the values of the Left that gave priority to a vision that emphasized

class consciousness and the struggle against economic racism. Whether they were ambivalent communists, reluctant radicals, wary fellow travelers, and/or committed leftists, they linked themselves to the passion and power of a radical vision and a radical activism. Their work was animated by and enabled by a vision that refused the terms of race liberalism promoted by the U.S. mainstream. They critiqued the Left even as they believed in many of its goals. In the end they were *artists on the Left* on their own terms, experimenters and protestors in both their activism and their art.

NOTES

INTRODUCTION

1. The list of scholars I include in the section "Design and Methodology" represents the contemporary Cold War scholars of African American literary history and the Left who have begun to reverse this trend. Even as late as 2001, Cold War scholarship could elide the importance of race. None of the nine essays in *Rethinking Cold War Culture* (Kuznick and Gilbert 2001) is about race, and race does not surface in its introduction as a feature of this "rethinking."

2. Esther Jackson, interview with the author (March 30, 1998).

3. While the Communist Party's notion of an African American nation developing in the American South was never a realistic political goal (and in fact was ridiculed by many African Americans), it was, nevertheless, a powerful paradigm that influenced African American cultural production for decades.

4. The Popular Front is probably best understood as that moment in the history of U.S. communism when the CP formed alliances with other groups sympathetic to the ideals and aims of communism. In the United States, the CP became involved in institutions like unions, civil rights, and literary and cultural organizations and downplayed its sectarian identity. Many of the people on the Left became targeted as "fellow travelers," meaning that they were on the Left, sympathetic to the ideals of communism, but not members of the Party.

5. The history of this document, as well as its predecessor, "An Appeal to the World," is exhaustively documented in Anderson (2003).

6. These statements were in stark contrast to the position taken by the U.S. delegation to the United Nations, which, during the 1940s, ensured that American racism would remain a domestic issue. Anderson (2003) brilliantly traces the way that

the international struggle for black equality became "Soviet-tainted" and therefore could be "repudiated as subversive, communistic, and even treasonous" (6).

7. For a description of the convention, see Gordon (1953).

8. The most extensive study of the FBI's war on positive portrayals of blacks in the Cold War is Noakes (2003). According to Noakes's research, the contest over how blacks would be portrayed in Hollywood films began in earnest during World War II as the Roosevelt administration became alarmed that stereotypical depictions of blacks "threatened to undermine the morale of blacks at a time when their loyalty and labour were needed to win the war." At the same time, the NAACP began pressuring Hollywood to "depict the Negro in films as a normal human being and an integral part of the life of America and the world." Despite these efforts, a study conducted in 1942 by the Office of War Information concluded that "black characters continued to be portrayed as 'basically different from other people, as taking no relevant part in the life of the nation, as affecting nothing, contributing nothing, and expecting nothing.'" When the NAACP stepped up its fight against racial discrimination in film, the FBI under J. Edgar Hoover decided to show that such racial militancy was more evidence of CP influence in Hollywood. One FBI report objected to the positive portrayal of the only black character in the 1947 film *Body and Soul* because it upset the racial hierarchy: "The negro appears as a fine, upstanding individual in comparison to everyone else in the cast." According to reports by the FBI under Hoover, exploring racial themes was a sign of "excessive criticism of American life" and possibly treasonous. For Hoover and the FBI under his reign, racial progress was purely and simply a sign of "communist agitation," and they continued throughout the 1950s to monitor, investigate, and censor films with themes of racial protest or that portrayed blacks positively.

9. See Schaub (1991, 91–115) for a thorough analysis of the impact of political and ideological pressures on American fiction produced during the Cold War. Focused on the artistic control exerted by leftist liberals in the 1950s, Schaub examines the New Critics' disillusionment with the Left and their turn toward the conservatism of the "Vital Center," in their determination to atone for what they considered their misguided innocence. Schaub argues that *Invisible Man* was part of this new conservatism: "The close fit between Ellison's analysis of the black American situation and the analysis of human nature set forth in the conservative discourse of the dominant criticism was at once a major source of the novel's success and its infamy." (92).

10. Yet black membership in the Party never exceeded more than two thousand even at the height of its popularity, after its defense of the Scottsboro Boys. The NAACP was initially reluctant to support the nine defendants, poor youths accused of gang rape, for fear that they were unsympathetic; the International Labor Defense, the CPUSA's legal apparatus, led the defense and garnered impressive international support for the cause. As the fascist threat to the Soviet Union became increasingly apparent in the mid-1930s, the CP abandoned its interest in the black (Southern) proletariat in favor of a broader coalition of blacks from all classes as part of the Popular Front (the international leftist movement opposing fascism).

11. In *Renewing the Left*, Harvey Teres reports that after one review of Richard Wright's *Native Son* in 1945 and the publication of a few essays and stories by James Baldwin in 1949 and the early 1950s, *Partisan Review*, the major anticommunist leftist publication in the United States, almost completely ignored race and black writing. Teres concludes that the absence of black voices in such publications as *Partisan Review* is "due only partly to blatantly racist attitudes on the part of whites. It is also the outcome of several decades of white progressive sympathy from afar, which did not involve sustained contact with a representative range of black experience" (1996, 228).

12. Wald, along with the circle of Cultural Front scholars, e.g., Smethurst, Mullen, Dolinar, Duffy, and Gore, among others, would all agree on this formulation.

13. See, for example, Teres's (1996, 228) comment on *Partisan Review*.

14. I've borrowed the term "race radicalism," which I discuss in more depth in the epilogue, from Jodi Melamed (2011, xvii).

15. See Dudziak (2002), Von Eschen (1997), Singh (2005), Anderson (2003), and Golubuff (2007).

16. The full title of this book-length petition is *Appeal to the World: A Statement on the Denial of Human Rights to Minorities in the Case of Citizens of the United States of America and an Appeal to the United Nations for Redress* (1947).

17. Dudziak (2002, 49) dates this pamphlet as 1950 or 1951.

18. The literary and cultural historian Shaundra J. Myers foregrounds another way that *Brown* was psychologically and politically limiting: "The decision's reach would eventually be broad and penetrating. Most Americans have experienced its ideological impact; the social policies spawned by *Brown* and the implicit ideals it conveys have shaped the very core of our beliefs, values, self-perceptions, and social relationships. Not only has *Brown* been the dominant ideal of racialization for the past 50 years, it has also been, as I argue here, an inconspicuous but key means of nationalizing African Americans, of containing them within and binding them to the nation" (2011, 8).

19. Most scholars refer to these ideas as examples of 1940s and 1950s race liberalism, rather than racial conservatism, as I insist on naming it. For the post–World War II period, when Jim Crow was still the law of the land, those who advocated racial integration, wanted to end Jim Crow, and supported mild forms of racial reform were considered the "liberals." Melamed (2011) calls them antiracist race liberals. But even blacks who were not part of the intelligentsia knew that these "liberal" ideas were not efforts at real equality and would not have called these ideas liberal. Among the adults in my family and neighbors, many of whom were union members, they would have been considered at best conservative.

20. These respondents were Hugh Gloster, Saunders Redding, and Alain Locke.

21. Atlanta University was dependent on subsidies from the state of Georgia and money from white donors. Any institution that was indebted to white foundations or white philanthropy was less than willing to critique these "official" policy statements on race progress. Perhaps the most important example of the way race liberals promoted a conservative racial narrative in the 1940s and 1950s (under the

name of racial "liberalism") is the almost universal acceptance of Gunnar Myrdal's 1944 document *An American Dilemma*. See Singh (2005, 142–151) for one of the best critiques of Myrdal's study as an example of "mid-century American liberalism" designed "to educate blacks into the acceptable forms of political thinking and behavior within the U.S. context."

22. The symposium is treated at length in chapter 1. The most conservative voices were the journalist Era Bell Thompson and Professor Hugh Gloster of Hampton Institute.

23. Jodi Melamed's (2011, 15) formulation is useful here. She shows how "racial liberalism" maintains power through its manipulation of race "as a cultural, psychological, or social problem—as a matter of ignorance, irrationality, feeling, or habit—to be corrected in the name of liberal-capitalist modernity rather than as internal to its political and economic structures."

24. "Artists on the left" is a reference to the title of Andrew Hemingway's (2002) study *Artists on the Left: American Artists and the Communist Movement, 1926–1956*.

25. Robins's (1992) invaluable documentation of FBI procedures for collecting information exposes the unreliability of FOIA files. Agents revealed that they received conflicting and false information that nonetheless got recorded in the files. As one agent put it: "Reportorial accuracy was seldom a consideration. Almost everyone in the organization was usually afraid to tell Hoover the truth for fear of upsetting him— and for fear of the inevitable punishment. As a result, Hoover often had to rely on information that had been sugarcoated for him" (18).

26. See http://www.commercialappeal.com/news/2010/sep/12/photographer-ernest-withers-fbi-informant/.

27. One can never be sure whether a file exists or not, according to Robins (1992, 18). Some are hidden, some listed under "dead file," and others simply irretrievable for various reasons, some of them bureaucratic mismanagement.

28. Andrew Hemingway is a major exception.

29. The term "discursive marks" is from Mullen (1999).

1. LLOYD L. BROWN: BLACK FIRE IN THE COLD WAR

1. Brown described these essays to me in correspondence that spanned the years 1995 through 2003.

2. *Masses & Mainstream*, in their 1952 Black History Month issue, printed a list of the black writers published in 1951: Abner Berry, Lloyd L. Brown, Louis E. Burnham, Alice Childress, Edgar Rogie Clark, W. E. B. Du Bois, James W. Ford, Yvonne Gregory, Lorraine Hansberry, Charles P. Howard, John Hudson Jones, William L. Patterson, Pettis Perry, John Pittman, Paul Robeson, Ed Strickland, Roosevelt Ward, Wesley Robert Wells, Charles White, and Doxey Wilkerson. Except for black publications, no magazines or journals, even leftist journals like *Partisan Review*, published black writers regularly in the 1950s or 1960s. "If we look at the range of African American

writing from the 1930s to the 1960s, we see that nearly all of it was ignored by *Partisan Review*, not to mention nearly every other white publication in the country" (Teres 1996). Teres lists all the mass-circulation magazines and "middlebrow magazines like *Harper*, *Esquire*, *Vanity Fair*, and *Saturday Review*" and finds that none of them "gave any serious commitment to publishing black writers" (212–213). Since Teres did not examine *Masses & Mainstream*, he does not include its history of publishing black writers. Hemingway (2002) says that *Masses & Mainstream* often achieved a sophisticated level of cultural critique.

3. See Murray and Callahan (2000). Murray writes to Ellison about *The Mark of Oppression* in either January or February of 1952: "Personally I find it just about the worst thing on the Negro since, well, since they were justifying white supremacy with the Bible. No time to get into what I think of it now, but I must say that I find myself in complete agreement with Lloyd Brown's reaction to it in (of all places) *Masses and Mainstream*, Oct 51, with a few objections of my own" (26).

4. There is a growing body of work on *Iron City*, including Manning (2009), Smethurst (2004), Lecklider (2012), and Wald's foreword to the Northeastern University Press edition of *Iron City* (Brown 1994).

5. Brown, letter to the author, August 10, 1996.

6. In *The Negro Novel in America*, one of the earliest and most influential African American literary histories, the critic Robert Bone (1958, 159) began the process of dismissing Brown, calling *Iron City* "a propaganda tract inspired by the Foley trial and written by a Party stalwart." Not only is Bone's attack politically motivated, but the events of *Iron City* have no relationship to the Foley trials of suspected communists.

7. Brown, letter to the author, July 18, 1996.

8. Brown also completed a second novel, *Year of Jubilee*, that was never published. The novel is a kind of sequel to *Iron City*, with some of the same characters appearing in new roles. The novel is especially valuable as a fictionalized history of urban renewal in major U.S. cities, exposing the ways those urban plans were designed to eliminate blacks from certain valuable pieces of city land in the cities. Typical of Brown's fiction, the political and historical events are based on actual stories, including an account of a racial massacre in Arkansas. Perhaps the most interesting aspect of the novel, however, are the references to Ralph Ellison's *Invisible Man*, which suggest that Brown was intent on extending the critique he had made of Ellison's novel in his 1952 review in *Masses & Mainstream*. Like *Invisible Man*, *Year of Jubilee* opens with a prologue, a sermon at a church in Iron City. Set in 1952, the novel features a portrait of a man with his blue eyes staring through rimless glasses (like *Invisible Man*'s Brother Jack), a riot scene near the end, and a series of speeches that the novel shows as designed to manipulate and control. The main character Val is saved from the police during a riot by a man who lives clandestinely in a basement apartment hidden from the police and on the walls of which are lithographs of famous race people. Val is given a talisman, a deerfoot knife, by a man whose son was killed in the Arkansas riot, much like Brother Tarp, who gives the Invisible Man a leg iron

to remind him of slavery and of Tarp's resistant spirit. The similarities to Ellison's novel were undoubtedly Brown's deliberate fictional rebuke of what he considered the reactionary politics of *Invisible Man*.

9. Brown, letter to the author.

10. In the poem Hayden contributed to the symposium, "Theme and Variation," he speaks in the voice of a narrator called "the stranger," watching and wondering about all that is being proposed in this symposium and musing on the instability of reality ("sly transience / flickering always at the edge / of things"). In contrast to the attempts of other symposium respondents to theorize about representations of blackness, Hayden's stranger says that reality is a "striptease" and that God is Houdini, presiding over a world in which the reality they seek to pin down is ever-changing. One senses Hayden's impatience with the symposium's catalog of advice for black writers, believing, as he did, that the artist must always confront this "changing permanence." When Hayden revised the poem for his 1966 volume *Selected Poems*, he retained the title but made minor changes in the poem.

11. In his biography of Gwendolyn Brooks, the critic George E. Kent presented an astute criticism of the *Phylon* symposium, which supports my claim that scholars like Alain Locke were employing a set of shifting terms in their attempts to define "universality." Kent argues that another level of concealment is represented by the symposium's attempts to formulate a standard for "universality" while refusing to acknowledge that they were negotiating for acceptance with a "skeptical and remote" audience, a white literary establishment with all the powers of judgment and reward. If one has to "transcend racial experience in order to achieve universality," Kent argues, then being "Negro" is excluded from the realm of universality (1990, 100).

12. In his 1949 book *The Vital Center: The Politics of Freedom*, the cultural critic and historian Arthur Schlesinger used the term "vital center" to describe what he considered the necessary balance between the radicalism of the left and the conservatism of the right. Though *The Vital Center* could pass during the 1950s as a moral corrective to both the right and the left, reclaiming democracy from both communism and fascism, contemporary critics like Thomas Hill Schaub (1991) have examined its moralistic arguments as masks for its own form of conservatism.

13. As Barbara Foley has shown in her 2006 essay "From Communism to Brotherhood: The Drafts of *Invisible Man*," before his anticommunist conversion, Ralph Ellison represented the Communist Party (called the Brotherhood in the novel) with an insider's knowledge of the Party and with a kind of tender respect. One passage about the non-Harlem Brotherhood, which Ellison omitted from the novel, almost perfectly describes Brown's depiction of Party activists in *Iron City*: "They were like no other people I had ever known. I liked . . . their selfless acceptance of human equality, and their willingness to get their heads beaten to bring it a fraction of a step closer. They were willing to go all the way. Even their wages went into the movement. *And most of all I liked their willingness to call things by their true names.* Oh, I was trully [*sic*] carried away. For a while I was putting most of my salary back into the work. I worked

days and nights and was seldom tired. It was as though we were all engaged in a mass dance in which the faster we went the less our fatigue. For Brotherhood was vital and we were revitalized" (Foley 2006, 169–170, emphasis mine).

14. "The most ambitious collective effort ever attempted in the field of literary studies," according to Sillen (1949).

15. See also Dudziak (2007) and von Eschen (1992).

16. In chapter 2 of *The Cold War at Home: The Red Scare in Pennsylvania, 1945–1960*, Philip Jenkins (1999) gives a thorough description and analysis of the role of the Communist Party in labor politics in Pittsburgh; however, I agree with Jerry Harris (1999), who notes in his review of *The Cold War at Home* that Jenkins "comes dangerously close to justifying the anti-Communist hysteria." Treating anticommunism, justifiably critiqued for its scattershot accusations against Americans, its efforts to undermine the New Deal, its thwarting of resistance to American capitalism, and its creation of an atmosphere of terror as somehow not all that consequential, as Jenkins does, is alarming as well as ahistorical.

17. At Brown's trial, witnesses were intimidated into falsely testifying that they had been misled into supporting communists. Witnesses were asked, "Did you know you signed a petition to put *a traitor* on the ballot?" and when the witnesses answered "No," the police had an airtight case against the communists.

18. See Wald's foreword to Brown (1994), Rampersad (2005), Denning (1996), and Foley (2006).

19. Brown, letter to the author, January 23, 1999.

20. Nadler (1995) notes that even though some black Living Newspapers were actually written, not a single one was ever produced, which he attributes both to conscious and unconscious racism and to Red-baiting, which denounced civil rights activity as communist.

21. The precursor text for this eulogy is Welborn Victor Jenkins's 1948 epic poem *The "Incident" at Monroe*, which also features a direct address to the dead victims: "Goodbye, Dorothy, you and Willie Mae, and George, the Soldier-boy, and Roger—." The similarities between Jenkins's poem and Brown's revision of it are striking. Both use direct address, speaking to the victims. Both summon images of the law and the FBI as deliberately impotent and represent a strikingly leftist political viewpoint. Brown might very well have used Jenkins's book, with its extensive photographs of the area, as sources for his descriptions of the murders.

22. Two years after James Baldwin's now famous and controversial attack on *Native Son* in his 1951 essay "Many Thousands Gone," Brown used *Iron City* to construct a parody of *Native Son* far more devastating than Baldwin's essay in its caricature of both the novel and the main character Bigger Thomas. While Baldwin criticized *Native Son* because it lacked, in his terms, the quintessential New Critical qualities of complexity, ambiguity, and paradox, Brown found *Native Son* objectionable because of its dependence on the very modern epistemologies that Baldwin embraces (Morgan 2004).

23. Brown had good reason to feel suspicious of scientific studies, which he felt were often based on unconscious and unexamined beliefs in black inferiority. In a 1951 *Masses & Mainstream* essay, "Psychoanalysis vs. the Negro People," he denounced the use of psychoanalysis by liberals as "the New Look in racism." Published in the same year as *Iron City*, Brown's essay reviewed *The Mark of Oppression* by two Columbia professors, Dr. Abram Kardiner and Dr. Lionel Ovesey (1951), who claimed in their psychoanalytic study of twenty-five northern urban Negroes that guilt and self-hatred were part of the "basic Negro personality." Brown could hardly find enough pejoratives for the book, calling it "a pseudo-scientific rationale for every phase of capitalistic activity from selling TV sets to promoting imperialist war," a combination of "stupidity, class snobbery and white chauvinist arrogance," and "a rationale for the oppressive system of white supremacy." Alarmed at the effort to use psychology and psychoanalysis to explain racial disparities, Brown insisted that the "marks of oppression" were on scarred backs, not in scarred psyches, and that the attempt to enlist psychology to explain away the political and economic causes of the victimization and brutality in black life was a "reactionary ideology and tool of capitalism" being used against the Negro people. This is the review that Murray was stunned to find himself in agreement with. See also Schaub (1991).

24. Brown, letter to the author, July 18, 1996. In stark contrast, the women in *Native Son* are uniformly portrayed as blind and helpless victims in a narrative world that most contemporary critics would agree, as Arnold Rampersad writes, is "fundamentally hostile to women, especially black women" (Rampersad 2005, xxii). While the women remain minor characters in *Iron City*, with little attention to their development as characters, they were consciously created as the antithesis of the female victims in *Native Son*. Among his communist characters, Brown includes the shrewd political operative Lucy Jackson. Wooed by Faulcon, Lucy insists that he become more active in the Scottsboro defense that she has organized at her church before she consents to his courtship. When the Lonnie James defense committee gets underway, the wives and female partners join in the community of support. Charlene, Paul Harper's wife, does the detective work to find evidence of his innocence and skillfully subverts the police wiretaps when she confers with her husband at the prison. Brown's class consciousness is more clearly evident than his attention to gender issues, but he was familiar with the debates among leftists over "The Woman Question," and he lines up squarely with the Party's progressive positions on gender in *Iron City*'s carefully designed portrayals of women as effective political leaders. As Barbara Foley (2003; 2006; 2010), and other feminist critics have shown, the legacy of the Left with regard to gender is contradictory. See Deborah Rosenfelt (1981), Dorothy Sterling (2003), Kate Weigand (2002), and Paula Rabinowitz (1991). Rosenfelt says, however, that leftist women writers often found the Party a genuine source of encouragement and a way of being connected to a larger intellectual, international, and political community.

25. The visual artist Alice Neel, for example, did as she pleased with her art, and, as the art critic and Neel biographer Pamela Allara (2000) says, Neel manipulated the Party hard line by confessing that she was just a bad communist.

26. Redding's review and Brown's vernacular experimentations precede by twenty-five years John Wideman's (1976) astute article on the use of black speech in American fiction. Wideman critiques the tradition in American fiction that devalues black speech by confining the black vernacular to the oral, nonliterate speech of black characters and framing it with the standard-English narration that signifies literacy. While I doubt that Redding would have gone so far as to call Brown a modernist, he did implicitly credit Brown with bringing in the new by breaking the old fictional patterns that limited and demeaned black speech.

27. Humboldt's real name was Charles Weinstock. Brown's comments about him were in a letter to the author (August 3, 1996), in which Brown described Humboldt as the one who guided his writing.

28. Guilbaut recounts the intense debate between Roger Garaudy and Louis Aragon carried on in the pages of the communist art reviews *Lettres francaises* and *Art de France* over the issue of art. In "Artistes sans uniformes," Garaudy satirized Aragon's support for "party-controlled art," insisting that it was a method of forcing artists "to wear a uniform."

29. Brown, letter to Eric Foner, August 31, 1998. In possession of the author.

30. Bonosky, telephone conversation with the author, February 9, 2009.

31. The literary and cultural historian Aaron Lecklider (2012) presents another remarkable but unnoted aspect of the modernist politics of *Iron City*. Lecklider shows how Brown disrupts the pattern of leftist acceptance of an antihomosexual narrative of sexual perversion, deployed mainly as a means of arming the Left against the threat of anticommunism. Lecklider argues that, rather than marginalizing sexual difference, Brown's novel performs an amazingly progressive and lyrical defense of sexual difference, claiming it as one of the sites of defiance against state-sanctioned repression and violence.

32. In a long interview (2009) with the author, Phillip Bonosky, who knew Lloyd Brown, suggests some of the internal struggles Brown had with the Communist Party. Bonosky said that Brown was more alienated from the Party than he would admit publicly. At one point he was nominated for the Central Committee but, according to Bonosky, didn't take the position because he felt he was being used by the Party, particularly by two members he did not trust, who later defected. Brown felt like the nomination was a hostile move particularly at a point in the Cold War when a public position as a communist was a "ticket to jail." Bonosky said Brown felt "that jailbird tingle" and decided to refuse the nomination. Brown was not disillusioned by the 1956 Khrushchev revelations about Stalin because, Bonosky says, his faith was in the Party, not always in the leaders. But he did quietly leave the Party and thereafter called himself a "communist with a small *c*." This complex and problematic relationship between Brown and the Party is not evident in the fictional representations of communists in his novel.

2. CHARLES WHITE: "ROBESON WITH A BRUSH AND PENCIL"

1. One black-and-white photograph is the only visual documentation of the mural. The photo is at the Chicago Public Library, Harold Washington Center.

2. I am indebted to Peter Clothier for this reading of *A History of the Negro Press*. In his unpublished manuscript, *Charles White: A Critical Biography*, he is the first to note the modernism of this work and the way White has structured it to reveal the modernist tone through stylized movement, heavily stylized figures, the power of the machines, and the juxtaposition of men and machines. Clothier also noted "the stylistic contradictions" in White's early work that he identifies as a conflict in White between representational realism and abstraction (65). More than any other commentator on White's work, Clothier historicizes the "stylistic contradiction" in White's work, tracing that contradiction back to what the art historian James Porter called "the diversified legacy of African realism" in White's work. White's fascination with this dual heritage may have been formed when he discovered the "tradition of stylization and abstraction" in African art in Alain Locke's 1925 *The New Negro*, though clearly he was also influenced by the Mexican School, as I write about later in this chapter. Citing "White's continuing battle between realism and abstraction," Clothier also attributes White's conflict to the struggle between "the fashionable forces of abstraction" of twentieth-century mainstream art culture and "the sense of social obligation to 'represent' his people" (88).

3. Peter Clothier's unpublished, partially completed, twelve-chapter manuscript, *Charles White: A Critical Biography*, based on a series of private interviews he did with White in the 1980s, is one of the earliest and best critical assessments of White's work. Clothier, the new dean at the Otis Art Institute in Los Angeles, California, met White at the institute in 1977 and was introduced to his work at the retrospective in Los Angeles that same year. Clothier says he was overwhelmed by the rhetorical and visual eloquence of the work, which he had never before fully appreciated. White agreed to be interviewed by Clothier, but, because of White's poor health, those interviews consisted of only five sessions and seven hours of tape before White died on October 3, 1979.

When he began his research for a biography of White, Clothier discovered an entire black art world—artists, critics, historians of art, great collections, patrons, "a cosmopolitan world better known in Europe than in the country of its habitat." Clothier gives the best description of how to situate White in the conflicting values of the art world in postwar America. He notes that White's lifelong preoccupation was to draw portraits of a black social world, a mode of representation that leading artists in Europe and those in the United States working in the European tradition had abandoned by the 1940s: "What is clear, though, is that the sheer energy and the mainstream acceptance of this direction swept artists like Charles White temporarily beyond the pale of major critical attention." Clothier does not deal with the possibil-

ity that White's left-wing political commitments to the ideals of world socialism and communism also contributed to his marginalization.

4. When White's wife, Frances Barrett White, said in an interview, "You touch blackness . . . you touch the Left," she was describing poetically what she saw as the integration between White's political ideals and his artistic goals.

5. Several of the Mexican muralists may have been a direct influence on White. Orozco's 1930s public mural *The Table of Brotherhood (or Fraternity of All Men)*, showing a black man in suit and tie seated at the head of a table around which are representatives of all races, was on view at the New School for Social Research in New York (LeFalle-Collins and Goldman 1996, 74) and probably seen by White. Rivera's massive mural of automobile production, *Detroit Industry* (1932–1933), commissioned by Edsel Ford and painted on the entrance walls of the Detroit Museum of Art, features blacks prominently as workers on the assembly line and was also on display in the early 1930s. One of Rivera's murals, the *Disembarkation of the Spanish at Veracruz* (1929–1951), showing Spaniards branding Africans and Indians working in chains as slave laborers and hanging from trees as Catholic monks pray over them, has all of the qualities we see in White's *Techniques Used in the Service of Struggle*. The surreal lynching tree, the black man chained and beaten down by a white overseer, the rounded figures piled on one another, the enlarged hands, and the Dali-esque landscape, with parts of a log cabin jutting into the sky, all suggest the influence of the Mexican School. Like Rivera's indigenous Mexicans, the people at the center of White's art were, as Feelings described them, "the most African-looking, the poorest, the blackest people in our ranks."

The Mexican school: Considering that White made many conscious decisions in his 1940s work to "emulate the tenets, techniques, art processes, and themes of the Mexican School," his questioning of formal experimentation is all the more incomprehensible since the Mexican artists were, as LeFalle-Collins and Goldman (1996, 70) maintain, first and foremost formal experimenters: "The Mexican movement of the 1920s—in contrast to the visual clichés of Soviet socialist realism—was a true avant-garde, preceding or paralleling similar movements throughout Latin America that fused the stylistic innovations of European cubism, futurism, and constructivism with formal innovations derived from their local aboriginal and African populations, expressing in this manner their own national realities and philosophies."

For all sorts of reasons—including the political climate in Mexico that viewed these artists as part of the cultural wing of the revolution, their national identity secured by the government, and the collective spirit created by the revolution—the Mexicans were freer to question and reject the demands to conform to the Party's standards of art. Siporin, one of White's mentors, declared that, like all young revolutionary artists, he was both at war with modernism and a part of it, but he also moved in the direction of Expressionism, he said, in order to represent in his work "the dynamism of the actuality with which I deal" (Hemingway 2002, 160). It is also

instructive to remember that Catlett stayed on in Mexico and continued in the direction of a politically engaged modernist art for the next sixty years.

6. See Clothier (n.d.), Barnwell (2002), Killens (1986), and Brown's FOIA file. In my interviews with Elizabeth Catlett, she said that both she and White were closely identified with the Left and the Communist Party in the 1940s and 1950s. Elizabeth Catlett, interview with the author, NYC, October 24, 2004.

7. Though the writer and critic Harold Cruse was a member of CNA, Cruse sneered (without documentation) that because of its exclusivity, "people in the Harlem cultural circles" referred to the CNA as "The Committee for *Some* Negroes in the Arts." And, in his typical knee-jerk reaction to the white left, Cruse pilloried the group for its "white leftwing patronage and control" (1967, 211, 216). In "Harry Belafonte and the Sustaining Cold War Radicalism of the Black Popular Front, 1949–1960," delivered in November 2012, at the American Studies Association annual meeting in Puerto Rico, the cultural critic Judith E. Smith also notes that CNA attracted a socially very distinguished group of New Yorkers, but she recognizes the importance of CNA's support for black political protest in an era of a "massive cultural erasure of black experience" (6–7).

8. Jack O'Dell, Julian Mayfield, Ossie Davis, Gwendolyn Brooks, Lorraine Hansberry, and Charles White, to name a few, all describe that move as essentially "organic," according to O'Dell, simply the next step for a black radical. The excommunist and white writer Dorothy Sterling described the civil rights movement as the "one bright spot on the political horizon" during the dark days of the McCarthy period. Like other radicals, black and white, who were involved during the 1940s in African American equality struggles as leftists, Dorothy Sterling became a civil rights protester and organizer. She also began writing progressive books about black history, many of them written for children. They were among the first children books to challenge the color line in the publishing industry (Sterling 2003, 201–225). See my discussion of the turn toward black nationalism and civil rights in the epilogue and later in this chapter on White.

9. This brings up, of course, a wide-ranging debate with differing critical opinions. I tend to agree with Hemingway, whose consideration of these issues is well documented, extensive, critically sharp, and measured. He notes that when the cultural critic Charles Humboldt dropped off the editorial board of *Masses & Mainstream* in 1949, there was a clear shift toward including fewer pieces of modernist art (2002, 214). Humboldt had argued, as early as 1946, that a hard line on modernist art "could alienate abstract artists" (216). In the *Daily Worker*, the critic and visual artist Joseph Solman described abstract expressionism as "a flight from reality," but in other *Daily Worker* articles his approach was more nuanced, with an appreciation of the need for formal sophistication for art to be aesthetically "meaningful" (217). There is clearly a vibrant, energetic, sometimes contentious discourse in the Marxist and communist art criticism throughout the 1940s. But, when Andrei Zhdanov became the chief theorist in Stalin's administration, he induced a rightward shift that resulted in "an

extreme antipathy to modernism [becoming] *de rigeur* among the Party's most authoritative cultural spokesmen" (222). According to the major Marxist art critic and White biographer Sidney Finkelstein, an artist like Jacob Lawrence, by flirting too dangerously with modernism, had become limited. The one artist that Finkelstein continued to approve of was Charles White, who, in his estimation, "came nearest to an art that could 'speak to the common people'" (222).

10. I have no evidence of, nor am I interested in, whether White was an official member of the Communist Party. Throughout this chapter, I am very careful to make the distinction that White was associated with communist organizations and worked with communist critics, artists, and activists. I am not trying to determine his organizational status, but I do intend to challenge and break with the practice of eliding, omitting, and/or minimizing his affiliations with the Communist Party.

11. In the Clothier manuscript, Clothier says that White wanted to clear up the circumstances of his birth before his death and thus revealed in a tape-recorded interview that his mother was never married to his father, a fact that White said was never discussed between mother and son (6).

12. Interview with the author, April 6, 2005.

13. There are numerous books about the influence of the Communist Party in Chicago during the 1930s to the 1950s; see especially Storch (2009) and Mullen (1999).

14. White autobiographical notes, Archives of American Art (AAA), 3189–3195, and oral interviews, Charles White estate, transcribed, September 14, 1970.

15. Clothier, Charles White oral interview, Charles White estate, transcribed, September 14, 1970, p. 29.

16. Daniel Schulman (2004) maintains that the Art Institute's policies were considered liberal at a time when others barred blacks from attending their institutions or tolerated racism. Schulman attributes these progressive attitudes to the institute's founding as "an instrument of social uplift and civic improvement" and to the influence of Charles Hutchinson, the president of the institute from 1882 until his death in 1924, who fully supported those policies (43).

17. White, Margaret Burroughs, Peter Clothier, Robert Bone, and Richard Courage very specifically use the designation Art Crafts Guild, though other critics call it the Arts and Crafts Guild.

18. Interview A, p. 8, Charles White estate. Undated, typed, 24 pages.

19. This is a line from the poet Margaret Walker's poem "Memory." She described the effects of poverty and unemployment in these terms:

> I can remember wind-swept streets of cities
> on cold and blustery nights, on rainy days;
> heads under shabby felts and parasols
> and shoulders hunched against a sharp concern;
> seeing hurt bewilderment on poor faces,
> smelling a deep and sinister unrest

these brooding people cautiously caress;
hearing ghostly marching on pavement stones
and closing fast around their squares of hate.
I can remember seeing them alone,
at work, and in their tenements at home.
I can remember hearing all they said:
their muttering protests, their whispered oaths,
and all that spells their living in distress.

20. Clothier, Charles White oral interview, Charles White estate, transcribed, September 14, 1970, p. 52.
21. Ibid.
22. Interview with author, April 1, 2008.
23. See Schulman (2009); Rosenwald Catalog. In 1940, William Carter called the mural *Chaotic Stage of the Negro, Past and Present*. In contrast to White's murals, WPA-era murals, which were displayed in public places like post offices, libraries, and schools, were apt to show an unproblematic view of American democracy at work.
24. Since the figure is somewhat racially indeterminate, Stacy I. Morgan's reading of the overseer figure as black is understandable. But, given White's militant black politics and the historical record of slavery and sharecropping in the U.S. South, it is more likely that the overseer is a white man.
25. See Hemingway (2002) for a discussion of WPA artists' attempts to portray progressive ideals in their public art works. Edward Millman's and Mitchell Siporin's murals for the St. Louis Post Office, portraying the history of Missouri from early settlement to Reconstruction, represent "the image of dignified labor" and "workers' power and other tropes that register their progressive politics." Generally, however, muralists did not violate the desire of local communities for "an essentially benign vision of America" (169).
26. Both Millman and Siporin had been to Mexico and had met Rivera, Orozco, and Siqueiros and worked on murals with Orozco and Rivera. See Clothier, Charles White oral interview, Charles White estate, transcribed, September 14, 1970.
27. Rockefeller had the mural destroyed in 1934 when he discovered the picture of Lenin in it.
28. He also said: "Another event was to take place which was to have a very significant effect on this thing. An effect in a positive way. I went to Mexico to work for a year and a half."
29. The 1949 portrait, *Frederick Douglass Lives Again* or *The Living Douglass*, which appeared on the cover of the *Sunday Worker* in 1950, is in the style of *The Trenton Six* and *The Ingram Case* and follows the same format, with cubist influences obvious in the flat, elongated lines of the figures and the almost architectural quality of the drawing. The massive head of Douglass looms like an Old Testament Moses as he

extends his right arm in a protective gesture over a group of eleven black men, all of whom fit snugly under it as they move through a barbed wire fence that appears to have been snapped by Douglass's powerful left fist. Douglass's hands and arms are constructed like a block of wood or iron, suggesting a godlike power. One of the men carries a book high over his head, and one dressed in a business suit carries a scroll that might be a proclamation or a document demanding justice, both suggesting the weapons used in breaking down oppressive forces. Hemingway says the painting intentionally evokes parallels with "documentary photographs and newsreel footage of Nazi concentration camps—even as [White] links the cause of these defendants with the historic struggle of Douglass's generation for freedom from chattel slavery" (2002, 150).

The hands of the figures in these 1949 drawings are massive and resemble mallets or blocks of iron. There is a geometric quality in the angularity of the features, with the noses triangulated, the mouths and eyes of each figure, which seem to be built of blocks, so similar that they are less individualized portraits than abstract representations of faces under severe threat.

30. Both of these phrases are from Fran's oral interview with Clothier (11) and reflect the excitement of their time organizing and working with the Committee for the Negro in the Arts (CNA).

31. Clothier, oral interview with Fran Barrett White, transcribed, Altadena, Calif., October 1980, 12.

32. AAA 3191, 215, 1950.

33. I deal with the blacklisting of black artists, intellectuals, writers, actors, etc. on the Left throughout *The Other Blacklist*. Some of this information on the blacklisting of black artists appears in each chapter. The leftist political activism and subsequent blacklisting of these figures are documented in their memoirs: Ossie Davis, *Life Lit by Some Large Vision: Selected Speeches and Writings* (2006); Ossie Davis and Ruby Dee, *With Ossie and Ruby: In This Life Together* (2000); Sidney Poitier, *This Life* (1981), and *The Measure of a Man: A Spiritual Autobiography* (2007).

34. At the First Constitutional Convention of the CNA on January 26, 1952, the photographer Roy DeCarava's opening speech, poetically entitled "There's a poem in our bread, a story in our meat," invited progressive artists to fight American cultural Jim Crow by considering every aspect of black culture both worthy subject matter for their art and the grounds for counteracting white racism. He urged those artists who come home tired from their day jobs to try to imagine how a culture despised by the outside world could be transformed through the symbolic representations of politically committed artists:

> Open your hearts! Feel the tenseness, the tenderness, the anguish, the joy that comes from being black. You know that Negro man walking down the street even though you never saw him before. He's with you, know him, or not. Feel artist, feel. Sing it, singer. Paint it, painter. Dance it, dancer. Write it, film it, it's you, it's me, it's us.

See it, feel it, smell it. The smell of the beauty parlor and straightening comb, the laundry and the pushcart. Ham hocks and collard greens, hop and john [*sic*] and pig's feet. Boiled potatoes, corn dumplings and codfish with tomato sauce. Fried plantains with chicken and yellow rice. Kidneys, chitterlings, lights, hog maw that was no good for the white folks, but good enough for us Negroes until science came along and said that they had more vitamins and minerals than all the choice cuts most Negroes never meet. There's a poem in our bread, a story in our meat! Use it!

White's work emblematized DeCarava's impassioned charge to use the materials of black life and culture in order to reach ordinary blacks, and once he returned from a 1951 trip to Europe and the Soviet Union, he said in his public pronouncements that he was even more firmly convinced that a socialist realist art was the way to achieve those goals (AAA, box no. 3191, 199–206).

35. Much of this is extensively reported in Fran Barrett White's taped interview with Clothier (19–25).

36. Interview with the author, April 1, 2008.

37. For discussions of this question, see Singh (2005, 124) and the correspondence between Horace Cayton, C. L. R. James, and Richard Wright.

38. See Cayton (1965) for this same sentiment.

39. These admonitions and advice were featured in the following articles: Charles White (1952; 1955) and David Platt (1951a; 1951b).

40. Hemingway (2002, 221) describes Andrei Zhdanov's role as head of the Leningrad Central Committee and his alignment with Stalin in Soviet purges as a parallel to his role as hard-line art critic and theorist.

41. Clothier, oral interview with Douglas Glasgow, transcribed, Altadena, Calif., 106.

42. Ibid.

43. Socialist realism and social realism are often difficult to distinguish. In *Social Realism: Art as a Weapon*, David Shapiro makes some distinctions that are helpful: social realism, the dominant American art in the 1930s, arose out of the desire of artists to use their art to "communicate social values" (28). To that end, art would serve as a means to focus on those values that could transform society. Promoted by the Marxists, and facilitated by the support of art programs of the WPA, social realism was mean to focus on and appeal to the working class. Socialist realism, promoted, paradoxically, as the Party was in decline in the United States, demanded a more politically correct art, selecting aspects of working-class life that reflected the positive aspects of life under Soviet control (28). In *The Proletarian Moment*, Murphy traces the shift in the discussions of the term "socialist realism," noting that in its earliest formulations, socialist realism stressed "the freedom of the writer in regard to form, style and genre" (1991, 102). As Murphy shows, debates on art and literature among Marxists and communists reflected a wide range of perspectives, and in their international discussions, socialist realism was described in broad, flexible, sometimes contradictory statements that insisted on upholding socialist principles but also allowed for artistic freedom.

44. In the section "The End of Democratic Front Aesthetics and the Emergence of Zhdanovism," in chapter 9, "Cultural Criticism Between Hollywood and Zhdanovism," Hemingway (2002) outlines a history of the changes in leftist aesthetics that help account for the shifts in White's work between the late 1940s and 1950s. Clearly there was a range of opinion in Marxist art criticism, and shifting opinions over the years, with critics and artists on every side. An example of these shifts is the art criticism of Joseph Solman, whose art reviews appear in *New Masses* and *Masses & Mainstream* between 1946 and 1948. A sophisticated artist and critic, Solman was, according to Hemingway, "a defender of modernism within Marxist criticism" (217). In contrast with the *Daily Worker* critic Marion Summers (aka Milton Brown), Solman believed that "To be meaningful aesthetically art had to be formally sophisticated and inventive" (217). But, as leftist art critics and artists committed to the values of democracy, pluralism, and the collective confronted the hegemony of abstract art and the domination of the art world by art dealers, critics, and gallery owners, they had little choice but to critique and reject what they viewed as the corporate control of art (101).

45. Fran White's interview with Clothier provides some insight into how White responded to these critics. She notes that the African American John Pittman was a critic Charlie admired and learned from: "[Pittman] was the art critic that I think of anybody over the years Charlie felt really gave him clues as to how he could grow. Everybody else either praised him or negatived [*sic*] him, John was the one critic that would seem to hit some chord in Charlie that would help him move from one period, to make change that he agreed with, and he would [be] almost feeling them and John would pinpoint them . . . He [Pittman] spent a long time in the socialist part of Europe as a correspondent" (10).

46. Clothier, oral interview with John Biggers, transcribed, Altadena, Calif., 15.

47. My efforts to assess the assets and liabilities in Charles White's vexed relationship with communism and the CP repeat the balancing act of most scholars of the Left. In "No 'Graver Danger': Black Anti-Communism, the Communist Party, and the Race Question," a thorough and balanced analysis of the problems and pitfalls of anticommunism for African American social, political, and intellectual agency, Eric Arnensen concludes that "revisionist historians on both sides of the issue often fail to consider the complex and individual histories of communism and the Communist Party." He cites A. Philip Randolph's anticommunism as an example: "Revisionist historians may not accept Randolph's indictment of the communist activists whose dedication and accomplishments they choose to celebrate. But they might fruitfully listen to the critique of—his jeremiad against, really—the party whose support for the goals of ending racial discrimination and inequality was not enough to offset its frequently destructive tendencies and the genuine harm it did to those with whom it disagreed. Communists' flaws—born of a voluntary acceptance of an organizational style and vision that required them to submit to what Randolph termed an 'alien master'—were not incidental but constitutive of their politics, at all levels of the party, at least for those who chose to remain in its ranks. Coming to terms with the CP's

uneven role in civil rights history requires us to take seriously the pragmatic, political, and ethical critiques lodged by anticommunist progressives. Such an engagement will leave us with a 'far grayer picture,' but one that can more accurately account for the larger tragedy of the American Left" (2001, 40).

48. See *Masses & Mainstream*. Obviously this was customary. Lloyd Brown's 1951 novel *Iron City* also was sold through *Masses & Mainstream* by subscriptions.

49. See Corwin (1950), his *Daily Worker* review of White's February 1950 show at the ACA Gallery. In the show are pictures of John Brown, Harriet Tubman, Gabriel Prosser, the Ingrams, the Trenton Six, two children holding broken toys, a mother awaiting the return of her soldier son, a flute player, and a blues singer. There is also *The Awakening* and *Frederick Douglass Lives Again*. "These forms are as large as the themes, and they are unequivocal, strong and clear." Clearly Corwin approves of White's art, and presumably so does the Communist Party. More praise: "But White shows us one valid way that an artist can work . . . [that] springs from a militant content and is directed in clear, simple, bold terms to the eyes of the people." It is clear to Corwin that White has chosen an artistic method and theme that the CPUSA approves of—its militancy, its clarity, its boldness. "He represents Negroes of the past and of today, who are not weak or crushed or caricatured or comic. They are heroic. . . . there is no doubting their dignity and their strength." But then here is the clincher, the suggestion of what he is doing wrong that Corwin believes must be corrected: "We have certain suggestions we would like to offer to White, even while we applaud the correctness of his basic orientation. His style, with its precisely modeled, architectonic forms, is a cold one, which may be alright. It's one way to get at things. But it occasionally runs into the danger of going dry or empty, where the modeling thins out or, especially in peripheral areas, where the meanings are lost. Another danger in such a style is that it may become static, and these pictures occasionally do in content as well as form. In many the characteristic mood is a tortured repose with upturned eyes and furrowed brows. The correlative danger is that the picture will be animated by superficial devices, and of this too, White should be careful. He succumbs at times to a kind of mannerism in which figures pose and gesture, but one doesn't know why."

50. In both "Charles White: Humanist Art" and the critical biography *Charles White: An American Artist*, Finkelstein (1953; 1955) makes clear his disapproval of White's move toward experimentalism: "In the latter two murals [*History of the Negro Press* and *Techniques Used in the Service of Struggle*] a move may be observed towards a stylization of painting and drawing technique. In 'The Negro Press' it is seen in the lines of the garments, carrying on the hard lines of the newspaper sheets, and to some extent also found in the sharply accented lines of the faces. In 'Techniques Used to Fight' it is found in the stylized linear patterns of the garments, faces and hair. This reflects the impact upon White of the experimental techniques which at the time clamored for the attention of every artist who thought himself to be 'advanced,' 'free,' 'modern.' . . . Yet a contradiction is created. While, in these murals, the stylization of line and of rhythm

make for a strong immediate impact on the eye, affecting even the sense of touch, creating a high tension and excitement, these same styles make it more difficult to disclose the inner sensitivity and psychological depth of the human beings who are the subject" (1955, 23–24; translated from original texts).

51. As Hemingway cautions, leftist critics and artists had every reason to be concerned about the "hegemony of modernist abstraction" because of "its authority in museums and the art press, and the corresponding devaluation of traditional skills and almost all variants of naturalism" (2002, 239). Thus, it is important to keep in mind that the artistic prescriptions of the Left, however reductive, were a response to something that had real political consequences. Indeed, by 1949, the major voices in art criticism, most notably Clement Greenberg, had canonized abstract artists like Jackson Pollock, whose art of pure expressionism, devoid of any figuration or easily apprehended social content, was considered the only route to a distinctive and excellent U.S. art tradition (Hemingway 2002, 239; Guilbaut 1984, 161). The rise of abstraction during the Cold War went hand in hand with the consignment of WPA art to the junk heap, the dismissal of socially relevant art as mere "propaganda," and the blacklisting of the creators of that art. White would have been particularly concerned with this new turn of events in the art world, for, if white leftist artists were worried about finding recognition and acceptance in mainstream art galleries and art journals—not to mention being blacklisted and jailed—a black social realist could hardly have felt sanguine about his or her prospects. Hemingway offers a balanced view of the merits of social realism to show that the "culture of the left" did indeed leave an important legacy in its insistence on a "realistic" representation of working people, black dignity, and class and race struggle. In his final summation of the works of painters like Raphael Soyer and Alice Neel—and, I would certainly add Charles White—who remained committed to the values of the Left even after they left the Party, Hemingway concludes: "Whatever its [the Communist Party's] limitations—it offered the most sustained critique available of class, racial, and sexual inequality" (247).

52. White's son Ian White says he does not think his father intended to represent any real figures in this drawing. Phone interview with the author, December 2012.

53. This last point about the "sounds" this painting represents was a suggestion made to me by the professor and literary critic Kenneth W. Warren.

54. Art historians dispute this characterization of the ascendancy of abstract art. Patricia Hill says that "all the art magazines including *Life*" show that abstract art did not become "hegemonic" in the late 1940s. See Hill's essays in *The Figurative Tradition and the Whitney Museum of American Art* co-written with Roberta Tarbell.

55. AAA interview, Box 10.

56. This interview is in the Charles White estate.

57. AAA interview, Box 3, 17.

58. White painted the top half of the card with the image of a black woman with an Angela Davis–style Afro. He placed a pink rose in the center of the bottom half. Using black and white cross-stitching as the background for the entire card, he made the

pink rose stand out as the only color on the card. The National United Committee to Free Angela Davis and All Political Prisoners published the card and one was sent to Governor Ronald Reagan.

59. Clothier oral interview of Fran Barrett White (26/41). Note that I am adding dual page numbers, because I numbered the entire interview consecutively to make it easier to find these references. In the manuscript, each interview is separately numbered.

60. The political nature of some of these cards is represented by the one Dalton and Cleo Trumbo sent bearing the photograph of a heavy-set, menacing, helmeted, and armed white police officer standing behind barbed wire, with the greeting "Merry Christmas to *You*! inscribed on the barbed wire. The cards are in the Charles White estate.

61. I am deeply grateful to Charles White's son Ian White for allowing me access to the Charles White Estate, for permission to use the images in this chapter, and for providing the cover image *Walk Together*. I also want to express my gratitude to Columbia University professor emeritus Edmund Gordon for sharing his extensive collection of Charles White art with me; giving me a private tour of the Heritage Gallery, the major repository of the Charles White collection; and for reading and critiquing this chapter. My deepest thanks to the art historian Daniel Schulman for help in my analysis of White's work and for generously reading and commenting on this chapter. The art curator Mark Pascale of the Art Institute of Chicago allowed me a private showing of *Harvest Talk*, and both Mark and Danny alerted me to the relationship between *Harvest Talk* and the FSA photograph by Marion Wolcott. Thanks also to the art historian Patricia Hills, professor of African American Studies, Boston University, who graciously read and commented on this chapter.

3. ALICE CHILDRESS: BLACK, RED, AND FEMINIST

1. Recent scholarship by Gore (2011) and McDuffie (2011) expands the discussion of Childress's relation to the Left. These two studies constitute the first comprehensive, book-length histories of black radical women of the United States (Washington 2013).

2. See Davies (2008, xv). In her biography of Claudia Jones, Davies comments on these absences as examples of the tendency to "[deport] the radical black female subject to an elsewhere, outside the terms of 'normal' African American intellectual discourse in the United States" (xv).

3. LaVinia Delois Jennings (1995, xv) says *Gold Through the Trees* was the first professionally produced play by a black woman.

4. As William Maxwell (2006) notes in his essay on Claude McKay's FBI files, unlike mainstream literary criticism institutions of the 1950s, J. Edgar Hoover's bureau always presumed the importance of black literary texts and traditions. Maxwell's research on the surveillance and suppression of black literary work and black writers provides evidence that black literary production was highly policed during the Cold War and therefore, to some extent, shaped by state-sponsored censorship.

5. Many scholars of the U.S. Left question the accepted periodization of the Popular Front as limited to the years 1935 through 1939. See Smethurst (1999), Wald (2001), Mullen (1999), and Dolinar (2012).

6. In fact, there is little mention of the politics of the 1950s at all in Jennings's biography, which focuses more closely on literary history and aesthetics.

7. The relationship of this essay to Maxwell Anderson's 1941 anti-Nazi play *Candle in the Wind* is worth considering. Childress might very well have seen Anderson's play about the German occupation of France since it opened in New York and starred the famous Helen Hayes, and she would have been drawn to its radical political views.

8. In his study of the relationship between Betty Friedan's feminist politics and her work in the left-wing labor movement of the 1940s and 1950s, Daniel Horowitz (2000) argues that Friedan reconstructed herself in the 1970s as a middle-class feminist, omitting much of her radical leftist past. Horowitz shows that Friedan distanced herself and her politics from her leftwing labor past in her famous text *The Feminist Mystique*, claiming that her feminism developed in response to the problems of middle class white suburban women. Childress did not turn away from her leftist politics, but she did not foreground her left radicalism, which is understandable given the repressions of the Cold War.

9. See, for comparison, the communist critic Moissaye Olgin's (1927) essay, "For a Workers Theater."

10. See Childress's letter to Hughes from June 3, 1957. She continues in the letter to scold Hughes for his reductionist representations of black culture: "Gin and watermelon is as much a part of white America's diet as any other food and drink, and yet I got the feeling that it was a part of Negro Culture and we had been shamed into denying it. Where did this watermelon phobia stem from? Out of thin air did we decide to become ashamed of watermelon eating and gin drinking because we liked these things . . . and thus stamped them as a mark of inferiority? I think not. This shame came out of white-mouthed minstrels grimacing from billboards over a slice of melon, Calendars bearing distorted drawings of Negro children sitting in the midst of melons, from white writers and artists who portrayed Negro men and women as gin-soaked, lazy people. Of course we have a right to drink gin, I agree with you. But there is nothing 'uppity' or foolish about drinking scotch. Must it be one or the other? Most restaurants and bars in the South do not allow Negroes to sit down and eat anything, and whatever melons or gins may be sold are there for white customers only. As for a Negro man making love to a woman by repeating the words water melon over and over . . . I think the protest then becomes so self-conscious that it defeats the protest." In this same letter, Childress expressed her disappointment with Hughes for disavowing his writing in his appearance before HUAC, which she called, dismissively, "one of those crazy committees." In 1949, in response to an argument with Sidney Poitier and other men of the Harlem Left, who claimed that only issues involving black men could represent racial struggle, she wrote the 1949 female-centered play *Florence*, reputedly overnight, to prove that black women's lives were

just as central to issues of underemployment, segregation, and racial violence as men's (McDonald 2012, 187). From 1949 on, all of Childress's work would reflect a black feminist viewpoint and a black cultural nationalism that allowed her to incorporate, improve on, and, perhaps inadvertently, conceal her leftist cultural politics. See also Beth Turner (1997, 45).

11. In a phone conversation with me, Jennings told me about the age change and also said that Jean's birth records are "sealed." Furthermore, Jennings said she was unable to locate a marriage certificate for Alice and Alvin Childress in any New York borough, despite Childress's nearly lifelong tenure in New York City.

12. The historian Martha Biondi identifies O'Neal as a "committed activist" blacklisted along with the actors Ossie Davis and Dick Campbell (2003, 177–178).

13. Some of the writing she did in the 1960s, particularly the 1966 play *Wedding Band*, was aided by a two-year visiting appointment to the Radcliffe Institute for Independent Study in Cambridge, Massachusetts, which she got with the help of the leftist writer Tillie Olsen.

14. A religious woman who was distributing Jehovah's Witness material in the black community at the time she was attacked, Ruby Floyd fled to the home of a black family who took her to the police and later testified on her behalf. And, of course, there was never the possibility of an unbiased trial because of the conviction of the entire community that in a Southern state black men accused of raping a white woman could never be exonerated. The NAACP argued that the death penalty for rape in Virginia was reserved for black men, and the CRC pleaded for executive clemency, both to no avail.

15. As with the other scenes in *Gold*, music is an important counterpoint to the action. The scene ends with John drumming as he names aloud the people and things he is fighting and dying for: "For . . . my mother . . . my father . . . my sister my people . . . Burney . . . for me . . . for the little children . . . freedom . . ." Then, as Ola smiles at him, perhaps for the last time, he slows the drum to an "intense but soft rhythm" and adds, "for Ola" (act 2, 9). In one instance, the play was described by a critic as a "showcase" for both African and African American *cultural* traditions and, in another, as the descendant of the minstrel tradition (Higashida 2011). Hansberry's review is particularly helpful because it alludes to two scenes that were lost in the archived version—the scene of the Haitian rebellion led by "Father Toussaint" to overthrow the French planters and Napoleon's army in 1849 and a scene depicting labor struggles in the British West Indies, both of which make the play's internationalism even more evident. Hansberry also notes that some of the best acting in the play was by Childress herself playing the Haitian woman, who, between shouting out her wares for sale, is clandestinely bringing news and materials for the rebellion.

16. In *Many Are the Crimes* (1999), Schrecker says that because of the reports on Africa by the African American press and the work of influential leaders like Paul Robeson and W. E. B. Du Bois, "the civil rights movement [in the 1940s] had a global perspective," covering freedom struggles and strikes in Africa, denouncing imperial-

ism, and linking American racism to South African apartheid. With the destruction of the Left, however, "the black community simply let Africa drop off the map," with the result that "Americans, both black and white, know less about Africa today than they did in the 1940s" (375–376). One of the results of not understanding these links between Africa and the Left is that black intellectuals in the 1980s and 1990s perpetuate views on Africa that almost amount to myth. In her 1996 dissertation, Elizabeth Barnsley Brown explains the theme of Africa in Childress's 1970 play *Mojo* as "an obvious outgrowth of the revival of the Black Aesthetic during the Black Arts Movement of the 1960s" (47) with no reference to the global articulations of the relationship between Africa and U.S. blacks in the 1940s and 1950s made by the black Left, specifically by Childress.

17. Childress may have begun to imagine her Mildred stories when she adapted and directed Langston Hughes' Simple stories for the production of *Just a Little Simple*, presented at the Club Baron in 1950.

18. For example, according to a phone interview I conducted with Esther Jackson in 2009, Lorraine Hansberry lived with Jones when she first came to New York. Childress became active with the Harlem Committee to Repeal the Smith Act at the time that Jones was being threatened with deportation.

19. See Davies (2008, xiv). Davies points out, however, that while Marx's grave bears a "towering" bust of Marx, Jones's is marked by only a simple flat stone.

20. According to the *Freedom* files, the paper was distributed throughout the United States, including North Carolina, California, Detroit, Chicago, Seattle, Boston, Birmingham, and in all the New York boroughs.

21. Lamphere (2003) states that Lloyd L. Brown was the ghostwriter for many, if not all, of the Robeson columns, which Robeson checked and apparently approved. This assertion was corroborated by Martin Duberman (1988, 393).

22. I want to refute the attack on *Freedom* made by Harold Cruse in his 1967 *The Crisis of the Negro Intellectual*. His chapter on *Freedom* seems to have but one purpose, and that is to discredit the newspaper as an integrationist tool of the Communist Party, divorced from and disinterested in the realities and needs of the black community. Cruse's critique of *Freedom* is a sign of the empty rhetoric and personal vindictiveness of *Crisis*. There is no consistent review or evaluation of articles and editorials in *Freedom*, just an unsubstantiated claim that *Freedom* was uninterested in black culture or "the social problems of people in ghettoes," when even a cursory glance at the paper shows that it focused on these very issues for its entire five years. Confronted with the overwhelming evidence of the paper's devotion to black issues, Cruse simply shifts tactics and manipulates the evidence. Unable to ignore *Freedom*'s extensive coverage of the Willie McGee case, Cruse simply insists that since very few Negroes in Harlem showed up for the Willie McGee defense rally in Harlem, that is evidence enough to show "what little influence *Freedom* newspaper had in Harlem." With no mention of the anticommunist assaults on *Freedom* and the black Left by McCarthy and HUAC, Cruse says that *Freedom* failed because of

"the political and creative default of the Negro leftwing intellectuals." Lloyd Brown says, and many critics of Cruse agree, that Cruse used *Crisis* as a private battleground to settle old scores, and he certainly felt that he had many to settle with the writers of *Freedom*, particularly Robeson and Hansberry. See Singh (2005) for an extended analysis of Cruse.

23. As the historian Martha Biondi puts it, the Cold War targeting of black leaders under the Smith Act meant that "any political link to Communists would have the taint of criminal subversion" (2003, 144).

24. In 1966, *Wedding Band* was so controversial that Childress could get it produced only at the University of Michigan. No New York producer would touch the play until Joseph Papp agreed to produce it at the Public Theater in 1972, more than six years after its opening. Then, on October 26, 1972, at the last of the three press openings—the one most of the critics attended—there was a horrifying moment for the cast when someone, reportedly wearing a dashiki and a turtleneck sweater, began making loud, hostile remarks during the love scenes between the two main characters, Herman, who is white, and Julia, a black woman. Ruby Dee, who played Julia in the Papp production, said that the mood of the play was shattered and the cast so dispirited that they did not even attend the cast party that night. The reviews, expectedly, were lukewarm, but despite this uncertain beginning, the play went on to become the strongest of any at the Public that season, and Papp began talking about taking it to Broadway.

As this mysterious dashiki'd figure suggests, *Wedding Band* seemed to have appeared at the wrong historical moment. A year after the Watts uprising, with black nationalism and black power in the political ascendancy, there was little sympathy, even on the Left, for the difficulties of an interracial affair, particularly one between a black woman and a white man. The novelist John Killens, Childress's friend and fellow leftist, felt that *Wedding Band* was not only the wrong play for an era of intense black militant struggle but that it was a betrayal of Childress's own political commitment.

25. Though whites were invited to write for the journal, the rule was that "no whites could be on the editorial board." See Biondi (2003, 265) and Smethurst (1999). Esther Jackson, in a 2009 phone interview with the author, said that Aptheker was so furious that he refused to subscribe to or read the journal, though before he died he sent a letter apologizing to Jackson.

26. See also Biondi (2003).

27. To forestall any claim that she identified with Julia because of her own interracial relationship, Childress (1973, 8) says that she was not married to a white person and never had "any kind of white relationship in my life."

28. Childress said explicitly in a 1967 article in *Black World*, "The Black Experience: Why Talk About That?" that she had political motivations for writing this play.

29. In *To Stand and Fight*, Biondi reports that Davis argued that "a new race discourse of individual success stories was displacing attention from the more urgent problem of group retrogression." Some blacks were getting high-paying, high-powered jobs

in industry and government, while most blacks could not get a job to drive a milk wagon or work in an airplane factory. These high-paying jobs were, Davis argued, "an attempt of the ruling class to head off and undermine the militant struggles of the Negro workers for jobs and freedom" (quoted in Biondi 2003, 183).

30. See Frazier in Singh (2005, 180), Von Eschen (1997, 158), and Biondi's (2003, 165, 183) term. See also Carter et al. (1956). Von Eschen (1997, 153–159) excellently analyzes the way race and racism were systematically reframed in domestic terms, thus displacing more militant civil rights arguments that racism was grounded in systems of domination.

31. In the 1967 Supreme Court decision *Loving v. Virginia*, the court specifically used the term "White Supremacy": "There is patently no legitimate overriding purpose independent of invidious racial discrimination which justifies this classification. The fact that Virginia prohibits only interracial marriages involving white persons demonstrates that the racial classifications must stand on their own justification, as measures designed to maintain White Supremacy. We have consistently denied the constitutionality of measures which restrict the rights of citizens on account of race. There can be no doubt that restricting the freedom to marry solely because of racial classifications violates the central meaning of the Equal Protection Clause" (*Loving v. Virginia*, 1967, 388, U.S. 12).

32. Childress set *Wedding Band* in 1918, the year after the 1917 silent protest parade in New York City organized by the NAACP to protest lynching and the year preceding the Red Summer of 1919, during which racial attacks on blacks occurred across the country in many cities. Some of these racially motivated attacks were directed toward black men in uniform, but a new spirit of self-confidence and self-assertion was evident as black men and women (Red Cross nurses) returned from fighting abroad determined to demand first-class citizenship, and Nelson represents that spirit. In his May 1919 editorial for *Crisis*, W. E. B. Du Bois firmly expressed this new spirit: "We return / We return from fighting / We return fighting."

33. This parallels the idea on political anger: "Anger becomes a political resource only when it is collective" (Hedin 1982).

34. See also Singh (2005, 13).

35. For my full discussion of this phrase, see Washington (1996).

36. See Singh (1999).

37. I am much indebted to James Smethurst's meditation on and analysis of the relationship between the "narratorial consciousness" and the representations of the "folk" and the literary Left's revisions of that relationship. In his chapters that consider the poets Sterling Brown, Langston Hughes, Gwendolyn Brooks, Melvin Tolson, Margaret Walker, and Robert Hayden, Smethurst emphasizes how the Left often problematized constructions of the "folk": "Similarly, in the work of many artists of the literary Left, and the critical writings of many intellectuals associated with the Communist Left, the problematic relation of the Left intellectual-writer to the working class (and, during the Popular Front, to the people) is raised again and again. This is particularly true in the work of African-American writers, such as

Brown and [Richard] Wright, where an identification with the folk is asserted along with a vanguard role for the African-American intellectual; then the two assertions are questioned both sharply and uneasily. In the case of Walker, the formal distinction between the 'prophetic' poems and the 'folk' poems calls into question the identification between the narratorial consciousness of the poems the represented and/or recreated folks, though this commonalty is never questioned by the denotative sense of Walker's poems" (1999, 185).

38. In my review of *A Short Walk* (Feminist Press, 2007), I focused on issues of cross-dressing and queer sexuality in the novel. See Higashida (2009) for an excellent reading of queer sexuality in the novel.

39. Alan Wald takes on this issue of the tensions between blacks and whites on the Left in "Through the Eyes of Harold Cruse."

40. Left-wing journals and illustrations typically portrayed the radical as a white working-class male. The masthead of *Masses & Mainstream*, for example, shows a muscular, bare-chested white man holding a mallet in one hand and a book aloft in the other.

41. In the summer issue of *Feminist Studies* (2002), a reproduction of Neel's portrait of Irene Peslikis is on page 374 of Denise Bauer's article and on the cover.

4. WHEN GWENDOLYN BROOKS WORE RED

1. Lawrence Jackson (2010, 196) puts Brooks in the chapter on "Afroliberals and World War II" and provides some evidence of Brooks's rejection of radicalism in the letters she wrote to her editor Elizabeth Lawrence "to defend her aesthetic" (210). I agree with Jackson that Brooks aimed "to dramatize her ability to belong to a world quite different from the black Chicago Marxist bohemia," but that makes my point that early on she was minimizing her leftist ties.

2. She published a second autobiographical sketch in 1996, *Report from Part Two*.

3. Alan Wald, e-mail to the author, November 2012.

4. See Mullen (1999, 228). In several footnotes, Mullen notes that Shaw and Kent "ascribe nonpolitical motives to her work," Shaw insisting that she was naïve, believing "innocently in the basic goodness of man and of Christianity, that integration was the solution to the black man's [*sic*] problems." Mullen says that both Smethurst and Ann Folwell Stanford (1992) try to "relocate Brooks as a figure much influenced by the Left cultural and political milieu of the Popular Front and Negro People's Front" (228n6). Mullen also notes that Brooks excludes her participation in the League of American Writers and in letters to Mullen "discounts the influence of Leftists and fellow travelers" (228n11).

5. Smethurst mentions both poems in his *The New Red Negro* and wrote to me in an e-mail that they show an indebtedness to Popular Front cultural politics.

6. These were the kinds of charges that were leveled at Charles White's experimental art in the 1950s as leftist criticism took a turn toward Soviet orthodoxy. Perhaps because

Kreymborg was himself an experimental imagist poet, he was particularly sensitive to Brooks's formal experimentations. He gave brief readings of several poems and was especially impressed with the ten war sonnets that close the volume, calling them "among the finest contributions any poet has made to war poetry" (1945, 28).

7. Here I am following Andrew Hemingway's (2002) argument in the chapter "The End of Democratic Front Aesthetics and the Emergence of Zhdanovism" (219–223).

8. Alfred Kreymborg, a friend of Carl Sandburg and the editor of the "little magazine" *Others* between 1916 and 1919, was part of the Americanist avant-garde poetry circles that aimed for transformations in poetry that would move toward a more inclusive modernism. Kreymborg's praise of Brooks may well have been expiation for his earlier crude racial views shown in his review of Jean Toomer, in which he praised Toomer for exhibiting that "frankly lyrical strain native to the darky everywhere" (quoted in North 1994, 149). Later, he moved to the left, and thus his modernist credentials and leftist politics made him, in many ways, the ideal reader for Brooks's early poetry.

9. Brooks left clues about her desires for secrecy and privacy in her Bancroft papers. In the *Poetry* review (January 1967) of Sylvia Plath's poetry, Eleanor Ross Taylor ends her review, "After Twenty Years," with this statement about confessional poetry: "The confessional poem seems so amiable, it is easily available to the reader; it makes the poet feel better; yet it uses the poet shabbily; the poem that seemed to him his very individuality tends to fall into a clinical type, and its grasp of the reader deprives that reader of *one chief pleasure of poetry, the feeling of having come upon a silence, a privacy, upon intellect existing unselfconsciously somewhere out of reach of camera.*" Brooks wrote on the cover of the issue, "See page 262," and then circled those lines I have italicized. I read this marginalia as a caution to anyone attempting to pin down Brooks's political or personal views and to suggest that, at least before 1967, Brooks meant to create a poetic persona that could not be easily apprehended.

10. At the risk of reifying the myth of her conversion, I wish to point to some examples of its reproductive vitality. The introductory essays on Brooks in both the *Norton Anthology of American Literature* and the *Norton Anthology of African American Literature* open with a story of Brooks's 1967 "shift" and thus reproduce the teleology of a "new" Brooks that emerges in the wake of the Fisk Black Writers Conference. Critics have been unable—or unwilling—to dislodge this conversion story. Dismissing the importance of race and class in Brooks's early poetry, one critic claimed that "Brooks's later work took a far more political stance. Just as her first poems reflected the mood of their era, her later works mirrored their age by displaying what *National Observer* contributor Bruce Cook termed 'an intense awareness of the problems of color and justice'" (Poetry Foundation n.d.). Toni Cade Bambara (1973) reported in the *New York Times Book Review* that at the age of fifty "something happened to Brooks, a something most certainly in evidence in *In the Mecca* and subsequent works—a new movement and energy, intensity, richness, power of statement and a new stripped lean, compressed style. A change of style prompted by a change of mind." "Though some of her work in the early

1960s had a terse, abbreviated style, her conversion to direct political expression happened rapidly after a gathering of black writers at Fisk University in 1967," Jacqueline Trescott (quoted in Poetry Foundation n.d.) reported in the *Washington Post*. Brooks herself noted that the poets there were committed to writing as blacks, about blacks, and for a black audience. If many of her earlier poems had fulfilled this aim, it was not due to conscious intent, she said. But from this time forward, Brooks thought of herself as an African determined not to compromise social comment for the sake of technical proficiency (Bryant 2007).

11. Such arguments encourage literary historians of the Left to reject the standard conversion narrative about Brooks. For example, as early as 1987 Houston Baker disputed the idea of Brooks's ascension to the enlightenment of the new black nationalist aesthetic and concluded: "she is more justly described as a herald than as an uninformed convert" (28).

12. For discussion of the relationship of black Popular Front and leftist writers and modernism, see especially Smethurst's (1999) chapter "Gwendolyn Brooks and the Rise of 'High' Neomodernism."

13. In 1987, Brooks agreed to publish this essay in my anthology, *Invented Lives: Classic Stories by and About Black Women*, but she withdrew the essay before publication, saying that she did not want to publish an essay that focused on disagreements between black women and men.

14. Reif-Hughes calls them "snapshots," but I reject that term because they focus not on the visual but on the interior life.

15. See Brooks's 1951 essay "Why Negro Women Leave Home."

16. Though Lawrence Jackson says that Brooks's first book of poetry *A Street in Bronzeville* "proved that the social realists had hit their stride" (2010, 205), neither her poetry nor *Maud Martha* could be considered poster books for social realism. In fact, as I will show, *Maud Martha* can be read as countering the social realism of Richard Wright.

17. See Mullen (1999).

18. Mullen, personal e-mail, October 13, 2012.

19. The scene with Bigger, Mary, and Jan in a diner in *Native Son* is a vivid contrast to the diner scene in *Maud Martha*.

20. Melhem (1987, 90) offers a particularly insightful reading of this ending.

21. Rex Gorleigh correspondence, 1945, Chicago South Side Community Art Center Archives, part 1, box 1, folder 20.

22. Significantly, William Dean Howells used "bitter" (1901) to reject Charles Chesnutt's *The Marrow of Tradition* in 1901 and, in an age of censorship of black anger, practically destroyed Chesnutt's publishing opportunities.

23. The letters from Brooks to Conroy are in the collection of Conroy's papers in the Newberry Library; those from Conroy to Brooks are in her papers at the Bancroft. This letter is at the Newberry, Box 4:189.

24. Conroy letter from July 17, 1962, to Brooks (Bancroft).

25. This letter, dated October 28, 1955, is at the Bancroft Library, in Box 1:28. There also is a photograph in Conroy's papers that shows Brooks sitting next to Margaret Taylor and Conroy's son.

26. In 1952, when Robeson was denied the chance to sing at any churches or high schools in Chicago, he gave a free concert before a crowd of five thousand in Washington Park, which served as the South Side's forum for free speech. The show was sponsored by the Committee for the Negro in the Arts and the Greater Chicago Labor Council. In addition to singing favorites like "Ol' Man River," Robeson promoted his *Freedom* newspaper. He also addressed the crowd with an appeal for unity: "If Negro fraternal, civic, religious, and social organizations join together this year they could force the powers in Washington to grant full civil rights status to the Negro people." Quoted in *Amsterdam News* (June 7, 1952). Brian Dolinar, e-mail to author, April 28, 2011.

27. Dolinar, e-mail to author, April 28, 2011.

28. In his introduction to the newly reissued Federal Writers Project *The Negro in Illinois*, the literary historian Brian Dolinar (2013) notes that although Wright knew about the park's political significance, he did not allude to it in his project report dated March 27, 1937: "Wright gives considerable space in the essay to the educational and recreational activities in the park, but only makes brief mention of its significance as an open forum. Washington Park was the center of black political and social life during the 1930s. It was where debates were held between Socialists and Communists, Christians and non-Christians, nationalists and pan-Africanists. It was where rallies, marches, and parades took place. Although Wright had spent much time there, he appears to have edited out any radical or racial commentary that would have sent up red flags indicating his own political views. To do otherwise might have cost him his job with the Writers' Project."

29. Named for the first president, the park is the largest of the four Chicago district parks surnamed Washington and was once, according to Brooks, rechristened Malcolm X Park by 1960s radicals.

30. Many thanks to my colleague Christina Walter for this insight about the poem and for the hours she spent reading these poems through the lens of her well-trained modernist eye.

31. Brian Dolinar, personal correspondence.

32. In the poem "IX truth" from the "Womanhood" section of *Annie Allen*, Brooks writes in metaphorical terms about the people's hard unwillingness to respond to the "fierce hammering" of change and challenge: "if the sun comes," the poet-narrator prophesies, those who have spent "so lengthy a / Session with shade" will be unable to respond to the urgencies of the sun, preferring instead "To sleep in the coolness / Of snug unawareness" (reprinted in Brooks 1994, 130).

33. Conversation with Professor Aaron Lecklider (American Studies Association annual meeting, Puerto Rico, November 2012) to whom I am indebted for the possible queer reading of the poem. Convincingly, he argues that the complete absence of gender

signifiers requires us to consider that Brooks's radicalism might extend to her views on sexuality.

34. In a letter to *Negro Digest* (July 1966), Brooks confronted and corrected a statement by a Stanford student, Ron Miller, that Brooks was not available for the civil rights struggle but was rather a sort of ivory-tower poet. The confrontation is discussed in Kent (1990, 193).

5. FRANK LONDON BROWN: THE END OF THE BLACK CULTURAL FRONT AND THE TURN TOWARD CIVIL RIGHTS

1. In his introduction to *Invisible Suburbs: Recovering Protest Fiction in the 1950s in the United States*, Josh Lukin proposes integrating two models for theorizing 1950s culture in order to avoid imposing a unitary view on the decade that would fail to account for or to include its historical realities. Lukin argues that views of the 1950s as "the complacent decade" or the "decade of conformity" ignore that decade's complexities and diversities. Lukin advises combining two opposite models to capture that diverse world, which he calls the "Containment Model" and the "Emergence Model." The containment model focuses on the decade as dominated by the institutional forces that brought us the political repressions of the Red Scare, ideological censorship, and sexual and racial conservatism. Lukin considers the containment model best represented by Lary May's 1989 anthology *Recasting America: Culture and Politics in the Cold War* and Elaine Tyler May's 1988 study *Homeward Bound: American Families in the Cold War Era*. The emergence model, "a complementary school of thought emphasizing resistance," is represented by such scholarship as Alan Wald on the work of leftists, Michael Denning's recovery of the Popular Front, Barbara Ehrenreich on male rebellion, John D'Emilio on gay movements, and Leila Rubb and Verta Taylor on feminism (xiv). What is useful about this integrative approach, especially in analyzing fiction, is that it avoids totalizing the decade as entirely dominated by the repressions of the Cold War or by resistance movements. Instead, it acknowledges the variety, diversity, contradictions, and overlap in this cultural moment and recognizes and recovers the agency of those in resistance work, particularly in civil rights struggles among marginalized groups. Though I discovered this book as I was finishing work on this chapter, I wish to call attention to this model since it describes what I attempt in this chapter on *Trumbull Park*, which is so clearly marked by themes and images of both containment and what I call resistance.

2. Bennett Johnson, phone interview with the author, January 24, 2004.

3. Bennett Johnson, e-mail to the author, July 9, 2012.

4. The group's politics in regard to communism were quite complicated. The United Packinghouse Workers of America (UPWA) was formed in 1943 out of the old CIO packinghouse unions. Leftists, communists, black militants, and white trade unionists

formed coalitions in the union that allowed the UPWA to maintain local control and, unlike other unions, to fight against the purge of communists, who were an essential part of the union's activism. See Halpern (1997, chaps. 6–7).

5. The term "packinghouse exceptionalism" was coined by Halpern (1997) to indicate the union's extraordinary commitments to leftist politics, civil rights, and women's equality.

6. See Smethurst (1999) for more on this point. I am indebted throughout *The Other Blacklist* to the brilliant scholarship of Smethurst on the black literary Left. He is especially illuminating in the way he historicizes the aesthetic practices of the Left and with his close readings and theoretical insights on the poetry of Gwendolyn Brooks, Langston Hughes, Sterling Brown, and the entire panoply of Black Popular Front poetry.

7. Stuckey wrote a commentary on the first edition of *Trumbull Park*, published by Regnery.

8. Phone interview with the author, April 9, 1997.

9. *Shelley v. Kraemer* (1948).

10. Phone interview with the author, May 14, 2004.

11. According to Evelyn Brown Colbert, the Brown's fourth child and only son, Frank London Brown III, was born three months after they left Trumbull Park and died forty-five minutes after he was born; his death, she believes, was probably caused by the tremendous stress of their lives during their years in Trumbull Park. Personal interview with the author, January 23, 2004.

12. New Criticism, named after John Crowe Ransom's book *The New Criticism* (1941), is a literary movement in North American and British English literature. The movement originated in the 1920s and developed throughout the first half of the twentieth century as a pedagogical practice supposedly focused on objective literary study. New Critical theory insists upon the following tenets: "autonomy" of the text, in that meaning is derived only from form and linguistics without consideration of aspects outside of the text (e.g., authorial intent or historical context); paraphrase as damaging to the text's autonomy because, as a restatement of meaning, paraphrase remains external to the text; "organic unity" of the text in that each part informs the meaning of a complex whole, yet the whole determines the meaning of each part; irony as the fundamental nature of the text; and close reading as the method to derive the essence of the text (i.e., "irony, paradox, ambiguity, and complexity"). New Criticism remains influential, particularly through its legacy of close reading. Critics, however, accuse New Criticism of promoting positivism and failing to recognize or acknowledge political connotations (Childs 1993).

13. See also Langston Hughes in the *New York Herald Tribune* (July 5, 1959).

14. See my foreword in Northeastern University Press's 2005 reprint of *Trumbull Park*.

15. Smethurst, Maxwell, Wald, Von Eschen, and Duffie, among others, have pioneered this kind of reading.

16. When Hansberry's play opened on Broadway, even her FBI informant could find no evidence of communist thought and concluded in the report, "The play contains

no comments of any nature about Communism as such but deals essentially with negro [*sic*] aspirations" (U.S. FBI, February 5, 1959). In "The Displacement of Anger and Blame in Lorraine Hansberry's *A Raisin in the Sun*," the literary scholar Odessa Rose cites four scenes omitted from the Broadway version *Raisin in the Sun*, omissions that she says reflect the antiradicalism of the play: (1) Travis kills a rat in their apartment, a scene reminiscent of the opening of Richard Wright's *Native Son*; (2) Beneatha cuts her hair into an Afro in act 2, scene 1, causing great disturbance among the family (even though the actor Diana Sands actually wore her hair in an Afro, she had to wear a wig for the play); (3) in act 2, scene 2, Lena and her neighbor Mrs. Johnson have a conversation over Booker T. Washington's ideology, in which Johnson clearly critiques white racism and predicts the violence the Youngers will face in their new neighborhood; and (4) the Younger family is attacked in their new home by an angry white mob, an autobiographical scene that Hansberry's own family experienced. Rose concludes: "*Raisin*, as it appeared in 1959, told the story of a group of people that just happened to be Negroes. With some minor adjustments, the characters could have just as easily been played by whites. Omitting these four scenes made *Raisin* a *universal* play about *universal* people struggling for *universal* goals, rather than the story of the life of the working-class Negro" (7).

17. See page 23 of Brown's FOIA file, particularly the footnote on the Progressive Party.

18. The historian Sterling Stuckey says that Brown was "on the Left politically" and "may have been in the Communist Party, but he didn't talk the jargon, and I have no evidence that he was a member" (April 9, 1997).

19. Oscar Brown Jr., a union member and open communist, wrote in *Freedom* in 1953 that the Packinghouse Workers Union was successful in disrupting HUAC's scheduled hearings in the summer of 1953 (Smith 2004, 302). This disruption of HUAC is an example of a coalition between radical leftists and civil rights organizers.

20. Brown was sent as UPWA program coordinator to cover the 1955 trial of the two white men accused of the murder of Emmett Till. His short story, "In the Shadow of a Dying Soldier," published in the *Southwest Review* in 1959, the same year as *Trumbull Park*, is based on his experiences covering this trial. As in *Trumbull Park*, Brown's focus is always on the internal struggle of the black resisters: the black men standing outside the courtroom, the landlady who defies white authorities, and, above all, Emmett's mother, Mamie Till, and his uncle, Mose Wright, who testify against white Mississippi men. Like the novel, the story emphasizes the small, barely noticeable changes in an oppressed people, who often seem too defeated to struggle, as they summon the courage to make change. Adam Green (2007) argues that *Trumbull Park* "confined itself to the events prior to 1955" and that Brown did not "venture further [to explore] the parallels with an even more disturbing event of racial violence: the death of Emmett Till in Mississippi in August 1955." Had Green been inspired to "venture further"— he would have discovered that this short story does indeed interrogate the meaning of Till's death in powerful ways.

21. The report filed on that day covers the investigative period 10–8, 10–12, 15–19, and 22/56; see pages 20 and 29.

22. In "F.B. Eyes: The Bureau Reads Claude McKay," Maxwell (2003) reads McKay as a kind of literary double agent, consciously writing back to the agents who were surveilling him, and masking his revolutionary intentions in "politicized formality." Maxwell takes the term "F.B. Eyes" from Richard Wright's unpublished poem "FB Eye Blues" (1949). In the poem the voice laments, through classic blues repetition, waking to find the FBI hiding under his bed and informing him of what he revealed about his dreams while sleeping (Maxwell 2003, 40).

23. From Richard Wright's unpublished poem "FB Eye Blues" (1949).

24. This was published in the *Daily Worker* (February 12, 1929). The African American communist Harry Haywood, a major figure in the CPUSA until he was expelled in the late 1950s, was involved in developing Comintern's black belt thesis. For more on African Americans, CPUSA, and the "national question," see Smethurst (1999, 21–25).

25. The entire debate over the "Negro Question" is recounted in chapter 5, "A Nation within a Nation," in Mark Solomon's *The Cry Was Unity: Communists and African Americans, 1917–1936* (1998, 68–91). Smethurst also has an extended discussion of response to the nation thesis in *The New Red Negro* (1999, 23–24).

26. As Laura Williams (2012, 7) notes, Wright, in his "Blueprint for Negro Writing" (1937) "indicted black writers as an educated class fixated on 'begging . . . white America' to accept black humanity. Demanding that black writers 'do no less than create values by which [their] race is to struggle, live and die,' Wright advocated the production of social realism, immersed in and evolving from black folklore, that 'will embrace all those social, political, and economic forms under which the life of [the Negro] people is manifest.'"

27. Graham (1990) says that growing up in Chicago, "one of the major centers of bebop music in the 1950s," deeply influenced Brown's life and his writing. Graham says that the new music of bebop "based on the same revolutionary impulses as the written literature of the thirties and forties" reflected "a more assertive dynamic in cultural expression." For the writers and artists who came after Richard Wright, this music functioned as an "abstract expression of a militant political mode that would become a central theme in the black experience in the 1960s."

28. Wald (2001, 295) writes that representing full-blown interracial class solidarity was difficult because "interracial utopia was not part of the day-to-day experiences of ordinary African Americans," but, because of his activities in a progressive left-wing union, Brown seems to have been well positioned to offer such a representation of interracial cooperation.

29. Phone interview with the author, May 14, 2004.

30. Thomas Schaub describes Ellison's protagonist's move underground as a self-induced paralysis (1991, 104–115).

31. The song continues with these lines, which are omitted in *Invisible Man*: "I'm white . . . inside . . . but, that don't help my case 'cause I . . . can't hide . . . what is in my face."

32. Smethurst (2004) notes similar gestures toward both civil rights and black popular front aesthetics in Lloyd Brown's *Iron City*.

33. Malcolm X gave literary and political prominence to the Bandung conference when he referred to it in his speech, "Not Just an American Problem, but a World Problem," given at Corn Hill Methodist Church in Rochester, New York, on February 16, 1965. He hailed Bandung as the first time in history that the dark-skinned nations of the world had united to reject colonialism and racism and to promote unity among the colonized. No European nation was invited, nor was the United States, their very absence, he claimed, signifying them as the world's colonizers. In *The Color Curtain: A Report on the Bandung Conferentce* (1956), Richard Wright, one of the attendees, gives a first-hand view of the conference. Adam Clayton Powell, then a U.S. congressman, attended the conference and asserted that far from being oppressed, Negroes in the United States were a privileged group. According to Lloyd L. Brown, the press praised Powell for his patriotism, and Congress passed a resolution commending Powell (letter to the author, October 23, 1998).

34. The Bandung organizers had "pointedly" excluded "the two great, rival centers of power in the modern world," the United States of America and the Soviet Union (Romulo 1956, 1).

35. Denning argues in *The Cultural Front* that the nationalism of the black cultural front "was inflected with a popular *internationalism*" that emphasized that ethnic or racial stories were always intended to lead to "the love for, and the unity among, all peoples of all nations" (1996, 132).

36. I want to thank Christopher Brown of the University of Maryland for this insight in how the marginalization of the Left continuously circulates.

37. According to Henry Regnery's 1996 obituary in the *New York Times*, "Regnery published some of the first and most important books of the postwar American conservative movement." The *Times* called it "one of only two houses known to be sympathetic to conservative authors." In 1951, Regnery published William F. Buckley Jr.'s *God and Man at Yale*. Two years later, Regnery published *The Conservative Mind*, a seminal book for American conservatism during the period. In 1954, Regnery published *McCarthy and His Enemies*, by Buckley and L. Brent Bozell Jr. The authors criticized McCarthy but were sympathetic to him, and McCarthy was pleased enough with the book that he attended a reception for them. Regnery also published two books by Robert Welch in the early 1950s, both of which can be read as anticommunist: *May God Forgive Us*, in which Welch accused many influential foreign-policy analysts and policymakers of being part of a conspiracy to further communism, and a biography of John Birch, who served as an intelligence officer during World War II and was killed by Chinese communists.

38. E-mail to the author, September 4, 2011.

39. Phone interview with the author, May 14, 2004.

40. This informant goes on to say that the term "left winger" in this particular case indicated that Brown was a rather outspoken person who was always attempting to gain

equal rights for the people of his race and that the term "left winger" in this particular case "had no other connotation whatsoever."

41. Phone interview with the author, May 14, 2004.

6. 1959: SPYCRAFT AND THE BLACK LITERARY LEFT

1. I'll refer to this as the *Roots* volume throughout this chapter.

2. The question of African history, culture, and independence were clearly the focus of AMSAC. In AMSAC's twenty-three-page statement of purpose, the centrality of Africa to the organization is constantly reiterated. The statement begins by defining the organization as "a group of American Negro scholars, artists, and writers who have joined together to study African culture," motivated by an awareness of Africa "swiftly emerging as a major participant in world history." One of AMSAC's missions was "to establish contact and cooperation with African governmental representatives in new York, African student organizations in the USA, international organizations, cultural groups and other American organizations primarily concerned with Africa." AMSAC planned a "Center of African Culture" in New York to facilitate interest in Africa, and a Festival was planned for 1960–1961 to be held in Africa. There is literally only one line in the entire statement of purpose that refers to American Negro culture. See "The American Society of African Culture and Its Purpose."

3. In *The Indignant Generation*, Lawrence Jackson (2010) states that the papers tended to question, radically, the psychological, cultural, and developmental value that lay at the bottom of the ideal of fully embracing—"integrating"—into a society that had been content to persecute Americans of African descent.

4. Brenda Gayle Plummer's (1996) assessment of the AMSAC conference mirrors my own conclusion that many ideological positions were represented at the conference: "Records of AMSAC reveal that internal ideological tensions were rife from the beginning, quite apart from CIA meddling. Cultural nationalism could impose and then disguise a fundamentally conservative outlook. This perspective never dominated because times were simply changing too rapidly" (254).

5. Hansberry's original speech for the *Roots* conference is in the Lorraine Hansberry papers, box 66, folder 4, Schomburg Center for Research on Black Culture.

6. I want to acknowledge Keith Gilyard's (2010) critique that my labeling Davis and Redding "conservative" is "reductionist" (350n20). However, I stand by my assessment of their politics even though in some contexts, as Gilyard notes, they would both be called "liberals" for their support of American democratic ideals. Eugenia Collier (who worked with Davis at Howard University) and Julian Mayfield in his unpublished article "The Foolish Consistency of Saunders Redding"—as well as Redding himself in *To Make A Poet Black*, *On Being Negro in America*, and *An American in India*—offer very clear documentation of a kind of politics that I consider "conservative": it offers very mild rebukes of white racist practice, is highly

individualistic, and desires an accommodation with and assimilation into the white American mainstream.

7. Chapter 9 of Wilford (2008), "Into Africa: African Americans," is the most comprehensive study of CIA involvement with AMSAC.

8. In its concern for African American cultural production and/or racial issues, the CIA seemed, at first glance, to be interested only in cosmetic touch-ups to its diversity program. It paid for an extended European tour of the opera *Porgy and Bess*, it lobbied Hollywood to tamp down any serious consideration of racial issues, and it urged filmmakers to plant dignified and well-dressed Negroes in crowd scenes. But there was something much more important and sinister afoot with the CIA's investment in black culture. Given the potential for a radical black politics to develop in the face of an increasingly militant civil rights movement in the United States and growing independence movements in Africa, the question was how to discredit the black Left, undermine any serious discussion of the U.S. race issue, and counter black-Left support for newly emergent independent black African nations.

9. In its early heady days of lavish CIA funding, the organization was so flush with money that it was able to promise members "travelling [*sic*] a distance of 450 miles or more from any direction to New York" a reimbursement "equal to 1/2 the cost of first class return air transportation," according to an "Arrangements Information Sheet" in the AMSAC papers. If members chose cheaper transportation, literally all of their travel cost could be paid by AMSAC. Half of the conference fee of $21 could also be reimbursed, and the banquet fee was paid for by AMSAC. All participants were asked to register with AMSAC at the Conference Hotel.

10. See AMSAC papers, Box 9, #3. AMSAC's ties to the CIA and the money from the agency were exposed by the *New York Times* in a series of articles in February 1967. Once AMSAC's ties to the CIA were revealed, Davis was hard pressed to get his funding renewed. As early as April 24, officials were issuing memos about AMSAC's "present tarnished image." Davis sent a letter to Assistant Secretary of State for Educational and Cultural Affairs Charles L. Frankel on June 9, pleading not to be dropped on the grounds that the image of the American Negro would be left in the hands of "black nationalists, to SNCC, and to those who excite the rage of the Negro poor by referring to the African and slave past, to injustices done and to empires lost; to those who feel they must ridicule American culture as a means of asserting their own validity" (6). Throughout the letter, Davis walks a fine line on the issue of intelligence, saying, "While it would be expected that such an organization would cooperate with the cultural activities of the United States Government, there must be adequate safeguards against such an organization being used for intelligence purposes." However, AMSAC was on its way to dissolution. By September 1, the internal memos about "terminal employee benefits" and "lack of funds here" showed that the organization was in its last days.

11. The phrase "The New Negro Liberals" is Lawrence Jackson's (2010).

12. See, for example, Alain Locke's essays written between 1936 and 1951, in which he began to refine definitions of social protest, making it clear that social protest was a

leftist term. This is particularly clear in several essays published in the collection of his works, *The Critical Temper of Alain Locke* (1983), including "The Negro: 'New' or Newer: A Retrospective of the Literature of the Negro for 1938"; "Of Native Sons: Real and Otherwise," which originally was published in *Opportunity* in January and February 1941; "Wisdom *De Profundis*: The Literature of the Negro, 1949"; "Inventory at Mid-Century: A Review of the Literature of the Negro for 1950"; and "The High Price of Integration: A Review of the Literature of the Negro for 1951."

13. The lecture—which was, significantly, supported by CIA funds—was later published in Wright's collection *White Man Listen*. The lecture series was sponsored by the Congress for Cultural Freedom (CCF), which Frances Stonor Saunders declares was "the centerpiece" of the CIA's covert cultural campaign from 1950 to 1967 (Saunders 1999, 88–91; Wright, "Literature of the Negro" 104–105).

14. See Von Eschen (1997, 175–176). She writes that AMSAC's "most important legacy lay in the area of scholarship," which helps make my point about the importance of the *Roots* volume as Cold War scholarship intended to shape African American literary study. She notes an earlier publication by AMSAC, *Africa Seen by American Negro Scholars*, published as a special edition of *Presence Africaine* in 1958 and republished in the United States in 1963. It minimizes racism, accuses communists of manipulating racial issues in international contexts, and omits the anticolonial work of the black leftist internationalists Du Bois, Hunton, and Robeson.

15. For a discussion, see Julian Mayfield's unpublished essay "The Foolish Consistency of Saunders Redding and Others." Redding's talk originally was titled "The Sanctions of the American Negro's Literary Art."

16. Many memoirs by blacklisted and politically active writers testify to the level of fear and intimidation of the Cold War and the effects of McCarthyism. Andre Schiffrin's *A Political Education: Coming of Age in Paris and New York* (2007) is one of the most informative about the effects of Cold War on the publishing industry.

17. In *Renewing the Left*, Harvey M. Teres (1996) devotes an entire chapter to the failure of *Partisan Review* to expose its largely white audience to African American cultural expression. Specifically, he notes that the journal included no articles on African American writing and none on race until 1940. The journal produced no coverage of race and segregation during the World War II years, and there was little change in that policy after the war. While the journal did later include an excerpt from Ralph Ellison's 1952 novel *Invisible Man* and published James Baldwin's earliest essays, Teres concludes: "If we look at the range of African American writing from the 1930s to the 1960s, we see that nearly all of it was ignored by *Partisan Review*, not to mention nearly every other white publication in the country. Among the writers who produced noteworthy work during this period yet whose work was never reviewed were W. E. B. Du Bois, Lorraine Hansberry, Margaret Walker, Arna Bontemps, Sterling Brown, Robert Hayden, John O. Killens, William Attaway, Chester Himes, Frank Yerby, Ann Petry, Willard Motley, Dorothy West, William Gardner Smith, Frank Marshall Davis, William Demby, John A. Williams, Owen Dodson, and J. Saunders Redding" (212–213).

18. At the time of the conference, he had recently returned from Puerto Rico, where he lived from 1954 to 1958, working with his wife, the physician Ana Livia Cordero, and the Puerto Rican Communist Party in the independence movement (Gaines 2007, 145). He also had worked with Robert Williams's armed self-defense civil rights movement in Monroe, North Carolina, in the late 1950s; had gone to Cuba to celebrate the Cuban independence struggle; and had signed a public statement against the United States for its Bay of Pigs invasion of Cuba. When he was indicted by the FBI in 1961 for participating in Williams's program, he and his wife escaped and left for Ghana, where he worked for President Kwame Nkrumah editing *The African Review* after Ghana gained independence. It is interesting to note that in a 1970s oral history Mayfield reported that, as a Marxist materialist, he was "cynical" about "searching back into our ancestral roots," and he said he had little faith in such things as looking to the African experience for a "discussion of spiritual values" (Mayfield 1970, 552-30) since he was fully aware of the corruption in African societies that had allowed for a collaboration with the slave trade.

19. See, for example, Schlesinger (1949).

20. The original speech is in the Lorraine Hansberry papers, box 66, folder 4, Schomburg Center for Research on Black Culture.

21. See the AMSAC papers, box 4, no. 4, Hoyt Fuller draft (5). Wachuu and Senghor were part of the African contingents feted by AMSAC with their lavish funds.

22. Ibid.

EPILOGUE: THE EXAMPLE OF JULIAN MAYFIELD

1. New studies of the black Left: Higashida (2011), Gore (2011), McDuffie (2011), and Wald (2012).

2. I refer here to the assertions that Barack Obama was mentored by a communist in Hawaii. In his autobiography *Dreams for My Father*, Obama mentions a man named Frank who became his mentor. Obama might have been referring to Frank Marshall Davis. In the 1940s Davis was a member of the Civil Rights Congress, the Chicago Civil Liberties Committee, and a supporter of Henry Wallace's Progressive Party.

3. When I interviewed Catlett in New York (October 25, 2004), she was very candid about her leftist past, but she insisted that I not name her a communist.

4. The Rosenbergs were executed in 1952 for allegedly spying for the Soviet Union. Most think that Ethel Rosenberg was innocent and that even her husband Julius was executed for political reasons since executions were usually reserved for spying during wartime, and the United States was not at war with the Soviet Union.

5. It is rarely noted that *The God That Failed*, an anthology of sketches by "prominent intellectuals" to document their disillusionment with communism, was paid for and promoted by the CIA.

WORKS CITED

Allara, Pamela. 2000. *Pictures of People: Alice Neel's American Portrait Gallery*. Boston: University Press of New England.

"American Society of African Culture and Its Purpose." N.d. AMSAC papers. Moorland-Spingarn Center, Howard University, Washington, D.C.

Anderson, Carol. 2003. *Eyes off the Prize: The United Nations and the African American Struggle for Human Rights, 1944–1955*. New York: Cambridge University Press.

Anderson, Michael. 2008. "Lorraine Hansberry's Freedom Family." *American Communist History* 7, no. 2: 259–269.

Archives of American Art (AAA). Smithsonian, Washington D.C.

Arnesen, Eric. 2001. *Brotherhoods of Color: Black Railroad Workers and the Struggle for Equality*. Cambridge, Mass.: Harvard University Press.

——. 2006. "No 'Graver Danger': Black Anti-Communism, the Communist Party, and the Race Question," *Labor* 3: 23–52.

Atlanta University and Clark Atlanta University. 1950. *Phylon* (Fourth Quarter). Atlanta, Ga.: Atlanta University.

Baker, Houston A. 1987. "The Achievement of Gwendolyn Brooks." In *A Life Distilled: Gwendolyn Brooks, Her Poetry and Fiction*, ed. Maria K. Mootry and Gary Smith. Bloomington: University of Illinois Press.

Baldwin, James. 1949. "Everybody's Protest Novel." In *The Norton Anthology of African American Literature*, 2nd ed., ed. Henry Louis Gates Jr. and Nellie Y. McKay, 1699–1705. New York: Norton, 2004.

——. 1951. "Many Thousands Gone." *Partisan Review* 18 (November–December): 665–680.

Baldwin, Kate A. 2002. *Beyond the Color Line and the Iron Curtain: Reading Encounters Between Black and Red, 1922–1963*. Durham, N.C.: Duke University Press.

Bambara, Toni Cade. 1973. "Review of *Report from Part One.*" *New York Times Book Review* (January 7).

Barnwell, Andrea. 2002. *Charles White.* Petaluma, Calif.: Pomegranate.

Barrett-White, Frances, with Anne Scott. 1994. *Reaches of the Heart: A Loving Look at the Artist Charles White.* New York: Barricade.

Bauer, Denise. 2002. "Alice Neel's Feminist and Leftist Portraits of Women." *Feminist Studies* 28, no. 2 (Summer): 375–395.

Bell, Bernard. 1989. *The Afro-American Novel and Its Tradition.* Boston: University of Massachusetts Press.

Bibby, Michael. 1995. "Conquering the Color Line: Body Politics in African American Poetics of the Early Cold War." American Studies Association, Pittsburgh, Penn.

——. 2006. "'A Most Uncanny Vision': Welborn Victor Jenkins's The *"Incident" at Monroe.*" Black Poetry Out of the Archive. Modernist Studies Association Annual Conference. Doubletree Hotel, Tulsa, Okla. (October 20). Lecture.

Biondi, Martha. 2003. *To Stand and Fight: The Struggle for Civil Rights in Postwar New York City.* Cambridge, Mass.: Harvard University Press.

Bone, Robert. 1958. *The Negro Novel in America.* New Haven, Conn.: Yale University Press.

Bonosky, Phillip. N.d. "Odyssey of a Writers Workshop in New York City in the 1950s." Unpublished memoir. In possession of the author.

——. 2007. Phone interview with the author.

Borstelmann, Thomas. 2001. *The Cold War and the Color Line: American Race Relations in the Global Arena.* Cambridge, Mass.: Harvard University Press.

Bradley, Van Allen. 1959. "Trumbull Park, Elm Street Politics and AP." *Chicago Daily News* (April 15).

Bragg, Robert. 2005. Oral interview with Nadine Wilmot. Bancroft Library, University of California, Berkeley.

Branch, William. 2000. Phone interview. (October).

Brooks, Gwendolyn. N.d. Comments about Conroy. Bancroft Library Banc MSS/83z. Carton 1, Folder 28.

——. 1937. "Southern Lynching." *Crisis* (June): 189.

——. 1945. Letter to Jack Conroy. Jack Conroy papers, Newberry Library, Chicago.

——. 1951. *Holiday* 10, no. 4 (October): 64.

——. 1951. "Why Negro Women Leave Home." *Negro Digest* (March): 26–28.

——. 1953. *Maud Martha.* New York: Harper.

——. 1962. "Of Frank London Brown: A Tenant of the World." *Negro Digest* (September).

——. 1966. *Negro Digest.*(July): 49–50.

——. 1972. *Report from Part One.* Detroit: Broadside.

——. 1983. Interview with Claudia Tate. In *Black Women Writers At Work,* ed. Claudia Tate. New York: Continuum.

——. 1994. *Blacks.* Chicago: Third World.

——. 1996. *Report from Part Two.* Chicago: Third World.

Brown, Elizabeth Barnsley. 1996. "'Shackles on a Writer's Pen': Dialogism in Plays by Alice Childress, Lorraine Hansberry, Adrienne Kennedy, and Ntozake Shange." Ph.D. diss. Chapel Hill: University of North Carolina.

Brown, Frank London. 1959. "Brown's Speech Slaps Housing." *Daily Defender* (May 19).

——. 1959. *Trumbull Park*. Chicago: Henry Regnery.

——. 1969. *The Myth Maker*. Chicago: Path.

Brown, Lloyd. 1949. "What I Saw in Mexico." *Masses & Mainstream* (November): 7–15.

——. 1949b. "Trumpets of Jericho." Review of Sidney Finkelstein's *Jazz: A People's Music*. *Masses & Mainstream* (January): 75–78.

——. *Iron City*. 1951. Boston: Northeastern University Press, 1994.

——. 1951b. "Which Way for the Negro Writer?" *Masses & Mainstream* (March–April).

——. 1951c. "Psychoanalysis vs. the Negro People." *Masses & Mainstream* (October): 16–24.

——. 1952. "The Legacy of Willie Jones." *Masses & Mainstream* (February): 44–51.

——. 1952. "The Deep Pit." Review of *Invisible Man*. *Masses & Mainstream* (June): 62–64.

——. 1952. Review of *Gold Through the Trees*. *Masses & Mainstream* (May): 64.

——. 1959. "The Negro Writer." Letter to editor. *Sunday New York Times Book Review* (May 24).

——. 1997. *The Young Paul Robeson: "On My Journey Now."* Boulder, Colo.: Westview.

——. 1999. Personal Interview.

Brown, Sterling. 1951. "Athletics and the Arts." In *A Documentary History of the Negro People in the United States*, vol. 6: *1951–1959: From the Korean War to the Emergence of Martin Luther King Jr.*, ed. Herbert Aptheker, 17–54. New York: Citadel.

Brownlee, Les. 1960. "Frank London Brown—Courageous Author." *Sepia* (June): 26–30.

Bryant, Jacqueline Imani. 2007. *Gwendolyn Brooks and Working Writers*. Chicago: Third World.

Carter, Robert L., et al. 1956. *Love of This Land: Progress of the Negro in the United States*. London: CEP.

Caute, David. 1978. *The Great Fear: The Anti-Communist Purge Under Truman and Eisenhower*. New York: Simon and Schuster.

Cayton, Horace. 1965. *Long Old Road*. New York: Trident.

Cheng, Charles. 1973. "The Cold War: Its Impact on the Black Liberation Struggle Within the United States." *Freedomways* 13, nos. 3–4: 184–199, 281–292.

Childress, Alice. 1950. *Florence*. *Masses & Mainstream* 31 (October): 34–47.

——. 1951. "For a Negro Theatre." *Masses & Mainstream* 4 (February): 61–64.

——. 1951. "For a Strong Negro People's Theatre." *Daily Worker* (February 16): 11.

——. 1951. *Gold Through the Trees*. Unpublished manuscript. Childress papers. Schomburg.

——. 1956. *Like One of the Family: Conversations from a Domestic's Life*. Boston: Beacon.

——. 1957. Letter to Langston Hughes, June 3. Langston Hughes Collection, Yale Collection of American Literature, Beinecke Rare Book and Manuscript Library, Yale Library, New Haven, Connecticut.

——. 1967. "The Black Experience: Why Talk About That?" *Negro Digest* 16 (April).

——. 1971. "Tribute to Paul Robeson." In *Paul Robeson: The Great Forerunner*, ed. The Editors of *Freedomways*, 272–273. New York: Dodd, Mead.

——. 1973. *A Hero Ain't Nothin' but a Sandwich*. New York: Puffin, 2000.

——. 1973. *Wedding Band: A Love/Hate Story in Black and White*. New York: Samuel French.

——. 1973. Interview by Ann Allen Shockley. Alice Childress Papers, MG 649, Schomburg Center for Research in Black Culture, New York Public Library, Astor, Lenox and Tilden Foundations, box 1, folder 6. Original archival location: Special Collections and Archives, John Hope and Aurelia Elizabeth Franklin Library, Fisk University, Nashville, Tennessee.

——. 1979. *A Short Walk*. New York: Coward, McCann, and Geohegan.

——. 1984. "A Candle in a Gale Wind." In *Black Women Writers, 1950–1980: A Critical Evaluation*, ed. Mari Evans. New York: Doubleday.

——. 1989. *Those Other People*. New York: Putnam.

Childs, Donald J. 1993. "New Criticism." In *Encyclopedia of Contemporary Literary Theory*, ed. Irena R. Makaryk, 120–124. Toronto: University of Toronto Press.

Christmas, Walter. 1949. "Advertising Jim Crow." *Masses & Mainstream* (September).

Clothier, Peter. N.d. *Charles White: A Critical Biography*. Unpublished. Altadena, Calif.: Charles White Estate.

——. 1970. Taped oral interview. "We start in Chicago." Charles White estate. September 14, 1970.

——. 1980–1981. Oral interviews. Altadena, Calif.: Charles White Estate.

Colbert, Evelyn Brown. 1980. "The Works of Frank London Brown." MA thesis, Chicago State University.

Communist Party USA. 1928. "The Comintern Resolution on the Negro Question in the United States." *Daily Worker* (February 12).

Corwin, Charles. 1950. "Charles White's Exhibit an Important Event in Art World." *Daily Worker* (February 20).

——. 1951. "White's Exhibit Is Valuable Object Lesson to Progressive Artists, Public Says." *Daily Worker* (February 26): 11.

Crossman, Richard, ed. 2001. *The God That Failed*. New York: Columbia University Press.

Cruse, Harold W. N.d. "AMSAC Writers Conference Notes." Robert F. Wagner Labor Archives, Box 2, Folder 13. Tamiment Library, New York University.

——. 1967. *The Crisis of the Negro Intellectual*. New York: William Morrow.

Davies, Carole Boyce. 2008. *Left of Karl Marx: The Political Life of Black Communist Claudia Jones*. Durham, N.C.: Duke University Press.

Davis, Frank Marshall. 1992. *Livin' the Blues: Memoirs of a Black Journalist and Poet*. Madison: University of Wisconsin Press.

Davis, John A., ed. 1960. *The American Negro Writer and His Roots: Selected Papers from the First Conference of Negro Writers*. New York: American Society of African Culture.

Davis, Ossie. 2006. *Life Lit by Some Large Vision: Selected Speeches and Writings*. New York: Atria.

Davis, Ossie, and Ruby Dee. 2004. *With Ossie and Ruby: In This Life Together*. New York: Perennial.

De Carava, Roy. 1952. "a poem in our bread . . . a story in our meat." Archives of American Art, Box 3191, pp. 199–206.

Denning, Michael. 1996. *The Cultural Front: The Laboring of American Culture in the Twentieth Century.* Brooklyn: Verso.

Dijkstra, Bram. 2003. *American Expressionism: Art and Social Change 1920–1950.* New York: Abrams.

Dolinar, Brian. 2009. "Introduction to Richard Wright's WPA Writings." *Southern Quarterly* (Winter).

——. 2012. *The Black Cultural Front: Black Writers and Artists of the Depression Generation.* Jackson: University Press of Mississippi.

——, ed. 2013. "Introduction." *The Negro in Illinois: The WPA Papers.* Champaign: University of Illinois Press.

Dorfman, Carl. 2001. Interview with author. New York (May 21).

Du Bois, W. E. B., et al. *Appeal to the World: A Statement on the Denial of Human Rights to Minorities in the Case of Citizens of the United States of America and an Appeal to the United Nations for Redress* (1947). Typescript. NAACP Records, Manuscript Division, Library of Congress (095.00.00) Courtesy of the NAACP [Digital ID # na0095p1].

Duberman, Martin B. 1988. *Paul Robeson: A Biography.* New York: Knopf.

Dudziak, Mary. 2002. *Cold War Civil Rights: Race and the Image of American Democracy.* Princeton, N.J.: Princeton University Press.

Egerton, John. 1995. *Speak Now Against the Day: The Generation Before the Civil Rights Movement.* Chapel Hill: University of North Carolina Press.

Evergood, Philip. 1953. "Charles White: Beauty and Strength." *Masses & Mainstream* 6, no. 8 (August): 36–39.

Fabre, Michel. 1990. *Richard Wright: Books and Writers.* Jackson: University Press of Mississippi.

——. 1993. *The Unfinished Quest of Richard Wright.* 2nd ed. Urbana: University of Illinois Press.

Finkelstein, Sidney. 1953. "Charles White's Humanist Art." *Masses & Mainstream* 6, no. 2 (February): 43–46.

——. 1955. *Charles White: Ein Kunstler Amerikas* (Charles White: an American artist). Dresden: Veb Verlag Der Kunst.

Foley, Barbara. 1997. "Roads Taken and Not Taken: Post-Marxism, Antiracism, and Anticommunism." Speech given at the MLA annual meeting, December.

——. 2003. *Spectres of 1919: Class and Nation in the Making of the New Negro.* Chicago: University of Illinois Press.

——. 2006. "From Communism to Brotherhood: The Drafts of *Invisible Man*." In *Left of the Color Line: Race, Radicalism and Twentieth-Century Literature of the United States*, ed. B. V. Mullen and J. A. Smethurst. Chapel Hill: University of North Carolina Press, 163–182.

——. 2010. *Wrestling with the Left: The Making of Ralph Ellison's* Invisible Man. Durham, N.C.: Duke University Press.

Folsom, Franklin. 1994. *Days of Anger, Days of Hope: A Memoir of the League of American Writers, 1937–1942.* Boulder: University Press of Colorado.

Gaines, Kevin. 2007. *African Americans in Ghana: Black Expatriates and the Civil Rights Era.* The John Hope Franklin Series in African American History and Culture. Chapel Hill: University of North Carolina Press.

Garaudy, Roger. 1946. "Artistes sans uniformes." *Art de France* 9 (November): 17–20.

Gates, Henry Louis, Jr., and Nellie Y. McKay, eds. 2004. *The Norton Anthology of African American Literature.* 2nd ed. New York: Norton.

Gery, John. 1999. "Subversive Parody in the Early Poems of Gwendolyn Brooks." *South Central Review: The Journal of the South Central Modern Language Association* 16, no. 1 (Spring): 44–56.

Gilyard, Keith. 2010. *John Oliver Killens: A Life of Black Literary Activism.* Athens: University of Georgia Press.

Goldsby, Jacqueline. 2006. *A Spectacular Secret: Lynching in American Life and Literature.* Chicago: University of Chicago Press.

Goldstein, Robert Justin. 2008. *American Blacklist: The Attorney General's List of Subversive Organizations.* Lawrence: University Press of Kansas.

Goluboff, Risa L. 2007. *The Lost Promise of Civil Rights.* Cambridge, Mass.: Harvard University Press.

Gordon, Eugene. 1953. "Negro Labor Is Advancing: The Second Annual Convention of the National Negro Labor Council Discuss Progress and Perspectives in the Fight Against Jimcrow." *Jewish Life* (February): 10–14.

Gore, Dayo F. 2011. *Radicalism at the Crossroads: African American Women Activists in the Cold War.* New York: New York University Press.

Gorman, Paul G. 1996. *Left Intellectuals and Popular Culture in Twentieth-Century America.* Chapel Hill: University of North Carolina Press.

Goss, Bernard. 1936. "Ten Negro Artists on Chicago's South Side." *Midwest: A Review* (December): 17–19.

Graham, Maryemma. 1990. "Bearing Witness in Black Chicago: A View of Selected Fiction by Richard Wright, Frank London Brown, and Ronald Fair." *CLA Journal* (March): 280–297.

Green, Adam. 2007. *Selling the Race: Culture, Community, and Black Chicago, 1940–1955.* Chicago: University of Chicago Press.

Guilbaut, Serge. 1984. *How New York Stole the Idea of Modern Art.* Chicago: University of Chicago Press.

"Gwendolyn Brooks." 2004. In *Norton Anthology of African American Literature,* 2nd ed., ed. Henry Louis Gates Jr. and Nellie Y. McKay, 1623–1625. New York: Norton.

Hall, Gwendolyn Midlo. E-mail to author, September 30, 2012.

Hall, James. 2001. *Mercy, Mercy Me: African-American Culture and the American Sixties.* New York: Oxford University Press.

Halpern, Rick. 1997. *Down on the Killing Floor: Black and White Workers in Chicago's Packinghouses, 1904–54.* Chicago: University of Illinois Press.

Hansberry, Lorraine. N.d. "Resume." Schomburg, Box 66.

——. 1951. "Letter to Edythe." Schomburg, Box 66.

———. 1952. "CNA Presents Exciting New Dramatic Revue." *Freedom* (May): 7.

———. 1959. "Closing Remarks." AMSAC Conference. Reprinted as "The Negro Writer and His Roots: Towards A New Romanticism." In *The Black Scholar* (March–April 1971).

———. 1964. *The Movement: Documentary of a Struggle for Equality.* New York: Simon and Schuster.

Harris, Jerry. 1999. *CyRev: A Journal of Cybernetic Revolution, Sustainable Socialism, and Radical Democracy.* http://www.net4dem.org/cyrev/archive/.

Harris, Trudier. 1982. *From Mammies to Militants: Domestics in Black American Literature.* Philadelphia: Temple University Press.

———. 1986. Introduction to *Like One of the Family . . . Conversations from a Domestic's Life,* by Alice Childress. Boston: Beacon.

Hayden, Robert. *Selected Poems.* New York: October House, 1966.

Hedin, Raymond. 1982. "The Structuring of Emotion in Black American Fiction." *Novel* (Fall): 35–54.

Hemingway, Andrew. 2002. *Artists on the Left: American Artists and the Communist Movement, 1926–1956.* New Haven, Conn.: Yale University Press.

Herzog, Melanie Anne. 2005. *Elizabeth Catlett: An American Artist in Mexico.* Seattle: University of Washington Press.

Higashida, Cheryl. 2009. "All the World's a Minstrel Stage: Alice Childress, Queer Feminism, and Black Anticolonialism." Paper presented at the American Studies Association Annual Meeting.

———. 2011. *Black Internationalist Feminism: Women Writers on the Left, 1945–1995.* Chicago: University of Illinois Press.

Hill, Patricia Liggins, et al., eds. 1988. *Call and Response: The Riverside Anthology of the African American Tradition.* Boston: Houghton Mifflin, 1998.

Hills, Patricia. 1980. *The Figurative Tradition and the Whitney Museum of American Art: Paintings and Sculpture from the Permanent Collection.* Exhibition co-curated and co-authored with Roberta Tarbell. New York: Whitney Museum of American Art.

Hirsch, Arnold R. 1995. "Massive Resistance in the Urban North: Trumbull Park, Chicago, 1953–1966." *Journal of American History* (September): 522–550.

Hood, Nicholas. 1953. "World Fight Against Jimcrow. *Jewish Life* (February): 14.

Horne, Gerald. 1986. *Black and Red: W. E. B. Du Bois and the Afro-American Response to the Cold War, 1944–1963.* Albany, N.Y.: SUNY Press.

———. 1988. *Communist Front? The Civil Rights Congress, 1946–1956.* Rutherford, N.J.: Associated University Presses.

———. 1994. *Black Liberation/Red Scare.* Newark: University of Delaware Press.

Horowitz, Daniel. 2000. *Betty Friedan and the Making of* The Feminine Mystique: *The American Left, the Cold War, and Modern Feminism.* Amherst: University of Massachusetts Press.

Howells, William Dean. 1901. "A Psychological Counter-Current." Reprinted in *Critical Essays on Charles Chesnutt,* ed. Joseph McElarth, 82. Independence, Ky.: Twayne, 1999.

Hughes, Langston. 1959. [Untitled.] *Jet* (April 2): 59.

Humboldt, Charles. 1949. "Communists in Novels." *Masses & Mainstream* (June): 13–21; (July): 44–65.

Ingram, Bob. 1959. "A Novelist Studies Trumbull Park." *Montgomery Advertiser* (April 19).

Iton, Richard. 2010. *In Search of the Black Fantastic: Politics and Popular Culture in the Post–Civil Rights Era.* Oxford: Oxford University Press.

Jackson, Esther. 1998. Interview with author (March 30).

Jackson, Lawrence. 2007. "Irredeemable Promise: J. Saunders Redding and Negro New Liberalism." *American Literary History* 19, no. 3 (Fall): 712–744.

——. 2010. *Indignant Generation: A Narrative History of African American Writers and Critics, 1934–1960.* Princeton, N.J.: Princeton University Press.

Jarvis, Arthur R. 2000. "The Living Newspaper in Philadelphia, 1938–1939." *Journal of Negro History* 85, no. 4 (Autumn): 241–259.

Jennings, La Vinia Delois. 1995. *Alice Childress.* New York: Macmillan.

Jenkins, Philip. 1999. *The Cold War at Home: The Red Scare in Pennsylvania.* Chapel Hill: University of North Carolina Press.

Jenkins, Welborn Victor. 1948. *The "Incident" at Monroe.* Atlanta, Ga.: United Negro Youth of America, an Organized Incorporated Charity.

Jones, Claudia. 1949. "An End to the Neglect of the Problem of the Negro Woman!" *Political Affairs* 28, no. 6 (June): 51–67.

Kardiner, Abram, and Lionel Ovesey. 1951. *The Mark of Oppression: A Psychosocial Study of the American Negro.* New York: Norton.

Kaiser, Earnest. 1949. "Racial Dialectics: The Aptheker-Myrdal School Controversy." *Phylon* 9, no. 4: 295–302.

Kelley, Robin D. G. 1996. *Race Rebels: Culture, Politics, and the Black Working Class.* New York: The Free Press.

Kent, George E. 1990. *A Life of Gwendolyn Brooks.* Lexington: University Press of Kentucky.

Killens, John O. 1984. "The Literary Genius of Alice Childress." In *Black Women Writers (1950–1980): A Critical Evaluation,* ed. Mari Evans. New York: Doubleday.

——. 1986. "Charles White: The People's Artist." *Georgia Review* 40, no. 2 (Summer): 451.

Koestler, Arthur. 1950. *The God That Failed.* New York: Harper and Brothers.

Kornweibel, Theodore, Jr. 1999. *Seeing Red: Federal Campaigns Against Black Militancy, 1919–1925.* Bloomington: Indiana University Press.

Kreymborg, Alfred. 1945. "Notable New Poet [review of *A Street in Bronzeville*]." *New Masses* (September).

Kuznick, Peter J., and James Gilbert, eds. 2001. *Rethinking Cold War Culture.* Washington, D.C.: Smithsonian Institution Press.

Lamphere, Lawrence. 2003. "Paul Robeson, 'Freedom' Newspaper, and the Black Press." Ph.D. diss. Boston College, 2003.

Lang, Clarence. 2009. "Freedom Train Derailed: The National Negro Labor Council and the Nadir of Black Radicalism." In *Anticommunism and the African American Freedom*

Movement: "Another Side of the Story," ed. Robbie Lieberman and Clarence Lang, 161–188. New York: Palgrave Macmillan.

Lecklider, Aaron. 2012. "'Mann Act, Woman-Act, Being-Black-and-Talking-Back': Intersections of Race and Sexuality in U.S. Radical Fiction." Paper presented at Race, Law, and American Literary Studies: An Interdisciplinary Conference. University of Maryland, College Park, March 29.

LeFalle-Collins, Lizzetta, and Shifra M. Goldman. 1996. *In the Spirit of Resistance: African-American Modernists and the Mexican Muralist School.* New York: American Federation of Arts.

Lieberman, Robbie, and Clarence Lang, eds. 2009. *Anticommunism and the African American Freedom Movement: "Another Side of the Story."* New York: Palgrave Macmillan.

Locke, Alain. 1983. *The Critical Temper of Alain Locke: A Selection of His Essays on Art and Culture.* Ed. Jeffrey C. Stewart. New York: Garland.

Lowney, John. 2006. *History, Memory, and the Literary Left: Modern American Poetry, 1935–1968.* Iowa City: University of Iowa Press.

Lukin, Josh. 2008. *Invisible Suburbs: Recovering Protest Fiction in the 1950s United States.* Jackson: University Press of Mississippi.

Madhubuti, Haki. 2001. "Gwendolyn Brooks: Beyond the Wordmaker—The Making of an African Poet." In *On Gwendolyn Brooks: Reliant Contemplation*, ed. Stephen Caldwell Wright, 81–96. Ann Arbor: University of Michigan Press.

Maguire, Roberta. 1995. "Alice Childress." In *The Playwright's Art: Conversations with Contemporary American Dramatists*, ed. Jackson R. Bryer, 48–69. New Brunswick, N.J.: Rutgers University Press.

Manning, Patrick. 2009. "The Communist Party, the Popular Front, and Reimagining 'America' in Lloyd Brown's *Iron City*." *Pennsylvania Literary Journal* (Winter).

Marshall, Paule. 2009. *Triangular Road: A Memoir.* New York: Basic Civitas.

Martin, Louis E. 1955. "Dope and Data." *Chicago Defender* (September 10).

Mathews, Jane De Hart. 1967. *The Federal Theatre, 1935–1939: Plays, Relief, and Politics.* Princeton, N.J.: Princeton University Press.

Maxwell, William J. 1996. "The Proletarian as New Negro: Mike Gold's Harlem Renaissance." In *Radical Revisions: Reading 1930s Culture*, ed. Bill Mullen and Sherry Lee Linkon, 91–117. Urbana: University of Illinois Press.

——. 2003. "F.B. Eyes: The Bureau Reads Claude McKay." In *Left of the Color Line: Race, Radicalism, and Twentieth-Century Literature of the United States*, ed. Bill V. Mullen and James Smethurst, 39–65. Chapel Hill: University of North Carolina Press.

——. Forthcoming. *FB Eyes: How J. Edgar Hoover's Ghostreaders Framed African American Literature.* Princeton, N.J.: Princeton University Press.

Mayfield, Julian. N.d. "The Foolish Consistency of Saunders Redding and Others." Unpublished essay. Schomburg, Julian Mayfield collection.

——. 1960. "Into the Mainstream and Oblivion." In *The American Negro Writer and His Roots*, 29–34. New York: The American Society of African Culture.

——. 1961. *The Grand Parade.* New York: Vanguard.

——. 1970. Interview with Malaika Lumumba. Moorland-Spingarn, Howard University. May 3.

McDermott, Douglas. 1965. "The Living Newspaper as a Dramatic Form." *Modern Drama* 8, no. 1 (May): 82–94.

McDonald, Kathlene. 2012. *Feminism, the Left, and Postwar Literary Culture.* Jackson: University Press of Mississippi.

McDuffie, Erik S. 2011. *Sojourning for Freedom: Black Women, American Communism, and the Making of Black Left Feminism.* Durham, N.C.: Duke University Press.

Melamed, Jodi. 2011. *Represent and Destroy: Rationalizing Violence in the New Racial Capitalism.* Minneapolis: University of Minnesota Press.

Melhem, D. H. 1987. *Gwendolyn Brooks: Poetry and the Heroic Voice.* Lexington: University Press of Kentucky.

Morgan, Stacy I. 2004. *Rethinking Social Realism: African American Art and Literature, 1930–1953.* Athens: University of Georgia Press.

Mullen, Bill. 1999. *Popular Fronts: Chicago and African-American Cultural Politics, 1935–46.* Chicago: University of Illinois Press.

Murray, Albert, and John Callahan, eds. 2000. *Trading Twelves: The Selected Letters of Ralph Ellison and Albert Murray.* New York: Modern Library.

Murphy, James Francis. 1991. *The Proletarian Moment: The Controversy Over Leftism in Literature.* Urbana: University of Illinois Press.

Myers, Shaundra J. 2011. "Worlds Beyond Brown: Black Transnational Identity and Self-Narration in the Era of Integration." Ph.D. diss. University of Maryland, College Park.

Nadler, Paul. 1995. "Liberty Censored: Black Living Newspapers of the Federal Theatre Project." *African American Review* 29, no. 4 (Winter): 615–622.

Nelson, Paul. 2001. "Orphan and Old Folks." *Minnesota History* 57, no. 7 (Fall): 368–379.

New York Times. 1967. AMSAC Papers, Box 9. February.

Noakes, John A. 2003. "Racializing Subversion: The FBI and the Depiction of Race in Early Cold War Movies." *Ethnic and Racial Studies* 26, no. 4 (July): 728–749.

North, Michael. 1994. *The Dialect of Modernism: Race, Language, and Twentieth-Century Literature.* Oxford: Oxford University Press.

Obama, Barack H. 2000. *Dreams from My Father: A Story of Race and Inheritance.* New York: Three Rivers.

O'Dell, Hunter (Jack). 2000. "Origins of Freedomways."

——. 2006. "Letter to William Patterson." In *Life Lit by Some Large Vision: Selected Speeches and Writings*, by Ossie Davis. New York: Atria.

Olgin, Moissaye. 1927. "For a Workers' Theatre." *Daily Worker* (April 2).

Paretsky, Sara. 2003. *Blacklist.* New York: Putnam/Penguin.

Pittman, John. 1951. "Charles White's Exciting 'Negro Woman' Show." *Daily Worker* (February 26).

——. 1953. "The Art of Charles White: He Combats the Racists' Ideas." (March 1).

Platt, David. 1951a. "Charles White Finds USSR Creating Finest Art." *Daily Worker* (December 13).

———. 1951b. "Soviet Art Reflects Life of a Heroic Society, Says White." *Daily Worker* (December 14).

Plummer, Brenda Gayle. 1996. *Rising Wind: Black Americans and U.S. Foreign Affairs, 1935–1960*. Chapel Hill: University of North Carolina Press.

Poetry Foundation. N.d. "Biography: Gwendolyn Brooks, 1917–2000." *Poetry*. http://www.poetryfoundation.org.

Poitier, Sydney. 2007. *The Measure of a Man*. San Francisco: HarperSF.

———. 1980. *This Life*. New York: Knopf.

Posgrove, Carol. 2005. *Divided Minds: Intellectuals and the Civil Rights Movement*. New York: Norton.

Powell, Richard J. 1997. *Black Art and Culture in the Twentieth Century*. London: Thames and Hudson.

Rabinowitz, Paula. 1991. *Labor and Desire*. Chapel Hill: University of North Carolina Press.

Rampersad, Arnold. 2002. *The Life of Langston Hughes*. Vol. 2: *1914–1967, I Dream a World*. Oxford: Oxford University Press.

———. 2005. Introduction to *Native Son*. New York: HarperPerennial.

Redding, J. Saunders. 1939. *To Make a Poet Black*. New York: Cornell University Press.

———. 1951. "Review of Lloyd L. Brown's *Iron City*." *Baltimore Afro-American* (August 4): 4.

———. 1954. *An American in India: A Personal Report on the Indian Dilemma and the Nature of Her Conflicts*. New York: Bobbs-Merrill.

———. 1959. "The Sanctions of the American Negro's Literary Art." Reprinted as "Keynote Address, the American Society of African Culture, March, 1959," in *Rhetoric of Racial Revolt*, ed. Roy L. Hill, 279–285. Denver, Colo.: Golden Bell, 1964.

———. 1962. *On Being Negro in America*. New York: Bobbs-Merrill.

Reif-Hughes, Gertrude. 1990. "Making It *Really* New: Hilda Doolittle, Gwendolyn Brooks, and the Feminist Potential of Modern Poetry." *American Quarterly* 42, no. 3 (September).

Retman, Sonnet. 2011. *Real Folks: Race and Genre in the Great Depression*. Durham, N.C.: Duke University Press.

Robins, Natalie. 1992. *Alien Ink: The FBI's War on Freedom of Expression*. New Brunswick, N.J.: Rutgers University Press.

Robinson, Cyril. 2011. *Marching With Dr. King: Ralph Helstein and the United Packinghouse Workers of America*. Santa Barbara, Calif.: Praeger.

Romulo, Carlos P. 1956. *The Meaning of Bandung*. Chapel Hill: University of North Carolina Press.

Rose, Odessa. 1998. "Pointing the Finger: The Displacement of Anger and Blame in Lorraine Hansberry's *Raisin in the Sun*." Paper written for English 628 seminar, Readings in African American Literature, University of Maryland.

Rosenfelt, Deborah. "From the Thirties: Tillie Olsen and the Radical Tradition." *Feminist Studies* 7 (Fall 1981): 371–406. Reprinted in *Listening to Silences: New Essays in Feminist Criticism*, ed. Shelley Fisher Fishkin and Elaine Hedges. New York: Oxford University Press, 1994.

Schaub, Thomas. 1991. "From Ranter to Writer: Ellison's *Invisible Man* and the New Liberalism." In *American Fiction in the Cold War*. Wisconsin: University of Wisconsin Press.

Schiffrin, Andre. 2007. *A Political Education: Coming of Age in Paris and New York*. Hoboken, N.J.: Melville House.

Schlesinger, Arthur M. 1949. *The Vital Center: The Politics of Freedom*. Boston: Houghton Mifflin.

Schrecker, Ellen. 1998. *Many Are the Crimes: McCarthyism in America*. Princeton, N.J.: Princeton University Press.

Schroeder, Patricia R. 1995. "Re-Reading Alice Childress." In *Staging Difference: Cultural Pluralism in American Theatre and Drama*, ed. Marc Maufort. New York: Peter Lang.

Schulman, Daniel. 2004. "'White City' and 'Black Metropolis': African American Painters in Chicago, 1893–1945." In *Chicago Modern, 1893–1945: Pursuit of the New*, ed. Elizabeth Kennedy. Chicago: University of Chicago Press/Terra Museum of American Art and Terra Foundation for the Arts.

——. 2009. "African American Art and the Julius Rosenwald Fund." In *A Force for Change: African American Art and the Julius Rosenwald Fund*, ed. Daniel Schulman, 51–80. Chicago: Spertus Museum and Northwestern University Press.

Shapiro, David. 1973. "Social Realism Reconsidered." In *Social Realism: Art as a Weapon*, ed. David Shapiro, 3–35. New York: Frederick Ungar.

Sherwood, Marika. 1999. *Claudia Jones: A Life in Exile*. London: Lawrence & Wishart.

Shiffman, Dan. 2007. "Richard Wright's 12 Million Black Voices and World War II–era Civic Nationalism." *African American Review* (Fall).

Sillen, Samuel. 1949. "Writers and the American Century." *Masses & Mainstream* 51, no. 1 (February): 44ff.

Singh, Nikhil Pal. 1999. *Interrogating Racial Identity and Interracial Relationships in the 1940s and the 1960s*. Commentary. Organization of American Historians, Toronto, Canada.

——. 2005. *Black Is a Country: Race and the Unfinished Struggle for Democracy*. Cambridge, Mass.: Harvard University Press.

Smethurst, James. 1999. *The New Red Negro: The Literary Left and African American Poetry, 1930–1946*. New York: Oxford University Press.

——. 2004. "This Train Takes on Every Nation: Lloyd Brown's *Iron City* and the Cultural Cold War." Paper presented at the ASALH Annual Meeting, Pittsburgh, Penn.

——. 2012. Columbia University Press reader's report.

Smith, Judith E. 2004. *Visions of Belonging: Family Stories, Popular Culture, and Postwar Democracy, 1940–1960*. New York: Columbia University Press.

——. 2012. "Harry Belafonte and the Sustaining Cold War Radicalism of the Black Popular Front, 1949–1960." Address to American Studies Association annual meeting in Puerto Rico.

Smith, Mona Z. 2004. *Becoming Something: The Story of Canada Lee—The Untold Tragedy of The Great Black Actor, Activist, and Athlete*. New York: Faber and Faber.

Smith, Shawn Michelle. 2004. *Photography on the Color Line: W. E. B. Du Bois, Race, and Visual Culture*. Durham, N.C.: Duke University Press.

Solomon, Mark. 1998. *The Cry Was Unity: Communists and African Americans, 1917–1936*. Jackson: University Press of Mississippi.

Stanford, Ann Folwell. 1992. "Dialectics of Desire: War and Resistive Voice in Gwendolyn Brooks's 'Negro Hero' and 'Gay Chaps at the Bar.'" *African American Review* 26, no. 2 (Summer): 197–211.

Steele, Vicky. 1950. "Chicago Southside Hails Prize-Winning Poet." *Daily Worker* (June 2): 9.

Stepto, Robert. 1977. "'I Thought I Knew These People': Richard Wright and the Afro-American Literary Tradition." *Massachusetts Review* 18, no. 3 (Autumn).

Sterling, Dorothy. 2003. *Four Score and More*. Portland, Me.: King Philip.

Storch, Randi. 2009. *Red Chicago: American Communism at Its Grassroots, 1928–35*. Chicago: University of Illinois Press.

Stonor Saunders, Frances. 1999. *The Cultural Cold War: The CIA and the World of Arts and Letters*. New York: The New Press.

Stuckey, Sterling. 1968. "Frank London Brown." In *Black Voices: An Anthology of Afro-American Literature*, ed. Abraham Chapman, 669–676. New York: New American Library.

——. 1969. "Frank London Brown—A Remembrance." Introduction to Frank London Brown's *The Myth Maker*. Chicago: Path.

——. 1997. Interview with author. April 9.

Tate, Claudia, ed. 1983. *Black Women Writers at Work*. New York: Continuum.

Teres, Harvey. 1996. *Renewing the Left: Politics, Imagination, and the New York Intellectuals*. New York: Oxford University Press.

Turner, Beth. 1997. "'Simplifying': Langston Hughes and Alice Childress Remember Jesse B. Semple." *Langston Hughes Review* 15, no. 1: 37–48.

United States Federal Bureau of Investigation. Alice Childress file obtained under provisions of the Freedom of Information Act. Assorted documents dated April 11, 1951–April 9, 1957. File no. 100-104258.

——. Charles White file obtained under provisions of the Freedom of Information Act. Assorted documents dated April 10, 1953. File no. 100-102344.

——. Frank London Brown file obtained under provisions of the Freedom of Information Act. Assorted documents dated Dec. 1955–Dec. 1957. File no. 1074998-000.

——. Lloyd Brown file obtained under provisions of the Freedom of Information Act. Assorted documents dated September 11, 1951–March 16, 1959. File no. 100-24616.

——. Lorraine Hansberry file obtained under provisions of the Freedom of Information Act. Assorted documents dated September 9, 1960. File no. 100-393031-44; New York 100-107297.

Von Eschen, Penny M. 1997. *Race Against Empire: Black Americans and Anticolonialism, 1937–1957*. Ithaca, N.Y.: Cornell University Press.

Wald, Alan. 1994. Foreword to *Iron City*, by Lloyd Brown. Boston: Northeastern University Press.

——. 1995. "Marxist Literary Resistance to the Cold War." *Prospects* 20: 479–492.

———. 2000–2001. "Narrating Nationalisms: Black Marxism and Jewish Communists Through the Eyes of Harold Cruse." *Science and Society* 64, no. 4 (Winter).

———. 2001. *Exiles from a Future Time: The Forging of the Mid-Twentieth-Century Literary Left*. Chapel Hill: University of North Carolina Press.

———. 2007. *Trinity of Passion: The Literary Left and the Antifascist Crusade*. Chapel Hill: University of North Carolina Press.

———. 2012. *American Night: The Literary Left in the Era of the Cold War*. Chapel Hill: University of North Carolina Press.

———. 2013. "'Triple Oppression' to 'Freedom Dreams.'" *Against the Current* (January/February): 24–27.

Washington, Mary Helen. 1987. "'Taming All That Anger Down': Rage and Silence in the Writing of Gwendolyn Brooks." In *Invented Lives: Narratives of Black Women, 1860–1960*, ed. Mary Helen Washington. New York: Doubleday.

———. 1997. "Disturbing the Peace." Presidential Address to the American Studies Association annual meeting. *American Quarterly*. Washington, D.C.

———. 2002. "Review of Alan Wald's *Exiles from a Future Time: The Forging of the Mid-Century Literary Left*. [University of North Carolina Press, 2002]." *Against the Current* (September/October): 41–44.

———. 2003. "Alice Childress, Lorraine Hansberry, and Claudia Jones: Black Women (Re)write the Popular Front." In *Left of the Color Line: Race, Radicalism, and Twentieth-Century Literature of the United States*, ed. Bill V. Mullen and James Smethurst, 183–204. Chapel Hill: University of North Carolina Press.

———. 2005. Foreword to *Trumbull Park*, by Frank London Brown. Lebanon, N.H.: Northeastern University Press/University Press of New England.

———. 2007. "Review of Alice Childress's A Short Walk." *Obsidian: Literature in the African Diaspora* 8 (Spring/Summer): 154–161.

———. 2011. "Review of Dayo Gore, *Radicalism at the Crossroads: African American Women Activists in the Cold War* [New York University Press, 2011], and Erik McDuffie, *Sojourning for Freedom: Black Women, American Communism, and the Making of Black Left Feminism* [Duke University Press, 2011]." *Women's Review of Books* (July).

———. 2013. "Review of Barbara Ransby's *Eslanda: The Large and Unconventional Life of Mrs. Paul Robeson* [Yale University Press, 2013]." *Women's Review of Books* (July/August).

Watts, Daniel H. 1970. "Big Brother." *Liberator*. (December): 3.

Weigand, Kate. 2001. *Red Feminism: American Communism in the Making of Women's Liberation*. Baltimore, Md.: Johns Hopkins University Press.

West, Anthony. 1959. "Books." *New Yorker* (April 25).

Wexler, Laura. 2003. *Fire in a Canebrake: The Last Mass Lynching in America*. New York: Scribner.

White, Charles. 1952. "Eyewitness Report on Soviet Art by an Outstanding Negro Painter." *Daily Worker* (November 23).

———. 1955. "Path of a Negro Artist." *Masses & Mainstream* (April): 33–42.

White, Walter. "Has Science Conquered the Color Line?" *Negro Digest* (December 1949): 37–40. Reprinted from *Look*.

Wideman, John Edgar. 1976. "Frame and Dialect: The Evolution of the Black Voice in American Literature." *American Poetry Review* 5, no. 5 (September–October): 34–37.

Wilford, Hugh. 2008. *The Mighty Wurlitzer: How the CIA Played America*. Cambridge, Mass.: Harvard University Press.

Williams, Laura C. 2012. "Brave New Narratives: Postrace Identity and the African American Literary Tradition." Ph.D. diss., University of Maryland, College Park.

Wixon, Douglas. 1998a. "'Black Writers and White': Jack Conroy, Arna Bontemps, and Interracial Collaboration in the 1930s." *Prospects* 23: 401–430.

——. 1998b. *Worker-Writer in America: Jack Conroy and the Tradition of Midwestern Literary Radicalism, 1898–1990*. Bloomington: University of Illinois Press.

Wright, Richard. 1937. "Blueprint for Negro Writing." In *Norton Anthology of African American Literature*, 2nd ed., ed. Henry Louis Gates Jr. and Nellie Y. McKay, 1403–1410. New York: Norton, 2004.

——. *Native Son*. 1940. New York: Harper Perennial, 1996.

——. 1956. *The Color Curtain: A Report on the Bandung Conference*. New York: World.

——. 1957. "Literature of the Negro in the United States." In *White Man Listen*, 104–105. New York: Anchor, 1964.

Young, Coleman. 1952. Report of Coleman Young to National Negro Labor Council. Ohio Historical Society Selections. Unpublished manuscript. November 21, 1952. PA box 7301.

INDEX